European Con Driving Licence Coursebook

Gateway Centre for Information Technology

Sivakumar Sunderalingam
Melani Thomas
Ruwini Perera
Hareendra Maithripala
Merill Fernando
Manjeewa Silva
R. Dharmapalan
B.L.V. Annesley

Published in 2001 by:
Nelson Thornes Ltd
Delta Place
27 Bath Road
CHELTENHAM
GL53 7TH
United Kingdom

 02 03 04 05 / 10 9 8 7 6 5 4 3 2

A catalogue record for this book is available from the British Library

ISBN 0 7487 6038 5

Illustrations by Derek Griffin and GreenGate Publishing Services
Page make-up by Greengate Publishing Services

Printed and bound in Italy by Canale

Contents

Foreword

The computer is a major part of society today. Every institution has some sort of computer and society is changing from depending on one another to depending on the computer for everything. Nobody wants to be left behind in the computer revolution. Nobody wants to be left out of something that is going on in everyday life.

Twenty years ago the toughest exercise was just locating information. Often, hours were spent at the local library combing through card catalogues and shelves. Today, with advances in information and communication technology (ICT), finding information is easy. Developing ICT skills, therefore, is becoming an essential component in everyday life.

The European Computer Driving Licence (ECDL) syllabus is designed to cover the key concepts of computing, their practical application and their use in the workplace and society in general. The ECDL is open to everyone – regardless of age, education, experience and background.

The ECDL is growing at a rapid rate with over 600 000 candidates worldwide. The ECDL is a Europe-wide qualification which has been designed specifically for those who wish to demonstrate their competence in the use of information and communication technology. The ECDL was developed by the Council of European Informatics Societies (CEPIS), with the support of the European Commission, and is administered in Britain by the British Computer Society (BCS). Candidates are given a logbook listing all the modules at the time of registration for the examination. The modules may be taken in any order and over any period of time – even all at once – offering maximum flexibility. When all modules have been successfully completed, the logbook is exchanged for a certificate from the BCS.

The ECDL is broken down into seven modules, each of which must be completed successfully before the ECDL certificate is awarded. This book provides everything you need to acquire the necessary skills to be successful in all modules. The book is designed for absolute beginners and provides step-by-step guidance for you to develop expertise in every module. Further, tutorials given at the end of each module help you to reinforce your skills and prepare for the tests.

We have used Microsoft Office 2000 as the engine to learn the skills required for the ECDL. The book will no doubt serve as a learning manual for Office 2000 applications too. In certain modules, we have gone beyond the requirement of the ECDL to make sure that we have left no gaps in the knowledge and skills needed to be ICT competent and to be confident in using Office 2000 applications.

ECDL Modules and the application software used

Module 1

Basic concepts of IT (theory)

Module 2

Using the computer and managing files (using MS Windows 2000 and 98)

Module 3

Word processing (using MS Word 2000)

Module 4

Spreadsheets (using MS Excel 2000)

Module 5

Database (using MS Access 2000)

Module 6

Presentation (using MS PowerPoint 2000)

Module 7

Information and communication
(using the Internet and e-mail)

Acknowledgements

The authors and publisher wish to thank Alison Groombridge for her subject advice and expertise in the development of this book. Alison has taught IT skills courses in colleges and schools (in South Yorkshire and Derbyshire). Whilst on the ICT team at AQA she worked on ICT subjects from Entry level to GCE A level. Alison is now an ICT tutor for a national training provider.

Screenshots and other Microsoft copyright material reprinted by permission from Microsoft Corporation. Microsoft and its products are registered trademarks or trademarks of Microsoft Corporation in the United States and/or other countries.

Photo credits

Iiyama (page 14)
3M (page 18)
Science Photo Library (page 33, top)
Hildigunnur Churchman (page 33, bottom)

MODULE 1

Basic concepts of IT

SECTION 1 | Introduction

Computers were initially developed to be calculating devices that could calculate at very high speeds. Since 80% of the work done on a computer is of a non-mathematical nature, it cannot merely be regarded as a calculating device. A computer is really a device that operates upon information or data.

Data can be anything, such as

- names of students and their weekly test marks
- personal information about the employees in a company
- details (name, age, sex, etc.) of passengers if the computer is employed for making airline or railway reservations
- numbers and symbols used in the application of computers for scientific research problems.

Input→process→output

All tasks can be categorised into three main steps: input, process and output. Figure 1.1 shows the order in which they are performed.

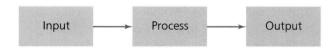

Figure 1.1 *Three stages of performing tasks*

Here are some examples of tasks and how they can be broken down into these stages.

Example 1 What is a student's average mark and what is the grade?

To calculate the average mark, you need to know the total number of subjects taken at the exam and the marks for each subject.

The tasks are:

Input the subject marks and the number of subjects taken.

Process add all the subject marks and divide by the number of subjects done; this will give us the average mark.

Output the answer should be written on a piece of paper; this is the output.

One way of showing how we calculated the average mark would be to use a diagram as shown in Figure 1.2.

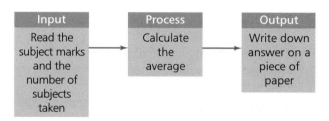

Figure 1.2 *Calculating the average mark*

Example 2 Preparing an employee's payslip

To do this task we need to ask the three data processing questions.

Input – what data do we need?
To prepare a payslip we would need this data:

 employee name
 employee number
 number of hours worked
 rate per hour.

Process – what do we do with this information?
To work out the total salary of the employee we have to multiply the rate for an hour with the number of hours worked.

Output – how do we present the answer?
The payslip is printed out on paper. It has the following information on it:

month
employee name
employee number
number of hours worked
rate per hour
total salary for the month.

Characteristics of computers

1 **Speed.** A computer is a very fast device which can perform many operations in the blink of an eye. To put it in a different way, a computer does in one minute what could take a person their entire lifetime.

When discussing the speed of a computer, we do not talk in terms of seconds or even milliseconds (1 ms $= 10^{-3}$ s or 0.001 s). Instead we measure in microseconds (10^{-6} s or 0.000001 s), nanoseconds (10^{-9} s or 0.000000001 s), and even picoseconds (10^{-12} s or 0.00000000001 s). A powerful computer is capable of performing about three to four million simple arithmetic operations per second.

2 **Accuracy.** Computers are very accurate; the degree of accuracy of any particular computer depends upon its design.

If the data input to the computer is wrong ('garbage in') the result it produces will be wrong ('garbage out'). This is called the GIGO (garbage in garbage out) principle.

3 **Power of remembering.** As a human being acquires new knowledge, the brain subconsciously selects what it feels to be important and worth retaining, and forgets the unimportant details.

With computers, this is not the case. Every piece of information is retained as long as desired by the user and can be recalled as and when required. Even after several years, the information recalled will be as accurate as on the day it was fed to the computer. A computer forgets or loses certain information only when it is asked to do so. So it is entirely up to the user to make a computer retain or forget a particular piece of information. A computer has this ability because of its secondary storage capability.

4 **No intelligence.** A computer is not a magical device. It can only perform tasks that a human being can. The difference is that it performs these tasks with unthinkable speed and accuracy. It possesses no intelligence of its own; its IQ is zero (at least at present). It has to be told what to do and in what sequence. Hence only the user can determine what task a computer will perform. A computer cannot make its own decisions in this regard.

5 **Interactivity.** A computer is interactive. It always responds to what you do.

6 **Programmability.** A computer is versatile. It functions with the software with which it has been loaded. The same hardware can serve as a message centre, wordprocessor, file system, image editor or presentation display.

Different types of computer

Computers are classified into several kinds by their memory capacity, their speed and the kind of jobs they are used for. They are mainly categorised into micro, mini and mainframe computers.

Microcomputer

Most microcomputers are 'desktop models' which range in price from a few hundred pounds to well over ten thousand pounds. They are usually accompanied by a single keyboard and printer, have one or two hard disk drives and may be connected to a network in a school, college or office. By using a telephone connection and a modem, the microcomputer user can be connected to the Internet and so can reach the most powerful information source the world has ever known.

Minicomputer

A minicomputer is a medium-sized computer; it can be anything from a very large and powerful micro to a small mainframe. A minicomputer system is where ten to fifty users are connected to one central processing unit (CPU). Such a

system is ideal for use in a single department within a college or university, or for use in a medium-sized business. Minicomputers are really small versions of the mainframe computer, and this was why the term mini was originally applied. The mini has been designed with multi-user access in mind, and is therefore usually easy to expand at least up to a certain maximum number of users.

Mainframe computer

Mainframes are the largest of the computer systems, (but not necessarily the fastest or most powerful) – they certainly won't fit on the top of your desk! It is common to have hundreds of simultaneous users on such a system. There is usually a vast amount of RAM, and many extra peripherals, such as tape and disk machines.

Laptop computer

Portable power came of age towards the end of the 1980s. Some laptop portables now have the same capacity as some of the larger microcomputers. In 1994 Intel's powerful Pentium processor found its way into portables too. Sixty four or 128 megabytes of main memory, together with a medium-capacity hard

disk and colour monitor were commonplace by 2000. In addition to this, the laptop portable can have sophisticated communication facilities. It is these portables that have revolutionised the way in which many people use their computers. If you have a computer available wherever you are, then you are most likely to make use of it.

Network computer

A network computer is one that is connected to a network (a number of other computers) either through a local area network or a wide area network (these terms will be discussed in detail in Section 4). Printers and hard disks can be shared within a network. A network computer can do jobs alone as well as on the network.

The difference between a dumb terminal and a smart terminal is that a smart terminal has a microprocessor. Smart terminals are useful because they can carry out a lot of information processing that otherwise would have to be done by the main computer. With a dumb terminal, you have to wait for the server to process your data, which is bad because: (a) it could result in a much greater volume of data to be transferred; and (b) the server (the main computer) could be trying to do that processing for hundreds of dumb terminals concurrently.

Laptop computers are becoming increasingly sophisticated and are now often used to replace desktop models

1 Why is it wrong to define a computer as merely a 'calculating machine'?

2 Which of the following is the most suitable definition of a computer:
 a a calculating device that can perform arithmetic operations at a very high speed
 b a device that operates upon information or data
 c a very accurate calculating device?

3 What are the three stages into which any task can be split?

4 The following chart is displayed relating to a one day cricket match. What are the raw data that are fed into the computer to prepare this chart?

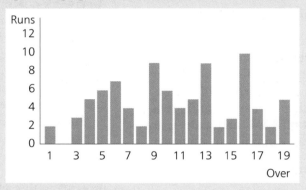

5 Write down the input, process and output for the following tasks:
 a students take three papers in an exam and the examination results (average, grade) are prepared using a computer
 b a retail shop owner uses a computer to prepare an invoice.

6 What characteristics of the computer have led to its widespread use?

7 What are the main characteristics of a computer?

8 What gives the computer the ability to remember any detail?

9 What does GIGO mean?

10 Why do errors occur in computers?

11 Write down the main types of computers in use.

12 What is the difference between a dumb terminal and a smart terminal?

Section 2 | Basic concepts of IT

Hardware

Hardware is the term used for the physical parts of a computer that can be seen and touched. This includes input devices (e.g. keyboard), the system unit and any output devices (e.g. monitors and printers). Figure 1.3 illustrates how these parts are linked together in a computer system.

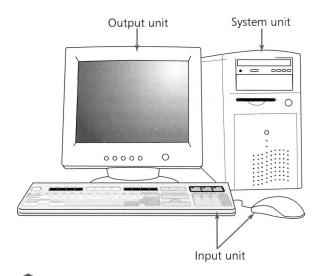

Output unit System unit

Input unit

Figure 1.3 *A simple computer system*

Input unit

Data and instructions are entered into the computer through the input unit. Therefore we can say that the input unit links the external environment with the computer system.

The following are all input devices:

- keyboard
- mouse
- tracker ball
- joystick
- light pen
- touch screen
- barcode reader
- optical character reader
- microphone
- scanner
- digital camera.

Output unit

The job of an output unit is just the reverse of that of an input unit. It supplies information and results of computation to the outside world. Thus it links a computer with the external environment.

The following are all output devices:

- visual display unit (VDU)
- printer
- plotter
- speakers.

System unit

The system unit is the central part of your computer system. It contains the following parts:

- central processing unit (CPU)
- disk drives
- power supply unit.

Central processing unit (CPU)

In order to work, every computer needs a 'brain' or a 'CPU'. At the core of every computer is a device roughly the size of a large postage stamp. This device is known as the central processing unit, or the CPU for short. This is the 'brain' of the computer: it reads and executes program instructions, performs calculations and makes decisions. The CPU is responsible for storing and retrieving information on disks and other media. It also handles information from one part of the computer to another like a central switching station that directs the flow of traffic throughout the computer system.

Disk drives

Disk drives provide a means of saving and retrieving your programs and data. There are two kinds of disk drives: diskette drives and hard disk drives. Diskette drives use removable diskettes to save and retrieve information. The fixed disk drive allows you to save greater amounts of information than you can save on a diskette.

Power supply unit

The power supply unit transforms the alternating current from the mains into direct current that the computer can use. Often a fan is built into the power supply unit, as the device can become quite warm.

Software

What is software?

A computer cannot do anything on its own. It works to pre-defined instructions that the programmer has installed in its system. Therefore all the problems are solved using these instructions or using instructions installer by the user. These instructions are written in a form that the machine can understand (machine language).

The general name given to all the computer programs is software. Software can be divided into two types: application software and systems software.

Application software

These are software that have been designed for a particular purpose.

Examples
- A payroll package – this produces payslips as the major output.
- Examination results processing package – this produces mark sheets as its main output.
- A wordprocessing package – this enables you to prepare a document.
- Programs written by scientists to solve their particular research problem.

These programs are known as application programs and the person who prepares application programs is known as an application programmer.

Systems software

Systems software controls the performance of the computer system. It is usually provided by the manufacturer and has three aims:

- to make the best use of the hardware
- to provide for common functions such as

program language translation, copying, disk clean-up and disk defragmentation, etc.
- to provide a simple interface between the user and the computer.

System software includes:

- operating systems – e.g. Windows, Unix
- compilers (which translate high level language into machine code)
- utilities – Scandisk, backup programs, etc.

Operating system (OS)

The most important piece of system software is the operating system. It controls the general operation of the computer. In other words the OS consists of one or more programs that directly control the hardware. For instance, the OS controls the operation of disk drives so that you need not worry about how data is stored on the disk and whether there is enough space to store further data.

Without an operating system, a computer would be useless, so the first thing a computer looks for when it is switched on is the operating system. Once the operating system has been found, the computer loads it into its main memory (RAM) from the disk. (The start-up process is explained in detail in the following section.)

Operating environments

Functions performed by an operating system include:

- controlling the use of peripherals such as disk units and printers
- loading and controlling the running of other programs (e.g. application programs)
- managing the main store (main memory) – this has to be shared between the OS and the user's programs
- providing an interface for the user to communicate with the computer system.

The start-up process of a computer

1 When the power is turned on a computer carries out a test (this test is called the POST – power on self test) to check whether its own components work properly. If any of its main components are not working an error message will be displayed.
2 Then the computer loads the operating system into its main memory from the disk (or diskette). This process of loading the operating system into memory is called the 'booting up' of the computer.
3 After the operating system is loaded the computer executes the commands in some special files (such as WIN.INI, CONFIG.SYS and AUTOEXEC.BAT in the Windows operating system), which set up the computer so that it can be used.

User interfaces

The user interface is what you see when you turn on a computer. It consists of the cursors, prompts, icons, menus, etc. which allow you to get something done by your computer. The user interface should be as easy to use as possible.

The following factors should be taken into account when designing a user interface for a program:

- use clear and simple language with no technical terms
- use easy-to-understand menus
- do not display too much text on the screen at the same time
- use easy-to-use help functions.

Basically there are two types of user interface:

- command-driven
- graphical user interface – GUI

Command-driven interfaces

With a command-driven interface you type in an instruction in order to get something done. These interfaces are not easy to use. If you are new to the interface software, you have to remember many commands to use the software quickly. Commands for different software packages are rarely the same, so people often get the commands mixed up.

If a command is not entered properly the user gets an error message stating that the command is incorrect. Figure 1.4 illustrates this with an example. When the correct command (*dir/w*) was entered the directory listing was shown but when the user typed an incorrect command (*show directories*) all the user saw was an error message.

```
C:\> dir/ w
Volume in drive C: has no label
Volume serial number is 1DF4-1D18
Directory of C:\
[ACDSEE32]        [NEWMP3]
[PROGRAMS]        [WINDOWS]
[MY DOCU~1]       [HAREEN]
[LETTERS]         [WINZIP]
DIPLOMA.DOC
   1 file(s) 23,345 bytes
  14 dir(s) 236,234,345 bytes free
```

Figure 1.4 *A command-driven interface*

Graphical user interface (GUI)

A graphical user interface is where the user communicates with the computer through pictures called icons and through pull-down menus. Microsoft Windows is an example of a GUI. It is a common way of using programs, which makes them easier to learn. Apple Macintosh computers were the first to use a GUI.

Advantages of GUIs

- It is easier to select an icon or a menu option than to type a command.
- The user does not need to remember the commands.
- Normally all programs have the same standardised format. Therefore, for example, it is easier to learn a new program if one has used Windows programs before (e.g. a 'software suite' which includes spreadsheets and wordprocessing software).

Multimedia

Multimedia is the term used for a collection of text and graphics with motion and sound, including video, audio, animation and photographs. It allows the user to interact with the software by using either a mouse or a keyboard.

A multimedia system consists of an ordinary PC, a CD-ROM drive, a sound card and speakers. Multimedia would be impossible without the technology of CD-ROM, because of the large storage capacity needed for photographs, animation and video clips.

Multimedia applications include:

- encyclopedias
- self-study programs
- games
- presentations
- movies and music videos.

Multimedia encyclopedia on CD-ROM

The advantage of having encyclopedias on CD-ROM is the very small amount of space that they take up. A paper-based encyclopedia which consists of 20 volumes might only occupy one CD-ROM in its multimedia version.

Searching for information on a CD-ROM takes only seconds. For example, to search for information on 'computers' you simply type in the word 'computer', and a list of articles that mention computers is displayed on your screen. If the same information had to be found in the paper-based version then the book containing 'C' has to be found and then the correct page, which may take a number of minutes.

Along with the text there are other added features such as video clips, with speech, of historic moments such as man's landing on the moon. You can also see animations showing how things work, such as the human heart.

Computer-aided learning (CAL)

Multimedia software can be an ideal teacher. Learning boring topics can be fun using multimedia. Computer-aided learning can be used to instruct pupils and then test them on what they have learnt.

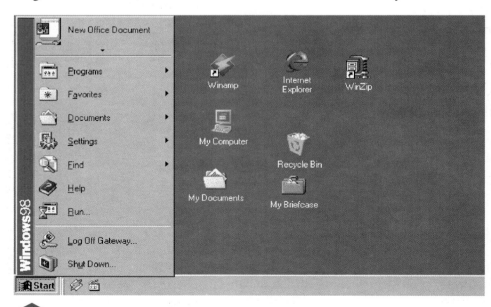

Figure 1.5 *The GUI of Microsoft Windows*

Basic units of stored data

Computers work by using pulses of voltage, which represent either the digit 0 or the digit 1. A low voltage pulse (0 V) represents a 0 and a high voltage pulse (5 V) represents a 1. Since there are only these two states in a computer, it is called a bistable device.

Bistable devices are used in computers because such devices are cheap, quick, reliable and take up only a small amount of space and energy. For this reason the binary number system, which uses the two digits 0 and 1 (for 'on' and 'off') is most suited to computers.

Bits and bytes

A bit (or a **bi**nary dig**it**) is a 1 or a 0 used to represent data. One byte contains eight bits. In most cases eight bits are needed to store one character. So a single character (letter, number or symbol on the keyboard) can be stored in one byte. The following example shows how the word 'dove' is represented in a computer.

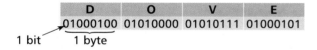

The binary code for the word 'DOVE'

ASCII Table

Computers use the ASCII code (American Standard Code for Information Interchange) to represent characters. In this code each character is always represented by the same order number. For example, in ASCII code the capital letter A is always represented by the order number 65, which is easily representable using 0s and 1s in binary (it is: 1000001).

English Letter	ASCII Code
A	01000001
B	01000010
C	01000011
D	01000100
E	01000101
F	01000110
G	01000111
H	01001000
I	01001001

An ASCII table for the letters a to i:

We normally refer to storage capacities in terms of kilobytes (Kb) megabytes (Mb) or gigabytes (Gb):

8 bits	=	1 byte
1 Kb	=	1024 bytes
1 Mb	=	1024 Kb
1 Gb	=	1024 Mb

Records and files

Files are data or programs, which are stored in backing storage such as on a disk or tape.

Any of the following can be regarded as a file once it has been saved:

- a word document
- a spreadsheet
- a presentation saved on disk
- a computer drawing.

A file consists of records. Records are items of data which together can be treated as a unit. The items all relate to one person or subject. All the records in a file are set out in a similar manner.

An employer will have several files for each employee. Examples of these files might be:

- **A personal details file.** Each record in this file will hold details about each employee, his or her name, employee number, address, etc.
- **A salary file.** Each record in this file contains all the data about the employee's salary: employee number, monthly salary, deductions, additions, etc.

The table below illustrates an employee personal details file. Each line of the file is called a record.

Name	Address	Date of birth
David Brown	20, College Rd, London	09/09/75
Sam Mills	34, Downing St, Manchester	28/07/75
Imran Careem	19, Church Rd, London	17/11/75
Steven Collins	56, School Rd, Oxford	01/01/76

TUTORIAL 1.2

1 What is meant by computer hardware?

2 Name three of the main hardware components.

3 List three different input devices.

4 List three different output devices.

5 Explain in your own words the following terms:
 processor, disk drives, power supply unit.

6 What are the parts contained inside the system unit?

7 Why does the power supply unit have a fan built into it?

8 What is a computer program?

9 What is meant by software?

10 Software is generally divided into two broad categories. What are they?

11 Here is a list of programs. Write down which category each of the programs belongs to:
 - a payroll program
 - a program which controls the keyboard
 - programs which control the disk drives
 - a car race
 - a program that processes examination results
 - programs that control the mouse
 - a compiler (a program that converts English-like instructions into machine code)
 - a virus scanner.

12 List the functions performed by the operating system.

13 Describe the start-up process of a computer.

14 What is a user interface and what are the factors that should be taken into account when designing the user interface of a program?

15 Why is it difficult for a beginner to learn a command-driven interface?

16 What is meant by a 'graphical user interface'?

17 What are the advantages of using a GUI?

18 What is meant by multimedia?

19 Why would multimedia be impossible without the technology of CD-ROM?

20 List three multimedia applications.

21 Why is a computer called a bistable device?

22 How are 0 and 1 represented in a computer?

23 Explain the following terms:
 bit, byte, record, file.

Section 3 | Hardware

Basic organisation of a computer

All computer systems perform the following five basic operations:

1 **Inputting.** The process of entering data and instructions into the computer system.
2 **Storing.** Saving data and instructions so that they are available for processing as and when required.
3 **Processing.** Performing arithmetic operations or logical operations on data (comparisons like 'equal to', 'less than', etc.) in order to convert the data into useful information.
4 **Controlling.** Directing the manner and the order in which operations are performed.
5 **Outputting.** Producing useful information or results for the user, in the form of a printed report or visual display.

The basic organisation is the same for all computer systems. A block diagram of the basic organisation of a computer is shown in Figure 1.6.

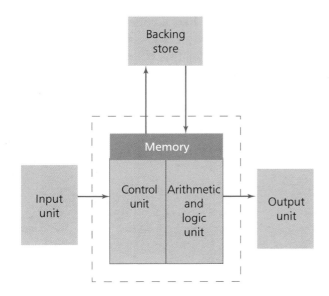

Figure 1.6 *Block diagram of a computer system*

Central processing unit (CPU)

The central processing unit can be divided into three main parts:

■ control unit
■ arithmetic and logic unit
■ main memory.

Arithmetic and logic unit (ALU)

The ALU of a computer system is the place where the execution of instructions takes place during the processing operation. All calculations are performed and all comparisons made within the ALU.

ALUs are designed to perform the four basic arithmetic operations (addition, subtraction, multiplication and division) and logic operations or comparisons, such as 'less than', 'equal to' or 'greater than'.

Control unit (CU)

The control unit controls and directs the operation of the entire computer system. Although it does not perform any actual processing on the data, the control unit acts as a central nervous system for the other components of the computer.

It obtains instructions from the program stored in main memory, interprets the instructions, and issues signals that cause other units in the system to execute them.

Memory

There are two types of memory:

■ random-access memory (RAM)
■ read-only memory (ROM).

Memory consists of a group of 'chips' made up of tiny electronic components. The data is held here temporarily, while processing takes place. The computer is able to access the data more quickly when it is held in the memory than when it is in backing storage.

Memory chip

Random access memory (RAM)

All running programs and their data are temporarily stored in RAM. Programs can both read from and write to RAM. In general RAM is volatile, i.e. information is lost when the power is turned off.

RAM is used:

- as the temporary store for programs which are running and data that is being used (e.g. if we are wordprocessing a document the RAM holds the wordprocessing programs, the document which is being typed and the operating system programs)
- to store data being transferred to and from peripherals
- to store output data, that is data ready to be sent to an output unit.

Since RAM is volatile any data stored is erased if there is a power failure. The following steps could be taken to guard against the loss of data in such situations:

- use a UPS (uninterrupted power supply) device, which contains a battery and so allows the computer to operate a few minutes after the power is lost. Users then have enough time to save their work on disk and turn off the computer
- save data onto hard/floppy disk regularly; this will minimise the loss of data.

Read-only memory (ROM)

ROM is used to store data or programs that are permanent. The information is generally put on the storage chip at the manufacturing stage and the contents of the ROM cannot be changed except under special circumstances. So a computer can read information stored in ROM but cannot write to it. ROM is non-volatile; information stored in ROM remains when power is removed from computer. Read-only memory is accessed randomly.

ROM is used:

- to store frequently used programs essential to the normal running of a computer
- to store the 'bootstrap program' – this is the program that tells a computer how to load the operating system from disk to RAM.

Input devices

Input devices are used to transfer data from the external environment to the computer system. The ideal input device takes the least amount of time and transfers the data accurately with very little help from the user. The device should also be inexpensive.

The input unit:

- accepts or reads data or instructions from the external world
- converts them to a format in which they can be handled by the computer
- submits them for further processing.

Keyboard

The keyboard is the most commonly used input device and has been used since computers were first introduced. They are intelligent devices and contain their own chips. Each key is a switch, which closes when that particular key is pressed.

The microprocessor scans the keyboard hundreds of times a second to see if a key has been pressed; if it has, a code that corresponds to that key is sent to the processing unit. The CPU then translates this code into the ASCII code (the code that computers use to represent characters on the computer keyboard), which is then used by the computer program.

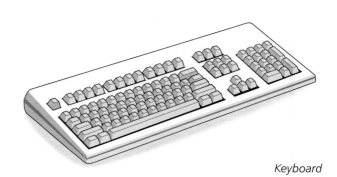

Keyboard

Mouse

A mouse is another popular input device that forms an essential part of a computer system. Its movements on the desktop are translated into digital information which in turn is fed to the computer, causing the cursor to move on the screen. Underneath the mouse there is a ball which rotates when the mouse is moved by the user and sensors pick up this movement. A mouse usually has two or three buttons, and these are used to make selections on the screen.

A mouse

Trackball or tracker ball

A trackball is an upside-down mouse. The mechanism is similar to the mouse except that the user rotates the ball and the 'mouse' stays still. Compared with a mouse, a trackball, takes up much less space, which is why trackballs are often used in laptop computers. Some people with certain physical disabilities find trackballs easier to use than other input devices.

A trackball

Joystick

A joystick is similar to a trackball. The cursor moves on the screen according to the way the stick is moved. Joysticks are mainly used for games, and also to target scanners in hospitals.

A joystick

Scanner

Scanners are input devices normally used to scan text or pictures. The scans are then stored in a computer's memory where they can then be accessed and modified using a desktop publishing package, before being printed. Scanners can be cheap, hand-held ones or flatbed types. Both black and white and colour scanners are available.

Optical character recognition (OCR) is where text on a page is scanned and then converted and fed into a wordprocessing package so that it can be modified according to the needs of the user. Scanners often come with OCR software. OCR nearly always fails to recognise certain characters, be they handwritten, typed fonts or symbols.

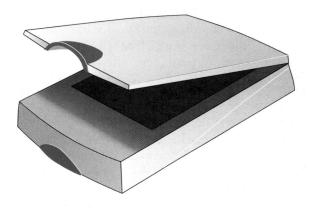

A flatbed scanner

Touch screen

A touch screen is a screen that is sensitive to touch. A selection can be made from a menu on the screen by touching part of it. These screens are used in banks, where customers who are not used to keyboards can obtain information about the services offered. You can also find touch screens in restaurants and bars. They provide a quick and efficient mode of data input.

Although this looks like a conventional computer monitor, this display includes additional components to make the screen touch-sensitive

Light pen

A light pen is another input device that can be connected to a computer. The 'pen' is used to select a point on the screen. The screen is refreshed about fifty times a second by a point of light travelling rapidly across it. A light pen can be used in design work (e.g. CAD) for drawing figures, lines, etc.

Barcode readers

A barcode consists of a set of parallel lines of differing thickness, often black and white, which represents a number. Often the number represented by the bars is also printed above or below the barcode. The reader scans the lines, and converts this to a number that can be stored and processed within the computer.

Barcodes can be read by:

- a hand-held 'wand', which is passed over the barcodes
- a stationary scanner, which scans as the barcode is passed over it.

When barcodes are used on shop goods, the number coded usually contains the following details:

- country of origin
- manufacturer
- an item number for the product.

Note that the price is not usually included in the barcode. This is because prices often change. Instead, the price is stored in the computer and when the price is needed it is accessed from there.

Barcodes are used in supermarkets, libraries, luggage handling systems at airports and warehouse stock control systems. Barcode readers are now able to read the barcodes at distances of five metres or more. This increased range has increased the number of applications.

A barcode

Magnetic ink character recognition (MICR)

Magnetic ink characters are the numbers you see at the bottom of cheques. Characters are printed using a magnetic ink. As the document passes through the reader the ink is magnetised and the characters are recognised by the strength of their magnetism.

Most European banks use MICR to encode the following information at the bottom of cheques:

- cheque number
- branch number of the bank
- customer account number.

The Best Bank

Pay _____ Only _____

£ []

⑈ 100342⑈ 45⑃3512⑊ ⑈ 25364850

A cheque, showing magnetic ink characters along the bottom

Optical character recognition (OCR)

OCR is useful as it converts text on paper to an electronic format that can be edited, using wordprocessing software. An optical character reader can recognise characters from their shape. Text is input using a scanner, and special OCR software converts the scanned image into standard ASCII code. After converting a scanned image (of a text document) into characters, the document can be edited using wordprocessing software.

OCR systems often fail to recognise hand-written characters and characters in unusual fonts. They can also confuse letters, particularly if the print is of poor quality (e.g. 'e' is mistaken for 'c' if the type is pale or broken).

Optical mark reader (OMR)

Optical mark readers are used to sense marks made in certain places on specially designed forms. Mark readers are used in multiple choice answer sheet marking, and capturing data from questionnaires and enrolment forms.

Multiple choice answer sheet

Instructions
Use soft pencil
Mark only one oval for each question
If a mark is wrong, mark the rectangle above it

1 A ⊠ B ⊠ C ▭ D ▭
 ⬭ ◯ ◯ ◯

2 A ▭ B ▭ C ▭ D ▭
 ◯ ◯ ◯ ◯

A typical multiple choice question answer sheet

Voice recognition

Voice recognition is the process of taking the spoken word as input to a computer program. While the concept could more generally be called 'sound recognition', we focus here on the human voice because we most often and most naturally use our voices to communicate our ideas to others in our immediate surroundings.

In the context of a virtual environment, the user would presumably gain the greatest feeling of immersion, or being part of the simulation, if they could use their most common form of communication, the voice.

At present voice recognition does not give good results

Smart cards

A smart card is a plastic card, which has its own processor and memory. One card can store about 8000 characters. Among the information stored in the card is the holder's identification data. These cards are used in a variety of applications such as:

- **Authorising personnel to enter a high security zone** – the user inserts the smart card into a reader and enters the password. If

the password matches with the information stored in the system, the user is able to enter the premises. The smart card can be programmed to self-destruct if the wrong password is entered too many times.

- **Telephone and transport cards** – the card is inserted into the telephone and the relevant amount deducted from the value of the card after the call.
- **Credit cards** – the card holds its owner's identification data and credit limit. It can also record any transactions made using the card.

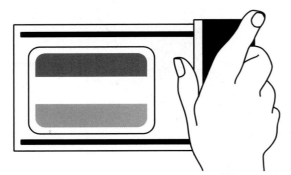

A smart card reader

Output devices

Output devices are used to obtain soft copies (what we see on the screen) or hard copies (printouts) of the results of processing. With the widespread use of electronic mail, output can also be in the form of an electronic message to another computer.

Display screens (monitors)

The most common form of output is the computer screen. It is more correctly called the 'monitor' and sometimes referred to as the visual display unit or VDU.

The 'clearness' of a computer screen is measured as its resolution. Screens are normally classed into different groups: low resolution, medium resolution and high resolution. High-resolution monitors use more pixels than low resolution ones. A pixel is the 'picture element' and refers to the smallest area of the screen that the computer can change.

The quality of a computer monitor is based on the following properties:

- its resolution
- the number of possible colours that can be displayed (although this also depends on the computer to which it is connected)
- its size (most monitors are described as 15 inch, 17 inch and 21 inch)
- its energy consumption and radiation output.

Different types of display screen

- **Standard television set** – an ordinary home television can be used for computer output.
- **Standard computer monitor** – these have higher resolution than TVs. Larger monitors with high resolution are used for specialised applications such as desktop publishing and CAD.
- **Liquid crystal display (LCD)** – these are screens made from two glass/plastic plates with liquid in between. LCDs are commonly used for calculators and laptop computers, as they are far flatter than is possible with cathode ray screens used in TVs and standard computer monitors.

A standard computer monitor

Printers

There are many different types of printer used for computer output. We will consider three types in this section:

- dot-matrix printers
- inkjet printers
- laser printers.

Dot-matrix printers

Dot-matrix printers work by firing a matrix of tiny pins (which are located in the print head), through a ribbon similar to that found in a typewriter. Such printers are cheap and have the lowest running cost of any other type of printer. As the head moves across the paper the correct pins are fired out to hit an inked ribbon and form the shape of the character required. The greater the number of pins, the higher the quality of the print.

Nine-pin dot pattern for the letter B

Dot-matrix printers are impact printers and are used to print multi-part stationery. So to print several copies of a document at the same time you will need to use a dot-matrix printer.

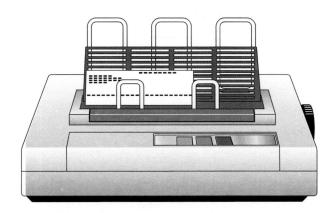

A dot-matrix printer

Inkjet printers

Inkjet printers can produce high quality text and graphics. They are quieter than dot-matrix printers. The technology involves ink flowing through the appropriate nozzles (usually in an array of 64) where it is then heated and a bubble formed. This expands to release a tiny droplet of ink onto the paper.

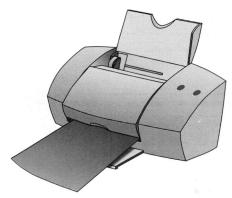

Inkjet printer

Laser printers

These non-impact printers offer high-speed printing and excellent quality text and graphics. A laser beam is used to form an image on a rotating, charged metal drum. This then picks up toner from the toner cartridge and transfers it onto paper. Very soon afterwards heat and pressure are applied so the toner sticks to the paper.

Since they are page printers they are very fast. The speed of a laser printer is typically about eight pages per minute. Colour laser printers are now available. They are mainly used for desktop publishing. Although they are expensive, they are likely eventually to come into widespread use.

Laser printer

Graph plotters

These are devices used for producing graphical output on paper, in particular plans, maps, line diagrams and three-dimensional drawings. Graph plotters use pens to produce images and different pens containing different coloured inks can produce multi-colour charts.

Plotters can be classified as pen plotters or as penless plotters. Penless plotters use various different technologies. At the moment high quality work for publication is done on electrostatic plotters.

A flatbed plotter

Computer output on microfiche (COM)

Computer output on microfiche is like ordinary printing but smaller and is recorded on high quality film. Microfiches are rectangular sheets containing a number of pages of data (typically 30 to 300) on each sheet. COM allows a large amount of data to be stored in a small space.

Voice synthesis

Voice synthesis is a software system for synthesising the dynamic characteristics of the human voice. It can be used in voice therapy or perceptual studies of vocal behaviour.

Voice output from a computer is more successful than voice recognition

Projector

Certain special projectors can be connected to a computer. Computer output is then projected on a screen (or a wall) when the output has to be shown to an audience.

This mutltimedia projector can be used to project images from a computer

Backing stores (secondary storage)

Computers can store data using chips inside the main processor (main store), or by other means, such as a magnetic disk or magnetic tape (called backing store).

Backing store is needed because:

- Main memory gets erased when the computer is switched off. A permanent backing store is needed from which programs and data can be retrieved when needed.
- Programs and data require very large amounts of storage. Since main memory is very expensive, secondary storage provides a cheaper form of bulk storage.

Magnetic disks

A typical magnetic disk has two useable surfaces (or sides) (see Figure 1.7). Each surface holds data on circular tracks, each track divided into equal sections called sectors. The disks are direct access. The track number and sector number are used as an address to find where certain data is on a disk. Data can be written to or read from magnetic disk. Both floppy disks and hard disks are types of magnetic disk.

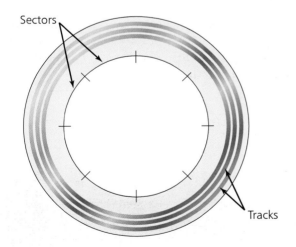

Figure 1.7 *How data is stored on the surface of a magnetic disk. Both hard disks and floppy disks have their surfaces divided by software into tracks and sectors*

Characteristics of hard disks

- The disks are usually fixed in the drive. They are built into a sealed unit to prevent contamination by dust and moisture.
- Access to data is faster than with floppy disks because the system that reads and writes data to the hard drive is very advanced.
- Hard disks store far more data than floppy disks (6.4–20 Gb or more).
- They are more reliable than floppy disks.

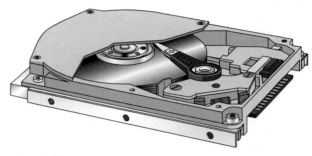

A hard disk

Characteristics of floppy disks

- Diameters vary, but 3.5 inches is the most common size.
- The amount of data stored is typically 1.44 Mb.
- Access to data is much slower than with hard disks because the head that reads and writes data into the floppy drive is not as advanced as that used with a hard disk drive.
- Floppy disks are also slower than hard disks because their rotation rate is slower.
- The disks are removable (portable) and easy to transport.
- A stiff plastic cover protects the disk.
- The data on the disk can be protected by sliding a small write-protect tab, which prevents the contents of the disk from being overwritten.

A floppy disk

Other removable disks

Zip disks and Jaz disks

These are electromagnetic disks which are used to store large amounts of data. Zip disks are available in two sizes: 100 Mb and 250 Mb. Their read/write speed is faster than floppy disks but slower than hard disks. They are portable and are the same size as floppy disks.

Jaz disks come in both 1 Gb and 2 Gb formats. They are larger than floppy disks and much faster.

Magneto-optical disks

There are various types of disk drive that use a combination of a laser, to heat the surface of the disk, and a magnetic head, to record data. These drives are available for both 3.5 inch and 5.25 inch disk formats. Magneto-optical disks have capacities ranging from 128 Mb up to several gigabytes.

Disk format

A new diskette (or disk) needs to be formatted before it can be used. Disks are formatted by running a format program which:

- writes track and sector numbers on the disk
- creates a table, which has control information so that the disk is ready for storing files.

Note: Only blank disks or those containing unwanted data should be formatted, as during formatting the operating system erases any data already on them.

Magnetic tape (data cartridge)

Magnetic tape is a serial access backing store (i.e. an item can be accessed only after reading all the items that come before it). The cartridges look similar to audio cassettes, except they are larger.

Because of their large capacity, data cartridges are mainly used for making backup (security) copies of hard disks. A 3.5 inch floppy disk can hold 1.44 Mb of data whereas a large hard disk holds in excess of 10 000 Mb. A simple calculation (10 000/1.44) shows that to back up such a hard disk when it is full of data you would need nearly 6500 floppy disks (and a large amount of time).

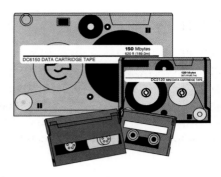

Magnetic tape

Optical disks (CD-ROM drives)

CD-ROM, or compact disk-read only memory, drives work with optical CD-ROM disks that are capable of containing significant amounts of data. The most common amount that a CD-ROM can hold is 650 megabytes. That is the equivalent of over 500 high-density floppy disks.

CD-ROMs are 'burnt' by the person or company that puts the information on the disk. Burning means that the data can't be erased or altered. To read this data, you need a CD-ROM drive. CD-ROM drives can also be used to play music CDs. CD-ROMs are an excellent means of storing and transporting graphic files and application installers.

All CD-ROM drives do not work at the same speed. The faster the drive, the faster the computer will be able to access data. This becomes particularly noticeable on CD-ROMs that contain video.

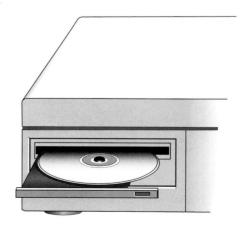

A CD-ROM drive; a CD is partially inserted

Performance

Although all computers are fast, different computers work at different speeds. Computers are capable of executing millions of instructions per second and so computer speed is measured in MIPS (million instructions per second).

What makes some computers faster than others? The factors involved are:

- **Clock speed** – this is the rate of clock pulses ('ticks') in the processor and governs the speed of the CPU. If the clock speed is 800 MHz the processor is capable of handling 800 million machine cycles per second.
- **Memory** – a computer can work faster if it has a larger memory.
- **Bus width** – a bus is a set of parallel lines that transport data from one place to another within a computer. The bus width refers to the amount of data that can be carried at one time. The greater the bus width the more data that can be carried.

New trends in computers

Portable computers

Portable computers are popular with workers who need to carry a computer with them when travelling. Laptop computers (also called notebook computers) are the most popular type. These computers have all the functions of a normal PC but are smaller and lighter.

A pen-based computer is even smaller than a laptop and accepts handwritten input directly on the screen.

The characteristics of portable computers are:

- they are lightweight and small
- they operate on the mains supply or on rechargeable batteries
- they are expensive compared with desktop models
- they have different displays to most desktop computers (laptops use LCD displays).

Some very small computers called 'palmtop computers' can be held in one hand.

Environmentally friendly computers

'Green computers' (not the colour!) are computers that have been built taking into account the needs of the environment. They use less electricity than ordinary computers. For example, if the computer is not used for a certain amount of time the screen will automatically switch off. Printers will also turn off after a short time, if no printing takes place. It is claimed that computers currently use 10% of the world's power supply.

Laser printers, however, are not very environmentally friendly; they emit ozone gas, which is harmful to the environment. They also use a lot of power, and used toner cartridges cannot always be recycled. This problem is somewhat relieved by designing the toner cassette or ink cartridge to be refilled instead of thrown away. All types of printers use a lot of power and a large quantity of paper. If information is used electronically, less electricity and paper are consumed.

1 What are the five basic operations performed by all computers?

2 Draw a diagram of the basic organisation of a computer and name its main parts.

3 Name the three main parts into which the central processing unit can be divided.

4 What are the operations performed by the ALU?

5 What is the function of the control unit?

6 From where does the control unit obtain its instructions?

7 What is the hardware component used to temporarily hold programs, input data, working area and output data?

8 What are the two types of memory?

9 What type of software is held on ROM?

10 Why is RAM called volatile memory?

11 List the steps that could be taken to guard against data being lost in RAM, in case of a power failure.

12 What is the most popular input device?

13 What is the advantage of a trackball over a mouse?

14 What are scanners used for?

15 Which input device is mainly used in games?

16 Which input device is most suited to design work?

17 What is the name of the input device, which is used in educational institutions, to make teaching easier?

18 Name an application that uses a light pen.

19 What are barcodes? Name three places where barcode readers are used to input data.

20 Why is the price of an item not coded when barcodes are used on shop goods?

21 Describe an application of MICR.

22 What is the name given to the system where scanned text is converted to standard ASCII code?

23 Suppose you have a large amount of text and graphics on paper and you want to edit it using a computer. What do you need to transfer this information into your computer so that you do not have to type the information in?

24 Describe an application of OMR.

25 Which group of people could most benefit from voice recognition?

26 What is a smart card and describe its applications.

27 List three different types of display screen.

28 Which factors can influence the quality of a monitor?

29 Which type of printer is cheapest and has the lowest running cost?

30 Which type of printer is most suited to printing multi-part stationery?

31 Why are inkjet printers expensive to run?

32 Which type of printer is considered the fastest?

33 Name the type of printer that you would use in each of the following applications:
 a to get a high quality black and white printout for the cover of a report
 b to print duplicate copies of an invoice where one copy is given to the customer and the second retained
 c to get a colour printout of a greeting card.

34 Which output device can be used to produce plans, maps and line diagrams?

35 What is the most suitable output device for displaying computer output to a large audience?

36 Explain in your own words the following terms and describe how each of the items is used. hard disk, floppy disk, CD-ROM, magnetic tape.

37 What is the advantage of floppy disks over hard disks?

38 What factors should you consider when storing diskettes?

39 How can you protect files in a diskette from being accidentally deleted or destroyed?

40 Why are floppy disks not usually used to back up a hard disk?

41 List the kind of storage device you would use in each of the following situations:
 a to save student information (which includes all possible information about the students, including their marks)
 b to distribute software, which requires large storage space
 c to save a college's archive file documents (these have accumulated over many years).

42 What does 'formatting' a diskette mean and why is it done?

43 Which factors affect the speed of a computer?

44 List some of the advantages and disadvantages of a portable computer compared with a desktop model.

45 What sort of energy-saving functions are found in modern computers?

TUTORIAL 1.3

Section 4 | Information network services

What is data communication?

Data communication is the transmission of data from computer to computer, phone to phone or between computers and phones.

Data communication consists of hardware and software and complicated communication technologies. It can be used to connect two computers in the same building or a lot of computers in several countries.

The rate at which the data can be transmitted is measured in baud (bps – bits per second). One baud is simply one bit per second. However, because extra information may be transmitted along with the data, the actual 'information baud rate' may be lower than the baud rate at which the network is transmitting.

Networks

A network is where several computers are linked together so that they can share the same programs and resources. The link might be between two computers in the same room or between several thousand in the same country or throughout the world.

Local area networks

Local area networks (LANs) offer high-speed communications of the order of Mbps between computers situated within a limited area. Typically, there are fewer than 500 devices linked by a network less than 2.5 km in length. They are usually owned and managed by a single organisation. High bandwidth, low error rate and also small delays are the main characteristics of local area networks.

File server

A file server is a computer dedicated to controlling a hard disk and handling users' files on a network. The users of the network can save their work to the file server; when they want to use the file again they can access it from any computer in the network.

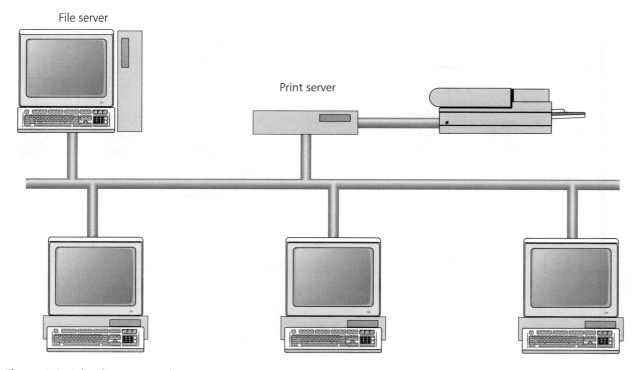

File server

Print server

Figure 1.8 *A local area network*

Print server

A print server is the computer within a network which controls the printer. Print jobs are sent to this server and organised in order of priority before being sent to the printer. For example, a system administrator's print jobs are normally carried out first even if other jobs are received first.

Wide area networks

Wide area networks (WANs) connect computers that are widely separated, but most WANs connect computers within a single country. WANs usually employ a packet switching technique (information is sent in 'packets' over the cables) and may be owned by one or more organisations for their exclusive use. Segments may be connected by radio or satellite communication links.

Advantages and disadvantages of networking

Advantages:
- duplication of data is avoided
- printers, scanners and other peripherals can be shared between users

- network software can be used, which is cheaper than providing software for each computer
- messages can be sent easily to other users.

Disadvantages:
- sophisticated equipment is needed for a WAN
- jobs have to be done manually when data cannot be sent
- file security must be strictly enforced
- wiring can be expensive to buy and install; it has to be hidden under the floor to avoid it trailing across a floor where it would be easily damaged and dangerous.

Modems

Computers understand only digital data (0s and 1s) and this cannot be transmitted over standard telephone lines, which are only designed to carry analogue signals (signals that vary).

A modem (short for modulator/demodulator) converts the analogue signals to digital signals and vice versa to allow digital data to be transmitted over telephone lines. Converting analogue to digital is demodulation; converting digital to analogue is modulation.

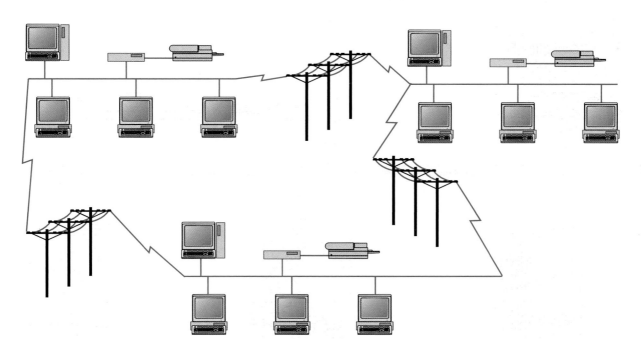

Figure 1.9 *A WAN connecting computers in three dispersed locations via telephone lines*

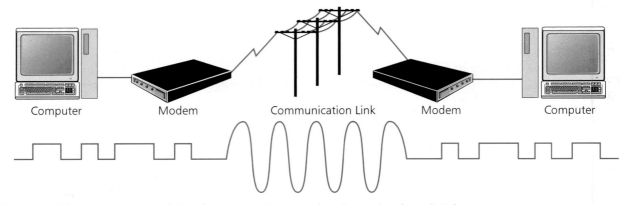

Figure 1.10 *Modems convert digital signals to analogue, and analogue signals to digital*

The speed at which data is transferred is measured in bits per second (bps). The transfer rate depends on the modem's speed. The faster the modem, the quicker the data is transferred and the less the cost of transmission.

Communication links

For a communication system to be useful it is necessary to establish a widespread set of links, accessible to most potential users. Since telephone lines are well established it is convenient to use them as the transmission network. There are other ways of transmitting data, some of which are outlined below.

Microwave transmission

Microwaves travel in a straight line, so they cannot bend around the curvature of the earth. Relay stations (often antennae situated in high places such as hilltops and buildings) are positioned at points approximately 50 km apart to extend transmission (Figure 1.11). Microwave transmission is fast, cheap and easy to implement. However, there are problems: for example, high buildings might disturb the signals that are being transmitted.

Figure 1.11 *Microwave transmission*

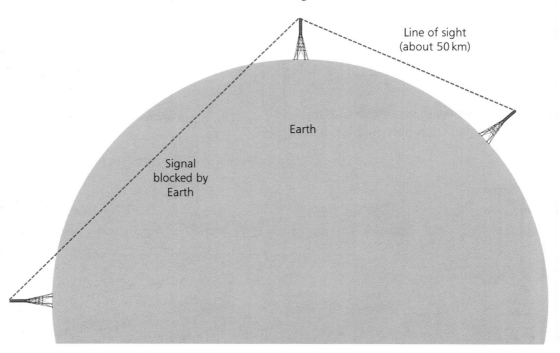

Satellite transmission

For satellite transmission you need earth stations, that send and receive signals, and a transponder. The transponder, which is a component of the satellite, receives data from an earth station and re-transmits the data to a receiving earth station, as shown in Figure 1.12.

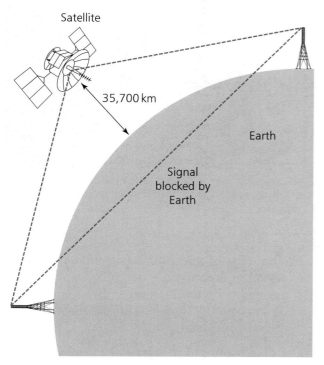

Figure 1.12 *Satellite transmission*

Basic methods of data transmission

There are three basic methods of transmitting data over a communication line: simplex, half duplex and full duplex, as shown in Figure 1.13.

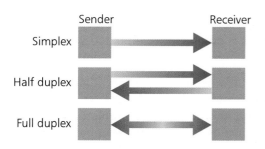

Figure 1.13 *Basic methods of data transmission*

Simplex

Communication is in one direction only. The device can only receive or only send data. Examples are television broadcasting and arrival/departure screens at airports.

Half duplex

Unlike simplex, data travels two ways; a half duplex system transmits and receives data (only one way at a time), e.g. a walkie-talkie. When a customer uses an ATM machine in a bank to enquire about their balance, a message is sent to the computer, and the reply is sent back using half-duplex transmission.

Full duplex

Transmission is in both directions at the same time. An example is a telephone conversation in which, good manners aside, both parties can talk at the same time.

Communication protocols

When we communicate with each other, there is a certain protocol that we follow. Even though we do not think about it, we first listen to someone and only then do we talk. In a conversation no two people talk at the same time.

Protocols exist in data communication too. A protocol is a set of rules and procedures set up to control transmission between two points, so that the receiver can properly interpret the data transmitted by the sender. Protocols are responsible for proper and orderly transmission of data between two computers.

Data communication services

Public switched data network (PSDN)

In packet (or public) switched data networks all data to be transmitted is first assembled into one or more message units, called packets, before being passed to its destination. The packets include both the source and the destination network addresses. The destination is determined by the destination address within the packet.

Integrated service digital network (ISDN)

ISDN is a high-speed, fully digital telephone service. Just as compact discs have applied digital technology to recorded music, ISDN upgrades the analogue telephone network to a digital system.

ISDN can operate at speeds of up to 128 kilobits per second, which is five or more times faster than current analogue modems.

ISDN can dramatically speed up transfer of information over the Internet or over remote LAN connections, especially in the case of rich media like graphics, audio, video or applications that normally run at LAN speeds.

The work of networking

Electronic mail (e-mail)

Electronic mail is sent through a computer to another computer using the telephone lines. Since the computer does not understand the analogue signal which the telephone is transmitting, it is converted to a digital signal by a modem.

To use e-mail you first type the address of the receiver and then type the message. The message is sent to your Internet service provider and from there to the receiver's Internet service provider where it is saved in the recipient's mail box. When the recipient logs on to the system the service provider sends any mail saved in the system to the recipient, who can then read the mail and reply. The message travels through the telephone cables as an analogue signal. Since the computer understands only digital signals modems are needed by the computers at both ends.

Advantages of e-mail over post
- E-mail uses less paper as mail can be read and replied to without printing.
- Delivery is fast, since messages can be received almost immediately and by a large number of recipients at the same time.
- The cost of e-mail is the same to anywhere in the world.

Telecommuting

Telecommuting is working at home and keeping in touch with the office and customers through a computer and a communications link.

Although this worker can hardly call the beach his office he still can keep in touch with his work place using his computer

The benefits of telecommuting include:
- saving in fuel costs
- saving in commuting time
- an opportunity to work at times that suit you and at your own pace.

The disadvantages of telecommuting include:
- the strain on families that results when a family member works at home
- lack of personal contact in the workplace
- telecommunication costs.

Electronic data interchange (EDI)

Electronic data interchange is the exchange of data by electronic means. It saves paper, so it reduces the number of trees that would be used and the pollution that would result from paper manufacture. It allows users to transmit invoices, purchase orders, etc. electronically. Filling out forms is completely eliminated with the introduction of EDI. The advantages of using EDI are:

- transmission of data between one application and another without human intervention
- it avoids unnecessary re-input of data, reducing labour and mistakes
- it reduces costs, due to efficiency of data flow.

Workgroup computing

Groupware is software shared among a group of people. Any data should be stored in a central place so that it can be accessed and changed by anyone working on it. The best place is in a central database on a network.

For example, scheduling software can examine the personal calendar file of each group member and find a time to have a meeting when none of the participants are otherwise busy.

The following list gives other applications of workgroup computing:

- contacting other members of the group easily (through the network) irrespective of time and distance
- sending e-mails among the members
- preparing joint text more efficiently using wordprocessing software
- video conferencing.

Videoconferencing

The technology of videoconferencing has advanced rapidly in recent years. Picture and sound quality of large room-based systems are reasonable, and the costs of installing and running them have dropped, so that they are now becoming a realistic option for institutions teaching or planning to teach across more than one site.

Geographically distant groups can hold meetings with the help of videoconferencing

The growth of network technology and in particular the Internet has led to a greater awareness of the potential of conferencing systems for teaching, collaborative work, assessment and student support. Videoconferencing is one example of a synchronous conferencing system, i.e. one that takes place in real time between individuals or groups who are usually separated geographically. Asynchronous conferencing systems, such as bulletin boards, do not require participants to be connected at the same time.

Electronic fund transfer (EFT)

EFT is the transfer of funds by means other than paper. Money is transferred from one place to another electronically. One of the most popular electronic fund transfer methods is the automatic teller machine (ATM) that people use to obtain cash quickly.

1 The customer is given step by step instructions on how to operate the cash dispensing machine.
2 The keyboard (input device). The customer types information in here, including the customer's secret number (PIN).
3 a This is where the customer inserts the plastic card. The card must be inserted the right way round.
 b From here, the amount of money the customer has keyed in is released.
 c This is the VDU screen where messages appear, such as 'Enter personal number'. The screen gives instructions to the customer.

Users can use bank services 24 hours a day

Other communication services

Telephone
The telephone is used to communicate over long distances. At present data is sent through the telephone lines in a patchwork of digital and analogue forms.

Fax

Fax is short for facsimile. Output from a computer or a scanned document can be sent over the standard telephone network and then reproduced on a fax machine at the receiving end of the line. A computer is not necessary to send a document by fax, but it is faster to send it directly through the computer than by making a printout and then putting this through the fax machine.

Telex

With telex, data is typed in at the source and a signal sent through the telex line to a destination machine which types out the message. This is tedious, as every time the message needs to be sent it has to be typed. Telex is almost obsolete now.

The Internet

The Internet is a global connection of computers. Surprisingly, the Internet is not really a network at all but a loosely organised collection of networks, accessed by a huge number of computers connected via communication links. The Internet allows you to access a large resource of information stored at different sites (called hosts or servers) in locations all around the world. The communication links that interconnect each host computer use a common method (protocol) of transmission, known as TCP/IP, which stands for transmission control protocol/Internet protocol.

Each computer connected to the Internet (remember, it is always spelt with a capital I) can act as a host. A host computer provides information for other people to access and retrieve. The Internet originated during the cold war between Russia and America in the 1960s.

The future of the Internet seems limitless. Many experts predict that the Internet is destined to become the centrepiece of all online communications.

Internet service providers

Internet service providers (ISPs) are companies that provide access to the Internet. This can be via a dial-up connection using a modem, or using an ISDN or permanent high speed connection.

Each user can access the Internet through connection on an existing network or via a modem from a remote site, such as a private residence. The data and information that can be accessed on the Internet comes in numerous different formats and there is a wide range of applications that interpret the information for the user.

World Wide Web (WWW)

The basis for the Web is the Internet. The Web is built on the Internet, and makes use of many of the mechanisms the Internet provides. The Internet is the physical aspect – computers, networks and services. It allows us to connect to thousands of other computers across the world. But this does not mean that those users can look at, and understand, the information available there. The Web is a common set of services on top of the Internet. The Web provides a set of protocols and tools that let us share information with each other.

The Web was developed with the concept of 'universal readership' in mind. Any participating system should be able to read the information on any connected system using a common set of tools:

- browsers
- servers/gateways
- addressing schemes
- common protocols
- format negotiation.

TUTORIAL 1.4

1 What is meant by data communication?

2 What is a computer network?

3 Explain briefly:
 a what a LAN is
 b what a WAN is.

4 What are the tasks performed by:
 a a file server
 b a print server?

5 List three advantages and disadvantages of networking.

6 What is the function of a modem?

7 What is the unit of measurement in which data transmission speed is measured?

8 List five communication media used for data transmission.

9 How far apart should the antennas be fixed in microwave transmission?

10 Through what medium does microwave transmission take place?

11 What are the basic components in satellite transmission?

12 Explain what is meant by simplex, half-duplex and full-duplex transmission.

13 Following is a list of data transmission methods. Write down the name of the method that each of them belongs to.
 a Allows data transmission in both directions at once.
 b Data transmission occurs in only one direction.
 c Data is transmitted in both directions, but only in one direction at a time.

14 Give examples for simplex, half-duplex and full-duplex data transmission.

15 What is a communication protocol and why is it used in data communication?

16 What is e-mail and what are the advantages of e-mail over traditional post?

17 What hardware and software are needed when you send an e-mail from your home PC?

18 What is the name given to the method of communicating with people in different parts of the world, using a telephone, a computer and a video camera?

19 Who is a telecommuter and what are the advantages and disadvantages of telecommuting?

20 Explain what EDI is and the advantages of using it.

21 Many tasks require groupwork involving several people. Explain how IT can be used in group-working.

22 Explain what EFT is and list two benefits to the customer of having ATM machines.

23 Describe the following:
 a Internet
 b WWW.

24 What are the advantages and disadvantages of shopping on the Internet?

25 Explain the following terms:
 a ISDN b PSDN c fax.

26 What is baud?

Section 5 | Applications and use of computers

Computers are being used in a wide range of areas such as:

- home (hobbies, household accounts)
- everyday life (banks, supermarkets, libraries, hospitals)
- commerce (payroll, stock control)
- industry (chemical plants, oil refineries, manufacturing of cars)
- education (simulation of laboratory experiments, computer-aided learning).

The following sections give an outline of the areas in which computers are commonly used.

Computer applications in day-to-day life

Home applications

Computers are now very common in the home. The introduction of the microchip made the computer affordable to most people. Most of the time home computers are used for writing letters, sending and receiving e-mail, playing games and browsing the Internet to gather information for school assignments, for shopping, watching movies, and so on.

Banking

The banking sector was one of the first users of computers. Banks had a central computer where all the transactions were entered at the end of the day after all the deposit and withdrawal slips had been collected from each of the branches. This was a tedious job as all the transactions had to be entered and this took a very long time.

Today, all transactions are entered then and there by the teller, so that work does not accumulate in any of the branches. As it is entered, each transaction is updated on the master file at the central computer, minimising the paperwork. The teller just types in the account number and is given instant access. Another popular application of this kind is the ATM (automatic teller machine). Let us see how this works.

The ATM system

Automatic teller machines are used to deposit and withdraw money and to check bank balances etc. The customer is issued with a plastic card where his or her account number, name and telephone number are stored. The customer can access their account by inserting their card into the machine and entering their personal identification number (PIN), which does not appear on the screen. The machine is connected to the central computer of the bank. The following information about the customer is held in an accounts file:

Account number	PIN number
Name	Address
Telephone number	Bank balance

A customer can access their account only if they use the card. The card is inserted into the machine and it asks for the PIN. If the correct PIN is typed, the computer will access the master file and find the corresponding customer record, otherwise, there will be an error message and no access will be allowed to the account. Once the correct record is selected, a menu with numerous options appears on the ATM screen. The customer is then able to choose whichever option they require.

ATMs are useful for both banks and customers. For banks, they help to reduce staff and for customers the ATM is a bank that is open 24 hours of the day.

Supermarkets

Another area in which computers are used is supermarkets. The goods each carry a unique barcode that gives the item number. A barcode reader is able to identify this number and present it to the computer. The computer has a record for each item in the supermarket with information such as the item number, item name, item description, price, quantity in stock, etc.

The central computer is able to identify the item number of every item sent to it using the barcode reader. It then sends the information that corresponds to the particular item to the

POS terminal to be printed. Further, the computer also does the necessary stock adjustment by subtracting the quantity sold of the particular item.

POS terminals are commonly used at supermarket checkouts

With such a system, both the customers as well as the management of a supermarket benefit. Customers can be satisfied that the correct amounts are printed and charged for the goods they have bought. The cashier can also be comfortable because there is no room for any error. The management have the advantage of speed of service, the need for fewer staff and better stock control.

Library

A library contains thousands of books, magazines and other items which a person may wish to borrow. Maintaining records of books and borrowers can be a complicated and tedious job, but is well suited to a computer system. Finding available books and reserving them are also made very simple with the use of computers.

To illustrate how a computerised library system operates, let us assume that for each book a book record is stored in the 'book file'. A book record will contain information such as:

- book number
- name
- author

- member number
- date borrowed
- reserved status
- date to be returned.

The computer also maintains a 'member file' which stores information about the library's members. A member record will contain information such as:

- member number
- name
- address
- maximum number of books allowed to be borrowed
- number of books borrowed
- book numbers of books borrowed.

To analyse how the system works let us consider that Ann wishes to borrow the book *Understanding Computers*. The librarian enters the book number and the member number into the computer. The computer accesses the two records from the book file and the member file. Then the computer checks:

- that the book is not reserved
- that the number of books borrowed by Ann is fewer than the maximum number allowed.

A computer is well suited for maintaining records of books and borrowers in a library

Only if both these conditions are satisfied is Ann allowed to borrow the book. Then the two records are updated in the computer. The computer system could also be used to find out information such as:

- which books have a particular person borrowed?
- which books have not been returned by the due date?
- who has borrowed the book *Banana the Wonder Fruit*?

A computerised library system such as this offers many benefits to both the members and the staff compared with a manual system. From the point of view of the staff, checking books in and out is much easier, and it is also easier to answer customer queries. From the members' point of view the service is quicker, and it is easier to find out if a book is available.

Hospitals

Computers are used extensively in hospitals. They can be used to monitor a patient's condition – such as their temperature and heart beat. Computers are extremely useful in intensive care units where every patient needs constant attention. They can be programmed to sound an alarm if there is any change from normal. They run for 24 hours a day, every day, so staff do not have to keep a constant watch. Some people with heart problems even use microprocessor-controlled devices (called pacemakers), which control their heartbeat rate.

Since computers have a vast storage capacity, all the patients' medical records can be saved on the hard disk. An **expert system** can use this data to diagnose. An expert system is a computer program designed to operate at the level of an expert in a particular field.

Commercial applications

Many businesses, large and small, use computers to help control their daily activities. Some of the more common uses are described in the following sections.

Payroll processing

Consider the preparation of monthly pay cheques for employees of a certain company. For each employee, a record is kept in the 'employee file'. Assume that each record contains the following information:

- employee number
- name
- address
- basic salary
- overtime rate
- overtime hours.

At the end of each month the total number of overtime hours worked by each employee is entered into the computer by a data entry operator. This data gets stored in the employee file. The payroll program then reads this file and prints the payslips. For each employee, the system:

- reads the employee record from the employee file
- calculates overtime pay (overtime rate x overtime hours)
- calculates gross salary (overtime pay + basic salary)
- calculates contributions to employees' pension funds
- prints this information (overtime pay, gross salary, employees' pension fund contributions) along with the employee number and name.

Stock control

A stock control system enables a user to manage stock more effectively. An 'item file' is used by the system and for each item in stock there is a record in the stock file. An item record may contain, among the other things:

- item number
- item name
- item description
- supplier
- cost price
- selling price
- quantity in stock
- re-order level
- re-order quantity.

When the quantity in stock is less than or equal to the re-order level, an order is placed and the amount to be ordered is the re-order quantity. An example of an item record is given below:

Item number	P2346
Item name	Ball joint
Item description	Ball joint for Toyota Corolla KE30
Supplier	Gateway Motor Spares
Cost price	£4000
Selling price	£5000
Quantity in stock	9
Re-order level	5
Re-order quantity	15

If a customer places an order for six ball joints there will be only three left. This number is less than the re-order level. Therefore an order for 15 ball joints (as that is the re-order quantity) is placed immediately with the suppliers of the goods.

The 'item file' also enables a sales clerk to answer queries such as:

- What is the price of part number Q2346?
- Who is the supplier of ball joints for the Corolla KE30?
- How many of part number Q2346 are there in stock?

Accounts receivable

All monies that a customer owes a company are recorded in an account receivable system. A shop that offers credit to its customers will keep the following information. For each customer, a customer record is created; this record will include data such as:

- customer name
- address
- telephone number
- credit limit
- amount owed by the customer
- date of last purchase
- date of last payment.

The computer uses the last two data items to determine the length of time the customer has owed money to the store. Based on the length of time, different types of notices can be sent to the customer. For example if the length of time is:

- less than 45 days, a statement showing how much is owed is sent to the customer
- 45–60 days, a reminder is sent to the customer
- 61–90 days, a strongly worded reminder is sent to the customer
- over 90 days, a final reminder is sent, plus a notice to the customer that the credit facilities have been suspended until payment is received.

The computer scans through the customer file and prints the appropriate notices. It can also show the total amount of money owed by the customer.

Office automation

Office automation is the use of technology to help people do their jobs faster and more efficiently. The availability of cheap processing power has made it possible to automate many office functions such as message distribution, record keeping and wordprocessing.

The best example is perhaps wordprocessing. Imagine using a typewriter to re-type an entire letter to correct an error in the 95th line of a 100-line document. With a wordprocessor it is simply a matter of locating the error and correcting it. The other facilities offered by wordprocessors include:

- search and replace
- change format
- spelling and grammar checkers
- mail merge.

Other applications included in office automation are:

- **E-mail** – a person is able to send a message to a colleague electronically without having to deliver it personally.
- **Database management** – storing and managing information on magnetic disk, which can be easily maintained and rapidly retrieved.
- **Spreadsheets** – used to help manage financial data.
- **Management Information Systems (MIS)** – provide information for managers and other users, who use this information in their decision making.

Office automation may result in 'paperless offices' in the future

Industrial applications

In many industries computers are used as control units or monitors. A computer can be used to detect the various changes that take place in a manufacturing process, so that even the minutest changes can be reported. In chemical plants, steel mills and oil refineries, temperature, pressure and various other factors are measured. If any discrepancies are found the system can either:

- inform the supervisor in charge
- adjust the equipment accordingly.

In car manufacturing, robots are used in all of the assembly lines to put together vehicles. Robots are particularly good at performing boring, repetitive tasks, of the kind found in many industries. They are also useful in areas which are hazardous (for example mining).

Educational applications

Another very important use of computers is in education. A computer can help to teach any subject in the National Curriculum. For example, in subjects such as biology, chemistry and physics, laboratory experiments can be simulated

on the computer. Equipment can be connected to a data logging system, where the readings are automatically fed to the computer on which various graphs and charts can be easily prepared. Some experiments can be done virtually, i.e. simulated on a computer.

Computers are now widely used for video-conferencing. They are also very useful for distance learning. Since almost all systems have access to the World Wide Web, finding information has become easier.

Computer-assisted instruction (CAI) is the name given to a teaching system (program) which operates on a drill-and-practice principle. For example, when learning the meaning of English words, a student sits at a computer and is presented with a word and its meaning. The student studies this and, when satisfied, tells the computer that the question session can start. The computer may then present several sentences in which the word is used. The student is asked to indicate the correct usage. The word can be presented as many times as the student wishes – the computer does not get irritated or bored. This type of program is useful when the memorising of material is important.

Another type of system is computer-assisted learning (CAL). This system aims to 'teach' in the traditional sense. The computer presents material, asks questions based on the student's performance, and determines whether or not to present new material or review topics already covered. In this way students can proceed at a pace which suits them.

In certain subjects, some concepts are difficult to explain using words and diagrams. In these cases, the computer can be used to explain such concepts more vividly by using its graphics capability to display pictures and even videos.

There are also some disadvantages in using CAI and CAL systems. They are:

- Teaching becomes impersonal: the computer does not understand the deeper significance of a student's answer.
- The student cannot ask questions which are not within the scope of the program.
- The computer cannot be a role model, like a person can.
- Tasks may become the 'yes/no' or 'tick the right answer' type.

1 How can IT be used in home applications?

2 Most banks now have ATMs.
 a What does ATM stand for?
 b What data is stored about the customer in the teller card?
 c Describe the purpose of the PIN.
 d What connections does the ATM make before dispensing money?
 e State the advantages to the customer and the bank of the ATM.

3 A supermarket uses a POS system. All the products sold carry barcodes.
 a Name a device used to input barcodes at the checkouts.
 b State the advantages that this type of system offers to the customer and the management compared with a manual system.

4 A new, computerised system is installed in your local library. What are the advantages that this will bring to its members and the staff compared with a manual system?

5 Explain how computers are used in hospitals to provide a better service for the patients.

6 What is the main output produced by a payroll application?

7 What information may be stored in an 'item file' in a stock control system?

8 How can an accounts receivable system help a petrol station, which offers credit to selected customers?

9 What is meant by office automation?

10 A manager believes that ICT could be used to improve work done in the office. List all the items of software and hardware (including data communication facilities) that need to be purchased. Justify your choices.

11 Compare a wordprocessor with a typewriter.

12 Name two industrial operations that are more suitably handled by robots.

13 Computers are being used in education in a variety of ways.
 a Name three such applications.
 b What are the advantages offered to a student by CAL and CAI systems?
 c What may be the disadvantages of using CAI and CAL?

Section 6 | Security, copyright and law

Software piracy

Software is the result of an idea that comes up in a person's mind. There is always a price to this idea. All software falls under copyright laws. If someone wants to use a particular piece of software the necessary charges will have to be paid to the author. Software piracy is making copies of software without the author's approval.

Countries where the software industry makes an important contribution to their economy are faced with serious difficulties due to software piracy. Software that has been produced with major investment may be available elsewhere at a fraction of the cost. Further, software piracy has a detrimental impact on the developer, as they do not get their return and become discouraged.

Curbing piracy has always been a daunting task. But now the counterfeiters are harnessing the power of the Internet and the allure and reach of online auction sites; this has triggered an exponential growth in the problem.

Combatting software piracy

Software piracy is big business these days; a counterfeit copy may cost only £2 when the original might sell for £500 or up to millions of pounds. A lot of factors have allowed this illegal industry to grow.

Software writers have tried many ways to rectify the situation but despite their efforts software piracy is thriving.

Raids on the rise

Efforts by software makers and authorities to crack down on illegal software merchants and contractors are escalating. Software pirates too, are rising to the challenge. Most governments are therefore bringing in legislation at a national level to curb this menace.

Warning signs of counterfeit software

- 'Too good to be true' prices for software.
- Gold or silver CDs.
- Products missing key elements, such as user manuals, certificates of authenticity or end-user licence agreements. Pirates often sell only the CD-ROM in a jewel case without retail packaging.
- Backup disks or CD-ROMs with handwritten labels.
- Watermark that is simulated with ink on the surface, or embossed.
- Poor imitations of security features, such as the hologram on the hub of the Windows 98 CD that says 'genuine' when tilted in light.
- Low quality print and letters that aren't evenly spaced. Counterfeiters often have a difficult time replicating the fonts, artwork styles and registered trademarks that Microsoft uses.
- Products marked with phrases that do not describe the transaction, such as: 'For distribution with a new PC only', 'Special CD for licensed customers only', 'Not for retail or OEM distribution' or 'Academic price – not for use in a commercial environment'. Counterfeiters often use these types of phrase to fool consumers into believing they are getting a genuine product that was overstocked or otherwise deserves to be discounted.

Sources: Microsoft, Corel.

Copyright law

What does software copyright imply?
- Someone owns the intellectual rights to all software.
- Users have to buy a licence to use the software.
- Others cannot copy programs without the agreement of the copyright owner.

What is permitted in copying a program?
- Public domain and shareware programs can be copied and distributed freely.
- Backup copying of program diskettes is permitted.

System security

System security involves the elimination of weaknesses or vulnerabilities that might be exploited to cause loss or harm. It means taking care of hardware, software and data.

The most important of these three components is simply protecting the computer system's information (data). Data security can be thought of as protection against accidental or intentional disclosure of confidential data, unlawful modification of data or the destruction of data.

Loss of data can have serious consequences, for instance:

- bad business decisions
- cashflow problems
- bad publicity
- failure to receive payments
- late delivery of goods.

Physical security

Computers must also be protected from natural disasters. Recent events include:

- millions of dollars of damage resulting from the 1989 San Francisco earthquake.
- the fire at Subang International Airport, which knocked out the computers controlling the flight display system. A post office near the computer room was also affected by soot which decommissioned the post office counter terminals. The computers were not burnt, but crashed because soot had entered the hard disks.

Computer safety
Computers and the other devices attached to them should carry a unique number so that if any items go missing the number can be noted down immediately.

Fire alarms
Computer room doors can be made fireproof. Smoke alarms should be installed in computer rooms.

Correct environment
Air conditioning can keep away dust and control humidity. The air inside a computer room should be pure and must be filtered.

Regular cleaning
All hardware components should be cleaned regularly so that dust does not collect and interfere with their function.

Software security

Regularly backing up data, avoiding viruses, using passwords and encryption are some of the steps that should be taken in order to safeguard software.

Virus-free
Antivirus software should always be used to scan a computer's memory and disks. If any virus is detected then it should be removed immediately.

Data backup
Always keep a backup copy of all your important files, thereby ensuring that the information will be safe. In large organisations magnetic tape streamers are usually used. Data backup avoids the worst problems arising from hard disk failure.

Preventing the overwriting of data
Files on floppy disks should be protected from accidental overwriting by sliding the small write-protect tab.

User identification and passwords
A user ID is a name or a number by which the system identifies the user. A password is a set of characters that a computer uses to identify the authenticity of the user. To gain access to the

system the user has to type in the user ID and password. Passwords should be changed regularly, should not be given to other users and should be difficult for others to guess. This procedure prevents unauthorised persons from accessing the computer.

Encryption

Data that needs a high level of security is encrypted or coded when transmitted. Data is coded before being sent, and decoded at the receiving end so that there is no risk of it being stolen during transmission.

Computer viruses

Computer viruses are small programs that attach themselves to other programs and attack software whilst copying themselves. They are programs that can disrupt your computer system by, for example, erasing all the files on the hard disk, corrupting the whole e-mail system, giving out odd messages or erasing important command files on the computer system.

- **Worm** – a worm is a program (usually stand-alone) that 'worms' its way through either the computer's memory or a disk and alters any data that it accesses.
- **Trojan horse** – a program that attaches itself to a seemingly innocent program. Trojan horses do not necessarily replicate themselves.

- **Logic or time bomb** – a program that is activated or triggered after or during a certain event. This may be after a certain number of executions or on a certain day such as Friday the 13th.

How do viruses transmit?

A computer virus is a set of computer instructions that use a legitimate program or replaces the instructions of a legitimate program. When a virus enters a system via a contaminated floppy disk it is usually attached to a program on that diskette or hidden in the programming code of the boot sector (where the start-up instructions are stored). The symptoms of a virus are often obscure and difficult to identify. Most computer systems are not protected against viruses. A vast variety of virus detection and protection programs are entering the market, but some are limited in what they can detect and cure.

Antivirus software

This is specially designed software that can be used to scan a computer's memory and disks to detect viruses. If any viruses are detected, the software can be used to disinfect (remove) them. Antivirus software can be installed to scan your hard disk every time you boot the computer, or if you prefer, at regularly scheduled intervals. It is also possible to configure the software so that it checks for viruses each time you copy a file from a diskette to your computer.

A virus is a harmful program that causes damage to programs and data

Computer security

Here are nine rules for data security:

1 Establish data security policies.
2 Establish password management procedures.
3 Control downloading of programs.
4 Test new or upgraded software in an isolated computing environment.
5 Purchase software from reputable sources only.
6 Never leave a network workstation unattended.
7 Back up data and programs on a regular basis and store them off site.
8 Establish an effective disaster recovery plan.
9 Practise 'safe computing'.

Safe computing

The following is a list of dos and don'ts for safe computing.

1 Don't use illegal software! If the software has been obtained illegally, how can you know that it doesn't contain a virus?
2 Always write-protect your systems and program disks. Write-protect tabs are easy to use and very effective.
3 Only copy files from the original distribution disks.
4 Always keep at least one set of backup copies of all original disks. This won't prevent a virus infection, but it will help in the recovery process if an infection occurs.
5 Do not loan out program disks. They may be infected when they are returned. If you must loan a disk, always check it for viruses or format it before using the disk on your computer system.
6 Make all the .COM and .EXE system and program files read-only by using the command ATTRIB+R. However, some viruses can now circumvent this method.
7 Always keep a lookout for strange occurrences:
 a When you do a directory listing, look at the volume label.
 b Observe whether your computer system is slowing down.
 c Watch for files that disappear.
 d Notice when there are attempts to access the disks when there should not be any read–write activity.
 e Watch whether the loading of programs takes longer than usual.
 f Keep a lookout for decreases in the main memory or reduction of disk space.
 g Watch for unusually large sizes on program files.
 h Watch for recent creation dates on old program files.
 i Watch for unusual displays on the computer screen.
8 Be cautious when using shareware software or any new software. There have been instances where commercial software has been sold with a virus.
9 If you are downloading software from a bulletin board or other computer network including the Internet, always download to a diskette. You should then scan the diskette for possible virus infections. (You may want to write-protect your hard disk during this operation.)
10 In a lab environment, do not allow users to run their own programs or boot the computer system with their own disks. Users should only have data disks that are not bootable. All program disks and hard disks in a lab must be checked frequently for viruses. If users are allowed to use their own program disks, they must be scanned before they are used in the computer lab.

11 Most important of all is to teach computer users about computer viruses so that they can recognise them. If users can identify viruses they will be able to prevent their spread. Although there are many viruses (over 10 000 to date), the main problems are caused by a handful of very familiar ones with names such as Jerusalem, Cascade, Form and Stoned. For example, the virus called Jerusalem B activates itself on Friday the 13th and proceeds to erase the files you may try to load from the disk. The virus Cascade causes letters to 'drop' to a pile at the bottom of the screen.

The UK Data Protection Act, 1998

This covers the processing of data manually or by computer. People who record and process personal data are called 'data controllers' in the Act. The Data Protection Act (DPA) places certain obligations on these data controllers (DC). Data controllers must inform the Data Protection Commission about the data being collected and how it will be used.

Data controllers have to follow a set of principles (called DP principles):

1 Processing of personal data will be done lawfully and fairly and will be processed for a valid reason.
2 Personal data shall be obtained only for lawful purposes.
3 Personal data shall be adequate and relevant and will not be excessive for the purpose for which it is used.
4 Personal data will be up to date.
5 Personal data shall not be kept longer than necessary.
6 Personal data will be processed according to the rights of the individual to whom the data belongs.
7 Suitable measures shall be taken to guard personal data against unauthorised access, accidental loss, destruction or damage.
8 Personal data shall not be transferred to a country outside the European Union, unless that country ensures adequate steps for the protection of data.

TUTORIAL 1.6

1 What is meant by:
 a software piracy
 b software copyright
 c industrial piracy?

2 What is permitted in copying a program?

3 What is prohibited in copying a program?

4 What is meant by system security?

5 What are the consequences a company might face after loss of valuable data?

6 What steps can a company take to prevent physical damage to computer equipment?

7 How could a company safeguard its software?

8 What is the purpose of user IDs and passwords?

9 What is meant by data encryption and why is it done?

10 What is:
 a backup copying
 b the purpose of backing up
 c the most suitable device with which to back up a hard disk?

11 What is a computer virus?

12 What is antivirus software?

13 What damage could a virus do to your computer and what are the steps that you can take to protect your computer from viruses?

14 What ethical problems, in your opinion, can arise from the use of information technology?

15 What are the DP principles?

SECTION 7 | IT and society

Information society

Before the industrial revolution nearly everyone worked in agriculture. People communicated by words or messages written on paper. Soon after the industrial revolution, life changed for most people. Factories were started where large numbers of people worked together. In order to administer them, there came a need for offices. With the development of trade arose a great deal of documentation. As technology advanced people wanted to find easy ways of completing the paperwork. The computer is probably the latest tool available from a series of machines that were developed over the years, such as the typewriter, telephone, fax, etc.

The present age is referred to as the 'information age' as most people's lives depend on information technology. A lot of people work in computer-related fields and computers affect everybody in one way or the other.

Communication, too, is becoming an integral part of IT, and it is for this reason that IT is now being replaced by ICT.

Is this dependency on computers good news?

Yes:

- Using computers speeds up our work and in the long run will increase productivity (i.e. a lot of work will be done in less time and more efficiently).
- Many tasks would be impossible without IT. Robots can work in areas that are not suitable for humans, such as in deep-sea exploration, and in mining where there might be harmful gases. Space travel and credit cards would be unheard of without computers. Computer technology is also used in medical research.
- A lot of new jobs have been created by the use of computers. Examples include: programmers, systems analysts, managers of information systems, network managers, hardware engineers, etc.
- It minimises human error and provides accurate information to support business decision making.

No:

- A vast amount of information is now held on computer systems, which has led to the issue of whether data is secure.
- Because of the introduction of new technology, the gap between the 'haves' and the 'have-nots' has further increased.
- Businesses and individuals that are dependent on computers can be at the mercy of large software and hardware companies.
- Keeping up to date can be an expensive business.
- It adds to the burden of unemployment.

Improvement in working conditions

Computers can be used to great advantage:

- in hazardous industrial processes – in the form of computer-controlled robots
- to perform complex jobs – these tasks include weather forecasting, censuses, clearing bank cheques, sending up rockets and satellites and the use of credit cards
- in computer-controlled traffic lights – these prevent the build-up of traffic that causes traffic jams
- where computers help people book holidays, air tickets and rail tickets more easily than in the past.

People versus computers

The big question is: which is better: people or computers? Let us consider points for and against.

Circumstances in which people are more appropriate than a computer:

- when the tasks to be performed are different each time
- when tasks need human input and which are therefore difficult or impossible to write programs for
- when human feelings need to be understood
- when a job needs creativity
- when unexpected or new situations are likely to occur.

Circumstances in which computers are more appropriate than people:

- when the same task has to be repeated many times
- to process jobs that need lots of calculations
- to perform tasks which require a high degree of accuracy
- when a task needs to be performed at a high speed
- when processing large volumes of data
- when performing tasks that require long-term memory.

Information superhighway

The Internet is the information superhighway. Many networks in industry, business, higher education and government institutions are all connected via these 'spider webs' of international communications networks. (This will be discussed in detail in Module 7).

Year 2000 implications

Many computer systems designed 10–15 years ago used only two digits for the year. For example, 1990 was represented in programs by '90'. The digits which represented the year 2000 were '00', which could be interpreted as '1900'. This could have caused severe errors in computer systems. This was referred to as the Year 2000 problem which is commonly called 'Y2K'. It was also called the millennium bug. All old computer systems with this error were meant to be modified before the new century began.

Electronic commerce

What is e-commerce?

While there is no one correct definition of e-commerce, it is generally described as a method of buying and selling products and services electronically. The main methods of e-commerce remain the Internet and the World Wide Web, but the use of e-mail, fax and telephones is also common. E-commerce encompasses all types of transaction: business-to-business, business-to-consumer and consumer-to-business.

Changing employment patterns

Since information technology was introduced, employment patterns have changed. Typical changes include:

- Less paper is being used in offices as information is now often sent through e-mail or on a disk. It is faster to transfer this way, and cheaper. There are no filing clerks – this job has been replaced with that of computer operators.
- Car manufacturers and similar organisations which use an assembly line have started using robots in their manufacturing processes. Since these processes operate all day and night it is easier and safer to use computer-controlled robots.
- Many people now work from home (telecommuting), where no travelling is involved and people can work when they choose and at their own pace. This is ideal for parents who want to be with their children but do not want to stop working. The disadvantage is that telecommuters will never be able to leave work and come home, because work is always at home!
- Another key area of computer use is in monitoring. Cashiers in banks and supermarkets can be monitored by the management by counting how long it takes to serve one customer with a certain number of items.

Do computers cause unemployment?

This is an area which should be thoroughly looked into by policymakers. When computers were first introduced it was thought that the unemployment rate would increase. But, although some jobs were replaced, with computers, new jobs were created. Such new jobs include computer operators, programmers, systems analysts, and computer hardware and software engineers – are all needed as never before.

Ergonomics

Computers and health

Repetitive strain injury (RSI), backache, eyestrain, headaches and skin rashes are some of the conditions which are related to the use of computers. By using various means, these conditions can be prevented.

The following factors should be considered in order to create an ergonomically suitable working environment:

- an adjustable chair
- the desk placed at the right height
- the screen placed at the right height
- correct lighting
- a support for the wrist and elbow
- sufficient space to work.

Repetitive strain injury (RSI)

Repetitive strain injuries occur from repeated physical movements causing damage to tendons, nerves, muscles and other soft body tissues. Occupations ranging from meatpackers to musicians have characteristic RSIs that result from the typical tasks they perform. The rise of computer use and flat, light-touch keyboards that permit high-speed typing, have resulted in an epidemic of injuries to the hands, arms and shoulders. The use of pointing devices, like mice and trackballs, has encouraged similar problems. The thousands of repeated keystrokes and long periods of clutching and dragging with mice slowly accumulates damage to the body. Correct typing technique and posture, the right equipment set-up, and good work habits are much more important in preventing injury than ergonomic gadgets like split keyboards or wrist rests.

Eyestrain

Visual problems, such as eyestrain and irritation, are among the most frequent complaints reported by computer operators. These visual symptoms can result from improper lighting, glare from the screen, poor positioning of the screen itself or copy material that is difficult to read. The problems can usually be corrected by adjusting the physical and environmental setting in which the computer user works.

You can also reduce eyestrain by taking 'vision breaks' (which may include exercises to relax eye muscles) after each hour or so of operating a computer. Changing focus is another way to give eye muscles a chance to relax. You need only glance across the room or out of the window, from time to time and look at an object at least 6 metres away. Other eye exercises might include rolling or blinking the eyes or closing them tightly for a few seconds.

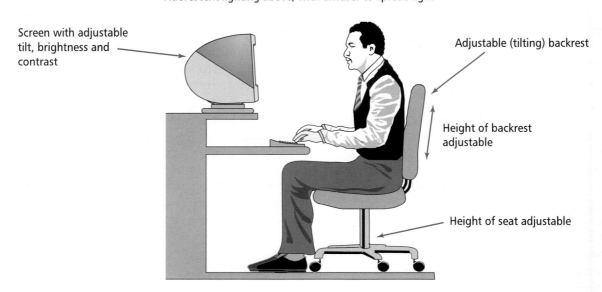

Fluorescent lighting above, with diffuser to spread light

Screen with adjustable tilt, brightness and contrast

Adjustable (tilting) backrest

Height of backrest adjustable

Height of seat adjustable

What you need to work efficiently and comfortably at a computer

Computers and privacy

The privacy issue has come so much more to the fore in the computer age that we tend to forget that privacy problems existed before computers. All computers have done, as they have in other areas, is to make the invasion of privacy faster and more efficient. But we have to be careful not to blame the technology for our privacy problems; the decision to gather data about people is not made by the computer, it is made by the people controlling the computer system.

For example, if you are travelling overseas, the airline you are travelling with will have details about you (where you are going, for how long you will be staying, where you will be staying, etc.). If you decide to eat out at a restaurant and give your credit card your personal details will be there as well. Even your family doctor has personal details about you and so does the local club you belong to. If you are a student the university will always have information about you saved in their computer systems.

Computers and crime

Computer crimes have been a cause of major embarrassment for some companies. A crime such as manipulating customer accounts can be committed by any person with access to the computer system. Very often the criminal cannot be identified. Computer crimes can affect the credibility of an organisation to a great extent. In fact some corporate victims do not prosecute the culprits even if they are caught, just to keep the matter from public attention and so retain their customers' trust.

TUTORIAL 1.7

1 The focus of our society has changed from agriculture to industry and from there to information.
 a What is the meaning of 'information society'?
 b What problems might people encounter in the information society?
 c What benefits might society gain from it?

2 List the situations in which a person might handle a job better than a computer.

3 List the situations in which a computer might handle a job better than a person.

4 'IT has caused unemployment'; give arguments for and against this statement.

5 With the introduction of computer-controlled technology, employment patterns have changed considerably. Name three such employment patterns.

6 List four new jobs that were created because of the introduction of computers.

7 As computers are used more and more, unemployment will probably increase. Write down a few of the steps, which could lessen this problem.

8 Give an example where computers have helped to improve working conditions.

9 List some of the organisations that may have personal data about us.

10 Explain a situation where the use of personal data might invade a person's privacy.

11 What is the main problem of computer crime?

12 What factors should be considered in providing an ergonomically suitable working environment?

13 What is RSI? How can it be avoided?

14 What problem is associated with VDUs?

15 What is e-commerce?

MODULE 2

Using computers and managing files

Operating systems

The operating system is a collection of systems software used to manage the overall operations of the computer. It provides the user with a number of facilities that allow them to use the computer hardware efficiently.

Features expected of an operating system

An operating system is expected to:

- start up and shut down the computer
- act as an interface between the user and the hardware
- perform housekeeping tasks such as file handling, disk and memory management
- allow the user to configure the system; this includes changing the types of printers, adding new hardware (such as sound cards), etc.

Types of operating systems

Operating systems can be broadly classified into two categories based on the type of interface provided to the user:

Command line interface
In this type of operating system the user must enter commands through the keyboard and each command will perform a specific action. This type of interface is very difficult for a beginner to use because the commands have to be remembered. Examples are MS-DOS and Unix.

Graphical user interface
This type of operating system allows the user to manipulate the computer in a more interactive way. These systems are more user-friendly than command-driven interfaces, because commands need not be learnt. Examples are Windows, OS/2 and Warp.

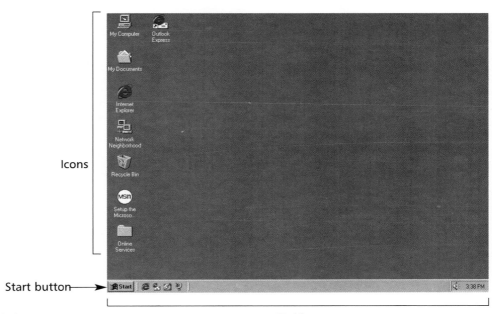

Figure 2.1 The Windows desktop

The Windows desktop

After you start Windows, the first thing you see is the **desktop**, the area on the screen where you work. Think of the desktop as your personalised workspace (Figure 2.1).

Several **icons**, or small pictures, are located on the left side of your desktop. Each icon represents an object, such as a **folder** or a **program**. Depending on how your computer is set up, your icons may be different from those in the illustration. The 'Start menu' can be accessed with the use of shortcut keys. For example, by pressing the Ctrl key and the Esc key simultaneously you can activate the Start menu. (The keyboard shortcuts are explained on pages 64–65.)

Exploring your computer

You can navigate around your computer in several different ways. For example, you can view your computer's contents by using either My Computer or Windows Explorer. Both navigational tools are easy to find – My Computer opens from the desktop, and Windows Explorer opens from the Start menu.

The taskbar and start button

You can use the taskbar and Start button to navigate easily through Windows. Both features are always available on your desktop, no matter how many windows you have open.

Buttons on the taskbar show you which windows are open, even if some windows are minimised or hidden beneath another window. You can easily switch to a different window by clicking its taskbar button.

Using the Start button, you can accomplish almost any task. You can start programs, open documents, customise your system, get help, search for items on your computer and more. Some commands on the Start menu have a right-facing arrow, which means additional choices are available on a secondary menu. If you place your pointer over an item with an arrow, another menu appears.

Depending on how your computer is set up, your Start menu may look slightly different from that shown in Figure 2.2.

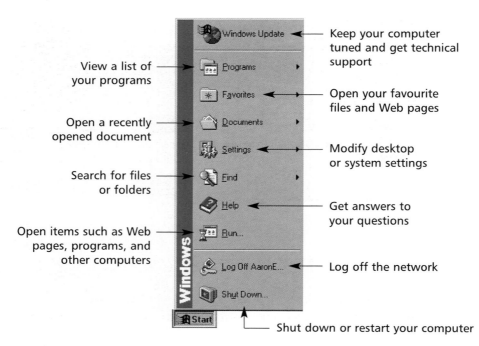

Figure 2.2 A typical Start menu

To use the Start menu:

1 Click the Start button.
(The Start menu appears.)
2 Click the item you want to open.
(Point to items with right-facing arrows to open secondary menus.)

My Computer

My Computer is helpful if you prefer viewing the contents of a single folder or **drive**. When you double-click My Computer on your desktop, available drives appear in a new window. When you double-click a drive icon, a window displays the folders contained by that drive. You can then double-click a folder to see the files it contains.

Some of the following icons may appear in your My Computer window.

Double-click	To
	View the contents of the hard disk, which is usually designated drive C.
	View the contents of a network drive, if your computer is connected to one.
	View the contents of a compact disk in the CD-ROM drive, if your computer has one.
	View tools you can use to modify your computer settings.
	Set up a printer and view information about available printers and print job status.
	View the folder contents.

To use My Computer to view your hard disk:

1 On the desktop, double-click My Computer.
The My Computer window appears.

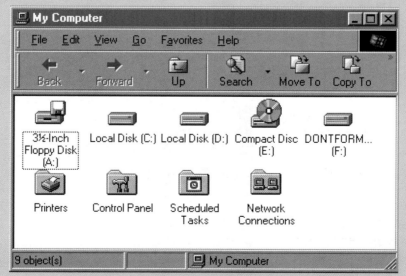

2 Double-click the icon that represents your hard disk.
Your hard disk window appears, and the contents of your hard disk are listed.

Windows Explorer

If you prefer to look at your files in a hierarchical structure, you will like using Windows Explorer. Instead of opening drives and folders in separate windows, you can browse through them in a single window. The left side of the Windows Explorer window contains a list of your drives and folders, and the right side displays the contents of a selected folder. You can use the View menu to change how the icons in the right half of the window appear.

To use Windows Explorer to view your hard disk:
1 Click the Start button, point to Programs, and then click Windows Explorer.
2 In the left pane, click the letter that represents your hard disk.
 The contents of your hard disk appear in the right pane.

Starting and closing programs

Most of the programs installed on your computer are available from one convenient location – the Programs section of the Start menu. Depending on how your computer is set up, what you see on the Start menu varies.

To start a program
1 Click the Start button, and then point to Programs.
 The Programs menu appears.

2 Point to the group (such as Accessories) that contains the program you want to start, and then click the program name.

Note: you can also open a program by clicking Run on the Start menu, typing the path and name of the program, and then clicking OK.

To close a program
Click the Close button in the top right corner of the program window.

Managing files and folders

In Windows, you can organise your documents and programs to suit your preferences. You can store these files in folders and you can move, copy, rename and even search for files and folders.

Creating files and folders

When you use a program and save your work, or when you install a program, you are creating files. You can store your files in many locations – on the hard disk, a network drive, a floppy disk, and so on. To better organise your files, you can also store them in folders.

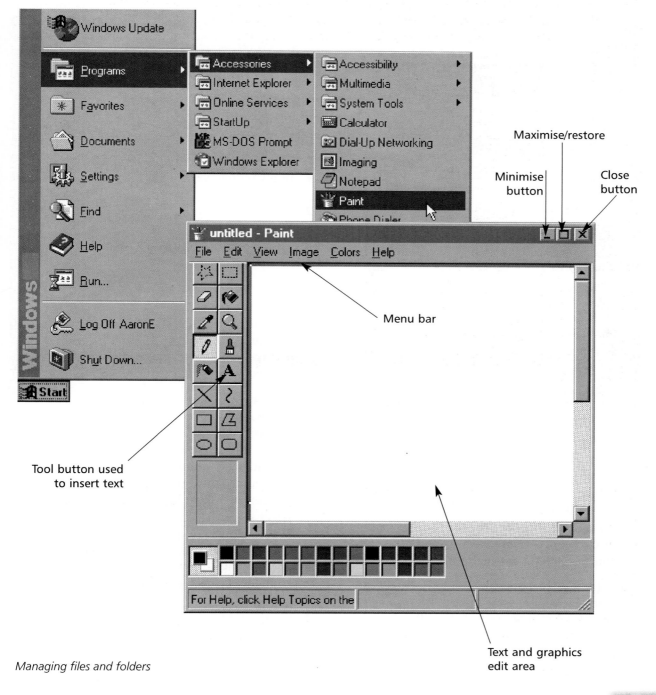

Managing files and folders

To create folders

1 On the desktop, double-click My Computer (or use Windows Explorer through the Start menu then <u>P</u>rograms).
 The My Computer window opens.
2 Double-click the disk drive or folder in which you want to create a folder.
 The drive or folder window opens.

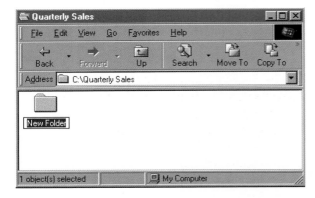

3 On the <u>F</u>ile menu, point to <u>N</u>ew, and then click <u>F</u>older.
4 Type a folder name, and then press Enter.
 The new folder appears in the location you selected.

To create files

One way of creating files on your computer is by starting the associated program and then saving the file in a folder.
 Another way is by using Windows Explorer or My Computer.

1 Open My Computer or start Windows Explorer.
2 Open the disk drive or folder in which you want to create the file.
3 On the <u>F</u>ile menu, point to <u>N</u>ew.
4 Then select the type of file that you wish to create, e.g. select Text Document to create a text file.
5 Type a file name and then press Enter.
 The new file appears in the location you selected.
6 Double-click on the file to open and edit it.

Note: file/folder names in Windows can be up to 255 characters, including spaces. However, file names cannot contain any of the following characters: \ / : * ? " < > |.

Opening files and folders

After you have located the file you want, you can double-click to open it.

To open a file or folder

1 On the desktop, double-click My Computer or Start then <u>P</u>rograms then Windows Explorer.
 The My Computer or Windows Explorer window opens.
2 Double-click the drive that contains the file or folder you want to open.
3 Double-click the file or folder.

Renaming files and folders

If you decide to change the name of a file or folder, you can quickly rename it.

To rename a file or folder

1 In a window, select the file or folder you want to rename.
2 On the <u>F</u>ile menu, click <u>R</u>ename, or press the F2 key.
3 Type a name, and then press Enter.

Copying and moving files and folders

When you create files and folders, you may want to copy or move them to another location. Unless you're an advanced user, you should avoid moving program and system files.

To copy or move a file or folder

1 In a window, select the file or folder you want to copy or move.
 Note: You can select multiple items. To select non-adjacent items, hold down Ctrl and click the items you want to select. To select adjacent items, hold down Shift while you select items. To select all of the items in a window, on the <u>E</u>dit menu, click Select <u>A</u>ll.
2 On the <u>E</u>dit menu, click <u>C</u>opy to copy the file, or click Cut to move the file.
3 Double-click the folder in which you want to place the file or folder.
4 On the <u>E</u>dit menu, click Paste.
 The file appears in its new location.

Deleting files and folders

Whenever you delete a file, it's temporarily moved to the Recycle Bin on your desktop. If you change your mind, you can restore the file. However, when you empty the Recycle Bin, all of the items in it are permanently deleted from your computer.

To delete files and folders
1 On the desktop, double-click My Computer. The My Computer window appears.
2 Select the file or folder you want to delete.
3 On the File menu, click Delete. The Confirm File Delete dialogue box appears.
4 Click Yes. The file is moved to the Recycle Bin.

To permanently delete files
1 On the desktop, double-click Recycle Bin. The Recycle Bin opens.
2 On the File menu, click Empty Recycle Bin.

Searching files and folders

(In Windows 95 and 98 this command is referred to as the 'Find' command.)
When you are looking for a particular folder or file, you can use the Search/Find command instead of opening numerous folders. The Search command lets you quickly search a specific drive or your entire computer.

To search a file or folder
1 Click the Start button, point to Search, and then click Files or Folders. The Search dialogue box appears.
2 In Search for/Find, type the file or folder name you want to find.
3 Click the Look in down arrow to specify where to search.
4 Click Search/Find Now. After a moment the results of the search appear.

Search screen for Windows 2000

Search screen for Windows 98 or 95

Search for/Find

This provides a place for you to type all or part of the name of the file you want to find. Leave this blank if you want the search to display all the files and folders.

Look in

This shows the location to start the search for the file you want to find. To specify a different location, click Browse. To see a list of previous locations, click the arrow.

The status bar at the bottom displays the number of files that were found.

To use advanced search methods to find files and folders

- Click Date to look for files that were created or modified on or between specific dates.
- Click Type to look for files of a specific type.
- Click Size to look for files of a specific size.
- Click Name and Contents to look for files with specific text.
 This provides a place for you to type some of the text contained in a file. If you don't know the file name, you may be able to find the file by typing some of its contents, particularly any unusual words you know it contains.
- Click Advanced to:
 Search subfolders search current folder including the subfolders.
 Case sensitive matches exact case.

Using wildcard characters

A wildcard character is a keyboard character such as an asterisk (*) or a question mark (?) that you can use to represent one or more real characters when you are searching for files or folders. Wildcard characters are used when you don't know what the real character is, or when you don't want to type the entire name. For instance, if you are searching for a file or a folder but you don't remember the whole name, you can use a wildcard character in place of one or more characters.

The Search windows use both the asterisk and question mark to broaden the scope of your searches.

Asterisk (*)

You can use the asterisk as a substitute for **any number of characters**. If you're looking for a file that you know starts with 'gloss' but you can't remember the rest of the file name, type **gloss*** as the name. The Find dialogue box will locate all files of any file type that begin with 'gloss' including 'glossary.txt', 'glossary.doc', and 'glossy.doc'. To narrow the search to a specific type of file, type **gloss*.doc**. In this case, the Find dialogue box will find all files that begin with 'gloss' and have the file extension '.doc', such as 'glossary.doc' and 'glossy.doc'.

Typing ***.*** results in a search that finds all files regardless of the file type or the length of the name.

Question mark (?)

You can use the question mark as a substitute for a **single character** in a name. For example, if you type **gloss?.doc** the Search window will locate the file 'glossy.doc' but not 'glossary.doc', as in the search using an asterisk. When you use the question mark, only one character will replace the question mark, appearing in the same location in the name where the question mark is placed.

Understanding files with extensions

The use of a file may vary from package to package, therefore each file should be uniquely identified by the application that created it. For this, each filename has a three letter text added to it to identify the application. This is known as a file extension.

For example, when a Microsoft Word document is created, apart from the file name the file extension '.**doc**' is added. The extension can be used to search files of a particular application. Table 2.1 shows some of the common extensions in use.

Table 2.1 *Some commonly encountered file extensions*

Extension	Application
.doc	Microsoft Word
.xls	Microsoft Excel
.ppt	Microsoft PowerPoint
.mdb	Microsoft Access
.bmp	Bitmap files
.gif	Generic information file
.jpeg	Joint experts photographic group
.txt	Text documents
.rtf	Rich text format
.pdf	Portable document format

Properties of a file

Getting information about a folder

Using Windows Explorer or the Search command you can get a lot of information about the number of files in a folder (even including its subfolders), size of files and the date when files were created/updated.

For any file or folder, right-click on it (use the right-hand mouse button) and click on Properties. A dialogue box displays all the information about the file or folder.

Properties of a folder

Viewing folders

You can easily change the appearance of the files in a folder and sort the files in a folder according to your requirements.

To change the appearance of items in a folder
1 In My Computer or Windows Explorer,
2 On the <u>V</u>iew menu, click Large Icons, Small Icons, List, or Details.

To sort the files in a folder
1 In My Computer or Windows Explorer,
2 On the <u>V</u>iew menu, click to Arrange Icons
3 And select the order in which you wish to sort the files.
 You can sort the items by name, size, date, and type, depending on the view.
Note: When you point to a menu command, the status bar at the bottom of the window displays a description of what that command does. On the <u>V</u>iew menu, you can click Status Bar if the status bar is not visible in your window.

Formatting a diskette

To format a disk
1 If the disk you want to format is a floppy disk, insert it into its drive.
2 In My Computer or in the right pane of Windows Explorer, right-click the icon for the disk you want to format.
3 On the pop-up menu, click <u>F</u>ormat.

Note:

- Do not click the disk icon with the left button, because you cannot format a disk if it is open in My Computer or Windows Explorer.
- Formatting a disk removes all information from the disk.
- You cannot format a disk if there are files open on that disk.

Shutting down your computer

When you have finished working in Windows, you use the Shut Down command on the Start menu to close windows and programs and prepare your computer for shutting down. If you have not already saved your work, you're prompted to do so.

Important

Do not turn off your computer until you see a message telling you that shut down is complete. If you turn off your computer without shutting it down correctly, you risk losing information.

To shut down your computer

1 Close all the programs that are running.
2 Click the Start button, and then click Shut Down.
 The Shut Down Windows dialogue box appears.

The Shut Down Windows dialogue box

3 Click OK if you want to turn off your computer.
 If your computer does not turn off automatically, a message will appear telling you when you can safely turn off your computer.

Printing

Before you can print any document, you have to first set up the printer. This means telling Windows about the type of printer you have.

You could have more than one printer connected to your computer. To see a list of all the printers installed in your computer open the Printers folder in the Taskbar/Control Panel.

To open the printers folder
1 Click Start point to Settings.
2 Click Printers.

Default printer indicated with a check mark

Selecting the default printer

Your print jobs are always sent to the default printer unless you specify otherwise. In the Printers dialogue box, the default printer has a check mark beside its icon. You can change your default printer at any time.

Printing a document

After you have set up a printer, you can easily print documents. In many programs, the Print command is available on the File menu.

To print an open document
On the File menu, click Print.

To set a default printer:
1 Click Start, point to Settings, and then click Printers.
2 Right-click the icon of the printer you want to set as the default.
3 A shortcut menu appears.
4 Select Set as Default.

To save a document as a print file
When the Print to File option in the Print dialogue box is activated, Microsoft Word prints your document to a file instead of to a printer; you can browse and select the destination you wish to store the file in.

Print to a file option

Working with frequently used files

There is a quick way of opening documents and programs that you use often. The Start menu lists the documents used most recently, so that you can quickly reopen them. The My Documents folder on your desktop is a convenient place for you to store frequently used files and folders.

For easy access to a file that you use frequently, you can also create a shortcut to it. A shortcut does not change the location of a file – the shortcut is just a pointer that lets you open the file quickly. The original file is not deleted, if you delete the shortcut.

To open recently used documents
1 Click the Start button, and then point to Documents.
 A list of your recently opened documents appears.

2 Click a document on the list.
 The document opens.

To move a file to the My Documents folder
Drag the file to the My Documents folder on your desktop.

To create a shortcut to a file
1 Use the right-hand mouse button to drag the file to the desktop.
2 On the menu that appears, click Create Shortcut(s) Here.

The shortcut appears on the desktop. You can copy or move the shortcut to another location.

Personalising your desktop display

In addition to customising your computer by using TV and Web-like options, you can personalise your desktop with pictures, patterns and colours by using the display control panel. You can display pictures, patterns or even scanned photographs as 'wallpaper', that is the background to your desktop. Using the different tabs in the Display Properties dialogue box, you can also change items such as the icons on your desktop, the colours of individual windows and the size of the objects on your screen. You can even add items to your active desktop or set up a screen saver.

To open the display control panel

1 Click the Start button, point to Settings, and then click Control Panel.
 The Control Panel window appears.
2 Double-click Display.

The Display Properties dialogue box appears. To set wallpaper, select an image or click the <u>B</u>rowse button. Click the other tabs in the dialogue box to set up a screen saver, change the desktop and window colours, add Active Desktop items, change your screen resolution, and so on.

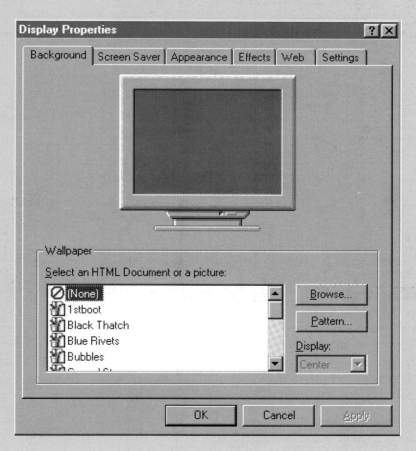

Customising the Start menu and the taskbar

You can customise the Start menu to help you work more efficiently. You can add folders or files that you open frequently, so that you can open them quickly from the Start menu at any time. Or you can create your own groups of files and programs. You can also add items to or remove them from the Start menu. For example, you can reduce the size of the Start menu by removing a program that you no longer use.

If you remove an item from the Start menu, you are not uninstalling the program or removing it from your computer.

To customise the taskbar
1 Click the Start button, point to Settings, and then click Taskbar & Start Menu.
2 The Taskbar Properties dialogue box appears.
3 Select the taskbar options you want.

To move the taskbar
Drag the taskbar to any edge of the desktop.

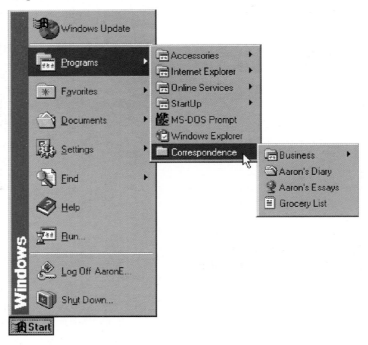

The Start menu

To customise the Start menu
1 Click the Start button, point to <u>S</u>ettings, and then click Taskbar & Start Menu.
 The Taskbar Properties dialogue box appears.
2 Click the Start Menu Programs tab.
3 Click Add or Remove, and then follow the instructions that appear on the screen.

You can also customise the taskbar to suit your needs. The taskbar is located at the bottom of the desktop by default, but you can drag it to any side of the desktop. You can also hide the taskbar until you want to use it, or you can always display the taskbar on top of other windows.

Using a mouse

A mouse is a hand-held device that controls the movement of a pointer on the screen. You use the mouse to perform tasks on your computer.

As you move the mouse, a mouse pointer moves on your screen.

When you position the pointer over an object, you can press (click or double-click) the mouse button to perform different actions on the

object. For example, you can double-click to open and work in files, click-and-drag to move files, and click to select files. In fact, you will probably use your mouse for most tasks. The pointer usually appears as an arrow, but it can change shape depending upon its environment.

The following sections explain other actions you can perform with your mouse.

Pointing and clicking

You perform most of the tasks on your computer by pointing at an object on your screen, and then clicking a mouse button. To point to an object, move the mouse until the tip of the mouse pointer is over the item or area you want.

Table 2.2 describes common click actions.

Table 2.2 Clicking the mouse

Action	Description
	Click: Press and release the left mouse button once.
	Double-click: Quickly press and release the left mouse button twice.
	Right-click: Press and release the right mouse button once. A shortcut menu appears.

You can switch left and right mouse buttons by changing the mouse set up.

Dragging

Moving objects on your screen is like moving objects around on your desk. For example, clicking and dragging an icon is like physically

picking up a pencil with your hand and dropping the pencil in a new location. Similarly, to move a screen object, you first position the mouse pointer on the object. Next, you 'pick up' the object by pressing and holding down the left mouse button. While still holding down the mouse button, move the mouse pointer to where you want to 'drop' the object, and then release the mouse button. The following illustration demonstrates dragging a document to a folder.

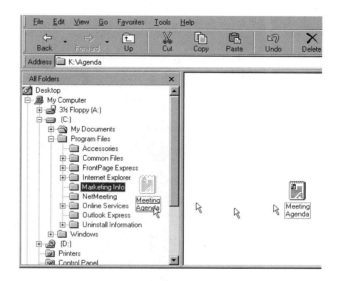

You can also drag to select text, such as words in a document or the name of a file. To select text, first insert your cursor (a blinking vertical line) where you want to start the selection. Then hold down the left mouse button, move the mouse pointer to where you want to end the selection, and release the mouse button.

Using Help in Windows

You can use the Help function from the Start Menu to get more information about a topic or a command.

To find a Help topic either:
- In Help, click one of the following tabs:
 - to browse through topics by category, click the Contents tab
 - to see a list of index entries, click the Index tab, and then either type a word or scroll through the list.

■ To search for words or phrases that may be contained in a Help topic, click the Search tab. In the left of the Help window, click the topic, index entry or phrase to display the corresponding topic in the right frame.

Keyboard shortcuts

General Windows keys

To quickly open shortcut menus you can use the application key () on a Microsoft Natural keyboard or any other compatible keyboard that includes the application key. Some other useful key functions are listed below.

To:	Press
activate the menu bar in programs	F10
carry out the corresponding command on the menu	Alt + underlined letter in menu
close the current window in multiple document interface (MDI) programs	Ctrl + F4
close the current window or quit a program	Alt + F4
copy	Ctrl + C
cut	Ctrl + X
delete	Delete or Del
display Help on the selected dialogue box item	F1
display the current window's system menu	Alt + Spacebar
display the shortcut menu for the selected item	Shift + F10
display the Start menu	Ctrl + Esc
display the system menu for MDI programs	Alt + - (hyphen)
paste	Ctrl + V
switch to the window you last used *or* switch to another window by holding down Alt while repeatedly pressing the Tab key	Alt + (tab)
undo your last action	Ctrl + Z

For My Computer and Windows Explorer only

To:	Press
close the selected folder and all of its parent folders	(Shift) while clicking the Close button
move backward to a previous view	Alt+ (left arrow)
move forward to a previous view	Alt+ (right arrow)
view the folder one level up	Backspace

For the desktop, My Computer and Windows Explorer

When an item is selected, you can use the shortcut keys shown in the following table.

To:	Press
bypass AutoPlay when inserting a CD	(Shift) while inserting the CD
copy a file	Ctrl while dragging the file
create a shortcut	Ctrl + (Shift) while dragging the file
delete an item immediately without placing it in the Recycle Bin	(Shift) + Delete
display Search: All Files	F3
display the item's shortcut menu	(Application key)
refresh the contents of a window	F5
rename an item	F2
select all items	Ctrl + A
view an item's properties	Alt + Enter *or* Alt + double click on mouse
refresh the Save As or Open dialogue box	F5

For dialogue boxes

To:	Press
cancel the current task	Esc
click the corresponding command	Alt + letter underlined in dialogue box
click the selected button	Enter
move forward through options	Tab
move backward through options	(Shift) + (Tab)
move forward through tabs	Ctrl + (Tab)
move backward through tabs	Ctrl + (Shift) + (Tab)
click a button if the current control is a button *or* select or clear the check box if the current control is a check box *or* click the option if the current control is an option button	Spacebar
open a folder one level up if a folder is selected in the Save As or Open dialogue box	Backspace
open Save In or Look In in the Save As or Open dialogue box	F4
refresh the Save As or Open dialogue box	F5

TUTORIAL 2.1

1 Start the Paint program in the accessories group.

2 If the window is not maximised, maximise it by clicking on the Maximise button.

3 Draw the flag of the Red Cross.

4 Save the file as **Red Cross** on your floppy disk.

5 Make a printout of the flag.

6 Exit the Paint program.

TUTORIAL 2.2

1 Start the WordPad program in the accessories group.

2 Type in the following paragraph:

Welcome to the year 2001 website of Aberdeen University Red Cross Society and Aberdeen University (British Red Cross) Group. AURCS was established in 1992 to promote and support the British Red Cross through Aberdeen University Group by offering Aberdeen University's students the opportunity to use and learn basic life support and community care skills.

3 Save the file on your floppy disk as **British Red Cross**.

4 Minimise WordPad.

5 Start the Paint program.

6 Open the file that you created in Tutorial 2.1 (Red Cross).

7 Select the flag (picture) and copy it.

8 Switch over to WordPad. (Click on the WordPad icon on the taskbar.)

9 Paste the flag (picture) at the beginning of the page, so that the flag looks like a logo.

10 Save the file by the same name, **British Red Cross**.

11 Make a printout of the document you made in WordPad.

12 Close the WordPad and the Paint programs.

TUTORIAL 2.3

1 Start Windows Explorer and create the following directory structure in your diskette.

2 Create a file called **UNAMES.TXT** in the Windows directory and enter the following names:
 Cybil Shepard
 Mark Morrison
 Bruce Wills
 Robby Williams
 Los Del Rio

3 Copy the file **UNAMES.TXT** to the subdirectory A:\DOS\TEMP.

4 Remove the DBASE directory from the diskette.

5 Change the name of the file **UNAMES.TXT** to **FNAMES.DAT**.

TUTORIAL 2.4

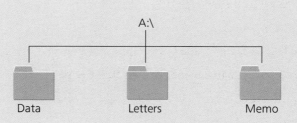

1 Create the files **EX1.TXT, EX2.TXT, EX3.TXT** in the Memo directory. The contents of the files should be as follows.
 EX1.TXT This is the file EX1.TXT
 EX2.TXT This is the file EX2.TXT
 EX3.TXT This is the file EX3.TXT

2 Using the Search\Find command search for the files with the *.COM extension in the directory C:\WINDOWS\ and copy them to the Data directory on the floppy disk.

▶▶

3 Create a new text file called **Summary** in the Data directory and type the following data into it (**Hint:** use the Search/Find command):
- the total number of files on your floppy diskette (do not count the folders)
- the total size of all the files on your floppy disk
- the names of the four largest files in the Data directory.

4 Move the files in the Data directory starting with C to the Letters directory.

5 Delete the files starting with MO in the Data directory.

6 Find all the files starting with E on your floppy disk and move all of them to the Letters directory.

1 Find the files in the C:\PROGRAM FILES directory (including subfolders) whose name starts with CO.
- Sort the list of files by their file size. What are the names of the five largest files?
- Change the appearance of the icons to large icons.
- Change the listing back to Details.

2 Find the files in the C:\PROGRAM FILES directory (including subfolders) whose name ends with ON.

3 Use the Windows Help function to find information on printing a document.

Create the following structure on your working diskette.

1 Start Notepad and maximise the window. (You may use WordPad instead of Notepad.)

2 Prepare a file called **TEST** having the contents as follows and save it in A:\DOS.
 This is line 1.
 This is line 2.
 This is line 3.
 This is line 4.
 This is line 5.

▶▶

Note: type only the first line, then using Copy/Paste get copies of the other lines and change each line to the correct number.

3 Copy the file **TEST** to the folder A:\WINDOWS and modify it as follows:
 This is line 1.
 This is line 2.

4 Change the name of the file you have in A:\DOS to **TEST1**.

5 In the DOS directory make a duplicate of **TEST1** and name it **TEST2**.

6 Modify the contents of the file **TEST2** as follows:
 This is sentence 1.
 This is sentence 2.

7 Delete the file TEST1 in the folder A:\DOS.

8 List all the files on your diskette beginning with the letter T and write the names of the files list to a text document called **TFILES.txt**.

9 Check the System Date and correct it if it is incorrect.

10 Create a shortcut to the **TEST** file and place it on the desktop.

11 Using the Search/Find command search for the files starting with README in the C:\WINDOWS directory (don't include subfolders) and copy all of them to A:\WINDOWS.

12 Create a new text file called **TEXTFILE** and type in the following data into it (**Hint**: use the Search/Find command and/or Windows Explorer):
 - **How many .TXT files are there in the C:\WINDOWS directory (not including subfolders)?**
 - **How many .TXT files are there in the C:\WINDOWS directory (including subfolders)?**
 - **How many subfolders are there in the C:\WINDOWS directory?**
 - **What is the name, size and date created/modified of the largest file in the C:\WINDOWS directory (not including subfolders)?**
 - **What is the name and date modified of the oldest file and the most recently used file on your computer's hard disk?**

13 Make a folder called **Name BACKUP** (where Name is your name, e.g. Smith Backup) on the hard disk (C:\) and back up all the files and folders on your floppy disk onto the C:\Name BACKUP folder.

14 Format your diskette in drive A:.

15 Move the **Name BACKUP** folder from the hard disk back to your floppy disk.

TUTORIAL 2.7

Create a file called **Answers to Tutorial 7.doc**. The data for this file is given in the Appendix on page 209. Using the file answer the following:

1 Enter your candidate identification number in the appropriate place, e.g. **CFIT (HO) 1005**

2 Explain how you would switch off a standard PC, using the correct method.

3 Using the Help function extract information about files and folders. Write some of the information in your text file.

4 How would you restore a desktop window? Enter your choice in the **Answers to Tutorial 7.doc** file.

 a ▣ b ▬ c ▤ d ✖

5 Create the following folder structure on your working diskette:

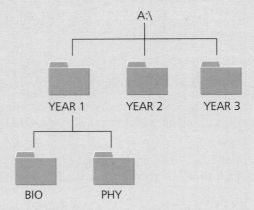

6 Create a directory named **COM** in A:\YEAR1 directory.

7 Create a file called **FIRST** in A:\YEAR1\BIO directory and type in the following:

Name	Marks
Ravi Fernando	68
Sarath Silva	80
Gamini Perera	27
Sunil Fernando	77
Shirani Fonseka	33

8 Copy the file **FIRST** to A:\YEAR1\PHY directory.

9 Edit the file **FIRST** in A:\YEAR1\PHY directory as follows.

Name	Marks
Amila Perera	57
Isuru Perera	66
Kamal Silva	59
Gamini Silva	49
Sriyani Fernando	89

10 Move the file **FIRST** in A:\YEAR1\PHY to A:\YEAR1 and rename it as **PHYMARKS**.

11 Delete the directory A:\YEAR1\PHY.

12 Rename the file **FIRST** in A:\YEAR1\BIO directory as **BIOMARKS**.

▶▶

TUTORIAL 2.7

13 Add the following line as the last line of the file **BIOMARKS**.

 Nimal Fernando 90

14 Which of the file types is often used in database files? Enter your choice in the file **Answers to Tutorial 7.doc**.

 a .doc
 b .bmp
 c .mdb
 d .jpeg

15 Count the number of files with the .txt extension on your working diskette. Enter your answer in the file **Answers to Tutorial 7.doc**.

16 Using the Help function extract information about e-mail.

17 Which of the following key combinations is used to switch between two or more windows? Write your answer in the file **Answers to Tutorial 7.doc**.

 a Esc + Enter
 b Shift + Enter
 c Ctrl + Alt + Delete
 d Alt + Tab

18 Print four copies of the file **Answers to Tutorial 7.doc** from a printer (if available) or save it as a print file on your diskette.

TUTORIAL 2.8

1 How would you set a printer as the default (standard) printer for your computer?

Create a file called **PRINTER.txt** and type in the steps you would take to set a default printer and save it in the root directory of your floppy disk.

2 What is the name of the default printer for your computer?

Open the **PRINTER.txt** file if you had closed it and add the name of the default printer in your computer to the end of the file.

3 Which of the following statements are true, about formatting floppy diskettes? Write your answer in the file **PRINTER.txt**.

 a It is a method of saving data.
 b Formatting a disk removes all existing information from the disk to create new sectors.
 c It is a method of arranging disorganised files.
 d You can format a disk if there are files open on that disk.

4 Format your diskette in drive A:.

MODULE 3 Wordprocessing

Wordprocessing software lets you create, edit, format, store, retrieve and print a text document.

Microsoft Word is a sophisticated package that includes many desktop-publishing-type features, a graphics package and a drawing package.

When you start Word, the document window shown in Figure 3.1 will be displayed on the screen.

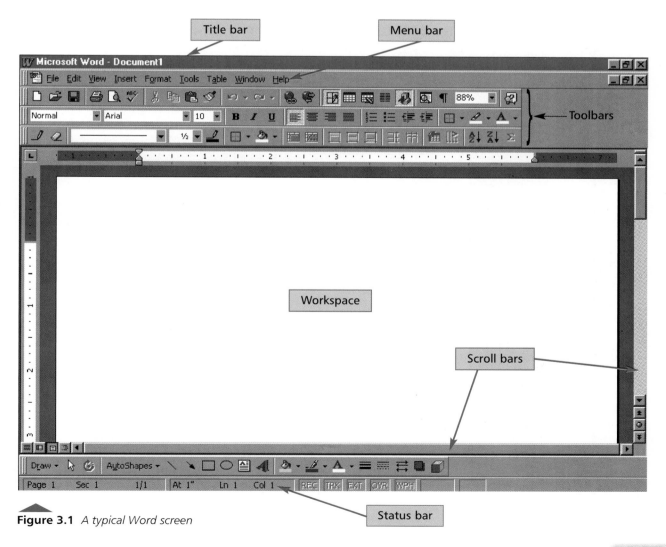

Figure 3.1 *A typical Word screen*

Starting Word

Switch on the computer. From the Start button, select Programs and click on the Microsoft Word icon.

Word automatically starts a new document for you; this document is called Document 1 until you save it (permanently record it onto disk). You will then be prompted to enter a name which you can later use to retrieve the document.

The Word workplace is what you see on your screen – the text area as well as the title bar, menu bar, toolbars and status bar. The Word workplace also includes elements such as menu commands, dialogue boxes and windows.

Depending on the view you use, different screen elements are available. You can also display or hide some screen elements as you wish.

Saving documents

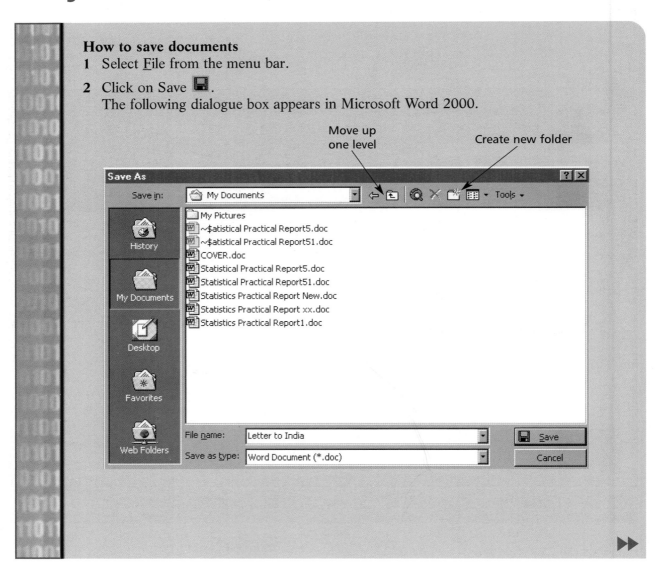

How to save documents

1 Select <u>F</u>ile from the menu bar.

2 Click on Save 💾.
 The following dialogue box appears in Microsoft Word 2000.

The following dialogue box appears in Microsoft Word 97.

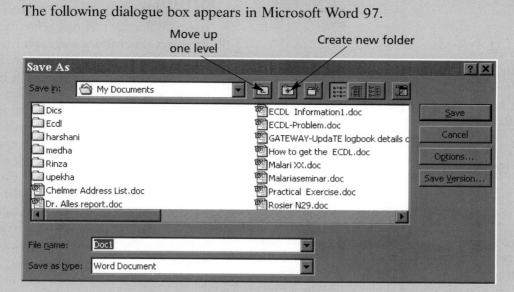

Move up one level

Create new folder

The first time you save a document, Word prompts you for a file name and subdirectory to which to save the file using the Save As dialogue box shown above. The Save As dialogue box gives you limited file management abilities. It has buttons to:

- **Move up one level**. This moves the file one folder closer to the root directory. To move in the other direction, simply click on the icon of the desired folder.
- **Create a new folder**. This lets you create a new folder inside the current folder. You can then save the file in the new folder.
- change **Views**. This allows you to change the way the files and folders are displayed.

Saving in different formats

By selecting *Save as type you can choose what type of format you wish to save your document in. This may be useful when working in different versions as well, for example, if you are working at a higher version level (Office 2000) you could save your document in Word 97 and open it on a computer which does not support Office 2000.

To save the document using a password click on the Options button.

Opening a document

To open a new document

1 Select File from the menu bar.
2 Click on New.

To open an existing document

1 Click Open.
2 In the Look In box, click the drive or folder that contains the document.
3 In the folder list, double-click folders until you open the folder that contains the document you want.

4 Double-click the document you want to open.

Closing a document

1 Select File.
2 Click on Close.

This will close the currently open document but will leave Word on-screen.

Quitting Word

1 Select the File menu.
2 Click on Exit.

The usual sequence of using Word

1 Start Word.
2 Create a <u>N</u>ew file i.e. start a new document or open an existing document file.
3 Type your text, add a picture or a chart, or make changes to an existing document.
4 Save (record) the document onto the disk.
5 Print the document.
6 Exit Word.

Typing a simple document

Start Word and begin typing the document. You should press Enter or Return only at the end of each paragraph. Word will automatically take care of moving the cursor down to the next line if you just continue typing. This function is called wordwrap.

It is very important that you use wordwrap rather than pressing the Return key yourself. To begin with, it is a lot less work to let Word wordwrap than it is to constantly watch the screen and press return each time the cursor gets to the right margin. Additionally, if you edit the document and remove a word, the line needs to be broken in a different spot. With wordwrap, Word takes care of that. Without wordwrap, you have to manually delete all your old returns and insert new ones. That takes a lot of time.

Editing text

Selecting text

It is very important to know how to select text. You must select all the text you wish to format prior to applying character formatting. Additionally, you need to select text before you can copy or cut it to the clipboard, and before you can use drag-and-drop editing. You can select text using either the mouse or the keyboard.

Selecting text using the mouse
Word has mouse shortcuts for selecting text:

1 **To select a single word** double-click on the word.
2 **To select a single sentence** hold down the Ctrl key and click anywhere in the sentence.

If you hold down the mouse button when you click and move the mouse cursor, you will select additional text one sentence at a time.

3 **To select an entire paragraph** move the mouse pointer to the left margin, beside the paragraph to be selected, until it turns into an arrow, then double-click to select that paragraph. If you hold down the mouse button on the second click, Word will go into paragraph selection mode. If you then move the cursor up or down, you will select additional text one paragraph at a time.

4 **To select all the text between the current cursor position and a different position** move the mouse cursor to the new position, hold down the Shift key and click with the mouse.

5 **To select the whole document** move the mouse cursor into the left margin until it turns into an arrow and then triple-click.

When editing text you can use the arrow keys to move between text. To erase a mistake you can use the backspace or the delete keys. Table 3.1 shows different ways of erasing and moving between text.

Table 3.1 Useful keyboard shortcuts

Keyboard shortcut	Function
Backspace	Deletes character to the left of the cursor.
Del	Deletes character to the right of the cursor.
Ctrl + Backspace	Deletes the word to the left of the cursor.
Ctrl + Del	Deletes the word to the right of the cursor.
Ctrl + Home	Moves to the beginning of the document.
Ctrl + End	Moves to the end of the document.
Shift + F5	Moves back to the last space you were working. It remembers three prior locations.

Deleting a word

Double-click on a word to select it, then press Del to delete it.

Deleting a block of text

1 Select the text that you want to delete.
2 Press the Del key.

Searching for text

The ability to search through a document and find a particular section of text or 'string', and if required replace it with another, is an extremely useful feature. There are various uses for Find and Find and Replace.

To find text

1 On the Edit menu, click Find.
2 In the Find What box, enter the text you want to search for.
3 Click Find Next.

To replace text

1 On the Edit menu, click Replace.
2 In the Find What box, enter the text you want to search for.
3 In the Replace With box, enter the replacement text.
4 Click Find Next, Replace, or All.
 Note: To cancel a search in progress, press Esc.

The More button displays advanced search and replace criteria. This button changes to Less while these advanced criteria are displayed. Click Less to hide the advanced criteria.

Spell checker

By default, Microsoft Word checks both spelling and grammar. If you want to check spelling only, click Options on the Tools menu, click the Spelling & Grammar tab, clear the Check Grammar with Spelling check box, and then click OK.

To check spelling and grammar

1 Click Spelling & Grammar on the standard toolbar.
2 When Word finds a possible spelling or grammatical error, make your changes in the Spelling & Grammar dialogue box.

Clear the Check Grammar check box if you don't want Word to check the grammar in the active document.

Formatting

It is not enough to type a document into Word; you should make the document look attractive. We will examine three types of formatting: page, paragraph and character.

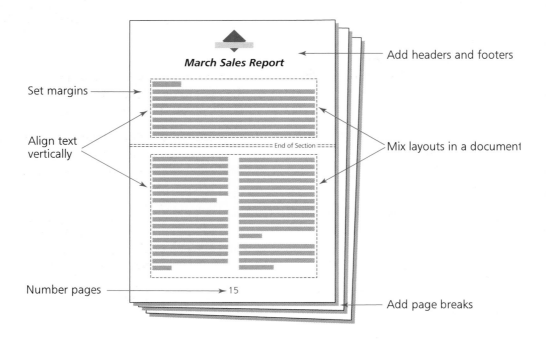

Page formatting

Page formatting controls how the document is printed on the page. The main focus of page formatting is the margins. Before changing the page format, you should make sure that no text is highlighted. Now, click on the File menu and then on Page Setup. That will bring up the tabbed dialogue box shown below.

The Page Setup dialogue box has four tabs, with the Margins tab shown in the figure above. This tab allows you to set the top, bottom, left and right margins, along with the margins at the top and bottom used for the headers and footers respectively. Headers and footers are textblocks that are printed at the top and bottom of a page, respectively. A page number is an example of a footer when it is printed at the bottom of the page.

Page breaks

Page breaks are inserted to keep two pages separate from each other.

To add a page break

1 Position the insertion point at the place where the page break is to occur and …
2 Either:
 a Select Insert from the menu and then click on Break

 or

 b Press Ctrl + Enter.

Paragraph formatting

Paragraph formatting controls how a particular paragraph appears on the page. You can control the spacing of the paragraph (single, double and so on), its justification, if its left and right sides are indented from the margin, if the first line is indented, etc.

You can apply the formatting by using the Formatting toolbar.

Indenting

An indent is the space between the margin and the beginning of the text.

There are two common uses of an indent:

- **A hanging indent**. Hanging indents are frequently used for bibliographic entries, glossary terms, resumés, and bulleted and numbered lists.

- **A first-line indent**. First-line indents are often used to mark the beginning of a new paragraph.

To alter the indenting for a paragraph

1 Select F̲ormat.
2 Select P̲aragraph.
3 Type in the value for the indentation.

Line spacing

Line spacing refers to the space between the bottom of one line and the bottom of the next line. Normally text is typed in 'single spacing' i.e. line spacing is one. Word automatically adjusts the line height to accommodate the size and font you are using.

To alter the line spacing in the document

1 Select F̲ormat.
2 Select P̲aragraph.

The three types of spacing that are most commonly used are single, double and one and a half spacing.

Text formatting

When formatting text, there are three major things you usually change: the typeface, the size of the font and its attributes. All three of these can be changed from the Formatting toolbar. There are other, less important, changes you can make to your fonts, but these are available only through a dialogue box.

Hyphenate

You can use the hyphenation feature to give your documents a polished and professional look. For example, hyphenation helps eliminate gaps or 'rivers of white' in justified text. Hyphenation also helps maintain even line lengths in narrow columns.

To hyphenate text automatically

1 On the T̲ools menu, point to L̲anguage, and then click Hyphenation.

2 Select the <u>A</u>utomatically Hyphenate Document check box.

3 In the Hyphenation <u>Z</u>one box, enter the amount of space to leave between the end of the last word in a line and the right margin.

4 To reduce the number of hyphens, make the hyphenation zone wider. To reduce the raggedness of the right margin, make the hyphenation zone narrower.

5 In the <u>L</u>imit Consecutive Hyphens to box, enter the number of consecutive lines that can be hyphenated.

Inserting special symbols

You can insert special symbols such as those shown below by using the following command.

1 Select the <u>I</u>nsert menu.
2 Click on <u>S</u>ymbol.
3 The Symbol dialogue box appears, displaying all the characters of a particular font. Click the List button to the right of the Font indicator, click on Wingdings or Symbol.
4 Click on the symbol or character you require, click <u>I</u>nsert; the special character is inserted into your text.
5 Click on the Close button to remove the dialogue from your screen.

Typical symbols might be:

Borders and shading

In a Word document, you can add a border to any or all sides of a table, a paragraph or selected text in a document. You can add a border, including a picture border (such as a row of trees), to any or all sides of each page in a document.

You can also add a border or line to a drawing object including a text box, an AutoShape or a picture.

> You can add borders, shading and shadows to your paragraphs. You can also do this around tables and around graphics

Applying borders and shadings

1 Select the table, paragraph or text to which you want to apply the border or shading.
2 On the F<u>o</u>rmat menu, click <u>B</u>orders and Shading; you now have three options:
 a click on the Borders tab if you want to apply borders
 b click on the Page Border tab if you want to apply a border to the whole page
 c click on the Shading tab if you want to apply shading.
3 Select the options you want, and make sure the correct option is selected under Apply To.
4 To specify that only particular sides get borders, click Custom under Setting. Under Preview, click the diagram's sides, or use the buttons to apply and remove borders.
5 To specify the exact position of the border relative to the text, click Options, and then select the options you want.

Tab stops

The simplest way to create text that is lined up in columns is to use tab stops. If you inspect the Ruler, by selecting <u>V</u>iew then <u>R</u>uler, you will see that Word provides default left tab stops at approximately every half inch. Text can be aligned at these tab stops simply by pressing the tab key to move to the next tab stop position.

Set tab stops

1 Select the paragraphs in which you want to set tab stops.

2 Click at the far left of the horizontal ruler until it changes to the type of tab you want:

3 Click on the horizontal ruler where you want to set a tab stop.

If you want to set precise measurements for tabs, click Tabs on the Format menu.

Clear or move tab stops

1 Select the paragraphs in which you want to clear or move a tab stop.
 a To clear a tab stop, drag the tab marker off the horizontal ruler.
 b To move a tab stop, drag the tab marker to the right or left along the horizontal ruler.

Set tab stops with leader characters

1 Select the paragraphs in which you want to insert leader characters before a tab stop.
2 On the Format menu, click Tabs.
3 In the Tab Stop Position box type the position for the new tab, or select an existing tab stop to which you want to add leader characters.
4 Under Alignment, select the alignment for text typed at the tab stop.
5 Under Leader, click the leader option you want, and then click Set.

Bulleted lists

To distinguish a list of points from the rest of the text it is usual to highlight them using bullets or point numbers. A bullet is a symbol at the start of each point as in Figure 3.2.

A list is an excellent way to stress important items in a document. Lists are quick and easy to read; the reader often looks at a list before reading the rest of the text. You can create lists in Word using bullets or numbers. Bullets are small symbols such as a dot, check box, diamond or arrow that attract attention to the start of each item in the list.

You can select some paragraphs and convert them into a bulleted or numbered list. If you add or insert another item of text, or delete an item, the bullets or numbers are automatically updated for you.

When you manually number the items in a list, Word converts the typed numbers to automatic numbering. If you begin a paragraph with a hyphen, Word automatically converts the paragraph to a bulleted item when you press Enter at the end of the paragraph.

To add bullets or numbers to a list of sentences

1 Select the items to which you want to add bullets or numbers.
2 To add bullets, click the Bullets button on the toolbar.
To add numbers, click the Numbering button on the toolbar.

To modify bullet or number formats

1 Select the paragraphs that have the bullet or number format you want to change.
2 On the Format menu, click Bullets and Numbering, and then click the tab for the type of list you want to modify.
3 Click Customise.
4 Select the formatting options you want.

Figure 3.2 *Examples of bulleted and numbered lists*

Removing the bullets or numbers

1 Select the items from which you want bullets or numbers removed.
2 To remove bullets, click the Bullets ☰ button on the toolbar.
3 To remove numbers, click the Numbering ☰ button on the toolbar.

To remove a single bullet or number, click between the bullet or number and the corresponding text, and then press Backspace. To remove the indent, press Backspace again.

Headers and footers

A header is any text or graphics that appear at the top of a page. A footer appears at the bottom of a page. They are useful in long documents as they can be used to indicate, for example, the chapter or section title. In business documents they may contain a reference number or company logo.

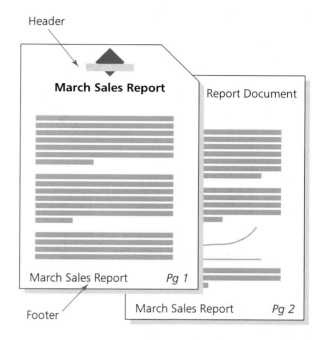

Header

March Sales Report

Report Document

March Sales Report *Pg 1*

Footer

March Sales Report *Pg 2*

To add or remove a header or footer
1 Select <u>V</u>iew.
2 Select <u>H</u>eader and Footer.
 In the outlines box you can type the header of the document; to move to the footer, click on 🖭 .
3 To return to the document, click on <u>C</u>lose.

▼ **Header and Footer**

In<u>s</u>ert AutoText ▾ 🔲 🔲 🔲 🔲 🔲 🔲 🔲 🔲 🔲 🔲 | <u>C</u>lose

Note: Auto correct options can be used to insert text that would be used in common letters and documents (e.g. page, author, page#, date, created by, file name and path).

To insert page numbers
1 On the <u>I</u>nsert menu, click Page N<u>u</u>mbers.
2 In the <u>P</u>osition box, specify whether to print page numbers in the header at the top of the page or in the footer at the bottom of the page.
3 Select any other options you want.

To insert the current date and time in a document:
1 Click where you want to insert the date or time.
2 On the <u>I</u>nsert menu, click Date and <u>T</u>ime.
3 To specify the format of the date or time, click a format in the Available Formats box.

To automatically update the date or time when you print the document, select the Update Automatically check box. Otherwise, the document will always be printed with the original date or time.

Printing

You will normally print a document when it is open and being displayed on the screen. You should always view your document in Print Preview before printing, in order to check the general layout of the page.

Tables

Tables are an easy way to arrange and adjust columns of text and numbers, and are much more flexible than tabs. A table can be inserted at any point in your text.

A table is made up of rows and columns of cells that you can fill with text and graphics. You can use tables to align numbers in columns and then sort and perform calculations on them. You can also use tables to arrange text and graphics, such as side-by-side paragraphs in a resumé. To create a simple blank table, click Insert Table, and then drag to select the number of rows and columns you want.

Sales office	Boxes of tulips sold
Paris	£4,986.00
Madrid	£3,785.00
Bonn	£3,579.00
Vancouver	£3.098.00
Total	£15,448.00

This simple table has borders and shading. The table contents can be sorted and summed

To print a whole document

1 Select the File menu.
2 Click on Print.

- To change the settings of the printer click on Properties.
- To print more than one copy, type the number in the Copies box.
- To print only specific pages, give the page numbers in the Page range, Pages box.
- To print only a selection of text, highlight the text that you want to print and click on the Selection option button.

To create a simple table

1 Click where you want to create a table.
2 Click the Insert Table button ⊞.
3 Drag to select the number of rows and columns you want.

Add shading to a table, a paragraph or selected text

You can use shading to fill in the background of a table, a paragraph or selected text.

1 To add shading to a table, click anywhere in the table. To add shading to specific cells, select only those cells, including the end-of-cell marks.
To add shading to a paragraph, click anywhere in the paragraph. To add shading to specific text, such as a word, select the text.
2 On the Format menu, click Borders and Shading, and then click the Shading tab.
3 Select the options you want.
4 Under Apply To, click the part of the document you want to apply shading to. For example, if you clicked a cell without selecting it in step 1, click Cell. Otherwise, Word applies the shading to the entire table.

You can use the Table AutoFormat command to add borders and shading to a table automatically.

Sort a list or table

1 Select what you want to sort.
2 On the Table menu, click Sort (for a table) or Sort Text (for a list).
3 Select the options for your sort.
4 Click OK to complete the sort.

Delete a table and its contents

1 Select the table by clicking it.
2 On the Table menu, click Delete and select Table.

Merge cells into one cell in a table

You can combine two or more cells in the same row or column into a single cell. For example, you can merge several cells horizontally to create a table heading that spans several columns.

1 Click the Tables and Borders button ⊞ to display the Tables and Borders toolbar.
2 Click the Eraser button ⊘ and then click and drag the eraser over the cell dividers you want to remove.

A quick way to merge multiple cells is to select them and then click the Merge Cells button ⊞.

Sum a row or column of numbers

1 Click the cell in which you want the sum to appear.
2 On the Table menu, click Formula.
3 If the cell you selected is at the bottom of a column of numbers, Word proposes the formula =SUM(ABOVE). Click OK if this is correct.

If the cell you selected is at the right end of a row of numbers, Word proposes the formula =SUM(LEFT). Click OK if this is correct.

AutoCorrect and AutoText

Word gives you two ways to store frequently used text, graphics and other items, and then insert them quickly into documents. You can use the AutoCorrect feature to correct and insert items as you type. With the AutoText feature, you can retrieve and insert an item by typing a few keystrokes or clicking the AutoText button. With both features, you can choose to insert text with or without its original formatting.

AutoCorrect automatically corrects many common typing, spelling and grammatical errors. You can easily customise the preset AutoCorrect options or add errors that you commonly make to the list of AutoCorrect entries.

The table on the next page describes what happens when you use AutoCorrect. To customise these options, click AutoCorrect on the Tools menu.

If you select the Replace Text As You Type check box in the AutoCorrect dialogue box, AutoCorrect can also automatically correct mistakes or insert text, graphics and symbols.

When you type:	Word does this:
two capital letters at the beginning of a word.	changes the second capital letter to a lower case letter.
a lower case letter at the beginning of a sentence.	capitalises the first letter of the first word in the sentence.
a lower case letter at the beginning of the name of a day.	capitalises the first letter in the name of the day.
with the Caps Lock key accidentally turned on.	reverses the case of the letters that were capitalised incorrectly and then turns off the Caps Lock key.

To add an AutoCorrect entry to correct a typing error
1 On the Tools menu, click AutoCorrect.

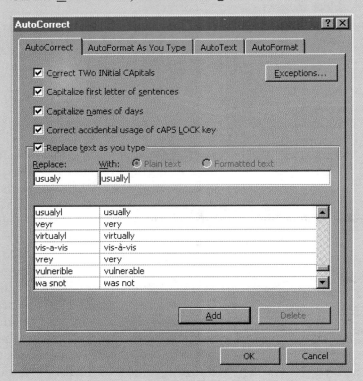

2 Make sure the Replace Text as You Type check box is selected.
3 In the Replace box, type a word or phrase that you often mistype or misspell (for example, type **usualy**).
4 In the With box, type the correct spelling of the word (for example, type **usually**).
5 Click Add.

Whenever you type an AutoCorrect name (for example, usualy) followed by a space or other punctuation, Word will replace it with the correction (in this case, 'usually').

Newspaper columns

Text in newspaper columns flows from the bottom of one column to the top of the next. To see newspaper columns, switch to page layout view.

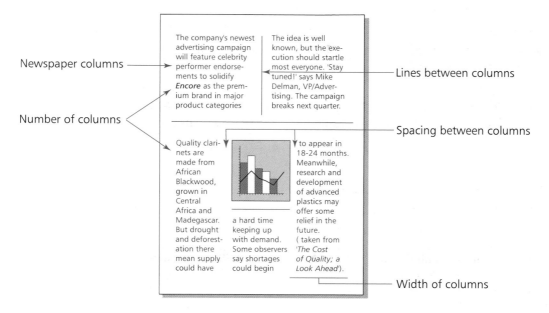

Newspaper columns

Number of columns

Lines between columns

Spacing between columns

Width of columns

To create a multiple column layout
1 Select **F**ormat.
2 Select **C**olumns.

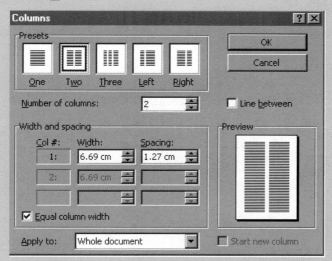

3 Specify the number of columns you want.
4 In the **A**pply To box, select the portion of the document that you want to format.
5 Choose OK.

Lines between columns

To add vertical lines between columns, click Columns on the Format menu. Select the Line Between box. To see the lines, switch to page layout view.

Spacing between columns

To adjust the space between selected columns, drag the column marker of either column to a new position on the ruler.

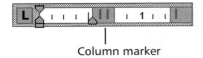

Column marker

Width of columns

To change the width of a selected column, drag the column marker on the ruler to a new position.

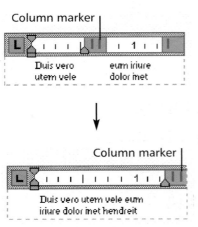

Mail merge

The mail merge feature of Word enables you to print many personalised letters from one standard 'form' letter.

Two documents are required for a mail merge as shown in Figure 3.3.

1 **The main document.** This contains the standard text plus areas that are marked as 'replaceable', e.g. personal information can be slotted into them.

2 **The data source.** This is a document containing the personal information which is to be slotted into the standard letter. Each person's information is in a separate paragraph.

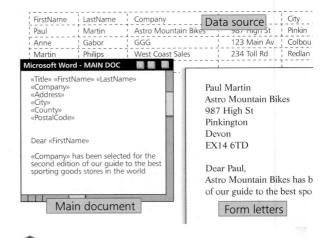

Figure 3.3 *An example of source documents and form letter in mail merge*

Creating a mail merge

1 To use an existing letter as a form letter, open the letter.
 Or to create a new letter, click New on the File menu, and then select a letter template.

2 On the Tools menu, click Mail Merge.

Mail Merge Helper	? X

Use this checklist to set up a mail merge. Begin by choosing the Create button.

1 [icon] Main document

Create ▼

3 Click Create, click Form Letters, and then click Active Window.
The active document becomes the mail merge main document.

4 Click Get Data.

5 To create a new list of names and addresses in Word, click Create Data Source, and then set up the data records.

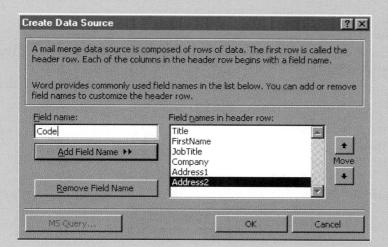

To enter values into the fields. Click on the Edit Data Source button on the Mail Merge Toolbar. The Data Form dialogue box will appear.

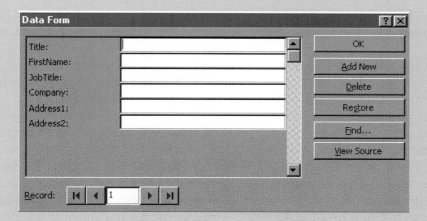

Or to use an existing list of names and addresses in a Word document or in a worksheet, database or other list, click Open Data Source.

6 After you designate the data source, Word displays a message. Click Edit Main Document.

7 In the main document, type the text you want to appear in every form letter.

8 Click where you want to insert a name, address or other information that changes in each letter. On the Mail Merge toolbar, click the Insert Merge Field button, and then click the field name that you want.

9 After you have inserted all of the merge fields and completed the main document, click the Mail Merge Helper button on the Mail Merge toolbar.

Macros

If you perform a task repeatedly in Word, you can automate the task using a macro. A macro is a series of Word commands and instructions that you group together as a single command to accomplish a task automatically. Instead of manually performing a series of time-consuming, repetitive actions in Word, you can create and run a single macro. It is, in effect, a custom command that accomplishes the task for you.

Here are some typical uses for macros:

- speeding up routine editing and formatting
- combining multiple commands
- making an option in a dialogue box more accessible
- automating a complex series of tasks.

Recording a macro

1 On the Tools menu, point to Macro, and then click Record New Macro.
2 In the Macro Name box, type a name for the macro.
3 In the Store Macro In box, click the template or document in which you want to store the macro.
4 In the Description box, type a description for the macro.
5 a If you don't want to assign the macro to a toolbar, a menu, or shortcut keys, click OK to begin recording the macro.
 b To assign the macro to a toolbar or menu, click Toolbars or Menus. In the Commands box, click the macro you are recording, and drag it to the toolbar or menu you want to assign it to. Click Close to begin recording the macro.
 c To assign the macro to shortcut keys, click Keyboard. In the Commands box, click the macro you are recording. In the Press New Shortcut Key box, type the key or key sequence you wish to use. Click Close to begin recording the macro.
6 Perform the actions you want to include in your macro.
 Note: the macro recorder cannot record mouse actions in a document window. You must use the keyboard when recording such

actions as moving the insertion point or selecting, copying or moving text. However, you can use the mouse to click commands and options when you are recording a macro.
7 To stop recording your macro, click the Stop Recording button ▪.

Running a macro

1 On the Tools menu, point to Macro, and then click Macros.
2 In the Macro Name box, click the name of the macro you want to run.
3 If the macro doesn't appear in the list, select a different list of macros in the Macros Available in box.
4 Click Run.

Templates

A template is a predefined format for a document. Many business documents such as letters, memos, forms and reports have set formats. A template can be used to define not only standard text but also aspects of text such as the font, borders, page size and orientation. Once a template has been created it can be recalled and used to produce the required document. This saves time and ensures consistency.

Word comes with many predefined templates and several Wizards to help you create documents such as letters and memos. To create most documents the 'normal document' template 'Normal.dot' is used. This is the template that you have been using to create your documents. If a document is started using File then New then a dialogue box containing the names of the templates appears. These are grouped by type, which you select by clicking on the appropriate tab. Under the General tab you can select the Normal template file by choosing Blank Document. Template files have the extension .dot and are stored in the Word template folder.

Word provides other template files, such as standard letters and memos, and it is possible to customise these. Figure 3.4 shows some of the template files available in Word.

Figure 3.4 *Word template files*

The Normal template

The Normal template is a general purpose template for any type of document. When you start Word or click <u>N</u>ew, Word creates a new blank document that is based on the Normal template. You can modify this template to change the default document formatting or content.

Word also uses the Normal template to store the AutoText entries, macros, toolbars, custom menu settings and shortcut keys you use routinely. Customised items that you store in the Normal template are available for use with any document.

You should store the Normal template in the Templates folder or in the User Templates or Workgroup Templates file location you specified on the File Locations tab (<u>T</u>ools menu, <u>O</u>ptions command). If Word cannot find the Normal template in any of these locations or in your Word program folder, it creates a new Normal template with the standard Word document formats and the standard menu, toolbar and shortcut key settings.

Creating a template

A template can store boilerplate text, custom toolbars, macros, shortcut keys, styles and AutoText entries. An easy way to create a template is by opening a document that contains the items you want to reuse and saving it as a template.

If you save a template in the Templates folder, the template will appear on the General tab when you click <u>N</u>ew on the File menu. If you save a template in a subfolder of the Templates folder, such as Memos or Reports, the template will appear on the corresponding tab when you click the <u>N</u>ew command.

To base a new template on an existing document

1 Click <u>O</u>pen on the <u>F</u>ile menu, and then open the document you want.
2 On the <u>F</u>ile menu, click Save <u>A</u>s.
3 In the Save As <u>T</u>ype box, click Document Template (*.dot). This file type will already be selected if you are saving a file that you created as a template.
4 Word proposes the Templates folder in the Save <u>I</u>n box. To save the template so that it will appear on a tab other than General, switch to the corresponding subfolder within the Templates folder.
5 In the File <u>N</u>ame box, type a name for the new template, and then click <u>S</u>ave.
6 In the new template, add the text and graphics you want to appear in all new documents that you base on the template, and delete any items you do not want to appear.
7 Make the changes you want to the margin settings, page size and orientation, styles and other formats.
8 Click <u>S</u>ave, and then click <u>C</u>lose on the <u>F</u>ile menu.

1 Start the wordprocessor.

2 Type in the simple letter shown below.

3 Make any necessary running corrections.

4 Press Enter only when starting a new paragraph and to break a sentence. (For paragraphs use wordwrapping.)

```
Chelmer Leisure and Recreation Centre
Park View Road
Chelmer Cheshire
CE9 1JS

Universal Gym (Europe) Ltd
Hutton
Brentwood
Essex
CM13 1XA

17 October 2001

Dear Sir

Health and Fitness Centre for Chelmer Leisure and
Recreation Centre.

As part of my studies for my BA in Business Studies,
Sport and Recreation, I am conducting a project on behalf
of Chelmer Leisure and Recreation Centre.

Chelmer Leisure and Recreation Centre wishes to
investigate the options for the enhancement of their
health and fitness facilities. Currently I am approaching
a number of potential suppliers with a view to collecting
information on the range of equipment available in the
marketplace. I would therefore be grateful if you would
supply me with appropriate publicity literature and
equipment specifications, together with price lists.

Thank you

Yours faithfully

Ms S Leveridge.
```

5 Save the document as **Letter1**.

6 Click on File then Save.

7 Enter **Letter1** in the File Name box.

8 Click on Save.

9 Close the document using File then Close.

10 Exit from the wordprocessor, by choosing File then Exit.

1 Start the wordprocessor.

2 Open the document called **Letter1**, using File then Open and selecting this file from the list displayed.

3 Insert two blank lines before 'Thank you'.

4 Add the following paragraph at the end of the text of the letter, before 'Thank you'.

> **I shall contact you again within a few weeks for more detailed discussions if the Leisure and Recreation Centre Manager feels that your equipment might meet our requirements.**

To make the document more meaningful:

5 Justify the paragraph areas only.

6 Increase the font size to 15. **Embolden** and underline the heading.

7 Change the typeface to Arial, Size 10 point for the paragraph areas only.

8 Delete the existing date and insert the date by selecting Insert then Date and Time.

9 Right align the date which you have just inserted in **Letter1**.

10 Change the line spacing to 1.5, in just the second paragraph, using Format then Paragraph then Indents and Spacing.

11 Use left indentation from Format then Paragraph then Indents and Spacing to move the conclusion of the letter 4 cm towards the right side of the document.

12 Save the new file using File then Save As, but this time using the file name **Letter2.doc**.

13 Close the document **Letter2.doc**.

14 You should now have two files, called **Letter1**, and **Letter2**. Using File then Open again check that this is so.

15 Click on Cancel to close the dialogue box.

1 Open the document **Letter2**.

2 View the document in Print Preview mode by choosing File then Print Preview.

3 Click on the Print button to call up the Print dialogue box.

4 Click on OK to print the document or print the document as a print file.

1 Use a new document and type in the two lines of the heading shown below (try to reproduce the font) and press Enter.

CHELMER LEISURE AND RECREATION CENTRE

AEROBICS OPEN DAY

Step One of the best ways to start your fitness programme. Our fitness demonstrators will be on hand to advise you on a suitable fitness programme.

Cycle Tone up those flabby thighs and strengthen those backs. Our cycles simulate real cycling conditions which can be individually tailored to your fitness programme.

Row Fancy yourself in the boat race? Try your hand at our computer controlled rowing machine.

2 Drag the left margin to the right 4 cm.

3 Key in the type of activity (e.g. Step, Row, Cycle) using the Arial font, embolden and make size 14 points.

4 After keying in the activity name press the tab key to tab the insertion point to line up with the left margin.

5 Enter the rest of the text comprising the activity; wordwrap will round onto the left margin. Use a different typeface such as Courier New, size 10 points.

6 Press Enter for a new line.

7 Repeat the last four steps for each aerobic activity.

8 Save this document as **Openday**.

TUTORIAL 3.5

1 After typing the heading and first line click on Format then Bullets and Numbering.

2 Select the Bullets tab, select the appropriate bullet and click on OK.

FINDINGS FROM MARKET RESEARCH

❑ Information has been collected from the returned questionnaires resulting in the following conclusions:

❑ A consensus of opinion that present facilities are inadequate and that attendance is poor.

❑ The numbers of users, particularly female, would increase if the facility was refurbished.

❑ The majority of users are car owners, so promotion in a wider area could attract new clients.

❑ Nearly two-thirds of the people surveyed had never used the existing multi-gym

❑ Aerobic activities are popular.

❑ Entertainment, such as satellite television, would be an attraction in the new fitness suite.

3 Save the document as **Bullets.doc**.

4 Make a copy of the above information to a new document by clicking on File then New.

5 Change the bullets in the copied document into numbers by clicking on Format then Bullets and Numbering.

6 Save the new document as **Numbering.doc**.

1 Start a new document to create a front page for your report.

2 Select Arial 15 point for the name of the institution.

3 For the title, select centre alignment by clicking on the appropriate icon.

4 Key in the words **Environment & Enterprise Project** using Times New Roman, embolden, italic, 15 points. Press Enter.

5 For the main title use Times New Roman, bold, 16 points.

6 Select right alignment.

7 Using Arial, italic in 14 points, key in the author, tutor, course and date.

8 Insert a picture for the front page by clicking on <u>I</u>nsert then <u>P</u>icture then Clipart.

9 Select the clipart you require and click on Insert.

10 Correct the size of the picture using the double-headed arrow handles at each corner.

11 Change it to a 'watermark' using Image Control in the Picture toolbar.

12 Add the necessary formatting to adjust the picture to fit the report cover using <u>F</u>ormat then <u>O</u>bject.

13 Change the print orientation to landscape (on A4 size paper) using <u>F</u>ile then Page Set<u>u</u>p then Paper <u>S</u>ize.

14 Click on <u>F</u>ile then <u>P</u>rint and print the document.

15 Save this document as **FRONT**.

the Manchester Metropolitan University
Crewe + Alsager Faculty

Environment & Enterprise Project

The Refurbishment of the Multi-Gym into a Fitness Suite at Chelmer Leisure and Recreation Centre

A Feasibility Study

By: Sarah Leveridge
Tutor: R. S. Symmond
Course: HND Business and Finance
Date: 1st February 2001

1 Open a new document and try setting up and using the following AutoCorrect entries, using Tools then AutoCorrect.

Replace	with
Am	Americans
W	women
U	unmarried

2 Type the following text using the AutoCorrect entries to speed up your typing.

Cleanliness

Americans put a great deal of emphasis on personal cleanliness. Most Americans are very sensitive to the smells and odours of the human body — sometimes their own, but especially someone else's. For this reason, most Americans bathe once a day and sometimes more during hot weather or after strenuous exercise. Americans are also very concerned about having clean hair and fresh breath.

Friendship & Dating

Americans are generally considered open and warm people who make new acquaintances easily. Americans often have many casual and informal relationships and few lasting friendships. However, in spite of this, many Americans are quite capable and more than willing to take the extra step needed to establish an enduring friendship.

American women have more personal freedom than women from some other countries and are not usually shy with Americans or foreigners. It is not unusual for unmarried women in the U.S.A. to live by themselves, share living quarters with other unmarried women or go to public places without a male companion.

3 Using the replace facility click on Edit then Replace to find all occurrences of the following words and replace them with alternative words as shown in the table below.

Find	Replace with
.	" "
Americans	French
women	men
unmarried	married

4 Change all occurrences of the text 'French' into uppercase (FRENCH) using the Replace command and selecting the option Match Case in the More option list.

5 Insert a header using View then Header and Footer with the text **European Relationships**.

6 Save the document as **Americans.doc**.

With a new document open:

1 Type the following text:

> ***Opening Times***
> ***Health Suite***
>
Monday	9.00am — 9.00pm	Ladies Only
> | Tuesday | 9.00am — 9.00pm | Mixed |
> | Wednesday | 9.00am — 9.00pm | Mixed |
> | Thursday | 9.00am — 1.00pm | Ladies Only |
> | | 1.00pm — 9.00pm | Mixed |
> | Friday | 9.00am — 9.00pm | Men Only |
> | Saturday | 9.00am — 1.00pm | Men Only |
> | | 1.00pm — 5.00pm | Mixed |
> | Sunday | 9.00am — 5.00pm | Mixed |

2 Work one line at a time using the tab key to move between one column and the next.

3 Press the Enter key to move to a new line.

4 Finally format the headings as shown in the sample.

5 Save the document as **Times**.

6 Move the pointer to the end of the existing text and set the tabulator as indicated below:
 left tab at 1.00 inch (2.5 cm)
 centre tab at 2.50 inch (6.5 cm)
 right tab at 4.00 inch (10.25 cm).

7 Click on the Tab button on the ruler and choose the appropriate tab type.

8 Point to where you wish to place the tab on the ruler and click to place a tab stop at that point.

9 Type in the following text, using the tab key to move between tab stops.

> Health Suite Passcards
> Gold Passcard. Use all our facilities including
> the Health Suite, Fitness Suite, Pool and Oasis.
>
3 Month	Gold Pass	£85.00
> | 6 Month | Gold Pass | £150.00 |
> | 12 Month | Gold Pass | £275.00 |

Now re-format the tabulator:

10 Select the text that you have just entered and use the Format then Tabs command to display the Tabs dialogue box on the screen.

11 Select the first tab, change its alignment to right and introduce a leader with ...

12 Choose Set, then OK.

13 Note the effect that this has on your document.

14 Remove the right tabulator using Format then Tabs.

15 Save the document.

1 Open a new document.

2 Type in the heading **How much fat is the limit?**

3 Create a table either by using T**a**ble then the Insert Table command or the Table button; set up three columns and one row (1 × 3).

4 Enter the text below into columns, moving between columns using the Tab button. Also use the Tab button to create each new row in the table. If you need to adjust the width of the columns do so by dragging the column boundary.

5 Save the document as **Fatlim**.

How much fat is the limit?		
Type of fat 12.5 st(80 kg) man	Saturated fat	Other fats
Inactive	28 g	68 g
Quite Active	35 g	82 g
Very Active	42 g	97 g
9.5 st (61 kg) woman		
Inactive	22 g	51 g
Quite Active	27 g	63 g
Very Active	31 g	74 g

6 Sort the table based on the header row for Saturated fat; use descending order.

7 Save the changes to **Fatlim**.

1 Open the document **Times**. This has existing tab stops.

2 Select the section showing the opening times.

3 Choose T**a**ble then Convert Text To Table.

4 Save the document as **Times1**.

1 Open a new document.

2 Type in the title shown below and format and centre it.

Chelmer Leisure and Recreation Centre
Market Research Questionnaire

Occupation		Sex (M/F)	
Age band		Smoking	
Under 20		Non-smoker	
21–30		Pipe and/or cigar	
31–40		Under 10 cigs a day	
41–50		20 cigs a day	
51–60		30 cigs a day	
Over 60			

Which of the following would you be interested in attending? (Please tick)	Not at all	Somewhat	Very much
Workshops on:			
Diet / nutrition			
Stress management			
Exercise			
Health screening			
Coronary risk assessment			
Cholestrol check			
Blood pressure check			
Flexibility			
Strength			
Dietary analysis			
Aerobic fitness			

Please return this questionnaire to Chelmer Leisure and Recreation Centre.

Thank you for your co-operation.

3 Place the insertion point on a new line and choose Table then Insert Table, and create a table with four columns. (1 × 4).

4 Enter the text in the table down to 'Over 60', using the tab key to move between the cells.

5 Press the tab key a few times to create a few empty cells. Leave one blank row and then select the first column of these empty cells and drag the column boundary on the bottom part of the table so that the cells will accommodate the text.

6 Enter the text in the lower part of the table into the new cells.

7 Select the last three columns and make the width of all the columns equal using Table then Distribute Columns Evenly.

8 Format the text as appropriate.

9 Save the document as **Question**.

To add borders and shading to the questionnaire:

a Select the first two lines i.e. the heading.

b Choose Format then Borders and Shading and then in the Borders tab choose Box, and an appropriate double-line.

c Next, select each set of boxes with labels and associated reply boxes and apply a single-line border with the grid.

d The top two sets of boxes would look better if they were separated. Select the top part of the third column (reduce the column size) and insert a column using Table then Insert Cells, and choosing Shift Cells Right.

e With the top part of the table selected move the column boundary to make this new column fairly narrow.

f Select the new column and remove any borders. In so doing you may manage to remove some of the borders that you have just created. Just insert them again. It's all good practice!

g Now apply shading to each of the cells shown as shaded in the example below.

h To do this, select the cell, and choose Format then Borders and Shading and then click on the Shading heading. This displays the Shading subdialogue box.

i Click on Custom; choose Shading, say 20%.

j Save your document as **Question** and print it.

Chelmer Leisure and Recreation Centre
Market Research Questionnaire

| Occupation | | | Sex (M/F) | |

Age band			Smoking	
Under 20			Non-smoker	
21–30			Pipe and/or cigar	
31–40			Under 10 cigs a day	
41–50			20 cigs a day	
51–60			30 cigs a day	
Over 60				

Which of the following would you be interested in attending? *(Please tick)*	*Not at all*	*Somewhat*	*Very much*
Workshops on:			
Diet / nutrition			
Stress management			
Exercise			
Health screening			
Coronary risk assessment			
Cholestrol check			
Blood pressure check			
Flexibility			
Strength			
Dietary analysis			
Aerobic fitness			

Please return this questionnaire to Chelmer Leisure and Recreation Centre.

Thank you for your co-operation.

Your task is to create a poster about Computers and unemployment to circulate to organisations that are interested in this subject.

1 Create the document **Unemployment** from the data given on page 209. The text is the draft of a poster, which is to be formatted.

2 Format the following using Format then Font:
 a the entire document to typeface Comic Sans MS, 10 point
 b increase the font size of the heading to 20 points.

3 Centre the paragraphs using the centre tabulator.

4 Type the following, after creating three blank lines following the last paragraph of the document. Use the same typeface as above:

 "What should we do?"
 "Is IT a threat to today's society?"
 Seminar on the 23rd Dec 2000
 Time 1.00 pm
 At the Culture Centre Hall

5 Insert two appropriate pictures using Insert then Picture then Clipart at the end of the page (use an appropriate wrapping technique).

6 Replace the word 'and' with the sign '&' using Edit then Replace.

7 Insert today's date as the header of the document using Insert then Date & Time and using View then Header & Footer.

8 Change paragraphs back to left alignment using the left tabulator.

9 Insert a page break at the end of the document using Insert then Break then Page Break.

10 Insert the following table on to the new page of the document using Table then Insert Table.

Keyboard shortcuts	Functions
Backspace	Deletes character to the left of the cursor
Del	Deletes character to the right of the cursor
Ctrl + Backspace	Deletes the word to the left of the cursor
Ctrl + Del	Deletes the word to the right of the cursor

11 Modify the width of the second column so that all the contents are represented in one row, using Table then Table Properties.

12 Modify the bottom margin so that the document would be represented in 3.5 cm using File then Page Set-up.

13 Remove the top borders and bottom borders of the first row so that only the shading is visible; use Format then Borders & Shading.

14 Save the document as **Poster.doc** and print four copies of the first page to a printer if available or as a print file to your working diskette using File then Print.

Create the following paper article in the format of newspaper columns. Use Format then Columns.

Chelmer Leisure and Recreation Centre Fitness News

The Benefits of Exercise

Wallop! It's hit you! When your most energetic event over the last few weeks was getting up to change the TV channel because the remote control wasn't working you suddenly realise that physical exertion can be quite unpleasant!

But fear not! After only a short spell at an activity class the benefits will start to show. You can expect an increase in stamina (those stairs won't seem too steep anymore), strengthening and toning of your once-invisible muscles, and an increase in the range of movement of those aching joints.

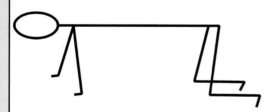

New Fitness Centre
Fight the Flab

In Chelmer Leisure and
Recreation Centre's
New Fitness Suite

Opening 16th September

SUMMER 2000

Six Sun-safe Tips for Sensible Tanning

1 Apply sun cream 30 minutes before going out in the sun and use sun cream all year round.
2 Avoid sun bathing between 11.00am and 3.00pm.
3 Re-apply sun cream regularly – cream can be removed by swimming, sweating and drying off.
4 Pace yourself! Don't take too much sun too soon. Melanomas take a few days to develop.
5 Keep babies and small children out of strong sun.
6 Always use moisturiser after sun bathing to prevent dry skin and peeling.

The month is May, the sun may shine and the melanomas may not be too far behind. The need for creaming-up has never been greater!

The strength of your cream is governed by its SPF – Sun Protection Factor. This gives you an indication as to how long you can stay in the sun without melting. The higher the SPF the greater the protection provided. The choice of an appropriate SPF depends upon your skin type and how it usually reacts to the sun.

For bookings and details of any activities and classes at Chelmer Leisure and Recreation Centre please ring 0191 366 6612

TUTORIAL 3.14

Part A

1 Create a document on How to get the ECDL, using the text on page 106.

2 Save the document in your working diskette as **C*f*ICT Notice.doc** using Eile then Save As.

3 Select Headers and Footers from the View menu.

4 Type the header **How to get the ECDL**.

5 Do the following to the header of the document:
 a centre the heading
 b embolden it
 c font size 15 points
 d typeface Arial
 e underline word by word only.

6 Switch between headers and footers using the Headers & Footers toolbar.

7 Insert the date by selecting Insert then Date and Time in the Footer area.

8 Click on Close using the Headers & Footers toolbar.

9 Start a new paragraph after the word 'Sri Lanka'

10 Move the conclusion (Thank you...) of the letter to between the last line of the paragraph and the text 'Manager'.

11 Use the technique of dragging and dropping to move the paragraph with the heading 'Word-processing...' to make the fourth paragraph of the document.

12 Change the C*f*ICT logo to a watermark.

13 Insert 6-point spaces before and after the following sub-headings: **Basic IT concepts, Using the computer and managing files, Wordprocessing, Spreadsheets, Database and filing systems, Presentation and drawing, Information network services.** Use Format then Paragraph.

14 Make the above sub-headings more attractive by using different character formatting (use Format Painter) as appropriate.

15 For each paragraph apply a first-line indentation (by 1.25 cm) by selecting Format then Paragraph.

16 Spell check the document (before saving) using Tools then Spelling and Grammar.

17 Save the changes using the same name, **C*f*ICT Notice.doc.**

▶▶

Part B

1 Open **C*f*ICT Notice.doc** using File then Open.

2 Select Tools then Mail Merge.

3 **First Step: Creating the main document**
 a Click on the Create button and select Form Letters.
 b To create the letter select Active Window as it is already opened. (The Active Window represents the C*f*ICT Notice.doc.)

4 **Second Step: Creating the data source**
 a Click on Get Data.
 b Select Create Data Source.
 c Use the following table to select the necessary fields from the dialogue box:

Field Names			
1	Title	4	Address line 1
2	First name	5	Address line 2
3	Last name	6	Salutation

 d Save the created data as **Address List.doc**.
 e Click on the Edit Data Source icon to enter the following records using the Data Form:

Title	First name	Last name	Address line 1	Address line 2	Salutation
Mr	John	Solomon	200/9, Edward Lane	Sussex	Sir
Miss	Jane	Hogan	90/8, Hide Park Lane	London	Madam
Miss	Amanda	Peterson	12/8, Liverpool Road	Essex	Madam
Miss	Lourdes	Brown	2, Henry Avenue	London	Madam
Mr	John	Adams	5, Cross Street	Yorkshire	Sir

 (**Note:** after adding the first record click on add to enter the next record)

 f Extract the appropriate fields and place them in **C*f*ICT Notice.doc** (the main document) as shown in the last page of the tutorial.

5 **Third Step: Merging the records to the main document**
 a Select the Mail Merge helper by clicking Tools then Mail Merge.
 b Select Merge.
 c Select New Document from the dialogue box and confirm the merging by clicking on the Merge button.

6 Remove the existing footer using View then Header and Footer.

7 Save the merged document as **C*f*ICT Notice to be posted.doc**.

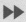

How to get the ECDL

«Title» «FirstName» «LastName»
«Address1»,
«Address2».

Dear **«Salutation»**,

The Gateway Centre for Information Technology is a leading IT training organisation and the first accredited test centre for the European Computing Driving Licence in Sri Lanka.

The European Computer Driving Licence syllabus has seven modules, which can be completed in any order. Both classroom and self-study courses are available from around 150 accredited institutions and training companies. In addition, many employers are getting accredited purely to be able to train and test their own staff.

Basic IT concepts

This first module covers concepts; IT and society, security, copyright and law, hardware systems and networks

Using the computer and managing files

Students have to demonstrate the ability to do basic tasks such as creating and deleting files and directories, saving files to a floppy disc, backing-up data and printing.

Wordprocessing

This module assesses basic and advanced wordprocessing skills. Basic tasks include creating, saving and printing documents, altering text appearances, creating headers and footers and using pagination. Advanced tasks include merging mail lists with a document, importing documents, tables and graphics, using tabs and templates and integrating software.

Spreadsheets

Students show they understand basic spreadsheet concepts and functions, and have practical experience in spreadsheet design and implementation. Tasks include creating, formatting, adjusting and printing spreadsheets, understanding absolute and relative cell referencing in formulae, using graphics and moving information between spreadsheets.

Database and filing systems

Students build a small database and create simple queries and reports from an existing database. Tasks may be set, such as searching, selecting and sorting data based on certain queries, modifying the database structure and presenting data in a particular sequence.

Presentation and drawing

These modules test presentation and drawing skills, using graphics tools, colours and shading, borders and fonts, retrieving pictures and preparing organisation charts and slide shows.

Information and communication

Students must show they understand networking concepts and the use of ECDL question papers, mail and information services.

Thank you,
Yours faithfully

Manager
GATEWAY Centre for Information Technology

1 Use the text on page 210 to create a file called **Script.doc**.

2 Save the file on your working diskette using the same name. Use <u>F</u>ile then Save <u>A</u>s.

3 Apply the style 'Heading 1' to the two titles in the document using F<u>o</u>rmat then Style.

4 Apply the style 'Heading 2' to the sub-headings. (The sub-headings are numbered from 1 to 9.) Use the shortcut key command so that you can apply the styles quickly.

5 Apply the Normal style to the rest of the text. Use the shortcut key command so that you can apply the styles quickly.

6 Using the Style command make the following changes to the Normal style:
 Font Times New Roman
 Font size 12 points
 Line spacing 1.5 lines

7 Using the Style command make the following changes to the Heading 1 style:
 Font Times New Roman
 Font style Bold
 Font size 24 points
 Underline Double underline
 Line spacing 1.5 lines

8 Using the Style command make the following changes to the Heading 2 style:
 Font Times New Roman
 Font style Bold
 Font size 16 points
 Underline Single underline
 Line spacing 1.5 lines

9 Insert the text **Copyright GATEWAY Centre for Information Technology** as a footer to the document.

10 Create a new style using F<u>o</u>rmat then Style. Name it Gateway Normal using the following add-ins:
 Font size 14 points
 Font Comic Sans MS
 Colour Blue
 Centre tab 7.5 cm

11 Select Automatically Update and create a nominate the shortcut key as Ctrl + R and confirm the styles that you created.

12 Apply the style Gateway Normal to the footer of the document using the shortcut key.

13 Apply page numbers (Roman numerals I, II, IV, IX…) using <u>I</u>nsert then Page N<u>u</u>mbers.

14 Close the footer.

15 Append the table which was created in Tutorial 3.12 as the last page of the document.

16 Insert a page break after the last paragraph using <u>I</u>nsert then <u>P</u>age Break.

17 Add the table of contents using <u>I</u>nsert then Inde<u>x</u> and Tables.

18 Save the document using the name **Script.doc**.

1 Open the file **Americans.doc** (created in Tutorial 3.7) using File then Open.

2 Copy the contents starting with 'Cleanliness…' to a new document.

3 Remove existing borders (if any) using Format then Borders and Shading and insert the Heading '**Relationships…**' embolden, italics and Times New Roman font at 26 points on the upper-left corner of the document.

4 Adjust the left margin to 0.5 inch (1.5 cm) and the right margin to 5.5 inch (14 cm).

5 Highlight the contents starting with 'Cleanliness…' (**note:** make sure to highlight only the text area) and convert the existing text to columns using Format then Columns (use three columns).

6 To give the document a professional look select Hyphenation by clicking on Tools then Language (make sure to place the cursor on the existing text).

7 Select Automatically Hyphenate the Document and click OK.

8 Delete the existing header and insert a new header using View then Header and Footer with the text in Figure 3.4 in the header area.

9 Do the necessary character formatting to the header area as shown in Figure 3.4.

10 Click on Close using the Headers & Footers toolbar.

11 Insert clipart after the heading 'Friendship & Dating'; use an appropriate wrapping technique to adjust the picture.

12 Use a drop cap for the first letter of the paragraph using Format then Drop Cap.

13 Create the table at the bottom of Figure 3.4 using Table then Insert Table on the same page of the document.

14 Make necessary alterations to adjust the table.

15 Centre the table using Table then Cell Height and Width.

16 Insert a page break between the table and the paragraph using Insert then Page Break.

17 Using a footer, number the pages using Insert then Page Numbers, select right alignment and change number format to Roman numbers (e.g.: I, II, IV) using the Format tab.

18 Embolden the page numbers which were inserted in the footer.

19 Change the case of the sections of the columns to Title Case using Format then Change Case.

20 Spell check the document using Tools then Spelling & Grammar.

21 Save the new document as **Relationships.doc.**

TIMES **Edition 45 Vol. 9**

Relationships...

TUTORIAL 3.16

Cleanliness

French Put A Great Deal Of Emphasis On Personal Cleanliness. Most French Are Very Sensitive To The Smells And Odours Of The Human Body – Sometimes Their Own, But Especially Someone Else's. For This Reason, Most French Bathe Once A Day And Sometimes More During Hot Weather Or After Strenuous Exercise. French Are Also Very Concerned About Having Clean Hair And Fresh Breath.

Friendship & Dating

French Are Generally Considered Open And Warm People Who Make New Acquaintances Easily. French Often Have Many Casual And Informal Relationships And Few Lasting Friendships. However, In Spite Of This, Many French Are Quite Capable And More Than

Willing To Take The Extra Step Needed To Establish An Enduring Friendship.

French Men Have More Personal Freedom Than Men From Some Other Countries And Are Not Usually Shy With French Or Foreigners. It Is Not Unusual For Married Men In The U.S. To Live By Them, Share Living Quarters With Other Married Men, Or Go To Public Places Without A Male Companion.

Continued Next week ...

Subjects of evaluation	Americans	French	Japanese	German	Indian	African
Cleanliness	L	M	H	L	L	L
Friendship	M	M	H	L	L	L
Dating	H	H	H	H	L	H
Marriage	L	M	H	H	H	H
Divorce	H	H	L	H	M	H

Table header: Countries

Key

L – Low rate
M – Medium rate
H – High rate

Figure 3.4

1 Open the document **Letter2.doc** (created in Tutorial 3.2).

2 Check if the top margin is 3 cm and change it if necessary using File then Page Setup then Margins.

3 Remove extra line breaks (if there are any) between paragraphs (leave only one blank line).

4 Move the heading of the letter to act as a header to the document; use Edit then Cut and View Header and Footer.

5 Switch the headers to the footer area to insert the text '**Confidential**'.

6 Centre the footer using the Centre button on the toolbar.

7 Indent the first line of each paragraph, so that the text starts 1 cm to the right of the left margin; use Format then Paragraph.

8 Delete the existing addresses.

9 Left align the date using the button on the toolbar.

10 Decrease the left indent for the conclusion area of the letter using Format then Paragraph so that it aligns with the date on the upper-left corner of the document.

11 Select Tools then Mail Merge.

12 **First Step: Creating the main document**
 a Click on the Create button and select Form Letters.
 b To create the letter select Active Window as it is already opened. (The Active Window represents **Letter2.doc**.)

13 **Second Step: Opening the data source**
 a Click on Get Data.
 b Select Open Data Source.
 c Open the data source Address List.doc that was created in Tutorial 3.14 part B.
 d Click on Edit Main Document when the message is prompted, so that you can insert the merge fields.
 e Extract the appropriate fields and place them in **Letter2.doc** on the upper-left corner of the document:
 «Title».«Last name»
 «Address line 1»
 «Address line 2»

14 **Third Step: Merging the records to the main document**
 a Select the Mail Merge Helper by clicking Tools then Mail Merge.
 b Select Merge.
 c Select New Document from the dialogue box and confirm the merging by clicking on the Merge button.

15 Save the merged document as **Letters to be posted.doc**.

MODULE 4

Spreadsheets

Introduction

Microsoft Excel is a powerful spreadsheet package, used for a wide variety of accounting purposes. Excel has many new features that will make your work easier and faster.

With new innovations in charting, list management, data analysis, application development and other areas, even the most complex tasks seem effortless.

Excel is also used to create reports such as summary reports and pay sheets.

Excel workspace

Note: most areas of the Excel workspace are common to the Word workspace.

This is what the workspace looks like when you open Excel.

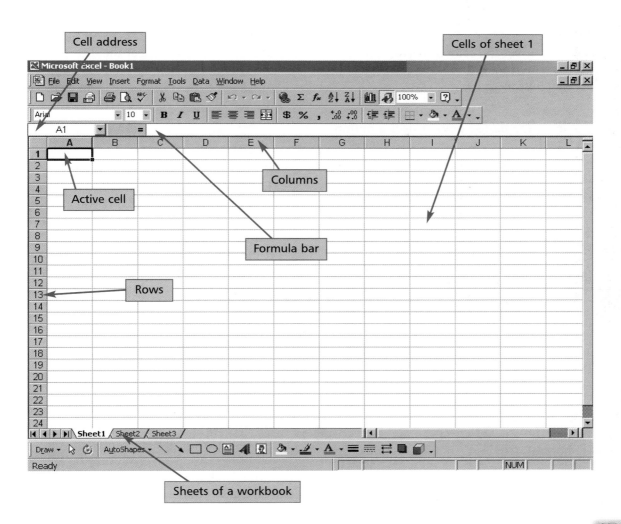

Choosing commands

Microsoft Excel commands are grouped in menus. Menu names appear on the menu bar displayed across the top of the application window. Different types of sheets have different menu bars. For example, if you are working with a chart, you will see the chart menu bar.

Some commands display a submenu. Submenus are indicated by a black triangle following the command name. Submenus contain additional, related commands.

When you choose a command name that is followed by an ellipsis (...), Microsoft Excel displays a dialogue box so you can enter more information or select options before carrying out the command.

In addition to choosing commands from menus, you can also choose commands from shortcut menus, or by clicking toolbar buttons.

Choosing a toolbar button

1 If needed, select the cells or objects you want the command to apply to.
2 Click the button you want.

Note: To see the name of the button in a ToolTip, leave the mouse pointer over a button for a moment. To see a longer description of the button, move the mouse pointer over the button and look at the status bar.

The Standard toolbar appears when you start Microsoft Excel. This toolbar contains buttons that help you complete your most frequent actions in Microsoft Excel.

To undo your last command
 Click the undo button.
Shortcut: Ctrl + Z

Alternative method
From the Edit menu, choose Undo.
You can undo the Undo command by choosing Redo from the Edit menu.

To repeat your last command
 Click the repeat button.
Shortcut: Ctrl + Y

Alternative method
From the Edit menu, choose Repeat.

Creating and opening workbooks

You can create a new workbook or open an existing workbook. You can also open several workbooks at once, or start Microsoft Excel and open a workbook automatically.

Creating a new workbook

 Click the New Workbook button.
Shortcut: Ctrl + N

Opening a recently opened workbook
From the bottom of the File menu, select the file name.

Opening a workbook

1 Click the Open button.
Shortcut: Ctrl + O
The File Name box displays a list of the Microsoft Excel files in the current directory. To see a list of Microsoft Excel files in another directory, select the directory from the Directories box, or type the name of the directory in the File Name box. Then select Microsoft Excel Files (*.XL*) from the Files of Type box.
To see a list of all the files in a directory, including Microsoft Excel files, select All Files (*.*) from the Files of Type box.
To see a list of files on another disk, select the disk from the Drives box. If you cannot find the workbook, choose the Find File button to search for the workbook.
If the workbook is on a network disk that you do not have access to, choose the Network button to connect to that network disk.
2 In the File Name box, type the name of the file you want to open, or select it from the list.
3 Choose the OK button.

Saving and closing workbooks

You should save your work frequently. You can set up Microsoft Excel so that it automatically saves your work at the time interval you choose. If you should lose work, you may be able to restore a backup copy of your workbook. You can also save your work in other file formats.

Saving a workbook

1 Click the Save button 🖫 (shortcut: Ctrl + S).
2 If you have not saved the workbook before, the Save As dialogue box will appear. In the File Name box, type a name for the workbook or accept the proposed name. The Microsoft Excel Workbook file format is automatically displayed in the Save As Type box. If you want to save the file in a format other than the Microsoft Excel Workbook file format, select that format in the Save File As Type box.
3 Choose the OK button.

Saving a workbook using a different name or file format

1 From the File menu, choose Save As.
2 In the File Name box, type a name for the workbook or accept the proposed name. The Microsoft Excel Workbook file format is automatically displayed in the Save As Type box. If you want to save the file in a format other than the Workbook file format, select that format in the Save As Type box.
3 Choose the OK button.

Closing a workbook

1 From the File menu, choose Close. If there are:
 a no changes, the workbook is closed immediately
 b unsaved changes, Microsoft Excel asks if you want to save changes.
2 Choose the Yes button to save changes, the No button to discard changes, or the Cancel button to cancel the command.
 If the workbook hasn't been saved before, the Save As dialogue box is displayed.
3 In the File Name box, type a name for the file or accept the proposed name.
4 Choose the OK button.

Selecting cells within a worksheet

Before you can carry out most commands or tasks in Microsoft Excel, you must select the cells you want to work with. You can select a single cell, or a range of cells that are adjacent or non-adjacent to each other. You can also move easily from cell to cell within a selection. If you select a single cell it is surrounded by a heavy border. If you select a range of cells, the range is highlighted.

Selecting a cell or range of cells

To select a cell
click the cell you want to select, **or** press the arrow keys to move to the cell you want to select.

To select a range of cells
point to the first cell of the range and drag to the last, **or**

1 select the first cell of the range
2 hold down the Shift key
3 use the arrow keys to extend the selection through the cells you want.

Entering numbers

You can enter two types of data in a worksheet:

- **Constant values:** that is data that you type directly into a cell. They can be a numeric value, including dates, times, currency, percentages, fractions and scientific notation, or they can be text. Values are constant and do not change unless you select the cell and edit the value yourself.
- **Formulae:** that is a sequence of constant values, cell references, names, functions or operators that produces a new value from existing values. Formulae always begin with an equal sign (=). A value that is produced as the result of a formula can change when other values in the worksheet change.

Numbers

To enter a number as a constant value, select a cell and type the number. Numbers can include numeric characters (0 through 9) and any of the following special characters:
 + - () , / $ % .
- You can include commas in numbers, such as 1,000,000.

- A single period (full stop) in a numeric entry is treated as a decimal point.
- Plus signs entered before numbers are ignored.
- To show negative numbers either precede them with a minus sign **or** enclose them within parentheses.

Data entry techniques

To enter data in a cell or cells
1 Select the cell or cell range into which you want to enter data.
2 Type the data.
3 Press Enter.

Note: Numbers are automatically right-aligned; text is automatically left-aligned.

Entering text

Text is letters, or any combination of numbers and letters. Any set of characters entered in a cell that Microsoft Excel does not interpret as a number, formula, date, time, logical value or error value is interpreted as text. When you enter text, the characters align to the left in the cell.

To enter text, select a cell and type the text. A cell can hold up to 255 characters. You can format the characters within a cell individually.

Aligning data within cells

To align data as required
1 Select the cells you want to format.
2 Click the Align Left, Centre, or Align Right button.

 Align Right button

 Align Left button

 Centre button

 Justify Align button

Centring cell entries across columns

To make text spread across several cells, and centre it in those cells

1 Select the cell that contains the data you want centred across a range of cells.

2 Extend your selection to include only adjacent blank cells to the right.
3 Click the Centre Across Columns button .

The text is displayed as centred across all the selected blank cells and will change with any column width adjustments.
Note: The data is still within the leftmost cells.

Adjusting column width

To change column width
1 Select the column or columns.
2 Drag the border to the right of a column heading (the lettered grey area at the top of each column) until the column is the width you want.

The width measurement is displayed at the left-hand end of the formula bar.

To adjust column width to fit the selection

1 Select the column or columns you wish to adjust to fit the data within them.
2 Double-click the border to the right of a column heading.

The column width adjusts to accommodate the longest cell entry in the column. This could be achieved using the AutoFit option in a row or column.

Inserting cells, rows and columns

You can insert blank cells, rows and columns and fill them with data. If you're moving and copying cells, you can insert them between the existing cells to avoid pasting over data.

To insert rows
1 To insert a single row, click a cell in the row immediately below where you want the new row. For example, to insert a new row above row 5, click a cell in row 5.
To insert multiple rows, select rows immediately below where you want the new rows. Select the same number of rows as you want to insert.
2 On the Insert menu, click Rows.

To insert columns

1 To insert a single column, click a cell in the column immediately to the right of where you want to insert the new column. For example, to insert a new column to the left of column B, click a cell in column B.

To insert multiple columns, select columns immediately to the right of where you want to insert the new columns. Select the same number of columns as you want to insert.

2 On the Insert menu, click Columns.

To insert blank cells

1 Select a range of existing cells where you want to insert the new blank cells. Select the same number of cells as you want to insert.

2 On the Insert menu, click Cells.

3 Click Shift Cells Right or Shift Cells Down.

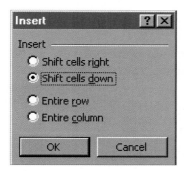

Formatting numbers

Formatting numbers as text

You must format the cells as text before entering the numbers.

1 Select the cells you want to format.

2 From the Format menu, choose Cells. You can also choose Format Cells from the shortcut menu.

3 Select the Number tab.

4 In the Category box, select Text.

5 In the Format Codes box, select the @ format.

6 Choose the OK button.

7 Enter numbers into the formatted cells. Numbers formatted as text align to the left of the cell.

Tip: You can quickly enter a number as text by preceding it with an apostrophe (').

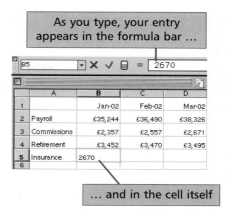

Formatting numbers with toolbar buttons

1 Select the cells you want to format.

2 Click the button that corresponds to the type of format you want. To change the currency type you can use Format then Cells.

Click	to
$	Apply the currency style
%	Apply the per cent style
,	Apply the comma style
+.0 .00	Increase decimal places
.00 +.0	Decrease decimal places

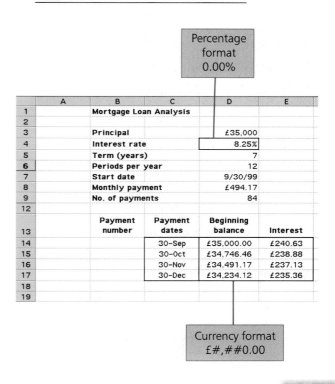

Creating and deleting text boxes

To create a text box

1. Click the Text Box button.
2. Position the crosshairs where you want one corner of the text box.
3. Drag until the box is the size and shape you want.
4. Type the text you want in the box.
 The text will wrap inside the box. If you want to start a new line, press Enter.

To delete a text box

Select it and then press the Del key. If you select text within the box rather than the box itself, only the selected text will be deleted.

Changing the font, size and colour of characters

Changing the font

To change the font ('typeface')

1. Select the cells or characters you want to format.
2. Click the arrow on the Font box.

3. Select a new font.

Changing the font size

To change the size of the text

1. Select the cells or characters you want to format.
2. In the Font Size box, type a font size (shown in points) or select one from the list.

Changing the font style to **bold**, *italic* or <u>underline</u>

To apply these styles

1. Select the cells or characters you want to format.
2. Click the Bold, Italic, or Underline button.

Note: If you click these buttons again, the formatting is removed.

Changing the font colour

To change the text from the usual black

1. Select the cells or characters you want to format.
2. Click the arrow next to the Font Colour button.

3. Select a font colour on the palette.

You can apply the same selected colour to other cells by making a selection and then clicking the coloured square on the Font Colour button.

Adding borders to a cell, or the whole worksheet

Heavy or light borders/lines can be added in the following way

1. Select the cells you want to format.
2. Click the arrow next to the Borders button.

3. Select a border style on the palette.

You can apply the same selected border style to other cells by making a selection and then clicking the style on the Borders button.

Filling in a series of numbers, dates or other items

The fill handle

When a fill handle is activated by the mouse pointer it changes to a black cross. This lets the user fill in values, dates or any other continuous data. To use the fill handle you should have a continuous range of information.

Fill handle

Using the fill handle

1. Select the first cell in the range you want to fill and enter the starting value for the series.

a This will fill the **same** contents into all cells specified.

b To **increment** the series by a specified amount, select the next cell in the range and enter the next item in the series. The difference between the two starting items determines the amount by which the series is incremented at each step.

2 Select the cell or cells that contain the starting values.

3 Drag the fill handle over the range you want to fill.

a To fill in **increasing** order, drag down or to the right.

b To fill in **decreasing** order, drag up or to the left.

Tip: To specify the type of series, hold down the right mouse button as you drag the fill handle over the range. Release the mouse button, and then click the appropriate command on the shortcut menu. For example, if the starting value is the date Jan-96, click Fill Months for the series Feb-96, Mar-96 and so on; click Fill Years for the series Jan-96, Jan-97 and so on.

Formatting cells and lists quickly with styles or built-in table formats

To format an entire list or other large range that has distinct elements (for example, column and row labels, summary totals and detail data) you can apply a built-in table design, called an AutoFormat. The design uses distinctive formats for the various elements of the table.

Applying an AutoFormat to a range

To AutoFormat a block of cells
1 Select the range you want to format.
2 On the Format menu, click AutoFormat.
3 In the Table Format box, click the format you want.

To use only selected parts of the AutoFormat, click Options, and then clear the check boxes for the formats you don't want to apply.

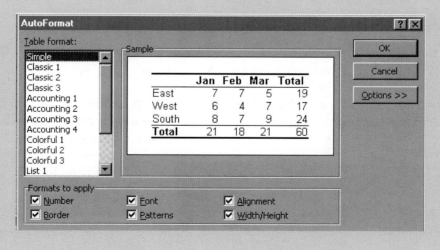

Printing

What to do before you print

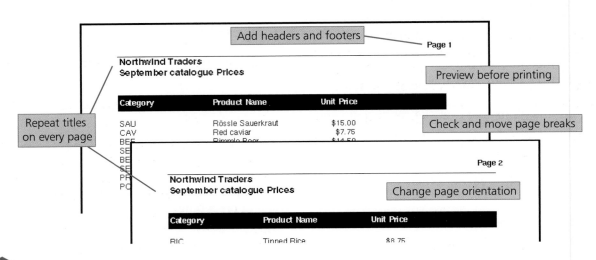

Figure 4.1 *Some of the general formatting tasks that should be considered before printing*

Print the active sheets, a selected range or an entire workbook

If the worksheet has a defined print area, Microsoft Excel will print only the print area. If you select a range of cells to print and then click Selection, Microsoft Excel prints the selection and ignores the rest of the print area defined for the worksheet.

To print your work as required
1 On the File menu, click Print.
2 Under Print What, select the option you want.

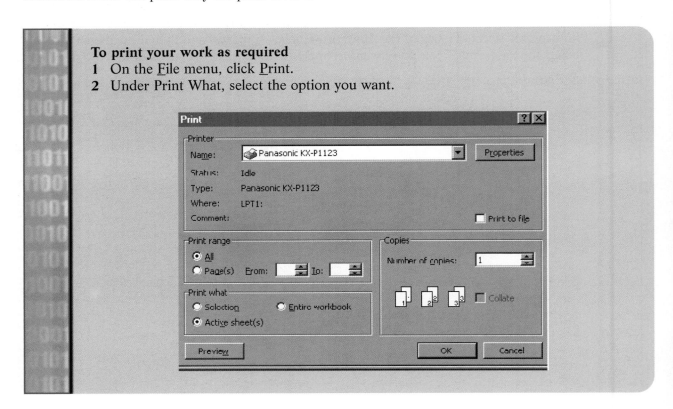

Formulae

How formulae calculate values

A formula is an equation that analyses data on a worksheet. Formulae perform operations such as addition, multiplication and comparison on worksheet values; they can also combine values. Formulae can refer to other cells on the same worksheet, cells on other sheets in the same workbook or cells on sheets in other workbooks. The example in Figure 4.2 adds the value of cell B4 and 25 and then divides the result by the sum of cells D5, E5 and F5.

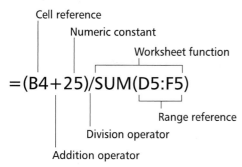

Cell reference

Numeric constant

Worksheet function

$$=(B4+25)/SUM(D5:F5)$$

Range reference

Division operator

Addition operator

Figure 4.2 *A typical mathematical formula, annotated to explain its components*

Formula syntax

Formulae calculate values in a specific order that is known as the syntax. The syntax of the formula describes the process of the calculation. A formula in Microsoft Excel begins with an equal sign (=), followed by what the formula calculates. For example, the following formula subtracts 1 from 5.

$$=5-1$$

The result of the formula is then displayed in the cell.

Cell references

A formula can refer to a cell. If you want one cell to contain the same value as another cell, enter an equal sign followed by the reference to the cell. The cell that contains the formula is known as a dependent cell because its value depends upon the value in another cell. Whenever the cell that the formula refers to changes, the cell that contains the formula also changes. The following formula multiplies the value in cell B15 by five. The formula will recalculate whenever the value in cell B15 changes.

$$=B15*5$$

Formulae can refer to cells or ranges of cells, or to names or labels that represent cells or ranges.

The difference between relative and absolute cell references

When you create a formula, references to cells or ranges are usually based upon their position relative to the cell that contains the formula. In the following example, cell B6 contains the formula =A5; Microsoft Excel finds the value one cell above and one cell to the left of B6. This is known as **relative referencing**.

	A	B
5	100	
6	200	=A5
7		

When you copy a formula that uses relative references, the references in the pasted formula update and refer to new cells which are related in the same way to the position of the formula. In the following example, the formula in cell B6 has been copied to cell B7. The formula in cell B7 has changed to =A6, which refers to the cell that is one cell above and to the left of cell B7.

	A	B
5	100	
6	200	=A5
7		=A6

If you don't want references to change when you copy a formula to a different cell, use an absolute reference. For example, if your formula multiples cell A5 with cell C1 (=A5*C1) and you copy the formula to another cell, both references will change. You can create an **absolute reference** to cell C1 by placing a dollar sign ($) before the parts of the reference that do not change. To create an absolute reference to cell C1, for example, add dollar signs to the formula as follows:

$$=A5*\$C\$1$$

This will now always refer to cell C1, wherever the formula is moved.

Worksheet functions

Microsoft Excel contains many predefined, or built-in, formulae known as functions. Functions can be used to perform simple or complex calculations. The most common function in worksheets is the SUM function, which is used to add ranges of cells. Although you can create a formula to calculate the total value of a few cells that contain values, the SUM worksheet function calculates several ranges of cells.

Entering a formula

1 Click the cell in which you want to enter the formula.
2 Type = (an equal sign).
 If you click Edit Formula then = or use the paste function button f_x

 Microsoft Excel inserts an equal sign for you.
3 Enter the formula.
4 Press Enter.

Tips:

▪ You can enter the same formula into a range of cells by selecting the range first, typing the formula, and then pressing Ctrl + Enter.
▪ You can also enter a formula into a range of cells by copying a formula from another cell.

Moving or copying a formula

When you **move** a formula, the cell references within the formula do not change.
 When you copy a formula, absolute cell references do not change but relative cell references do.

To move or copy a cell
1 Select the cell that contains the formula you want to move or copy.
2 Point to the border of the selection.
3 **a** To **move** the cell, drag the selection to the upper-left cell of the paste area (Microsoft Excel replaces any existing data in the paste area).
 b To **copy** the cell, hold down Ctrl as you drag.

Tip: You can also copy formulae into adjacent cells by using the fill handle. Select the cell that contains the formula, and then drag the fill handle over the range you want to fill.

Using the formula bar

This is a bar at the top of the Microsoft Excel window that you use to enter or edit values or formulae in cells or charts. It displays the constant value or formula used in the active cell. To display or hide the formula bar, click Formula Bar on the View menu.

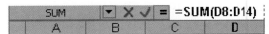

Entering a formula that contains a function

To enter the formula
1 Click the cell in which you want to enter the formula.
2 To start the formula with the function, click Edit then Formula = in the formula bar.
3 Click the down-arrow next to the Functions box.
4 Click the function you want to add to the formula; if the function does not appear in the list, click More Functions for a list of additional functions.
5 Enter the arguments.
6 When you have completed the formula, press Enter.

Statistical functions

Statistical worksheet functions perform statistical analyses on ranges of data.

SUM adds all the numbers in a range of cells e.g. SUM(A2:C2).

AVERAGE returns the average (arithmetic mean) of the arguments.

COUNT counts the number of cells that contain numbers above and numbers within the list of arguments. Use COUNT to get the total number of entries in a number field within a range or array of numbers.

MAX returns the largest value in a set of values.

MIN returns the smallest number in a set of values.

STDEV estimates standard deviation based on the sample within the range of cells specified (standard deviation is a measure of how widely values are dispersed from the average value or mean).

Logical functions

You can use the logical functions either to see whether a condition is true or false or to check for multiple conditions. For example, you can use the **IF** function to determine whether a condition is true or false: one value is returned if the condition is true, and a different value is returned if the condition is false.

IF returns one value if a condition you specify evaluates to TRUE and another value if it evaluates to FALSE.

Use IF to conduct conditional tests on values and formulae.

Syntax of the IF function

This can be written:

IF(logical_test,value_if_true,value_if_false)

Logical_test is any value or expression that can be evaluated to TRUE or FALSE.

Value_if_true is the value that is returned if logical_test is TRUE. If logical_test is TRUE and value_if_true is omitted, TRUE is returned. Value_if_true can be another formula.

Value_if_false is the value that is returned if logical_test is FALSE. If logical_test is FALSE and value_if_false is omitted, FALSE is returned. Value_if_false can be another formula.

Examples

In the following example, if the value in cell A10 is 100, then logical_test is TRUE, and the total value for the range B5:B15 is calculated.

Otherwise, logical_test is FALSE, and empty text ("") is returned; this blanks the cell that contains the IF function.

IF(A10=100,SUM(B5:B15),"")

Suppose an expense worksheet contains in B2:B4 the following data for 'Actual expenses' for January, February and March: 1500, 500, 500. The range C2:C4 contains the following data for 'Predicted expenses' for the same periods: 900, 900, 925.

You can write a formula to check whether you are over the budget for a particular month, and generate text for a message using the following formulae:

IF(B2>C2,"Over Budget","OK") equals "Over Budget"

IF(B3>C3,"Over Budget","OK") equals "OK"

Suppose you want to assign letter grades to numbers referenced by the name AverageScore as shown in Table 4.1.

Table 4.1 *Table relating average scores to a letter code*

If AverageScore is	then return
Greater than 89	A
From 80 to 89	B
From 70 to 79	C
From 60 to 69	D
Less than 60	F

You can use the following nested IF function:

IF(AverageScore>89,"A",IF(Average Score>79,"B",

IF(AverageScore>69,"C",IF(Average Score>59,"D","F"))))

In the preceding example, the second IF statement is also the value_if_false argument to the first IF statement. Similarly, the third IF statement is the value_if_false argument to the second IF statement. For example, if the first logical_test (Average>89) is TRUE, "A" is returned. If the first logical_test is FALSE, the second IF statement is evaluated, and so on.

Lookup and reference functions

When you need to find values in lists or tables or when you need to find the reference of a cell, you can use the lookup and reference worksheet functions. For example, to find a value in a table by matching a value in the first column of a table, use the VLOOKUP worksheet function.

VLOOKUP searches for a value in the leftmost column of a table, and then returns a value in the same row from a column you specify in the table. Use VLOOKUP instead of HLOOKUP when your comparison values are located in a column to the left of the data you want to find.

Syntax of the VLOOKUP function

A lookup function is used in the following way: VLOOKUP(lookup_value,table_array,col_index_num,range_lookup)

Lookup_value is the value to be found in the first column of the array. Lookup_value can be a value, a reference or a text string.

Table_array is the table of information in which data is looked up. Use a reference to a range or a range name, such as Database or List.

- If range_lookup is TRUE, the values in the first column of table_array must be placed in ascending order:
- ..., −2, −1, 0, 1, 2, ..., A–Z, FALSE, TRUE
- otherwise VLOOKUP may not give the correct value. If range_lookup is FALSE, table_array does not need to be sorted.
- You can put the values in ascending order by choosing the Sort command from the Data menu and selecting Ascending.
- The values in the first column of table_array can be text, numbers or logical values.
- Upper case and lower case text is equivalent.

Col_index_num is the column number in table_array from which the matching value must be returned. A col_index_num of 1 returns the value in the first column in table_array; a col_index_num of 2 returns the value in the second column in table_array, and so on. If col_index_num is less than 1, VLOOKUP returns the #VALUE! error value; if col_index_num is greater than the number of columns in table_array, VLOOKUP returns the #REF! error value.

Range_lookup is a logical value that specifies whether you want VLOOKUP to find an exact match or an approximate match. If TRUE or omitted, an approximate match is returned. In other words, if an exact match is not found, the next largest value that is less than lookup_value is returned. If FALSE, VLOOKUP will find an exact match. If one is not found, the error value #N/A is returned.

Remarks

- If VLOOKUP cannot find lookup_value, and range_lookup is TRUE, it uses the largest value that is less than or equal to lookup_value.
- If lookup_value is smaller than the smallest value in the first column of table_array, VLOOKUP returns the #N/A error value.
- If VLOOKUP can't find lookup_value, and range_lookup is FALSE, VLOOKUP returns the #N/A value.

	A	B	C
1	Air at 1 atm pressure		
2	Density	Viscosity	Temp
3	(kg/cubic m)	(kg/m*s)*1E+05	(degrees C)
4	0.457	3.55	500
5	0.525	3.25	400
6	0.616	2.93	300
7	0.675	2.75	250
8	0.746	2.57	200
9	0.835	2.38	150
10	0.946	2.17	100
11	1.09	1.95	50
12	1.29	1.71	0

Figure 4.3 *Examples of the VLOOKUP function in use*

Examples

On the worksheet in Figure 4.3, where the range A4:C12 is named range:

- VLOOKUP(1,Range,1,TRUE) equals 0.946
- VLOOKUP(1,Range,2) equals 2.17
- VLOOKUP(1,Range,3,TRUE) equals 100
- VLOOKUP(0.746,Range,3,FALSE) equals 200
- VLOOKUP(0.1,Range,2,TRUE) equals #N/A, because 0.1 is less than the smallest value in column A
- VLOOKUP(2,Range,2,TRUE) equals 1.71

Editing a formula

To edit an existing formula in a cell

1 Click the cell that contains the formula you want to edit.
2 In the formula bar, make the changes to the formula.
3 If you want to edit a function in the formula, edit the arguments in the function.
4 Press Enter.

Charts

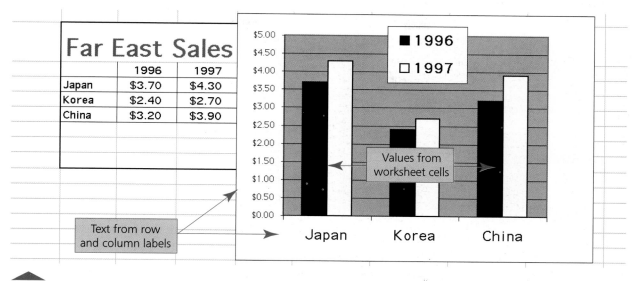

Figure 4.4 *A bar chart plotted from data in the spreadsheet*

You can display Microsoft Excel data graphically in a chart. Charts are linked to the worksheet data they are created from and are updated when you change the worksheet data.

You can create a chart from cells (or ranges) that are not next to one another.

To create a chart from data contained in a worksheet

1 Select the cells that contain the data you want to appear in the chart; if you want the column and row labels to appear in the chart, include the cells that contain them in the selection.
2 Click Chart Wizard.
3 Follow the instructions in the Chart Wizard.

Changing the cell range used to create a chart

1 Click the chart you want to change.
2 On the Chart menu, click Source Data, and then click the Data Range tab.
3 Make sure the entire reference in the Data Range box is selected.
4 On the worksheet, select the cells that contain the data you want to appear in the chart.

If you want the column and row labels to appear in the chart, include in the selection the cells that contain them.

Changing chart labels, titles and other text

Most chart tools, such as category axis labels, data series names, legend text and data labels, are linked to the cells on the worksheet used to create the chart. If you edit the text of these items on the chart, they are no longer linked to the worksheet cells. To change the text of these items and maintain links to worksheet cells, edit the text on the worksheet.

Changing category axis labels

■ To change category axis labels on the **worksheet**, click the cell that contains the label name you want to change, type the new name, and then press Enter.
■ To change category axis labels on the **chart**, click the chart, and then click Source Data on the Chart menu. In the Category Axis Labels box (see the top of the next page) on the Series tab, specify the worksheet range you want to use as category axis labels. You can also type the labels you want to use, separated by commas, for example: Division A, Division B, Division C
If you type the label text in the Category Axis Labels box, the category axis text is no longer linked to a worksheet cell.

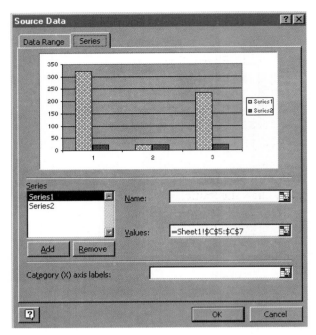

Changing category axis labels

Changing data series names or legend text
- To change legend text or data series names on the **worksheet**, click the cell that contains the data series name you want to change, type the new name, and then press Enter.
- To change legend text or data series names on the **chart**, click the chart, and then click Source Data on the Chart menu. On the Series tab, click the data series names you want to change. In the Name box, specify the worksheet cell you want to use as the legend text or data series name. You can also type the name you want to use.
 If you type a name in the Name box, the legend text or data series name is no longer linked to a worksheet cell.

Changing data labels
- To change data labels on the **worksheet**, click the cell that contains the information you want to change, type the new text or value, and then press Enter.
- To change data labels on the **chart**, click once on the data label you want to change to select the data labels for the entire series, and then click again to select the individual data label. Type the new text or value, and then press Enter.

If you change the data label text on the chart, note that it is no longer linked to a worksheet cell.

To edit chart and axis titles
1 Click the title you want to change.
2 Type the new text you want.
3 Press Enter.

Using a list as a database

In Microsoft Excel, you can easily use a list as a database. When you perform database tasks, such as finding, sorting, or subtotalling data, Microsoft Excel automatically recognises the list as a database and uses the following list elements to organise the data:

- the columns in the list are the fields in the database
- the column labels in the list are the field names in the database
- each row in the list is a record in the database.

Sorting a list

You can rearrange the rows or columns of a list based on the values in the list by sorting. When you sort, Microsoft Excel rearranges rows, columns or individual cells by using the sort order that you specify. You can sort lists in ascending (1 to 9, A to Z) or descending (9 to 1, Z to A) order, and sort based on the contents of one or more columns.

Microsoft Excel sorts lists alphabetically by default. If you need to sort months and weekdays according to their calendar order instead of their alphabetic order, use a custom sort order. You can also rearrange lists in a specific order by creating custom sort orders. For example, if you have a list that contains the entries 'Low', 'Medium' or 'High' in a column, you can create a sort order that arranges rows that contain 'Low' first, rows that contain Medium next, and rows with 'High' last.

Sorting rows in ascending/descending order
If you previously sorted a list on the same worksheet, Microsoft Excel uses the same sorting options unless you change them. To do this:

1. Click a cell in the column you would like to sort by.
2. Click the Sort Ascending button

or the Sort Descending button .

Sorting multiple columns
You can sort on more than one column at the same time by using the Sort dialogue box.

To do this
1. Click anywhere inside the table that you wish to sort.
2. Click Data and select Sort.

3. Select from the drop-down lists the columns that you wish to sort.

Filtering a list

Filtering is a quick way to find a subset of data in a list. To filter a list:

1. Click any cell in the list.
2. Point to Filter on the Data menu.
3. Click AutoFilter.

Microsoft Excel displays arrows to the right of the column labels in the list. To select the value you want to show in the list, click the arrow, and then click the value.

A filtered list displays only the rows that contain the value you specify. The list in Figure 4.5 is filtered to show only the rows for the salesperson Davolio. Microsoft Excel indicates the filtered items with some visual cues. The filtered row numbers are blue. The AutoFilter arrows in columns that have selected values are also blue.

Display a subset of rows in a list by using filters

You can apply filters to only one list on a worksheet at a time. To do so:

1. Click a cell in the list you want to filter.
2. On the Data menu, point to Filter, and then click AutoFilter.
3. To display only the rows that contain a specific value, click the arrow in the column that contains the data you want to display.

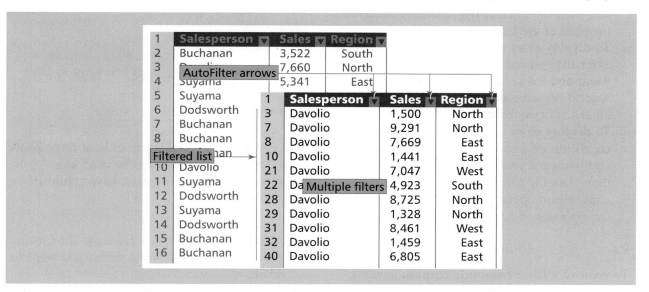

Figure 4.5 *Filtering a list*

4 Click the value.

5 To apply an additional condition based on a value in another column, repeat steps **3** and **4** in the other column.

To filter the list by two values in the same column, or to apply comparison operators other than equals, click the arrow in the column, and then click Custom. For information about displaying rows by comparing values, click.

Note:

- When you apply a filter to a column, the only filters available for other columns are the values visible in the filtered list.
- You can apply up to two conditions to a column with AutoFilter. If you need to apply three or more conditions to a column, use calculated values as your criteria, or copy records to another location. You could use advanced filters.

Display a subset of rows by comparing values

To find specific values in rows in a list by using one or two comparison criteria for the same column, click the arrow in the column that contains the data you want to compare, and then click Custom.

- **To match one criterion,** click the comparison operator you want to use in the first box under Show Rows Where, and then enter the value you want to match in the box immediately to the right of the comparison operator.
- **To display rows that meet two conditions,** enter the comparison operator and value you want, and then click the And button. In the second comparison operator and value boxes, enter the operator and value you want.
- **To display rows that meet either one condition or another condition,** enter the comparison operator and value you want, and then click the Or button. In the second comparison operator and value boxes, enter the operator and value you want.

Remove filters from a list

To remove a filter from one column in a list, click the arrow next to the column, and then click All.

To remove filters applied to all columns in the list, point to Filter on the Data menu, and then click Show All.

To remove the filter arrows from a list, point to Filter on the Data menu, and then click AutoFilter.

Automatic filter options

Click	to
All	display all rows
Top 10	display all rows that fall within the upper or lower limits you specify, either by item or percentage: for example, the amounts within the top 10 per cent of sales
Custom	apply two criteria values within the current column, or use comparison operators other than AND (the default operator)
Blanks	display only rows that contain a blank cell in the column
NonBlanks	display only rows that contain a value in the column

Note: The Blanks and NonBlanks options are available only if the column you want to filter contains a blank cell.

Filter a list by using advanced criteria

Your worksheet should have at least three blank rows above the list that can be used as a criterion range. The list must have column labels.

To filter in this way

1 Copy the column labels from the list for the columns that contain the values you want to filter.

2 Paste the column labels in the first blank row of the criterion range.

3 In the rows below the criterion labels, type the criteria you want to match. Make sure there is at least one blank row between the criterion values and the list.

4 Click a cell in the list.

5 On the Data menu, point to Filter, and then click Advanced Filter.

6 To filter the list by hiding rows that don't match your criteria, click Filter the List, in-place.

To filter the list by copying rows that match your criteria to another area of the worksheet, click Copy To Another Location, click in the Copy To box, and then click the upper-left corner of the paste area.

7 In the Criteria Range box, enter the reference for the criterion range, including the criterion labels.

To move the Advanced Filter dialogue box out of the way temporarily while you select the criteria range, click Collapse Dialogue button .

Tip: If the worksheet contains a range of named criteria, the reference for the range will appear automatically in the Criteria Range box.

Examples of advanced filter criteria

Advanced filter criteria can include multiple conditions applied in a single column, multiple criteria applied to multiple columns, and conditions created as the result of a formula.

Three or more conditions in a single column
If you have three or more conditions for a single column, type the criteria directly below each other in separate rows. For example, the following criterion range displays the rows that contain either 'Davolio', 'Buchanan' or 'Suyama' in the Salesperson column.

Salesperson
Davolio
Buchanan
Suyama

Criteria from two or more columns
To find data that meets one condition in two or more columns, enter all the criteria in the same row of the criterion range. For example, the following criterion range displays all rows that contain 'Produce' in the Type column, 'Davolio'

in the Salesperson column **and** sales values greater than $1000.

Type	Salesperson	Sales
Produce	Davolio	>1000

Note: You can also specify multiple conditions for different columns and display only the rows that meet all the conditions by using the AutoFilter command on the Data menu.

To find data that meets either a condition in one column or a condition in another column, enter the criteria in different rows of the criterion range. For example, the following criterion range displays all rows that contain either 'Produce' in the Type column, 'Davolio' in the Salesperson column **or** sales values greater than $1000.

Type	Salesperson	Sales
Produce		
	Davolio	
		>1000

To find rows that meet one of two conditions in one column and one of two conditions in another column, type the criteria in separate rows. For example, the following criterion range displays the rows that contain 'Davolio' in the Salesperson column and sales values greater than $3000, **or** the rows for salesperson Buchanan with sales values greater than $1500.

Salesperson	Sales
Davolio	>3000
Buchanan	>1500

Conditions created as the result of a formula
You can use a calculated value that is the result of a formula as your criterion. When you use a formula to create a criterion, do not use a column label for a criterion label; either keep the criterion label blank, or use a label that is not a column label in the list. For example, the following criterion range displays rows that have a value in column G greater than the average of cells E5:E14; it does not use a criterion label.

=G5>AVERAGE(E5:E14)

Notes:
- The formula you use for a condition must refer to the column label (for example, Sales) or the reference for the corresponding field in

the first record. In the above example, G5 refers to the field (Column G) for the first record (Row 5) of the list.

- You can use a column label in the formula instead of a relative cell reference or a range name. When Microsoft Excel displays an error value such as #NAME? or #VALUE! in the cell that contains the criterion, you can ignore this error because it does not affect how the list is filtered.

Headers and footers

To put page numbers or other text above or below the worksheet data on each page, you can add headers or footers to your printed worksheet. Headers print at the top of every page, footers appear at the bottom of every page.

Headers and footers are separate from the data on your worksheet – they appear only when you preview and print. In addition to headers and footers, you can repeat worksheet data as print titles on every page.

You can use the built-in headers and footers in Microsoft Excel or create your own.

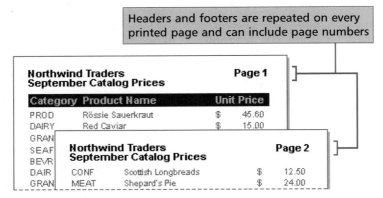

Headers and footers are repeated on every printed page and can include page numbers

To add a header or footer

1 Click the worksheet.
2 On the View menu, click Header and Footer.
3 In the Header or Footer box, click the header or footer you want.

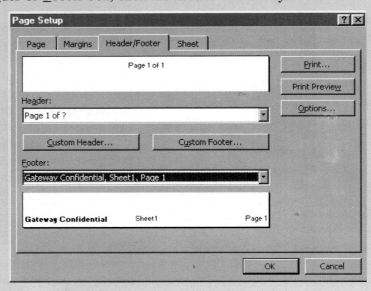

4 To create your own header and footer, click on the <u>C</u>ustom Header or C<u>u</u>stom Footer buttons.

5 Click in the <u>L</u>eft Section, <u>Centre</u> Section, or <u>R</u>ight Section box, and then click the buttons to insert the header or footer information (such as the page number) that you want in that section. You can also type in anything you wish, and it will appear just as you have typed it.

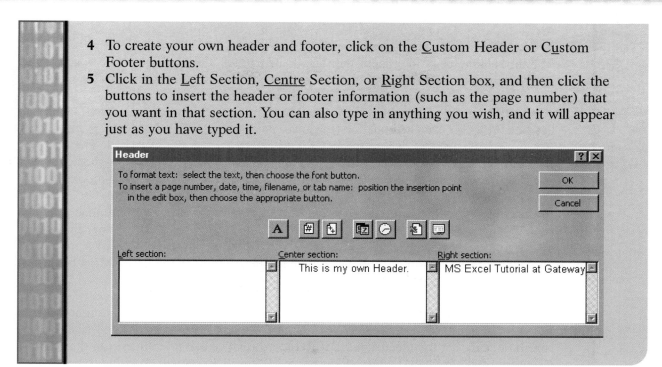

Macros

Automating tasks you perform frequently

If you perform a task repeatedly in Microsoft Excel, you can automate the task with a macro. A macro is a series of commands and functions that are stored in a Visual Basic module and can be run whenever you need to perform the task. You record a macro just as you record music with a tape recorder. You then run the macro to repeat, or 'play back', the commands.

Before you record or write a macro, plan the steps and commands you want the macro to perform. If you make a mistake when you record the macro, corrections you make will also be recorded. Each time you record a macro, the macro is stored in a new module attached to a workbook.

With the Visual Basic Editor, you can edit macros, copy macros from one module to another, copy macros between different workbooks, rename the modules that store the macros, or rename the macros.

Recording a macro

To record a macro

1 On the <u>T</u>ools menu, point to <u>M</u>acro, and then click Record.

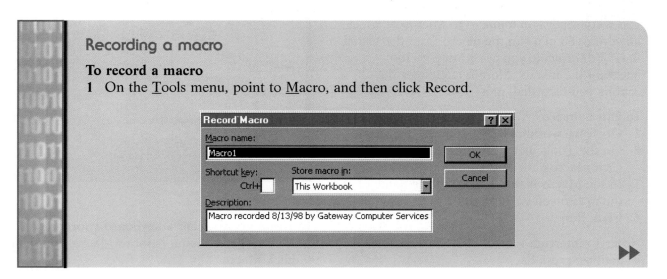

2 In the Macro Name box, enter a name for the macro.
 The first character of the macro name must be a letter. Other characters can be
 letters, numbers or underscore characters. Spaces are not allowed in a macro name
 (an underscore character works well as a word separator).

3 To run the macro by pressing a keyboard shortcut key, enter a letter in the Shortcut
 key box. You can use Ctrl + letter (for lower case letters) or Ctrl + Shift + letter
 (for upper case letters), where the letter is any letter key on the keyboard. The
 shortcut key letter you use cannot be a number or special character. The shortcut
 key will override any default Microsoft Excel shortcut keys while the workbook that
 contains the macro is open.

4 In the Store Macro In box, click the location where you want to store the macro.
 If you want a macro to be available whenever you use Microsoft Excel, store the
 macro in the Personal Macro Workbook in the XLStart folder.
 To include a description of the macro, type the description in the Description box.

5 Click OK.
 If you select cells while running a macro, the macro will select the same cells
 regardless of which cell is first selected because it records absolute cell references. If
 you want a macro to select cells regardless of the position of the active cell when you
 run the macro, set the macro recorder to record relative cell references. On the Stop
 Recording toolbar, click Relative Reference. Microsoft Excel will continue to record
 macros with relative references until you quit Microsoft Excel or until you click
 Relative Reference again.

6 Carry out the actions you want to record.

7 On the Stop Recording toolbar, click Stop Recording.

Running a macro

After you record a macro, you can run it in
Microsoft Excel or from the Visual Basic Editor.
You will usually run a macro in Microsoft Excel,
however, you can run the macro from the Visual
Basic Editor while you are editing it. To
interrupt the macro before it completes the
actions you recorded, press Esc.

To run a macro

1 Open the workbook that contains the macro.
2 On the Tools menu, point to Macro, and then
 click Macros.
3 In the Macro Name box, enter the name of
 the macro you want to run.
4 Click Run.

Note: To interrupt a macro before it completes
its actions, press Esc.

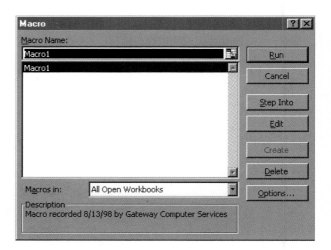

To run a macro from a keyboard shortcut

1 On the Tools menu, point to Macro, and then
 click Macros.

2 In the Macro Name box, enter the name of the macro you want to assign to a keyboard shortcut.

3 Click Options and the following screen will be seen.

4 To run the macro by pressing a keyboard shortcut key, enter a letter in the Shortcut Key box. You can use Ctrl + letter or Ctrl + Shift + letter, where the letter is any letter key on the keyboard. The shortcut key will override any default shortcut keys assigned by Microsoft Excel, while the workbook that contains the macro is open.

To include a description of the macro, type the description in the Description box.

5 Click OK.

6 Click Cancel.

Running a macro from a button or graphic control

You can assign a macro to a button, drawing object or a graphic control on your worksheet. When you click the button or drawing object, or change the control (for example, by clicking a check box or an item in a list) your macro will run automatically.

1 Click the button or graphic control so that selection handles appear.

2 Right-click a selection handle for the button or graphic control, and then click Assign Macro on the Shortcut menu.

3 **a** To assign an existing macro to the button or graphic control, enter the name of the macro in the Macro Name box, and then click OK.

 b To record a new macro to assign to the button or graphic object, click Record.

The worksheet below is based on a student's income and expenditure for a term. Enter the data exactly as shown.

	A	B	C	D	E	F
1			PERSONAL FINANCES - TERM 1			
2	INCOME		Week 1			
3	Opening Bals		0			
4	Grant		500			
5	Loan		400			
6	Parents		300			
7	Total Income					
8						
9	EXPENDITURE					
10	Accomodation		60			
11	Food		30			
12	Books		75			
13	Other		20			
14	Total Expenditure					

1 Using the spell checker through Tools then Spelling and Grammar, correct the spelling for the text 'Accomodation'.

2 Alter the text in Cell A5 from 'Loan' to Bank Loan. (You could achieve this by moving the cursor on the text and pressing the F2 key or by clicking twice on the text which is to be altered.)

3 Alter the text in Cell A11 from 'Food' to Food and Travel.

4 Change the column width of Column A to 15 using Format then Columns then Width.

5 Change the row height of Row 1 to 15 using Format then Row then Height.

6 Calculate the Total Income in Cell C7 using the SUM function (the result should be 1200).

7 Calculate the Total Expenditure in Cell C14 using the SUM function (the result should be 185).

8 In Cell A16 enter the text **Closing balance**.

9 In Cell C16 enter the formula to deduct the Total Expenditure from Total Income (the result should be 1015).

 Note formula: Closing balance = 'Total income – Total expenditure'

10 The worksheet should now appear as shown at the top of the next page.

11 Save the workbook as **Terms.xls**.

12 Using the Fill method copy the contents of C2:C16 to Column D.

13 Delete the values from D4 to D6, because these incomes vary every week.

14 Carry the Closing Balance from Week 1 to the Opening Balance in Week 2 by typing =C16 in cell D3.

15 Make the following amendments to Week 2:
 Food and travel 35
 Books 15

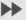

	A	B	C	D	E	F
1			PERSONAL FINANCES - TERM 1			
2	INCOME		Week 1			
3	Opening Bals.		0			
4	Grant		500			
5	Loan		400			
6	Parents		300			
7	Total Income		1200			
8						
9	EXPENDITURE					
10	Accomodation		60			
11	Food		30			
12	Books		75			
13	Other		20			
14	Total Expenditure		185			
15						
16	CLOSING BALS.		1015			

The worksheet at Step 10

16 Using Week 3 as the model, use the fill method to make the worksheet for the following three weeks up to Week 5.

17 The Closing Balance at the end of Week 5 should be 495, as shown below.

	A	B	C	D	E	F	G
1			PERSONAL FINANCES - TERM 1				
2	INCOME		Week 1	Week 2	Week 3	Week 4	Week 5
3	Opening Bals.		0	1015	885	755	625
4	Grant		500				
5	Loan		400				
6	Parents		300				
7	Total Income		1200	1015	885	755	625
8							
9	EXPENDITURE						
10	Accomodation		60	60	60	60	60
11	Food		30	35	35	35	35
12	Books		75	15	15	15	15
13	Other		20	20	20	20	20
14	Total Expenditure		185	130	130	130	130
15							
16	CLOSING BALS.		1015	885	755	625	495

18 Save the workbook again and exit Excel.

1 Open the Workbook you created in Tutorial 4.1.

2 Select the entire Rows 1 and 2 and embolden them.

3 Select Column A and embolden the labels.

4 Select Column A again and change the font size to 8 point.

5 Select the range C3:C16 and centre the values.

6 Select the range C3:C16 again and format them to the $ currency.

7 Delete Column B and format the decimal places in the currency section to zero decimal places.

8 Insert a new row between Row 1 and Row 2.

9 Select the range A1:F1 and centre the heading across the columns.

	A	B	C	D	E	F
1	PERSONAL FINANCES - TERM 1					
2	INCOME	Week 1	Week 2	Week 3	Week 4	Week 5
3	Opening Bals.	$ -	$ 1,015.00	$ 885.00	$ 755.00	$ 625.00
4	Grant	$ 500.00				
5	Loan	$ 400.00				
6	Parents	$ 300.00				
7	Total Income	$ 1,200.00	$ 1,015.00	$ 885.00	$ 755.00	$ 625.00
8						
9	EXPENDITURE					
10	Accomodation	$ 60.00	$ 60.00	$ 60.00	$ 60.00	$ 60.00
11	Food	$ 30.00	$ 35.00	$ 35.00	$ 35.00	$ 35.00
12	Books	$ 75.00	$ 15.00	$ 15.00	$ 15.00	$ 15.00
13	Other	$ 20.00	$ 20.00	$ 20.00	$ 20.00	$ 20.00
14	Total Expenditure	$ 185.00	$ 130.00	$ 130.00	$ 130.00	$ 130.00
15						
16	CLOSING BALS.	$ 1,015.00	$ 885.00	$ 755.00	$ 625.00	$ 495.00

10 Switch off the gridlines using Tools then Options.

11 Apply a bottom border to Row 9 and Row 16.

12 Apply a right border to Column A.

13 Freeze the columns on the left and the rows on top of cell B4 using the Window then Freeze panes.

14 Insert drawing objects (text boxes) and apply formatting as shown below.

	A	B	C	D	E	F
1		PERSONAL FINANCES - TERM 1				
2						
3	INCOME	Week 1	Week 2	Week 3	Week 4	Week 5
10	EXPENDITURE					
11	Accomodation	$ 60.00	$ 60.00	$ 60.00	$ 60.00	$ 60.00
12	Food and Travel	$ 30.00	$ 35.00	$ 35.00	$ 35.00	$ 35.00
13	Books	$ 75.00	$ 15.00	$ 15.00	$ 15.00	$ 15.00
14	Other	$ 20.00	$ 20.00	$ 20.00	$ 20.00	$ 20.00
15	Total Expenditure	$ 185.00	$ 130.00	$ 130.00	$ 130.00	$ 130.00
16						
17	CLOSING BALS.	$1,015.00	$ 885.00	$ 755.00	$ 625.00	$ 495.00
18						
19		Income & expenditure for the first 5 weeks of the Autumn Term.			On target !	
20						
21						

Create the worksheet shown below.

1 Use AutoFill to enter the months.

2 Format the worksheet as shown:
 a title centred across Columns A to E
 b cell labels emboldened and centred
 c values centred in cells.

3 Use the SUM function to calculate the quarterly totals in Cell E4 then copy the formula to Cells E5 and E6 using AutoFill.

4 Calculate the totals in Row 9 using SUM and AutoFill. (Don't just type the totals in!)

	A	B	C	D	E
1	Insurance Sales - First Quarter				
2					
3		**Motor**	**Life**	**Property**	**Total**
4	**Jan**	1465	1243	2456	5164
5	**Feb**	1345	1456	1987	4788
6	**Mar**	1132	2310	1598	5040
7					
8	**Quarterly Average**				
9	**Quarterly Total**	3942	5009	6041	14992
10	**% of Total**				

5 Calculate the quarterly average for each category and format it to zero decimal places.

6 Express the quarterly totals (B9:D9) as fractions of the total sales (E9).

 Use absolute cell addressing to do this (in Cell B10 enter **=B9/E9**).

7 Format the '% of Total' row to show a percentage to two decimal places.

8 Insert a text box with the following text in the worksheet: **This worksheet shows a sales analysis of the three major insurance categories.**

9 Switch off the gridlines.

10 Select only the range as shown below, and apply the Classic 3 format using AutoFormat. Click on the Options button and deselect the font, alignment and the width/height.

	A	B	C	D	E
1	Insurance Sales - First Quarter				
2					
3					
4	**Jan**	1465	1243	2456	5164
5	**Feb**	1345	1456	1987	4788
6	**Mar**	1132	2310	1598	5040
7					
8	**Quarterly Average**	1314	1669.667	2013.667	4997.333
9	**Quarterly Total**	3942	5009	6041	14992
10	**% of Total**	26%	33%	40%	

11 Save the workbook as **Insurance.xls**.

TUTORIAL 4.3

Prepare the worksheet shown below and calculate the Total and Average Marks (the calculations are shown as XXX in the worksheet here).

1 Using the functions you have learnt find the maximum, minimum and number of students (use MAX, MIN and COUNT functions).

	A	B	C	D	E	F
1	Student Record Sheet					
2	Name	Ass 1	Ass 2	Ass 3	Total	Average
3	Jean	90	55	58	xxx	xxx
4	Claude	76	89	58	xxx	xxx
5	Jacqueline	45	48	67	xxx	xxx
6	Ash	55	58	57	xxx	xxx
7	Harshitha	78	64	58	xxx	xxx
8	Landani	65	89	58	xxx	xxx
9						
10	Maximum	xxx	xxx	xxx	xxx	xxx
11	Minimum	xxx	xxx	xxx	xxx	xxx

2 Format the Average column to two decimal places.

3 Find the minimum, maximum and the number of students in the relevant column.

4 Give the heading for column G as Grade. Using the IF function find the grade for each student using their average and the table given below.

Average	Grade
0–25	Fail
26–50	Pass
51–75	Merit
76–100	Honours

5 Type the text **Assessments greater than 50** and, using the COUNT IF function, calculate the marks greater than 50 for all the assessments.

6 Save the worksheet as **Students**.

Create the following worksheet.

	A	B	C	D	E	F
1	**Sunfilled Holidays**					
2			**Holidays Sold - Europe**			
3						
4		**1st Quarter**	**2nd Quarter**	**3rd Quarter**	**4th Quarter**	**Total**
5						
6	**Italy**	85	99	200	93	xxx
7	**Spain**	150	246	355	145	xxx
8	**Portugal**	120	180	300	123	xxx
9	**Greece**	168	277	320	162	xxx
10	**France**	70	120	250	110	xxx
11						
12	**Total**	xxx	xxx	xxx	xxx	xxx
13						

1 Enter the data and format the worksheet as shown, i.e. data centred in columns, column widths adjusted, headings and labels emboldened.

2 Total the first column in Cell B12. Copy the formula to the other cells.

3 Calculate the totals across in a similar way.
As a check, the grand total for all the holidays should be 3573. If not check your data!

4 Save the workbook as **EURO SALES.xls**.

Now create the chart shown below.

5 Set the chart and axis titles as shown.

6 Switch off the legend.

7 Insert the chart as a new sheet and name the sheet as **Qtr1 Bar**.

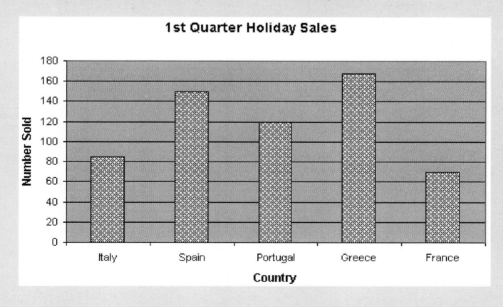

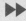

TUTORIAL 4.5

8 Make a copy of the chart in a new sheet and name it **Qtr1 Pie**.

9 Change the chart type in the copy to a pie chart.

10 Switch on the legend.

11 Explode the slice for Greece.

12 Insert data labels as percentage values.

The chart should now appear as shown here.

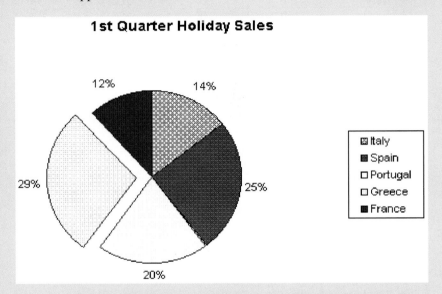

13 Now create a 3-D bar chart as shown below and name it **Year 3D Bar**.

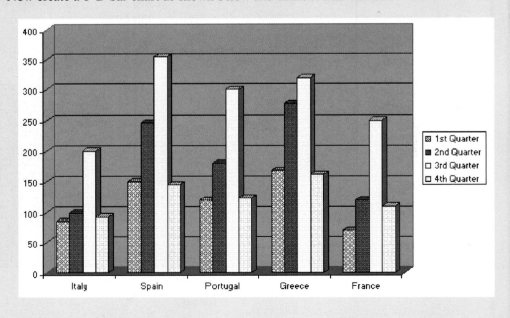

1 Open the worksheet you created in Tutorial 4.5.

2 Click on the Qtr1 Pie sheet and make a copy of it. Name the sheet **Pie New**.

3 Change the heading of the chart to **1st Quarter European Holiday Sales**.

4 Alter the chart title to size 14 point and embolden.

5 Insert a callout with the text as shown below.

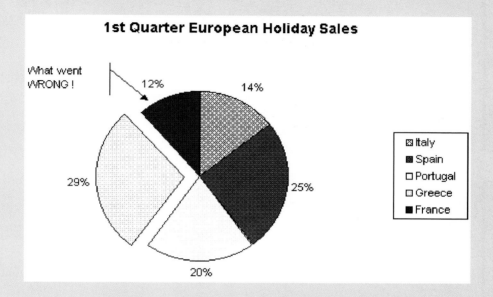

6 Create a line chart to compare the sales for Italy and Spain for the four quarters:

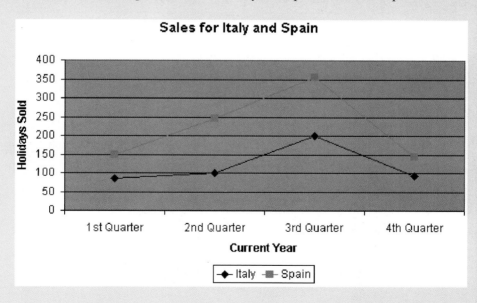

7 Insert another line chart to compare the sales for Italy and France for the four quarters.

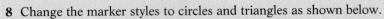

8 Change the marker styles to circles and triangles as shown below.

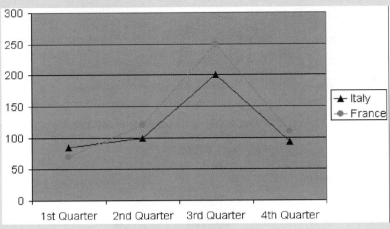

Prepare the bill for Apple Company shown below.

	A	B	C	D	E
1		**Apple Company**			
2	**Item No.**	**Description**	**Quantity**	**Rate/Unit**	**Total Amount**
3	A101		5		xxx
4	A202		3		
5	A404		12		xxx
6	A707		6		xxx
7	A808		6		xxx
8					
9					
10					
11		**Total Amount On Date {Date}**			xxx

1 Using the NOW function insert the current date at the bottom.

2 Create a lookup table to find the description and rate/unit so that the user has only to enter the item number and the quantity (use the VLOOKUP function).

Item No.	Description	Rate/Unit
A101	Transistors	$120.00
A202	Capacitors	$88.00
A303	Processors	$1,200.00
A404	Sound Blaster	$6,000.00
A505	CD-ROM	$1,500.00
A606	UPS	$20,000.00
A707	Ribbons	$800.00
A808	Data switches	$1,400.00

TUTORIAL 4.7

TUTORIAL 4.8

1 Create the worksheet shown here and enter the records.

	A	B	C	D	E
1	Customer Code	Customer Name	Tour Code	Departure Date	No. Of People
2	1024	Jason Knight	A	10-May-99	2
3	1057	Jimmy Dean	A	15-Mar-99	4
4	1054	Mario	D	24-Oct-99	3
5	4546	Carl	D	22-Jan-99	9
6	5465	Mark	C	01-Jan-99	2
7	7678	Anthony	B	12-Dec-99	5
8	5467	Julius	D	11-Sep-99	2
9	3787	Peter	A	13-Mar-99	5
10	6876	Rommel	C	28-Oct-99	3
11	5466	Tarin	B	03-Nov-99	1
12	3787	Chris	D	27-Aug-99	3
13	6388	Boris	A	26-May-99	2
14	8678	Alice	A	09-Nov-99	2
15	8798	Hootie	C	18-Jun-99	6
16	3278	Oasis	B	11-Dec-99	4
17	6877	Michael	A	30-Dec-99	5
18	3877	Priestly	D	25-Dec-99	1
19	3888	Shannon	C	02-Jun-99	7

2 Insert a new row at the top of the spreadsheet and add the title **Knight Travels**.

3 Give Column F the heading **Tour Description**.

4 Using the VLOOKUP function and Table 1 (below), find the Tour Description for Column F.

Table 1		
Tour Code	**Description**	**Cost Per Person**
A	Caribbean Cruise	150,000
B	Tour to Holy Land	130,000
C	Sai Devotees Tour	22,000
D	Tour To America	175,000

5 Give Column G the heading **Total Tour Cost**.

6 Using the VLOOKUP function find the total cost of the tour for each customer by multiplying the number of people by the cost per person.

7 Give Column H the title **Discount Amount**. Using the following table find the discount amount for each customer (note: use the IF function):

Number of people	Discount
1	No discount
2	5%
3	7%
4	9%
5	11%
6 and above	15%

Name Column 1 **Net Cost** and calculate the net cost for each customer.

Note: Net Cost = Total Tour Cost − Discount Amount

8 Save the workbook as **Knight Travels**.

TUTORIAL 4.9

1 Create the worksheet shown below.

	A	B	C	D	E
1	Order No.	Order Date	Co.Ref	Co. Name	Value
2	14000	10-Mar	1453	Wilson Garages	3200.00
3	14001	8-Mar	2413	Patel Industries	1466.00
4	14002	11-Mar	1453	Wilson Garages	98.76
5	14003	11-Mar	1289	Marsden Products	4456.00
6	14004	10-Mar	2413	Patel Industries	567.00
7	14005	11-Mar	955	Tilley Transport	1678.00
8	14006	10-Mar	2375	Patel Kitchen	55.54
9	14007	9-Mar	1453	Wilson Garages	2654.00
10	14008	12-Mar	2245	Goldfield Stables	123.85
11	14009	12-Mar	1289	Marsden Products	1652.54

2 Sort the customer orders in ascending order of date using <u>D</u>ata then <u>S</u>ort.

3 Sort the records within Co. Name in reverse date sequence using <u>D</u>ata then <u>S</u>ort.

4 Add two more fields to the database:
the VAT field will hold the 17.5% VAT to be added to the value of an order
the Total field will hold the VAT field added to the order value field.
Formulae: VAT = Value*17.5%
 Total = Value + (Value*17.5%)

5 Format the last three columns using the $ sign and add borders for the rows and the columns using the <u>F</u>ormat menu.

The worksheet should now look like this:

	A	B	C	D	E	F	G
1	Order No.	Order Date	Co.Ref	Co. Name	Value	VAT	Total
2	14008	12-Mar	2245	Goldfield Stables	123.85	21.67	145.52
3	14009	12-Mar	1289	Marsden Products	1652.54	289.19	1941.73
4	14003	11-Mar	1289	Marsden Products	4456.00	779.80	5235.80
5	14004	10-Mar	2413	Patel Industries	567.00	99.23	666.23
6	14001	8-Mar	2413	Patel Industries	1466.00	256.55	1722.55
7	14006	10-Mar	2375	Patel Kitchen	55.54	9.72	65.26
8	14005	11-Mar	955	Tilley Transport	1678.00	293.65	1971.65
9	14002	11-Mar	1453	Wilson Garages	98.76	17.28	116.04
10	14000	10-Mar	1453	Wilson Garages	3200.00	560.00	3760.00
11	14007	9-Mar	1453	Wilson Garages	2654.00	464.45	3118.45

6 Insert a new sheet using <u>I</u>nsert then Worksheet.

7 Copy the areas A1 to E11 to the inserted worksheet and name it **New Orders**.

8 Insert four blank rows at the beginning of the worksheet and insert a heading in the very first row **Orders for the Month of July 1999**.

9 Merge and centre the heading using <u>F</u>ormat then <u>C</u>ells then Alignment.

10 Type the text **VAT** in Column B and in Column C **17.5%** using the third row of the worksheet.

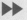

TUTORIAL 4.9

11 In the new sheet, change the formula for calculating the VAT amount to one using absolute referencing to the cell where the VAT amount (C3) is to be changed. Do not type in the value for the formulae.

12 Using AutoFilter extract all the records for the 9th or 11th of March.

13 Extract the records with order numbers between 14005 and 14009 inclusive.

14 Extract the records for each day and calculate the total sales for each day.

15 Extract records where Co. Name begins with W and the total value is greater than $1000.

16 Insert a date as the footer using View then Headers and Footers then Custom Footers. Place them in the right section using the text **Orders 1999**.

17 Save the workbook as **Orders.xls**.

TUTORIAL 4.10

Part A

Create a worksheet based on the data shown below.

Surname	Forename	Area	Job	Age	Availability
Morrison	James	Manchester	Driver	33	12-Jun
Cohen	Harry	Essex	Gardener	65	13-Jun
Wilson	John	Sussex	Guide	34	20-Jun
Sutton	Tony	Manchester	Driver	39	23-Jun
Sutton	Linda	Surrey	Canteen	54	22-Jun
Smith	Louse	Surrey	Kitchen	50	26-Jun
Goldfield	Chris	Yorkshire	Guide	34	30-Jun
Muir	Sue	Essex	Warden	43	30-Jun
Ali	Kate	Sussex	Warden	16	30-Jun
Burton	Judy	Lancashire	Kitchen	50	2-Aug
Pierce	Karen	Surrey	Guide	20	2-Aug
Maycock	Ray	Birmingham	Gardener	40	4-Aug
Posey	Malcolm	London	Driver	25	30-Aug
Baker	Tony	Sussex	Canteen	66	5-Aug

1 Extract all the drivers.

2 Extract the drivers in Manchester.

3 Extract the helpers living in Essex.

4 Extract the helpers aged over 50.

5 Extract the helpers from Surrey, available before 25th July.

6 Extract all helpers whose surnames end with 'n'.

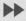

7 Extract all the helpers from Lancashire and Manchester.

8 Save the workbook as Helpers.

Part B

1 Create the file **Production.xls** from the data given on page 209.

2 Save the spreadsheet in your working diskette using File then Save As and the original name.

3 Insert the heading **Production Analysis for the Millennium** between the first and second rows using Insert then Rows.

4 Embolden the main title and subtitles using Format then Cells then Font.

5 Using the appropriate functions calculate the total and average in the next columns. (Use the SUM and AVERAGE functions.)

6 Using the AutoFill or Copy handle tool copy the rest of the values for the rest of the row.

7 Insert borders around the table and change the font colour of the table to red using Format then Cells.

8 Format all the figures of the worksheet except the average column to two decimal places, using Format then Cells.

9 Create a bar chart for the first quarter and fourth quarter using Insert then Charts (enhance the chart with data labels, tiles, etc.).

10 Insert a footer **Analysis 2002** using View then Headers & Footers.

11 Copy the chart created as a new sheet and name the worksheet **Second**.

12 Save the spreadsheet as **TutorialXX.xls** and print two copies of the table to an output printer or print to a file using File then Print.

TUTORIAL 4.11

1 Enter the table below using a new workbook.

Order number	Style number	Quantity	Washing cost (£)	Machine cost (£)	Freight cost (£)	Total cost (£)	QC charge for finished products (%)	Total FOB value (£)
X004	RT34003	15000	8	4.5	2	Formulae	4	Formulae
T002	WT34003	25000	6	2.2	5	Formulae	6	Formulae
A003	FT34003	6000	3	1.5	1	Formulae	5	Formulae
B009	RT34003	87300	8	4.5	2	Formulae	4	Formulae
C005	FT34003	20000	3	1.5	1	Formulae	5	Formulae
D002	PT35008	90000	2.5	3.5	7	Formulae	4.5	Formulae
Z007	WT34003	60000	6	2.2	5	Formulae	6	Formulae
E008	FT34003	3000	3	1.5	1	Formulae	5	Formulae
P009	FT34003	75000	3	1.5	1	Formulae	5	Formulae

2 Format the cells appropriately with the currency sign (£) using Format then Cells then Number.

3 Calculate the total cost per item using the following formulae:
 a Insert a column (between Columns G and H) to represent cost per item without freight (£).
 b Calculate the above formulae in the new column and the total FOB value (£).

Note the following formulae:

Total cost per item = Washing cost + Machine cost + Freight cost

Cost without freight cost per item (£) = Total cost per item – Freight cost per item

Total FOB value (£) = (Quantity*Total cost per item)
 + (Quantity*Total cost per item) * (QC charge for finished products %)

4 Insert another new column as the last column of the table. Head this column **Total FOB price contracted** and calculate the formulae.

The company decided to contract out 25% of the quantity from each style to sub-contractors due to bottlenecks in their own factories. In order to forecast the budget for production costing they decided to allocate a fixed sum of £ 2.00 as machine cost/item per style, £3.00 as freight cost / item and 5% as the QC charge for finished products. The company also decided that they could handle the washing themselves. Use the following formula to find the FOB price for the styles that are contracted.

Note: Total FOB price contracted = ((Quantity*25%) * (Washing cost/ Item + 2.00 + 3.00)) + ((Quantity*25%) * Washing cost/ item + 2.00 + 3.00))*5%

5 Insert a main heading in Row 1 with the text **Total production Costs for the 1st Quarter 1999**.

6 Add borders inside and outside of the table using Format then Cells then Borders.

7 Sort the records in order of order number using Data then Sort.

8 Calculate the average as the last row of the table for the headings Washing cost, Machine cost and Freight cost.

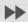

9 Embolden the headings using the Format menu bar.

10 Format the figures in the column 'Total FOB value' as integers (so that they appear without decimals).

11 Insert a header using <u>V</u>iew then Headers and Footers then Custom Header. Place it in the left section using the text **Production Plan 1999**.

12 Copy the entire worksheet to Column AA and Row 20 and proceed with the following changes.

13 Extract the records for the Style FT34003 and produce a 3-D bar chart for the Total FOB value. Use AutoFiltering to do this. (See the top of the next page.)

14 Give the chart the title **Total FOB Price for the year 1999**.

15 Switch off the legend using Chart then Chart Options then Legend.

16 Adjust the worksheet to landscape so that the chart and the table fits onto one page.

17 Print the worksheet out using <u>F</u>ile then <u>P</u>rint. It should look like Figure 4.21.

18 Save the document as **Production.xls**.

The 3-D bar chart (see Step 13)

Create spreadsheets of the following data to monitor changes in the Transport Department.

Details	Drivers	Time keepers	Porters
Salary allowance	$250	$500	$150
EPF	10%	10%	10%

Speed Wheel Transport Pvt (Ltd.)

Employee's name	Category	Basic salary
Fred	Porter	$1000
Nigel	Driver	$2500
Mark Marino	Driver	$2500
Lance Cruz	Time keeper	$4500
Michael	Porter	$1000
Anne	Driver	$5000
Kelly	Time keeper	$6000
Mitchell	Driver	$4500
Kate	Driver	$6500

Gross salary = Basic salary + allowance

Net salary = Gross salary − EPF

1 Add four new columns to the end of the table heading them as **Allowance, Gross salary, EPF** and **Net salary** respectively.

2 Embolden the headings.

3 Using the IF function calculate the allowance in dollars (do not type the value for the formulae; use absolute cell references).

4 Using the SUM function calculate the gross salary.

5 Calculate the EPF using 10% as an absolute cell; generate the values.

6 Calculate the net salary using the above formulae.

7 Format the above columns to the currency symbol $.

8 Add borders to the whole table and to each cell.

9 Extract records for Driver and produce two pie charts, one for gross salary and one for net salary.

10 Save the workbook as **Salary-Net.xls**.

11 Copy the Gross salary pie chart to a new workbook using File then New.

12 Save the new workbook as an Excel template with the name **Gross Salary.xls**.

Databases

Introduction to databases

A database is a collection of information related to a particular subject, entity or event. The data needs to be organised in a particular structure within a database.

On top of the database there is special software called a database management system (DBMS) to maintain and retrieve information from the database.

Order information
in a spreadsheet

Product information
in a filing cabinet

Suppliers' phone
numbers in a
card file

Customer addresses
in a mailing list

Relational databases

A relational database is a collection of tables, or components, where two or more of them are connected through a common field (column).

The main advantage of using a relational database is that it eliminates data redundancy, that is the duplication of data. This means that it helps to prevent the user from storing the same data in two different places.

The relational feature also makes the database more efficient. If one record in a particular table is updated, then all the other records connected to it are also automatically updated. The same procedure can be adapted for deletion of records.

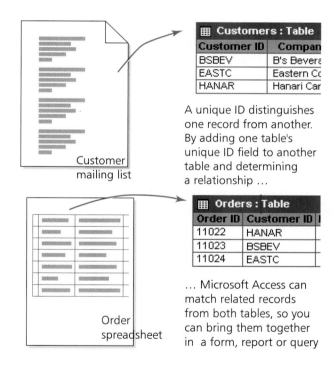

Customer
mailing list

A unique ID distinguishes one record from another. By adding one table's unique ID field to another table and determining a relationship ...

Order
spreadsheet

... Microsoft Access can match related records from both tables, so you can bring them together in a form, report or query

Access databases

Access is a database management system, which provides a means of storing and managing data or information. Microsoft refers to Access as a relational database product, since it allows you to relate data from several different sets of tables.

There are four main components of an Access database to be considered at this introductory level. These are:

149

- tables
- reports
- queries
- screen forms.

Tables

Access stores data in tables that are organised in rows and columns. The basic requirement for a database is that there is at least one table. The columns in the table represent specific details. Each row, which contains a collection of specific details, is known as a record.

Queries

A query is used to retrieve a set of records from the database. This type of query is known as a select query. Access provides other types of queries but this is the one most commonly used.

Reports

Reports are used to print information. The output may be based on all the data from a table or query, or a set of selected records can be output. In addition to data from records, reports may show summary information relating to the data in the records displayed.

Screen forms

Screen forms are used to customise the way in which the data from records in tables or queries is displayed on screen. Their main purpose is to provide a user-friendly interface for the entry of new records or for editing existing records.

Designing a database

Before you use Microsoft Access to actually build the tables, forms and other objects that will make up your database, it is important to take time to design your database. Good database design is the keystone to creating a database that does what you want it to do effectively, accurately and efficiently.

Steps in designing a database

1 Determine the purpose of your database.
2 Determine the tables you need in the database.
3 Determine the fields you need in the tables.

Creating a database using the Database Wizard

1 When Microsoft Access first starts up, a dialogue box is automatically displayed with options to create a new database or open an existing one. If this dialogue box is displayed, click Database Wizard, and then click OK.

If you have already opened a database or closed the dialogue box that displays when Microsoft Access starts up, then click New Database on the toolbar.

2 On the Databases tab double-click the icon for the kind of database you want to create.
3 Specify a name and location for the database.
4 Click Create to start defining your new database.

Creating a database without the Database Wizard

1 Start Microsoft Access by clicking on its icon in the Start menu.
2 In the panel Create a New Database Using choose the Blank Access Database option and then press the OK button.

> **3** In the New Database dialogue box select the drive and directory in which you wish to store your database. If you do not change the directory your database is likely to be stored in the My Documents folder provided by Windows.
> **4** In the File Name box type in the file name.
> **5** Click on Create.

Tables

A table is a collection of data about a specific topic.

For example, a table can contain data about a product: product ID, product name, etc. Features of such a table are shown in Figure 5.1.

Using a separate table for each topic means you store the data only once, which makes your database more efficient and reduces data entry errors. Tables organise data into columns (fields) and rows (records) as shown in Figure 5.2.

Creating a table

In Table Design View, you can add or delete fields, or customise fields by setting properties.

See page 153.

Defining the fields in a table

Adding a new field

Add a field to a table by entering the field name and data type in the upper portion of Design View. Rename a field by changing its name in the Field Name column (see Figure 5.1).

Setting a field's data type

The data type defines what kind of values you can enter into a field. For example, you can't enter text into a currency field. By choosing an appropriate data type, you can ensure that data is entered in the correct form for sorting, performing calculations and other operations.

To set or change a field's data type

1 Click in the Data Type column.
2 Click the downward pointing arrow.
3 Select the data type from the list.

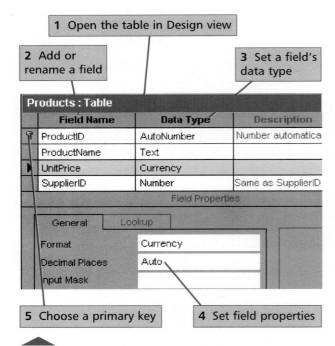

Figure 5.1 *Some of elements in a table*

Figure 5.2 *How tables are organised*

To create a table in Design View
1 Go to the Database window.
2 Click the Tables tab.

3 Click on the New button.

4 Select Design View and click on OK to display the table design.

Table 5.1 shows you the data types available in Access.

Table 5.1 *Data types available in Access*

Data type	Description
Text	Text and numbers. By default Access will make a text field 50 alphanumeric characters long (you can enter up to 50 letters and numbers). If you know the length of the longest piece of data to be entered you can specify this as anything from 1 to 255 characters. Examples of text type fields: names and addresses.
Number	Numerical data on which you intend to perform mathematical calculations, except calculations involving money. You will see later that there are different number data types that you can choose, which define the size of number you wish to store and whether the data consists of whole numbers only or decimal fractions. Examples of numeric fields: student marks, number of items in stock.
AutoNumber	Sequential 'whole numbers' are automatically inserted in Access so you don't need to enter the data in the field. This data type is used primarily to give uniqueness to each record, for example a membership number or a product identification number.
Date/Time	Dates and times. A variety of display formats are available or you can create your own. Example: date of joining
Currency	This means money. Don't use the number data type for currency values, because numbers to the right of the decimal may be rounded during calculation. The currency data type maintains a fixed number of digits to the right of the decimal. Example: membership fee.
Yes/No	Yes/No, True/False, On/Off. With this data type there are only two possibilities. Example: smoker/non-smoker.
Memo	Lengthy text and numbers. A memo field can contain up to 32,000 characters. Example: description of a hotel in a travel company's database.

Defining field properties

Field properties are a set of characteristics that provide additional control over how a field works. For example, setting the format property to Currency for a field with a number or currency data type automatically adds commas, a dollar sign and two decimal places (e.g. $1,234.50).

To set a field property:

1 In the table's Design View select the field whose properties you want to set.
2 Click the property you want to set in the bottom part of the window.
3 Set the properties as explained in Table 5.2.

Table 5.2 *Description of field properties*

Property	Description
Field size	Maximum length of the text field or type of number
Format	How data is displayed; use predefined formats or customise your own
Input mask	Data entry pattern
Caption	Default field label in a form or report
Default value	Values entered in the field when records are created
Validation rule	An expression that defines data entry rules
Validation text	Text for invalid data
Required	Whether or not an entry must be made
Allow zero length	Allows you to store a zero length string ("") to indicate data that exists but is unknown
Indexed	Single-field index to speed searches

Primary key

You use a unique tag called a primary key to identify each record in your table. Just as a licence plate number identifies a car, the primary key uniquely identifies a record.

A table's primary key is used to refer to a table's records in other tables. For example, a student number from the student table is used to refer to student information so that it can be viewed or printed with information from the class and class details tables.

To set the primary key:

1 Click the field you want to use as the primary key.
2 Click Primary Key on the toolbar.

Index

An index lists the terms and topics discussed in a printed document, along with the pages they appear on. You can create an index entry for:

- an individual word, phrase or symbol
- a topic that spans a range of pages.

Working with data in the table

Figure 5.3 shows some of the processes you are likely to want when handling tables of data, and where to look for the required commands.

Switching views

You can change to other views of a table using the Switch Views button on the toolbar. The button is available in both table views:

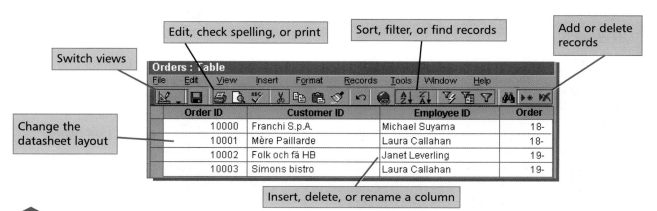

Figure 5.3 *Working with data in a table*

Edit, check spelling or print

- Click the Cut, Copy or Paste buttons on the toolbar to edit selected text, fields, whole records, or the entire datasheet.
- Click the spelling button on the toolbar to check for spelling errors in the selected text or memo fields.
- Click the print button on the toolbar to print your datasheet or click the print preview button to see how the datasheet will look when printed.

Sort, filter or find records

- You can sort the rows of your datasheet by the data in one or more adjacent columns.
- To sort into descending or ascending order, numerically or alphabetically:
 Click the field you want to sort by, and then click the Sort Ascending or Sort Descending button on the toolbar. Microsoft Access sorts from left to right.

- You can limit the records you see in your datasheet by filtering in these ways:

Filter by selection
1 Click on the data you want to filter.
2 Click the Filter by Selection button on the toolbar.

Filter by Form
1 Click the Filter by Form button on the toolbar.
2 Choose which data to display from a list of the values in one or more fields.
3 Click on the Apply Filter button

Advanced filter
For the most control when filtering or sorting, point to Filter on the Records menu, and then click Advanced Filter/Sort. To apply an advanced filter or to filter by form, click the Apply Filter button on the toolbar.

Removing a filter
To remove filtering that you have applied, click on the Apply Filter button again.

You can find, or find and replace values in these ways:

- Click the Find button on the toolbar to find a value in a field in every record in which it occurs.
- Click Replace on the Edit menu to replace a value that you find.

Adding or deleting records

- **To add a record:**
 Click New Record on the toolbar. This button displays a blank row for you to fill in at the end of the table.
- **To delete a record:**
 Click any field in the record.
 Click the Delete Record button on the toolbar.

Changing the datasheet layout

- **To move a column:**
 1 Click the column heading.
 2 Click and hold down the mouse button on the selected column heading and drag the column to the desired location.
- **To hide a column:**
 1 Click it.
 2 Click Hide Columns on the Format menu.
- **To freeze the leftmost column so that it continues to display as you scroll to the right:**
 1 Click the column.
 2 Click Freeze Columns on the Format menu.

Inserting, deleting or renaming a column

When you add or delete a column, you are adding or deleting a field in the table.

- **To insert a new column to the left of the current column:**
 Click Column on the Insert menu.
- **To name a new column:**
 Double-click the column heading and then type the desired name.
- **To delete a column:**
 Click the column heading to select it.
 Click Delete Column on the Edit menu.
- **To rename a column:**
 Double-click its column heading and then type a new name.

Saving a table

After you have finished defining the fields:

- Click the Save button on the toolbar.
- Choose <u>S</u>ave from the File menu to save the table that you have designed,

or

- Click on the Close button at the top right corner to save the design table.

Queries

You use queries to view, change and analyse data in different ways. You can also use them as the source of records for forms and reports.

Select queries

A select query is the most common type of query. It retrieves data from one or more tables and displays the results in a datasheet (see Figure 5.4) where you can update the records (with some restrictions). You can also use a select query to group records and calculate sums, counts, averages and other types of totals.

Creating a query

1 In the Database window, click the Queries tab, and then click New.
2 In the New Query dialogue box, click Design View.

3 Click OK.
4 Click the name of the table or query you want to base your query on, and then select the fields from which you want to retrieve data.
5 Click an additional table or query if desired, and then select the fields you want to use from it. Repeat this step until you have all the fields you need.

Sorting a table

A sequencing principle is used to order data, alphabetically or numerically. The sort order can be either ascending or descending.

When you specify a sort order in Design view or Datasheet view, you can perform simple sorts; this means you can sort all records in ascending or descending order (not both). When you specify a sort order in Query Design view or in the Advanced Filter/Sort window, you can perform complex sorts. This means you can sort records in ascending order by some fields and in descending order by others.

Filters vs select query

The basic similarity between select queries and filters is that they both retrieve a subset of records from an underlying table or query. How you want to use the records that are returned determines whether you use a filter or a query.

Figure 5.4 *Query screen and datasheet for a select query*

As a guide:

- **Use a filter** to temporarily view or edit a subset of records while you are in a form or datasheet.
- **Use a query** if you want to do any or all of the following:
 - view the subset of records without first opening a specific table or form
 - choose the tables containing the records you want to work with and add more tables at a later date if necessary
 - control which fields, from the subset of records, displayed in the results
 - perform calculations on values in fields.

Multiple criteria in a query

You can use more than one criterion to retrieve a set of records from a table. Examples of the OR and AND operators in use are shown below in Figures 5.5, 5.6 and 5.7.

OR operator

Field:	CompanyName	Region	City
Table:	Customers	Customers	Customers
Sort:	Ascending		
Show:	☑	☑	☑
Criteria		"SP"	
or:		"RJ"	

Region is SP **or** RJ

Query1 : Select Query

Company Name	Region	City
Comércio Mineiro	SP	São Paulo
Familia Arquibaldo	SP	São Paulo
Gourmet Lanchonetes	SP	Campinas
Hanari Carnes	RJ	Rio de Janeiro
Que Delícia	RJ	Rio de Janeiro

Figure 5.5 *Use of the OR operator in a query*

AND operator

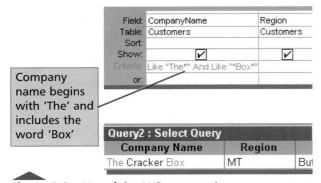

Field:	CompanyName	Region
Table:	Customers	Customers
Sort:		
Show:	☑	☑
Criteria	Like "The*" And Like "*Box*"	
or:		

Company name begins with 'The' and includes the word 'Box'

Query2 : Select Query

Company Name	Region	
The Cracker Box	MT	But

Figure 5.6 *Use of the AND operator in a query*

Combining the AND and OR operators

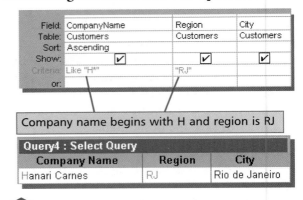

Field:	CompanyName	Region	City
Table:	Customers	Customers	Customers
Sort:	Ascending		
Show:	☑	☑	☑
Criteria	Like "H*"	"RJ"	
or:			

Company name begins with H and region is RJ

Query4 : Select Query

Company Name	Region	City
Hanari Carnes	RJ	Rio de Janeiro

Figure 5.7 *Use of the AND and OR operators together*

Forms

A screen form can be used to customise the way in which records from tables and queries are presented on screen. They provide a user-friendly interface for the addition of new records or the editing of existing ones. The form can be designed to suit your own requirements.

Uses of forms

You can use forms for a variety of purposes as shown in Figure 5.8.

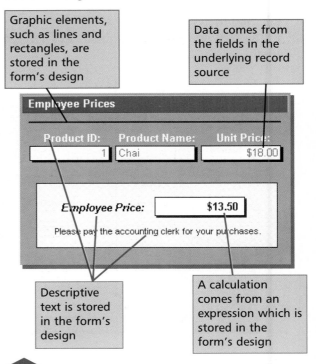

Graphic elements, such as lines and rectangles, are stored in the form's design

Data comes from the fields in the underlying record source

Descriptive text is stored in the form's design

A calculation comes from an expression which is stored in the form's design

Figure 5.8 *The components of a database form*

Most of the information in a form comes from an underlying record source. Other information in the form is stored in the form's design.

You create the link between a form and its record source by using graphical objects called controls. The most common type of control used to display and enter data is a text box.

Creating a form

To create a new form

1 Click the Forms tab in the database window.
2 Click New.
3 In the New Form dialogue box click Design View.
4 Click the name of the table, or query, that includes the data you want to base your form on.
 (**Note:** If you want to create a form that uses data from more than one table, base your form on a query that includes the tables you want to add.)
5 Click OK.

Customising a form

Figure 5.9 shows some of the ways in which a form can be customised.

Adding a field to a form

You can add other fields from the form's record source.

 Click the Field List button on the toolbar (or click Field List from View menu) to display a list of all the fields in the record source.

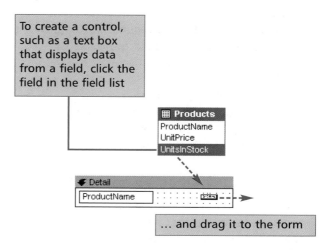

Adding a control to a form

Everything you add to a form is a control. Text boxes, labels, list boxes, option buttons, command buttons and lines are examples of different controls. The way you create a control depends on whether you want to create a bound control, an unbound control or a calculated control.

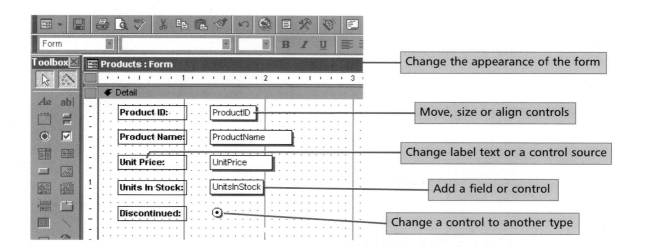

Figure 5.9 *Some of the ways in which a form can be customised*

Bound control

A bound control on a form is one that gets its contents from a field in the underlying tables or query.

A bound control's property is set to a field name in the table or query. A text box that displays an employee's last name, for example, is bound to the LastName field in a table of employees' details.

Unbound control

An unbound control is one that is not connected to a field. You can use unbound controls to display informational text, such as instructions about using a form, or graphics and pictures from other applications. Lines and rectangles are unbound controls. You can also use unbound controls to accept user input, and then perform an action based on that input.

Calculated fields

A calculated field is a field defined in a query that displays the result of an expression, rather than stored data.

To input a calculated field

1 Open a form or a report in Design view.
2 Click the tool in the toolbox for the type of control you want to use; in this case a calculated control.
 (**Note:** A text box is the most common type of control to use to display a calculated value, but you can use any control that has a control source property.)
3 Click on the form or report where you want to place the control.
4 If the control is a text box, you can type the expression directly into the control.

Label

Use this procedure to create a stand-alone label (a label that isn't attached to another control). To create a label that's attached to a control, just create the control and Microsoft Access automatically attaches a label to the control when you create it.

For a stand-alone label:

1 Open a form in Design view.
2 Click the Label tool in the toolbox.
3 On the form click where you want to place the label.
4 Type the text for the label.

Check box

To create a check box, toggle or option button that's bound to a Yes/No field:

1 Open a form or a report in Design view.
2 Click the appropriate tool in the toolbox. If you're not sure which tool to use, place the pointer over the tool until the ToolTip appears.
3 Click the Field List button on the toolbar to display the field list.
4 Click the appropriate field (a field with a Yes/No data type) in the field list and drag it to the form or report.

Combo box

This control is like a list box and a text box combined. In a combo box, you can type a value or click the arrow so that you can click an item in the list that drops down.

1 Open a form in Design view.

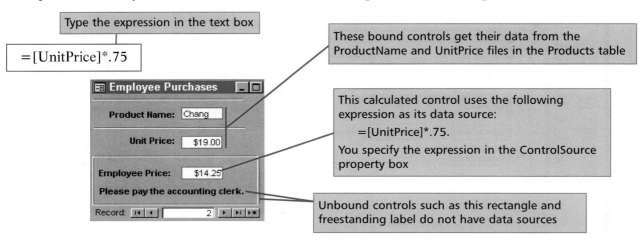

Type the expression in the text box

=[UnitPrice]*.75

Employee Purchases

Product Name: Chang

Unit Price: $19.00

Employee Price: $14.25

Please pay the accounting clerk.

Record: 2

These bound controls get their data from the ProductName and UnitPrice files in the Products table

This calculated control uses the following expression as its data source:
 =[UnitPrice]*.75.
You specify the expression in the ControlSource property box

Unbound controls such as this rectangle and freestanding label do not have data sources

2 Click the Control Wizards tool in the toolbox if it's not already pressed in.

3 In the toolbox, click the Command Button tool.

4 On the form, click where you want to place the command button.

5 Follow the directions in the Wizard dialogue boxes. In the last dialogue box, click Finish to display the command button in Design view.

Insert a picture from another file
To insert the picture

1 Click where you want to insert the picture.

2 On the Insert menu, point to Picture, and then click From File.

3 Select the picture you want to insert by double-clicking it.

Customising an AutoFormat for a form or report

1 Open an existing form or report in Design view.

2 On the Format menu, click AutoFormat.

3 In the AutoFormat dialogue box, click an AutoFormat in the list.

4 Click the options button, and then make sure the attributes you want to modify are selected.

5 Click the customise button, and then click a customisation option. You can do one of the following:

- create a new AutoFormat based on the open form or report
- update the selected AutoFormat based on the open form or report
- delete the selected AutoFormat from the list.

6 Click OK twice to close the dialogue boxes.

Moving, sizing and aligning controls

You can move, size or align controls that are selected.

1 To select a control (a text box, for example) click it. To select several controls, hold down the Shift key as you click each control.

ProductID ———————Selected control

2 Once you select a control, you can drag the pointer to:

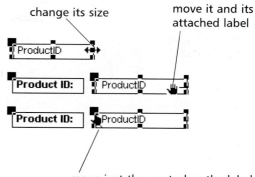
change its size
move it and its attached label
ProductID
Product ID: ProductID
Product ID: ProductID
move just the control or the label

3 To align controls, select the controls you want to align, then point to Align on the Format menu and click Left, Right, Top, Bottom or To Grid as required.

Reports

A report is an effective way to present your data in a printed format. Because you have control over the size and appearance of everything on a report, you can display the information the way you want to see it.

Most of the information in a report comes from an underlying table or query, which is the source of the report's data. Other information for the report is stored in the report's own design.

See Figure 5.10 on the next page, which shows some of the features of a typical report.

Creating a report using design view

In the database window:

1 Click the Reports tab.

2 Click New.

3 In the New Report dialogue box click Design View.

4 Click the name of the table or query that contains the data you want to base your report on (if you want an unbound report, don't select anything from this list).

5 If you want to create a report that uses data from more than one table, base your report on a query.

6 Click OK.

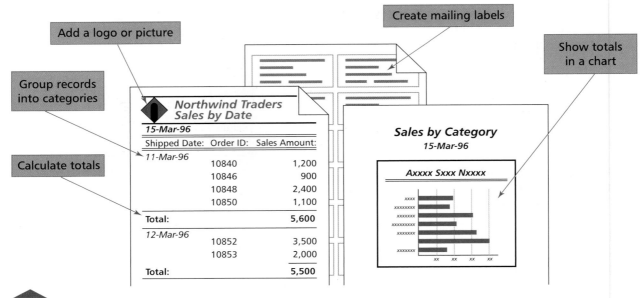

Figure 5.10 *A report, and some of the things it can contain*

The screen that you use to create a report using Design view looks like this:

Sections of a report

The information in a report can be divided into sections (see Figure 5.11). Each section has a specific purpose, and prints in a predictable order on the page and in the report.

In Design view, sections are represented as bands (see Figure 5.12), and each section that the report contains is represented once. In the printed report, some sections may be repeated many times. You determine where information appears in every section by using controls, such as labels and text boxes.

Figure 5.11 *The sections within a printed report*

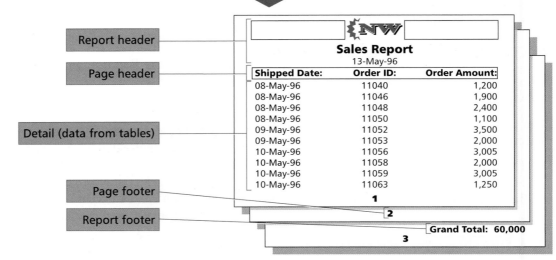

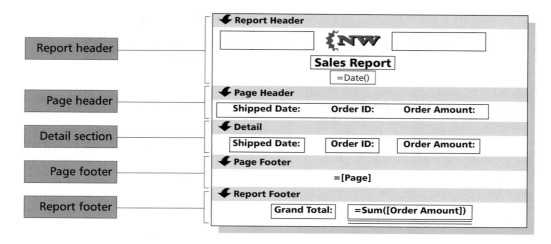

Figure 5.12 *The sections as they appear in Design view, on screen*

Report header

The report header appears once at the beginning of a report. You can use it for items such as a logo, the report title or the print date. The report header is printed before the page header on the first page of the report.

Page header

The page header appears at the top of every page in the report. You use it to display items such as column headings.

Detail section

The detail section contains the main body of a report's data. This section is repeated for each record in the report's underlying record source.

Page footer

The page footer appears at the bottom of every page in the report. You use it to display items such as page numbers.

Report footer

The report footer appears once, at the end of the whole report. You use it to display items such as report totals. The report footer is the last section in the report design but appears before the page footer on the last page of the printed report.

Grouping

By grouping records that share a common value, you can calculate subtotals and make a report easier to read. In the report shown in Figure 5.13, orders shipped on the same date are grouped together.

Figure 5.13 *Grouping of records in a printed record*

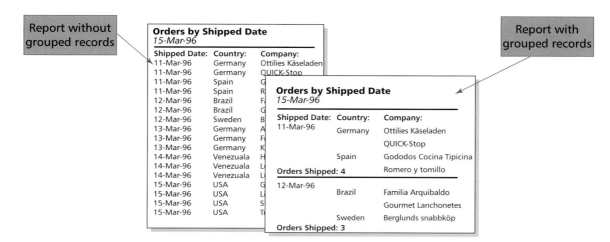

Grouping records in a report

You can group on up to ten fields or expressions in a report.

1 Open the report in Design view.
2 Click the Sorting and Grouping button on the toolbar to display the Sorting And Grouping box.
3 Set the sort order for the data in the report.
4 Click the field or expression whose group properties you want to set.
5 Set the group properties in the following list (you must set either Group Header or Group Footer to Yes in order to create a group level and set the other grouping properties):

- **Group Header**
 adds or removes a group header for the field or expression.

- **Group Footer**
 adds or removes a group footer for the field or expression.

- **Group On**
 specifies how you want the values grouped. The options you see depend on the data type of the field on which you're grouping; if you group on an expression, you see all the options for all data types.

- **Group Interval**
 specifies any interval that is valid for the values in the field or expression you're grouping on.

- **Keep Together**
 specifies whether Microsoft Access prints all or only part of a group on the same page.

This task is to create a new database table/file to be used by an institution. You will create the table and enter some data. Part of the file creation is the appropriate design of the fields, including the type and size of the fields.

1 Create a database called **Class Information**.

2 Create a new table in Design view.

3 Define the structure of the basic table with reference to the following information and define Class Number as the primary key:

Field name	Data type
Class Number	AutoNumber
Class Day	Text
Class Time	Date/Time
Class Tutor	Text
Class Activity	Text
Type	Text

4 Set the field properties as indicated below:

Field name	Property	Setting
Class Day	Field size	Select an appropriate length (e.g. Monday).
Class Time	Format	Select an appropriate date format (e.g. 12:30).
	Required	Yes
Class Tutor	Field size	Select an appropriate length (e.g. Mr. Brown).
	Required	Yes
Class Activity	Field size	Select an appropriate length (e.g. Microsoft Word).
	Required	Yes
Type	Field size	Select an appropriate length (e.g. Male, Female or Mixed)
	Validation rule	Select an appropriate validation rule.
	Validation text	Select an appropriate user-friendly error message.

5 Save the table as **Class**; enter two records randomly and close the Class Information database.

TUTORIAL 5.1

Task 1

This task is to create a new database table/file to be used by Chelmer Estate. You will create the table and enter some data into this. Part of the file creation is the appropriate design of the fields, including the type and size of the fields.

1 Create a new database called **Chelmer Estate**.

2 Create a new table in the Chelmer Estate database, called **Properties**, which should include the following fields:

Field name	Data type
Property Number	AutoNumber
Address	Text
Town	Text
House type	Number (1or 2)
Number of bedrooms	Number
Garage	Number (1 or 2)
Garden length	Number
Leasehold/freehold	Yes/No
Selling price	Currency
Heating	Number (1 or 2)
Date of entry	Date/time
Notes	Memo

3 Save the table definition as **Properties**.

Task 2

1 Open the Properties table.

2 Set the field length to the text fields thus:
 Address: 30
 Town: 25

3 Select the Town field and enter the default value as **Chelmer**.

4 Index the Town field.

5 Create validation rules for the House type (2), Garage (2) and Heating (2) fields, which prevent numbers higher than the valid number for their respective categories being entered. Also create corresponding validation messages in the validation text property.

6 Select the Leasehold/freehold fields and set the format to 'Leasehold'/'Freehold' instead of Yes/No.

7 Save the table definition again and close the Chelmer Estate database.

This task is to create a new database table/file to be used by the Silver Line Company. You will create the table and enter some data into this. Part of the file creation is the appropriate design of the fields, including the type and size of fields.

1 Create a database called **Employee Information**.

2 Create a new table in Design view and save the table as **Employee**. Choose the appropriate data type and field size for each field.

Field name

Employee Number
First Name
Last Name
Birth Date
Address
Home Phone
Department Name
Salary

3 Set the field properties as indicated below
 a Employee Number should start with an alphabetic character and others should be only numeric characters (using input mask, i.e. L999).
 b Make the field Birth Date a short date, using the short date setting in the Regional Settings Properties Dialogue box, in the Windows control panel.
 c For the Home Phone field you should use your own format to implement because the numbers are different from city to city and connection to connection.

The following table shows some useful input masks and the type of values you can enter in them.

Input mask	Sample values
(000) 000-000	(206) 555-024
(999) 999-999	(206) 555-024, () 555-024
(000) AAA-AAA	(206) 555-TEL

4 Change the Department Name field to a combo box.

5 Format the Salary field to Euro currency and two decimal places.

6 Insert a new field called Division, top of department name field.

7 Enter two records to the table.

8 Create a simple customised data entry form and save it as **Employee Form**.

9 Add a header to the form with the words **Employee Data Entry Form**.

10 Enter one more record using the form for data entry.

TUTORIAL 5.4

1 Create a table called **Result** and enter the data given below.

2 The table below provides the ID number, name, sex, division and the corresponding scores of the participants in a quiz competition. You decide on the field length for each column based on the given data.

3 Select the Division field as a combo box.

ID number	Name	Sex	Division	Score
A001	Peter	M	Accounts	86.0
A005	Mario	M	Accounts	87.0
A009	Rebecca	F	Production	78.0
A014	Joel	F	Computer	90.0
A002	Guy de Martin	M	Computer	70.0
A006	Jill	F	Production	86.0
A010	Charles	M	Computer	76.0
A011	Joseph	M	Accounts	67.0
A015	Sue	F	Accounts	80.0
A003	Martin	M	Accounts	79.0
A007	Richad	M	Computer	78.0
A012	Solomon	M	Accounts	85.0
A016	Jane	F	Computer	97.0
A017	Rambo	M	Accounts	89.0
A018	Russell	M	Production	73.0
A004	Felina	F	Computer	82.0
A008	Irene	F	Production	81.0
A013	John	M	Production	83.0

4 Sort the table with records stored in ascending sequence of ID numbers. Save this query as **SORT**.

5 List all records where score is higher than 80. Save this query as **G80**.

6 List all records where score is lower than 85 and display only the Score field. Save this query as **L85**.

7 List all records where score is in the range 80.0 to 90.0. Save this query as **BETWEEN**.

8 List the names and scores of all the female participants whose scores are in the range 80.0 to 90.0. Save the query as **F80_90**.

9 List the names and scores of all the male participants in the Accounts division whose scores are in the range 80.0 to 90.0. Save this query as **A80_90**.

10 List all the names starting with the letter R using the LIKE operator, and remove the fields Sex and Division from this query. Save this query as **RQRY**.

11 The name Richard is spelt incorrectly, Find the name **Richad** and change it.

12 Create a simple form to enter data; give an appropriate name for the heading.

13 Save the form as **Result Form**.

14 Enter one more record, using the form which you have designed.

15 Create a simple report showing all the information sorted by Name field and save the report as **Score Report**.

1 Create a table called **Membership** (see below) in the member database. Use the appropriate data type and field size.

Field name	Data type	Size / format
Member number	Number	Long
Title	Text	4
First name	Text	15
Last name	Text	15
Town	Text	15
Date of birth	Date/time	Short
Membership fees	Currency	Rs

2 Enter the data given below:

Membership number	Title	First name	Last name	Town	Date of birth	Membership fees
1	Mr	Andrew	Walker	Chelmer	12/3/53	Rs1500.00
2	Mrs	Denise	Cartwrite	Meriton	11/29/60	Rs1000.00
3	Mr	Jason	Perry	Chelmer	3/6/82	Rs2000.00
4	Miss	Ann	Forsythe	Chelmer	5/8/77	Rs750.00
5	Mrs	Donna	Jameson	Branford	4/12/77	Rs1000.00
6	Miss	Petra	Robinson	Branford	7/7/84	Rs1750.00
7	Mr	Davies	Ali	Chelmer	12/12/56	Rs2000.00
8	Mr	David	Harris	Meriton	4/9/83	Rs1200.00

3 Extract the queries given below and save under the name given.
- Sort the table according to the first name. Save the query as **SORT**.
- Extract all male members. Save your query as **MR**.
- Extract all members who live in Chelmer. Save the query as **CHELMER**.
- Extract every member whose first name begins with the letter D. Save the query as **D_QRY**.
- Extract all members whose date of birth is after 01/01/80. Save this as **DATE**.
- Extract all members who pay a membership fee of more than, or equals to, Rs1500. Save the query as **Rs1500**.
- Extract the members who live in Chelmer and pay a membership fee more than Rs1500. Save this query as **C1500**.
- Extract every member who lives in Meriton and whose first name begins with the letter D. Save this query as **MD_QRY**.
- Extract the members who are born in the 1970s and save the query as **1970s**.

4 Create a simple form for members. Use your own format and heading and save it as **Membership Form**.

5 Insert a new field called **Telephone Number** in the membership table and fill the table with the appropriate numbers.

6 Save the database.

7 Close the table and the application.

TUTORIAL 5.5

1 Create a database called **Invoice**.

2 Create a suitable table for the data given below and name the table **Invoice Table**.

3 Make the Amount column currency and format it to two decimal places.

Date	Invoice number	Customer name	Amount
04-Jan-93	14001	Adams Audio	1512
04-Jan-93	14002	Hudson Music	2760
11-Jan-93	14003	Babson Sound	1582
11-Jan-93	14004	Hudson Music	2089
11-Jan-93	14005	Adams Audio	2356
25-Jan-93	14006	Adams Audio	1022
25-Jan-93	14007	Wilson Stereo	679
01-Feb-93	14008	Babson Sound	3903
01-Feb-93	14009	Hudson Music	2035
08-Feb-93	14010	Babson Sound	3903
08-Feb-93	14011	Hudson Music	1044
28-Feb-93	14012	Adams Audio	2162
01-Mar-93	14013	Adams Audio	1976
08-Mar-93	14014	Wilson Stereo	2598

4 Extract the following queries and save them under the names specified below.
- Extract invoices for which the amount is more than 2000. Save this query as **Amount**.
- Extract the invoices which were made on the 11th of January 1993 for which the amount is more than 2000. Save this query as **D2000**.
- Extract all the purchases made by the customer Adams Audio in the month of January. Save this query as **ADAMS**.
- Sort the Customer field. Save this query as **Sort**.
- Extract customers Adams Audio and Wilson Stereo where amounts are more than 2000. Save this query as **AW2000**.
- Extract all invoice numbers ranging from 14001 to 14009 and sort the invoice numbers into ascending order. Save this query as **S14001**.

5 Create a report to display all the information and sort the report according to customer name. Save the report as **Customer Report**.

Presentation

Introduction

PowerPoint is a presentation graphics package from Microsoft. PowerPoint provides you with all the tools you need to put together attractive and persuasive presentations suitable for sales pitches or conferences. It has all the tools, like Wizards, templates and AutoLayouts, which can help to create presentations quickly and easily.

The display of information is a very important aspect of any presentation. Most speakers use slides for displaying information. In addition to slides you may also require handouts and a set of notes that outline your presentation. Such notes and handouts can be made using the slides you created for the presentation.

Whatever material you prepare, to make the presentation effective you need to:

- know your audience
- keep the content simple
- start with the familiar visuals
- make each slide independent
- use space effectively
- use text and colour effectively.

Creating presentations

Switch on the computer. From the Start button, select Programs and click on the Microsoft PowerPoint icon. You should now see the Start-up dialogue box shown at the top of the next column, or shortcut icon.

You can select any of the following options:

- the AutoContent Wizard
- template
- a blank presentation.

After selecting click the OK button.

The Start-up dialogue box

Wizards

Wizards are like presentation experts. They prompt the user with questions, and based on the user's response, they create the presentation the user wants.

Using the AutoContent Wizard

1 When you select AutoContent Wizard it will show you a dialogue box explaining what the Wizard will do. Click the Next button.
2 In the proceeding boxes the Wizard will show you the various types of pre-designed presentations you can find in PowerPoint.
3 In each box select the option that you require and click the Next button.
4 When you come to the final dialogue box click Finish to have the Wizard create the presentation.

Using a template

When you select Template it will display the dialogue box shown in Figure 6.1, entitled New Presentation.

You have three choices:

- Select Blank Presentation on the General tab.
- Start a new presentation based on an existing PowerPoint design (colour scheme) on the Design tab.

- Start a new presentation, based on an existing PowerPoint theme (including an existing design and slide layout), on the Presentations tab. Use the Preview box to select the presentation you want.

If you select one of the first two options, PowerPoint will show the New Slide dialogue box shown in Figure 6.2. Select the AutoLayout you want and click OK.

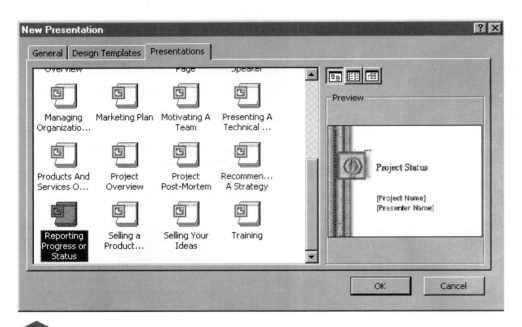

Figure 6.1 The New Presentation screen

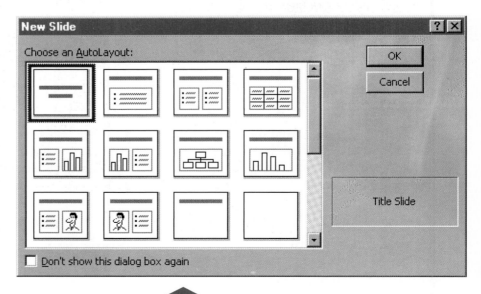

Figure 6.2 The New Slide dialogue box

Creating a blank presentation

If you select Blank Presentation in the Start-up dialogue box PowerPoint will display the New Slide dialogue box shown. Select the AutoLayout and start creating the presentation.

AutoLayout

Figure 6.3 shows an AutoLayout of a presentation slide. The boxes inside are called placeholders. To enter text, pictures, charts, etc. within them, click inside the boxes to activate them.

PowerPoint views

PowerPoint offers you five viewing options to view your slide. They are:

- slide view
- outline view
- slide sorter view
- notes pages view
- slide show.

You can switch between them by using view buttons at the left of the horizontal scroll bar or the View menu on the menu bar.

Text boxes

Using text boxes you can add text to any place on your slide, without the need for an existing placeholder.

To add text boxes

1 Click the Text Box button on the drawing toolbar. The mouse pointer will turn into a cross-hair.
2 Click where you want the paragraph to start the drag and draw a box of the size you want.
3 Enter your text inside the box then click outside it when you are finished.

Promoting and demoting paragraphs

Using these buttons you can promote and demote paragraphs, thus creating an effective hierarchy in your slides.
In a placeholder you can have five levels of text.

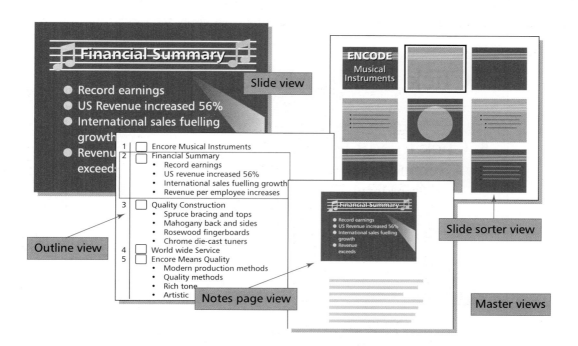

Figure 6.3 *Use of placeholders in an AutoLayout*

Selecting text

To select text in a PowerPoint slide, you can do the following

- Click and drag to select text.
- Double-click on a word to select the text.
- Triple-click in a paragraph to select it.
- Hold down Shift and use the cursor keys (←, →, ↑, ↓, Page Up, Page Down, End, Home, Ctrl + End, Ctrl + Home).
- Click at the start of a block, hold down Shift, and click at the end of the block. Press Esc or click elsewhere on a slide to deselect the text.

Formatting text

You can format text in PowerPoint using a variety of fonts, font sizes, emphasis (bold, italic, underline, shadow, colour, bullets and line spacing). You can apply formatting to selected text using the buttons on the Formatting toolbar.

Developing your presentation

Changing the layout of a slide

When you are developing your presentation you may want to change the layout of a slide or slides. To change the layout of the current slide in Slide View or Slide Sorter View, click the Slide Layout button on the Common Task toolbar and choose the layout you want, then click Apply.

PowerPoint will add all the elements on the current layout to the new one. The layout may look untidy, with elements overlapping each other. Drag them to suitable positions or resize them.

Slide Master

If you want to modify more than half of the slides in your presentation you can modify the Slide Master. This defines the default format for title and text objects for all the slides in the presentation.

To modify the Slide Master

1 Select View Master Slide Master.
2 Apply the formatting you want by clicking inside the appropriate area.

Note: Text you see inside Slide Master is not for editing. Just apply the formatting you want.

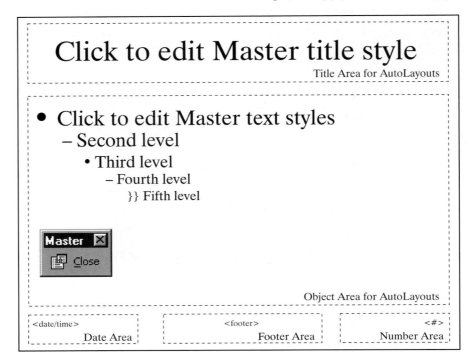

Changing the design of the template

1 Click the Apply Design button on the Common Tasks toolbar or select Format then Apply Design.
2 Choose the design template.
3 Click Apply.

Outlining your presentation

The first thing to do when creating a presentation is to decide what you are going to include.

In a complex presentation you can use outlining to build and arrange your presentation in the most effective order. Outline view displays only the text in slides, without graphs, charts, etc.

Switch to outlining view by clicking the Outlining View button on the horizontal scroll bar or by selecting View then Outline. Figure 6.4 shows what the screen looks like.

Rearranging your slides

If you want to change the order of appearance of your slides you can use the Slide Sorter view.

To select, click the Slide Sorter button shown below, which is on the horizontal scroll bar, or select View then Slide Sorter.

You should now see a screen something like Figure 6.5 on the next page.

To rearrange slides, click on the slide you want to move and drag it to the left of the slide before which you want it to appear.

Creating notes pages

PowerPoint allows you to add speaker's notes to your presentation, to enlarge upon your idea. This may help you to deliver the information in your slide more effectively.

Click the Note Pages button or select View then Note Pages.

1 In Note Pages view you will see the current slide at the top of a page with space underneath.
2 Enter your speaker's notes in that space.
3 Use the Previous Slide and Next Slide buttons to move between slides.

Figure 6.4 *Outline view*

Figure 6.5 *Slide Sorter view*

Notes Master

This is similar to Slide Master. You can change the format of your note pages by using Notes Master. To choose it, select View, Master then Notes Master.

Previewing the slide show

To preview the slide show click the Slide button. It will show your slides one by one taking the full screen. Press N for the next slide, P for the previous slide.

Drawings

The Drawing toolbar offers you many ways of making your document attractive by including illustrations and diagrams. Some examples are shown in Figure 6.6.

To insert any drawing into your document
1 Click on the drawing tool from the Drawing toolbar.
2 Now move the mouse pointer into the document (the pointer will be cross-shaped).

3 Click and drag with the mouse to insert the drawing.

After inserting the drawing you can change its size and position easily by:
1 clicking once on the drawing (the handles will appear)
2 dragging on any one of the handles.

Using the Drawing toolbar

The Drawing toolbar has tools you can use to draw, manipulate and format all kinds of drawing objects. To display this toolbar, click the Drawing button on the standard toolbar.

When you click a button on the toolbar that includes a triangular arrow, a menu appears. You can move some of these menus closer to your drawing objects for easier access. If the menu that appears has a solid bar along the top edge, drag the bar to move the menu.

Creating shapes

You can automatically create a variety of shapes by using the AutoShapes tools on the Drawing toolbar.

Figure 6.6 *A few ways of livening up your slide with drawings*

The AutoShapes menu contains several categories of shapes. In addition to lines there are basic shapes, block arrows, flowchart elements, stars and banners, and callouts.

To draw an AutoShape, click the AutoShapes button, point to a category and then click the shape you want. Click the document to add the shape at its default size, or drag it to the size you want. You can change one AutoShape to another. Select the AutoShape you want to change, click Draw on the Drawing toolbar, point to Change AutoShape then select the new shape. All AutoShapes have sizing handles, and many have one or more adjustment handles. You can drag the handles to change the size or shape of an AutoShape.

Add text to objects

You can add text to any drawing object (except straight lines, freeforms and connectors) by simply clicking the object and then typing your text. The text attaches to, and moves with, the object.

If you don't want to attach the text to a drawing object, use the text box tool on the Drawing toolbar.

Add lines, curves and freeforms

You can use the lines tools on the AutoShapes menu to draw straight or curved lines, freeform lines and single or double arrows. To draw a line or freeform, click AutoShapes on the Drawing toolbar, point to Lines, click the tool you want and then drag. If you just want to draw a straight line, click Line on the Drawing toolbar.

You can use the formatting tools on the Drawing toolbar to modify lines, curves and freeforms. For example, you can colour lines, change their thickness, add arrowheads or make them dotted or dashed.

Freeform and curves

The AutoShapes menu on the Drawing toolbar includes several categories of tools. In the Lines category, you can use the curve, scribble and freeform tools to draw lines and curves, as well as shapes that combine both lines and curves (see Figure 6.6). When you want an object to look as if it were drawn with a pen, use the scribble tool. The resulting shape closely matches what you draw on the screen. Use the freeform tool when you want a more refined shape – one without jagged lines or drastic changes in direction.

When you want to draw curves with greater control and accuracy, use the curve tool. To change the basic shape of a curve or freeform by moving, deleting and adding vertices, click Edit Points on the Draw menu (Drawing toolbar).

You can enhance freeforms and curves just as you can AutoShapes. For example, you can add colour or a pattern, change the line style, flip or rotate them and add a shadow or 3-D effect – but you can't convert a freeform or curve to an AutoShape.

Curve Freeform Scribble

Figure 6.6 *Types of line that can be used*

Adding special text effects

1 On the Drawing toolbar, click the WordArt button.
2 Click the special effect you want, and then click OK.
3 In the Edit WordArt Text dialogue box, type the text you want to format, select any other options you want, and then click OK.
4 To add or change effects to the text, use the buttons on the WordArt and Drawing toolbars.

Shadows and 3-D effects

Shadow effects

You can add depth to a drawing object by using the shadow tool on the Drawing toolbar. To adjust the shadow position or change its colour, click Shadow Settings, and then use the tools on the Shadow Settings toolbar.

3-D effects

You can add a 3-D effect to lines, AutoShapes and freeform objects by using the 3-D tool on the Drawing toolbar. With 3-D options, you can change the depth of the drawing object and its colour, angle, direction of lighting and surface reflection. To modify the 3-D effect of a drawing object, click 3-D Settings, and then use the tools on the 3-D Settings toolbar.

You can add either a shadow or a 3-D effect to a drawing object, but not both. If you apply a 3-D effect to a drawing object that has a shadow, the shadow disappears.

Drawing objects

You can use the conventional drawing tools in the Drawing toolbar shown in Figure 6.8 to draw an object of your own. You can also use AutoShapes to avoid more complicated drawing, such as arrows and speech balloons.

Figure 6.8 *The Drawing toolbar*

Note: You can add shadows, 3D shapes and colours to an object by first selecting the object, clicking inside it and then using the respective buttons in the Drawing toolbar (shown in Figure 6.7) to make the required changes.

Repositioning, resizing, aligning and rotating objects

You can reposition any object on a PowerPoint slide by clicking on it (if it's a text object, click on its border) and dragging it to where you want it.

You can also resize any selected object by dragging one of its sizing handles to the required size. Dragging a side handle alters the object in only that dimension, whilst dragging a corner handle resizes the object both horizontally and vertically.

To align two or more selected objects with each other, click the Draw button on the Drawing toolbar to display a pop-up menu, then select the type of alignment you want.

To rotate a selected object click on the Free Rotate button 🔄 on the Drawing toolbar.

Then click on one round handle of the object you want to rotate and drag it in the appropriate direction. Hold down Shift if you want to make the object rotate in 15° jumps rather than smoothly. Click on the Free Rotate button again when you've finished rotating the object.

Selecting objects

To work on objects in PowerPoint you need to select them. By selecting several objects you can format and position them all at once.

- **To select one object** click on it. PowerPoint will display a border around it with handles on each corner and on the middle of each side.
- **To select further objects**, hold down Shift while you click on each subsequent object; alternatively drag the mouse around the objects you want to select.
- **To deselect an object or a number of objects** click elsewhere the slide (or outside any selected object) or press Esc.
- **To deselect one of a number of objects** hold down the Shift key and click on the object to deselect it.
- **To select all the objects on one slide** click Edit, then Select All, or press Ctrl + A.

Inserting objects in a presentation

Graph or chart

You can either:
- create the graph in Excel and paste it on your slide, or
- use a Microsoft Graph Applet for creating the graph from scratch.

Inserting from Excel
1 Click the right button somewhere on the chart you want to insert.
2 Select Copy from the Edit menu.
3 Switch back to PowerPoint.
4 Right-click on the graph placeholder.
5 Choose Paste from the Edit menu.

Creating a graph from scratch

To create a graph from scratch on the current slide:

1 If the slide has a graph placeholder, double-click it. Otherwise click the Insert Graph button on the standard toolbar.

PowerPoint will display the graph sample datasheet and graph.

2 Drag through the rows in the datasheet that contain the sample data and delete it by pressing Del or right-clicking and choosing Clear Contents from the Context menu.

3 Enter your own data in the datasheet, just as you would in an Excel spreadsheet. The graph window will graph your data as you enter it.

4 Format your graph using the menus and the toolbars. The graph function works like a stripped-down version of Excel.

5 Close the datasheet by clicking its Close button.

To return to the slide, click elsewhere on it.

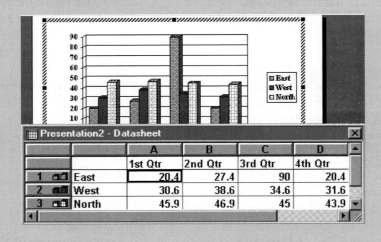

Inserting a picture

To insert a picture

1 Click inside the Clip Art placeholder in the slide, or click the Clip Art button in the standard toolbar (or select <u>I</u>nsert then Picture then Clip Art).

2 Choose the picture and click Insert. Position and resize as you wish.

Inserting a sound or a video clip

1 Select <u>I</u>nsert then Movies & Sounds.

2 Select the source for the sound or video (from Microsoft Clip Gallery or video from the file).

3 Select the sound or the video clip.

4 Click Insert.

Inserting an organisation chart

1 Double-click on the organisation chart placeholder or choose Insert then Object, choose Ms Organisation Chart and then click OK.
2 Create your chart in the Organisation Chart applet.

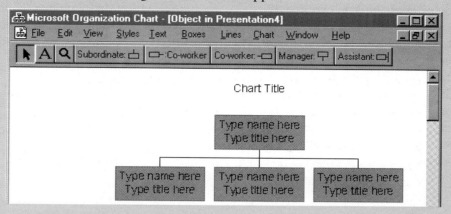

3 Select File then Update Presentation.
4 Choose File then Exit to add the chart to the slide.

Animating an object

1 Select the object.
2 To set preset animations, choose Slide Show then Preset Animations.
3 Select the type of animation from the sub-menu and then click OK.
4 To set custom animations ,right-click on the object and choose Custom Animations from the Context menu.
5 Select the type of animation you want and click OK.

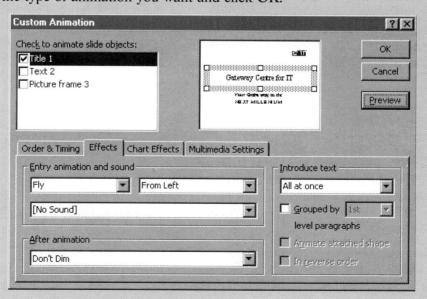

Finalising the presentation

Assigning transitions and timings

Instead of simply having each slide replace its predecessor on screen when you click the mouse on the slide or press N, you can assign transitions and timings to slides.

Transitions are visual effects that animate the changeover from one slide to the next; you can accompany them with sounds, and you can run many of them at varying speeds. You can also assign timings to slides, so that PowerPoint automatically advances the presentation after the selected number of seconds, leaving you free to roam the room and give your accompanying speech.

Assigning a transaction to a slide

1 Switch to Slide Sorter view.
2 Right-click on the slide you want.
3 Select Slide Transitions from the Context menu.

You will see the dialogue box shown in Figure 6.9.

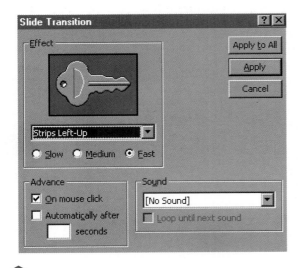

Figure 6.9 *The Slide Transition box*

4 Assign the transitions and click Apply to apply to the current slide, or Apply All to apply the transitions to all the slides of your presentation.

Creating build slides

Build slides are slides that you reveal one bulleted point at a time to keep the audience in suspense until the right moment. To create build slides, you have to first select the Custom Animation dialogue box as described earlier.

Next, in the Introduce text group box, choose how the text in the object should appear; all at once, by word or by letter.

- You can use the Grouped By... Level Paragraphs check box to group text by paragraphs of a certain level.
- Select the In Reverse Order text box if you want the text to appear in reverse order.
- Select the Animate Attached Shape check box if you want the shape to which the text is attached to be animated as well.

Creating hidden slides

For manually timed presentations where you need to have extra information up your sleeve should the need for it arise, you can create hidden slides that will not appear unless you choose specifically to display them.

To create one or more hidden slides in Slide Sorter view, select the slides, right-click and choose Hide Slide from the Context menu. To create a hidden slide in Slide view, choose Slide Show then Hide Slide. To unhide selected slides, choose Hide Slide again from the Context menu or the Slide Show menu. In Slide Sorter view, PowerPoint will display a strikethrough box over the slide number to indicate a hidden slide:

When you are running a presentation, PowerPoint gives no indication on screen that a hidden slide is available. To display a hidden slide, press H when the slide before it is displayed or right click and choose Go then Hidden slide.

Setting slide timings

This is the best way to set precise timings for the slides on a slide show and have PowerPoint assign the appropriate amount of time for each slide.

Here is how to do it
1 Choose Slide Show, Rehearse Timings to start the slide show and display the Rehearsal dialogue box. The Rehearsal dialogue box

shows two clocks; the left one displays the total presentation time elapsed, while the right shows the time for the current slide.

2 Rehearse your presentation and click the Play button or press the spacebar to move to the next slide. PowerPoint will record the time you spend on each slide. If you fluff your lines, click the repeat button to start timing the slide again.

3 When you finish your presentation, PowerPoint will display a message box giving you the total time for the slide show and asking if you want to record the new slide timings.

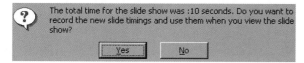

4 Choose Yes to apply the new timings to your slides.

Arranging slides for printing

To arrange slides for printing:

1 Select File then Page Setup.
 You will see the dialogue box shown in Figure 6.10.
2 Make your choices and click OK.

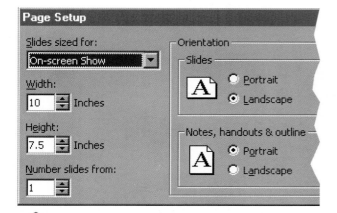

Figure 6.10 *The Page Setup box*

Handout master

Before you print out your handouts, you will probably want to modify the Handout Master, which controls the elements (other than slides) that appear on each page of the audience handout. For example, you might want to add to each handout page your name, the company, title of the presentation, the date or a blank notes box to encourage your audience to take notes.
 To modify the Handout Master:

1 Select View, Master, Handout Master.
2 Do necessary modifications.
3 Close.

Adding headers and footers

Either click in the relevant area of the Handout Master or use View then Header and Footer.

Modifying the Title Master

The Title Master is the slide template for the initial title slide of the presentation (and any subsequent title slide).
 To modify the Title Master:

1 Select View then Master then Handout Master.
2 Do the necessary modifications.
3 Close.

Printing

1 Choose File then Print.
2 Select the options you want.
3 Click OK.

Setting up the slide show

1 Select Slide Show then Setup.
2 Specify the type you want.
3 Click OK.

Giving a presentation

When you've finished finalising the details of your slide show and have rehearsed it, running it will seem a mere formality. To run it, choose View then Slide Show, or Slide Show then View Show. Press N or the spacebar to move to the

next slide (unless you set automatic transitions); press P to move to the previous slide and press Esc to stop the presentation.

Using the Slide Navigator

When running the slide show, you can navigate easily using the Slide Navigator feature. Right-click and choose Go ⟨X⟩ Slide Navigator from the Context menu to display the Slide Navigator dialogue box. Then choose the slide in the Slides List box and click the Go To button.

Saving a presentation file

You may wish to save an existing presentation under another file format such as Rich Text Format or as a presentation template, image file format, or for use by another software type or version number. To do this use the Save As menu, shown in Figure 6.11.

Figure 6.11 *The Save As screen, showing some possible file types*

Publishing a presentation or HTML file to the Web

To make sure your presentation looks the way you want in your Web browser, preview the presentation as a Web page before you publish it. To do this:

1. Open or create the presentation or Web page you want to publish over the Web.
2. On the File menu, click Save as Web Page.
3. In the File Name box, type a name for the Web page.
4. In the folder list, select a location for the Web page.
 Learn about where to save on the Web.
5. To change the Web page title (the text that appears in the title bar of your Web browser), click Change Title, type the new title in the Page Title box, and then click OK.
6. Click Publish.
7. Select the options you want.
8. To select additional Web page formatting and display options, click Web Options. Select the options you want, and then click OK.
9. Click Publish.

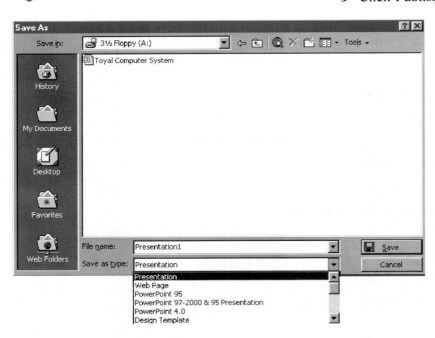

TUTORIAL 6.1

You are to create a three-page presentation for an International school.

1 Insert on all three pages a suitable picture from clipart as a logo. Do not insert the picture separately on each page.

2 Insert the current date on the bottom right-hand corner of each page.

3 Type the following text on the first page (use bullets for each department):
 - **Gateway International School**
 - **Gateway Computer Services**
 - **Gateway Educational Services**.

4 On the second page type the text given below:

 In the U.K... By 2002
 All schools, colleges,
 As many community centres
 Should be connected to the
 Grid, enabling 75% of them
 use their own E-mail address.

5 On page 3 type the heading **IT is the Key for the next Millennium** and insert a clipart image under the heading.

6 Using the slide show, give the presentation on screen.

7 Print the presentation if you have a printer available, or save the presentation to a file.

TUTORIAL 6.2

1 Insert the title **PowerPoint Central**. This title should appear on all three pages.

2 Draw a line below the title.

3 Insert an appropriate background.

4 Select and apply an appropriate font style and size for the presentation.

5 Insert page numbers at the top right-hand corner of each page.

6 Save the presentation file as **Internet**.

7 Insert three action buttons: these buttons are Home, Next and Previous.

 Make the title 32 point in size on all three pages.

8 Input the following text:

Page 1 text
Title Mission Statement
Body A clear statement of your company's long-term mission. Try to use words that will help direct the growth of your company, but be as concise as possible.

Page 2 text
Title The Team
Body ■ List the CEO and key management by name.
 ■ Include previous accomplishments to show these are people with a record of success.
 ■ Summarise the number of years of experience in this field.

Page 3 text
Title Market Summary
Body Market: past, present, and future.
Review those changes in market share, leadership, players, market shifts, costs, pricing or competition that provide the opportunity for your company's success.

9 Using a slide show, give the presentation on an overhead screen.

10 Print the presentation on an available printer or save the presentation to a file.

Your task is to make a three-page presentation for the Chelmer Leisure and Recreation Centre.

1 Find an appropriate template (background) for the three pages, and use it.

2 Use Times New Roman font in all three pages.

3 Insert an appropriate picture from clipart as a logo; it should appear on all three pages.

4 Type the following title; it should appear in all three pages:

 Chelmer Leisure and Recreation Centre Aerobics Open Day

5 Type the following text on the first page:

 Step One of the best ways to start your fitness programme. Our fitness demonstrators will be on hand to advise you on a suitable fitness programme.

6 Type the following text on the second page:

 Cycle Tones up those flabby thighs and strengthens backs.
 Our cycles simulate real cycling conditions, which can be individually tailored to your fitness programme.

7 Type the following text on the third page:

 Row Fancy yourself in the boat race? Try your hand at our computer-controlled rowing machine.

8 Change all three slides' orientation to portrait.

9 Hide the second slide.

10 Using Slide Show, make the presentation on screen.

11 Save the presentation as **Chelmer**.

TUTORIAL 6.4

1 Apply an appropriate design to the page using Apply Design.

2 Animate both slides using Custom Animations (use your own animation effects).

3 Add the page title **Organisation Chart**, in 36 point type, and create an organisation chart as shown below. (Create this diagram either by means of boxes which you can draw yourself or by using the facilities available in your presentation software.)

Organisation chart

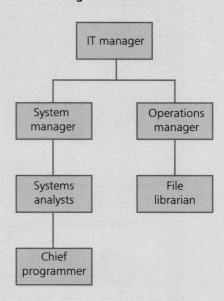

4 Insert a new slide and create the bar graph shown below. Title it **Bar Chart**, using the same font size as in Step 3.

	Beverage	Confectionery	Condiments
Sales (in thousands)	67	56	45

1 Use an appropriate format to design the slides shown below using Format then Apply Design.

2 Type your name and insert the current date and time on the first page.

3 Animate the slides using Custom Animation.

4 Add a slide transition; use your own effect.

5 Print the presentation on an available printer or save the presentation to a file.

TUTORIAL 6.6

Task 1

1 Open Microsoft PowerPoint.

2 The first slide is to be a title slide; select the correct format for this slide.

3 Give the name of the company on the title slide as **Silver Line Limited**.

4 Create a logo for the company; you may use clipart or design one.

5 Add the logo that you created in all three slides; do not add it to each individually.

6 On the second slide create an organisation chart for the business (type only the designations) with one person at the top and three reporting to him.

7 Add a heading **Organisational Chart**.

8 The management list is as follows:

John Chairman
Peter Marketing Manager
Knight Production Manager
Nick IT Manager

9 Use italic and underline to highlight each person's name.

10 Title this slide **Silver Line Team**.

11 Change the font size of all the headings to 40 points.

12 Edit the organisation chart on the second slide to include the names.

13 Print the three presentation slides on the same page.

14 Close the application and save the presentation as **Silver Line**.

Task 2

1 Create the file **Introduction** with slides similar to those shown on page 212.

2 Delete Slide 5, entitled **Topic One**.

3 Change the layout of Slide 1 to **Title Slide**.

4 Increase the size of the picture in Slide 7.

5 Change the font colour of Slide 1 to blue.

6 Number the slides.

7 Insert the current date on each slide.

8 Spell check the presentation.

9 Change the orientation of the slides.

10 Preview the slide in 35 mm slides using File then Page Setup.

11 Save the file as **New Introduction**.

12 Close the application.

Task 1

1 Open the presentation application.

2 Find a background which you think is appropriate for the Gateway Computer Society and use it.

3 Use the first slide as a title slide and select the correct format for this slide.

4 Type **Gateway Computer Services** as the header; do this for all three slides at once!

5 Create a logo for the Society; you may use clipart or design one yourself.

6 Add the logo that you have created to all three slides at once.

7 Type **Our Mission Statement** and **Our Vision Statement** on the first slide.

8 On the second slide create an organisation chart for the Society (type designations and the name), with one person at the top and three reporting to him.

9 Make the heading **Organisational Chart**.

10 The management list is as follows:

John Marks	President
Jennifer Lourdes	Secretary
Sunil Joshi	Treasurer
Michael Smith	Co-ordinator

11 Use bold for each person's name.

12 Type **We Have Achieved Our Target** in Slide 3.

13 Make all the body text 40 point type.

14 Print the presentation three slides to a page.

15 Close the application and save the Presentation as **Gateway Computer Society**.

Task 2

1 Open the file **Introduction** from the working diskette.

2 Delete the second slide.

3 Copy the picture from Slide 7 and paste it on the second slide.

4 Change the background of Slide 4 'Vocabulary'.

5 Number the slides on the right corner.

6 Change the orientation of the slides.

7 Save the file as **Intro**.

8 Close the application.

Information and communication

Introduction

In recent years communication systems have developed so that it is quite easy to access a great deal of information. To communicate effectively users need to have a computer workstation, a modem linked to a telephone line and an appropriate software application.

Users can communicate with each other by linking two or more computers via a modem. This form of communication is known as electronic communication. A wide area network (WAN) can be considered a perfect example of the setup described above.

Just such a system is shown in Figure 7.1.

What is the Internet?

The Internet (sometimes called the Net) is a vast, global network of computer that are connected together. Rather than one network, the Internet is a loosely organised collection of thousands of networks. Almost anyone who has the use of a computer and modem can access it.

The World Wide Web (WWW)

The World Wide Web is the graphical, multimedia portion of the Internet. To view files on the Web, you need a Web browsing software such as Internet Explorer or Netscape. You use

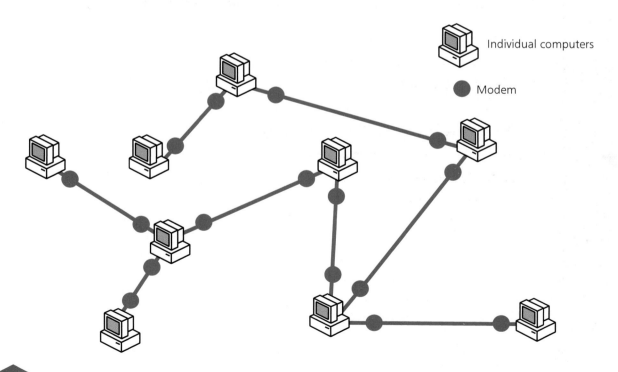

Individual computers

Modem

Figure 7.1 *Communication over a wide area network*

this software to view different locations on the Web, which are known as web pages. A group of web pages is known as a website. The first page of a website is often called the home page.

Figure 7.2 shows how web pages are connected within a website.

Figure 7.2 *A diagram to show how the website browsing concept works*

Hyperlinks

A hyperlink is a connection from one page to another destination, such as another page or a different location on the same page. The destination is frequently another web page, but it can also be a picture, an e-mail address, a file (such as a multimedia file or Microsoft Office document) or a program. A hyperlink can be text or a picture.

When a site visitor clicks the hyperlink, the destination is displayed in a Web browser, opened or run, depending on the type of destination. For example, a hyperlink to an AVI file opens the file in a media player and a hyperlink to a page displays the page in the Web browser.

In Figure 7.3 the word 'services' is a hyperlink. When the site visitor clicks it, the Services page is displayed.

Figure 7.3 *An example of a hyperlink, via the word* **services**

URLs

Just as each household has a unique address, each web page in the world has a unique Internet address, sometimes called a URL (uniform resource locator). For example, the Internet address of Microsoft is:

http://www.microsoft.com/

When you create a hyperlink, its destination is encoded as a URL such as:

http://example.microsoft.com/news.htm

or

file://ComputerName/SharedFolder/FileName htm.

A URL contains a Web server or network location, path and file name. A URL also identifies the protocol that will handle the file, such as HTTP, FTP or FILE:

http://www.microsoft.com/frontpage/productinfo/default.htm

Protocol Web server Path File name

What is HTTP?

The acronym HTTP stands for hypertext transfer protocol; this is a means of communicating using links. The HTML you often see at the end of the URL stands for hypertext markup language; a language, used to make pages, that takes advantage of multimedia pictures, sound and even film clips.

What is an ISP?

The main trunks, or backbones, of the Internet are run by the major telecommunications

carriers. These carriers provide access to the Internet through smaller companies called Internet service providers (ISPs). Users can get access to the Internet through an ISP, allowing them to browse the World Wide Web, to download files, and to send and receive e-mail.

Accessing the Internet

For you to connect to the Internet you will need:
- a computer
- a telephone connection
- a modem
- an Internet account with an ISP
- Internet software (browser, e-mail client, etc.).

Connecting to your ISP

Before you can begin to use a Web browser to browse the Internet you need to first connect to your local ISP.

To do this you need to:

1 Dial the number given to you by your ISP (this will probably be a local number). Once you have done this you will be connected to the ISP, which is in turn connected to other computers on the Internet.
2 Identify yourself to the ISP by typing the user name and password given to you. This way the ISP knows that you are accessing the Internet through them and will be able to charge you accordingly.

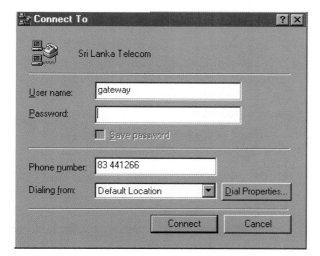

Typing your user name and password

3 Once the ISP server recognises your user name and your password you can start any e-mail software (such as a web browser, WebTV, Internet, etc.) and use the Internet.

Exploring the Internet

You can browse web pages (or 'surf the net' as it is called) in several ways. You can open any web page by typing its address in the address box of your web browsing software. And when you're viewing a web page you can navigate the Internet by clicking on links (underlined text or special pictures) which when clicked cause you to go to the next web page. This occurs only when you move the mouse pointer over a link. When you click a link, another web page appears.

You can also use the toolbar buttons (shown in Figure 7.4) to move between web pages.

The following table describes the Internet Explorer toolbar buttons and how you can use them to navigate the Internet.

Button	Description
Back	Moves to a previously viewed web page.
Forward	Moves to the next web page.
Stop	Stops the downloading of a web page.
Refresh	Updates the currently displayed web page (reloads the currently displayed page).
Home	Jumps to your home page.
Search	Opens a web page that lists the available search engines.
Favourites	Displays a list of web pages you've designated as your favourites.
History	Displays a list of recently visited sites.
Mail	Opens Outlook Express or Internet News.
Print	Prints a web page.

Figure 7.4 *The Internet Explorer toolbar*

Changing view/display modes

Show/hide the toolbars
On the View menu click on the toolbars that you want to display or hide.

Show/hide the status bar
On the View menu click on the status bar to display or hide.

Changing the font size
On the View menu select Fonts and select the font size you want (Largest, Larger, Medium, Smaller, Smallest).

Explorer bar
The Explorer bar is a way to browse through a list of links, such as your history or channels, while displaying the pages those links open on the right side of the browser window. For example, if you click the Search button on the toolbar, the Explorer bar opens and you can use it to search for the website you want.

You can display your favourites list, history list, channels, or search by clicking the toolbar. In addition, you can gain access to these items by clicking the View menu, and then pointing to Explorer bar.

Loading web pages without pictures (to display all web pages faster)
1 On the View menu in the browser, click Internet Options.
2 Click the Advanced tab.
3 In the Multimedia area, clear the Show Pictures box.

Note: If the Show Pictures or Play Videos check box is cleared, you can still display an individual picture or animation on a web page by right-clicking its icon and then clicking Show Picture.

Also: If the pictures on the current page are still visible after you clear the Show Pictures check box, you can hide them by clicking the View menu and then clicking Refresh.

Searching the Internet

The Internet is a vast store of information with millions of computers connected around the world, so finding the information that you want can be time consuming.

If you know the URL (like www.cnn.com, mtvindia.com, www.microsoft.com) then there is no problem, but if you want to find information on some topic, like the sites that sell a popular book you cannot simply use an address.

One possibility is a search engine. This is a site that allows you to type in a request and then returns locations (URLs) of web pages that match the content.

You can find information on the Web in a variety of ways:

- Click the Search button on the toolbar to gain access to a number of search providers. Type a word or phrase in the Search box.
- Type go, find, or ? followed by a word or phrase in the address bar. Internet Explorer starts a search using its own predetermined search provider.

Choosing terms and syntax

- Enter synonyms, alternate spellings and alternate forms (e.g. dance, dancing, dances) for your search terms.
- Enter all the singular or unique terms that are likely to be included in the document or site you are seeking.

- Avoid using very common terms (e.g. Internet, people) which may lead to a mass of irrelevant search results.
- Determine how your search engine uses capitals and plurals, and enter capitalised or plural forms of your search words if appropriate.
- Use a phrase or proper name, if possible, to narrow your search and therefore retrieve more relevant results (unless you **want** a large number of results).
- Use multiple operators (e.g. AND, NOT) if a search engine allows you to do so.
- If you receive too many results, refine and improve your search. (After perusing the results, you may become aware of how to use NOT, e.g. Boston AND hockey AND NOT Bruins).
- Pay attention to proper spacing and punctuation in your search syntax (i.e. no space when using '+' means '+term' not '+ term').

Exploring using the Yahoo page

One of the most popular search engines on the Internet is Yahoo (see Figure 7.5). Yahoo acts as the menu on the Internet. It helps you to connect to addresses easily, instead of typing the address in the address column.

To change your home page

Your home page is the page that is displayed every time you open Internet Explorer. Make sure it is a page that you want to view frequently. Or make it one that you can customise to get quick access to all the information you want, such as the msn.com home page.

To do this:

1 Go to the page you want to appear when you first start Internet Explorer.
2 On the Tools menu, click Internet Options.

Figure 7.5 *The Yahoo website*

3 Click the General tab.
4 In the Home page area, click Use Current.

Favourites

Internet Explorer provides faster and easier access to your favourite web pages. By using the Favourites folder you can create a link to the websites that are visited frequently by just clicking them on the menu. To add a web page to the Favourites folder:

1 Select Favourites on the menu bar.
2 Click on Add Favourite.

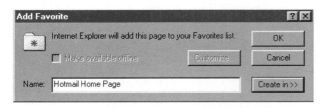

3 In the Name box type in any name you wish to assign to your web page and click OK once you have finished.

Downloading a web page

1 On the File menu, click Save As.
2 Double-click the folder in which you want to save the page.
3 In the File Name box, type a name for the page.
4 In the Save As Type box, select a file type:

- To save all of the files needed to display this page, including graphics, frames, and style sheets, click Web Page, complete. This option saves each file in its original format.
- To save just the current HTML page, click Web Page, HTML only. This option saves the information on the web page, but it does not save the graphics, sounds, or other files.
- To save just the text from the current web page, click Text Only. This option saves the information on the web page in straight text format.

Saving pictures from a web page

As you view pages on the Web, you will find information that you would like to save for

future reference or share with other people. You can save the entire web page, or any part of it, text, graphics or links. You can print web pages for people who don't have access to the Web or a computer.

To save a page or picture without opening it
1 Right-click the link for the item you want.
2 Click Save Target As.
3 In the Save As dialogue box, choose the path that you want to save and click OK.

To copy information from a web page into a document
1 Select the information you want to copy.
2 Click the Edit menu.
3 Click Copy.

To create a desktop shortcut to the current page
1 Right-click on the page.
2 Click Create Shortcut.

To use a web page image as desktop wallpaper
1 Right-click the image on the web page.
2 Click Set As Wallpaper.

Printing a web page

When you print a web page, you can print the page as you see it on the screen, or you can print selected parts of it, such as a frame. In addition, you can specify that you want to print additional information in the headers and footers, such as the window title, page address, date, time and page numbers.

The following topics provide more information:

To change the appearance of a page when it prints
1 On the File menu, click Page Setup.
2 In the Margins boxes, type the margin measurements in inches.
3 In the Orientation area, select either Portrait or Landscape to specify whether you want the page printed vertically or horizontally.
4 Click Headers. In each Headers and Footers box, specify the information to be printed by using one or more of the variables. Variables can be combined with text, for example, 'Page &p of &P'.

To print the contents of a frame

1 Right-click in the frame.
2 On the menu that appears, click Print.
3 Set the printing options you want.

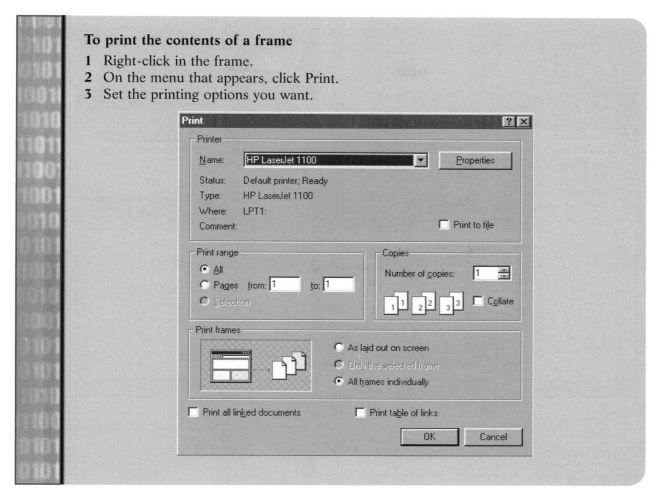

Electronic mail

Electronic mail (e-mail) is the process of sending messages directly from one computer to another. These messages can be sent back and forth at any time. The cost of sending e-mail is quite minimal; it is less than a normal phone call yet is faster than 'snail mail' (mail that travels via the postal service). Depending on the modem speed, two parties can exchange e-mail from one country to another within less than two minutes.

Getting started

With an Internet connection (from your Internet service provider) and e-mail software (such as Microsoft Outlook Express), you can exchange e-mail messages with anyone on the Internet.

A typical Microsoft Outlook Express window is shown in Figure 7.6.

E-mail address

Before you can send and receive e-mail messages you need to have an e-mail address given to you by your ISP.

An Internet e-mail address consists of a user name and a domain name, with the two separated by an 'at' sign (@). In the following example, 'thushara' is the user name and 'lanka.net' is the domain name.

thushara@lanka.net

The domain name extension indicates the domain type. Some common domain types are:

Domain	Meaning
Com	Company
Net	Internet related
Org	Organisation
Edu	Educational

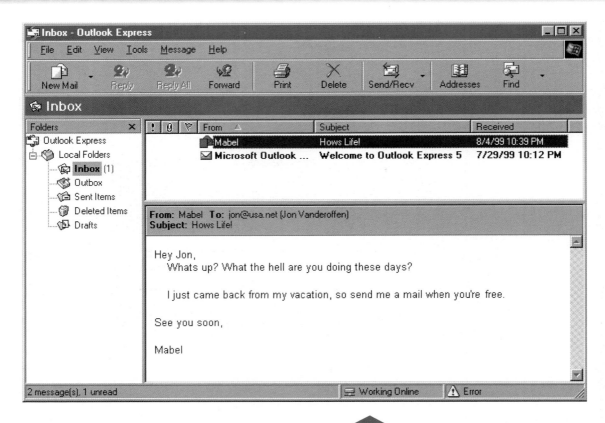

Figure 7.6 *A typical Microsoft Outlook Express window*

E-mail folders

Almost all e-mail software has the following folders:

In box
 All the new mail which you receive will be put inside a box called the In box and if there is any unread mail, a closed symbol like this will be displayed beside the new mail (*). When you double-click on the message you can open and read your new message.

Out box
 Once you have composed all your new messages but before they are sent, they will be placed in the Out box. Once an individual connects to their ISP, the messages are sent and are then placed in the Sent Items box, if despatch is successful.

Deleted items
 If you want to delete any unwanted messages just select the message and press the Del key on the keyboard. This routine will delete the mail, and the deleted mail will be placed in the Deleted Items box. If you want to delete the mail permanently, select the message from the Deleted Items box and press the Del key to delete the item permanently.

Changing the priority of an outgoing mail message

When you send a high-priority message to someone, it arrives in the recipient's In box with an alert icon next to it (usually an exclamation mark) so that he or she knows it is important and should be read immediately.

In the message window, click the Tools menu, point to Set Priority then click a priority option.

Sending an e-mail

1 On the toolbar, click the New Mail button.
2 In the To and/or Cc boxes, type the e-mail name of each recipient, separating names with a comma or semicolon (;).
 To use the Bcc box, click the <u>V</u>iew menu, and then select All Headers.
3 In the Subject box, type a message title.

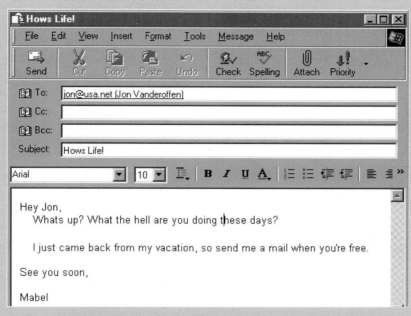

4 Type your message, and then click the Send button on the New Message toolbar.

- If you are composing a message offline, your message will be saved in the Out box. It will be sent automatically when you go back online.
- To save a draft of your message to work on later, click the <u>F</u>ile menu, and then click <u>S</u>ave. You can also click Save <u>A</u>s to save a mail message in your file system in mail (.eml), text (.txt) or HTML (.htm) format.

To, Cc and Bcc boxes

You can send a message to recipients by separating their e-mail names with semicolons (;) in the To, Cc and Bcc boxes.

Receiving e-mail

In the same way you check the post box everyday for any mail you have received, you need to check for e-mail too. In Outlook Express, checking for e-mail will cause any queued messages to be sent as well.

Box	Meaning
To	Message is sent directly to the recipient.
Cc	(Carbon copy) A copy of the message is sent to the recipient, and the recipient's name is visible to other recipients of the message.
Bcc	(Blind carbon copy) A copy of the message is sent to the recipient, and the recipient's name is not visible to other recipients of the message.

To check for new messages

1 Connect to your Internet service provider (ISP).
2 Click the Send/Recv button on the toolbar.

Send/Recv

Any messages in your Out box will also be sent.

3 Outlook Express will show you a progress bar on the number of new messages you have received that day.

Replying to a message

1 Open the message to which you want to reply.
2 To reply to the sender of the message, click Reply.

Reply

3 To reply to all of the recipients in the To and Cc boxes, click Reply to All.

Reply All

Forwarding a message

1 Select the message you want to forward, and then on the Message menu, click Forward.

Forward

2 Type the e-mail name for each recipient. Separate each name with a comma or a semicolon (;).
3 Type your message then click the Send button on the toolbar.

Replying versus forwarding

Replying and forwarding are two different actions, even though the end result (sending a message) is the same.

In replying you send a message answering the message you received from someone.

In the e-mail in Figure 7.7 Mabel is replying to an e-mail that Julian has sent. Notice that the original message that Julian sent is included when she replies. This way it will be easier for Julian to know what Mabel is writing about.

In forwarding you send the message you received on to somebody else. For instance, if you were too lazy to check the price of a Walkman for your friend, you could forward his or her original message to some other friends, hoping they reply to you with the prices.

Attaching files

When composing an e-mail package it is possible to send attached documents; these may have been created using various other packages. For instance, if you made an Excel spreadsheet of a marketing research, you could then send the Excel file to your fellow researchers as an attachment.

If you have a photograph that you want to send to a friend, you can attach it to an e-mail.

To insert a file in a message

1 Compose your new message and enter the details in the To, Subject, etc.
2 On the Insert menu, click File Attachment and then find the file you want to attach.
3 Select the file, and then click Attach.
4 The file is listed in the Attach box in the message header.

To open and save a file attachment

1 **To open a file attachment:**
 - At the bottom of the message window, double-click the file attachment icon
 or
 - in the preview pane, click the file attachment icon in the message header, and then click the file name.

2 **To save a file attachment:**
 - At the bottom of the message window, double-click the file attachment icon
 or
 - in the preview pane, click the file attachment icon in the message header, and then click the file name.

Signatures

You can use a signature to automatically add text to the messages you send. For example, you can create a signature that includes your name, job title and phone number. You can also use a signature to add a paragraph about how you want others to respond to your messages.

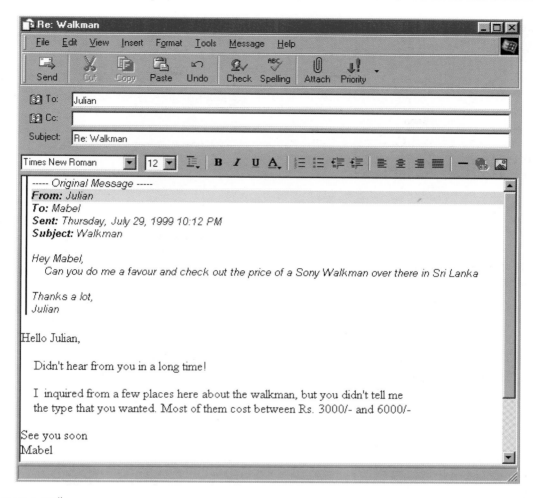

a *Replying to an e-mail*

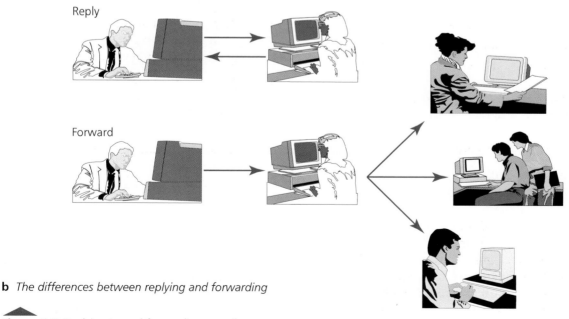

b *The differences between replying and forwarding*

Figure 7.7 *Replying to and forwarding e-mails*

To add a signature to outgoing messages

1 On the Tools menu, click Options, and then click the Signatures tab.

2 To create a signature, click the New button and then either enter text in the Edit Signature box or click File, and then find the Text or HTML file you'd like to use.

3 Select the Add Signatures To All Outgoing Messages check box.

The address book

The address book provides a convenient place to store contact information for easy retrieval by programs such as Microsoft Outlook Express. Figure 7.8 shows a typical address book section.

Figure 7.8 *The address book in Microsoft Outlook Express*

To add a contact to your address book
1 In the address book, select the folder to which you want to add a contact.
2 Click the New button on the toolbar, and then click New Contact.
3 On the Name tab, type at least the first and last names for the contact.
 A display name, sometimes called the nickname, is required for each contact. The advantage with this is that you will not need to remember the person's exact e-mail address (e.g. jon@mack.tra) since Outlook Express will know who you mean when you give the nickname.
4 On each of the other tabs, add the information you want.

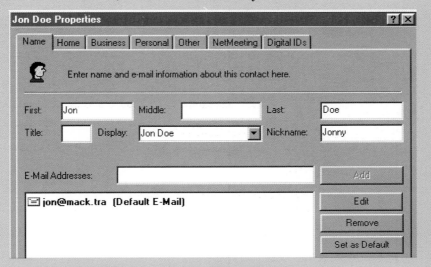

You will then be able to use the Display/Nickname when sending messages.

To add contacts to your address book from Outlook Express

When you receive e-mail, you can add the sender's name and e-mail address to your address book from within Outlook Express.

- Open the message, right-click the name you want to add, and then click Add to Address Book.
- You can also set up Outlook Express so that people whose messages you reply to are automatically added to your address book.
- In Outlook Express, click the Tools menu, and then click Options. On the General tab, click Automatically Put People I Reply To In My Address Book.

Organising messages

Creating a New Mail folder

To add a folder, click the File menu, point to Folder, and then click New Folder. Finally, in the Folder Name box, type the name you require.

Moving or copying a message to another folder

In the message list, right-click the message you want to move or copy. Click Move To or Copy To, and then click the folder you want to move it to.

Sorting messages to a New Mail folder

In either your In box or news server, click the View menu, point to Sort By, and then click Group Messages by Subject (for mail) or Group Messages by Thread (for newsgroups).

TUTORIAL 7.1

1 Name two types of network system and briefly explain them.

2 Explain why you need a modem to communicate with another computer/network.

3 What is WWW?

4 Use a diagram to describe the concept of web page browsing.

5 Explain what is meant by a home page.

TUTORIAL 7.2

1 Describe the meaning of URL. Give three examples.

2 Using one of the above examples identify the main components of a URL.

3 What are the types of protocol used in Internet?

4 Explain what a hyperlink is and how to identify one on a web page.

5 Explain the role of an ISP (Internet service provider) and give examples of ISP companies in Sri Lanka.

6 Name five basic components that are used to get an Internet connection.

7 Name the typical type of software used to access information on the WWW and give examples.

TUTORIAL 7.3

1 Explain the functions of the tool buttons given below in relation to a web browser:
 a Home
 b Refresh
 c Stop
 d History.

2 Visit the website http://www.adobe.com and extract information about Adobe Photoshop.

3 Save the complete web page accessed in **2** onto your working diskette.

4 Add the web page to favourites for future reference.

5 Save the Adobe logo onto your working diskette.

TUTORIAL 7.4

1 Explain the task of a search engine and provide three examples.

2 Use an appropriate search engine to get information about the Y2K crisis.

TUTORIAL 7.5

Part 1

You are planning a holiday in New York, USA.

1 Find the British Airways website and describe the information it contains.

2 List the flights and times from Manchester to New York.

3 Find the Internet address (the URL) of another airline offering flights to New York.

4 What is the main difference in the information these two sites give you?

Part 2

You need information to help you buy a computer.

1 Find the IBM UK computer site and describe the information it contains.

2 Use the site to find details of a desktop PC suitable for use in the home.

3 Comment on the convenience of the site for finding the information about specifications and costs.

4 Find the Internet address (URL) of another computer manufacturer.

5 What is the main difference in the information these two sites give you?

TUTORIAL 7.6

Send an electronic mail to your tutor giving brief answers to the following questions:

1 What do the various parts of an e-mail address mean?

2 How can a file be sent by e-mail?

3 How can you send the same e-mail message to many people at the same time?

4 Explain what is meant by 'reply' with respect to an e-mail?

5 Explain what is meant by an e-mail attachment and outline the way attachments are used.

6 Use the attachment function and attach the web page which you saved in Tutorial 7.3, along with an e-mail, to your institute.

7 What is an e-mail signature and why do you use it?

8 Write down the function of each folder in Microsoft Outlook Express:
 a In box
 b Out box
 c Deleted items
 d Sent items.

Appendix
Files for tutorials

The data for some of the files used in the tutorials is given in this Appendix. Students can either key these in themselves, or they can be keyed once and supplied to students as files.

Answers to Tutorial 7.doc

This data is needed as a Word file for Tutorial 2.7 on page 70.

Answers

Candidate Identification Number: _____

Batch Number: _____

Name: _____

1.	
2.	
3.	
4.	
5.	
6.	
7.	
8.	
9.	
10.	
11.	
12.	
13.	
14.	

Note : Not all questions require this document.

Unemployment

This data is used as a Word file for Tutorial 3.12 on page 102.

Do computers cause unemployment?
When computers were first introduced to the business world, it was thought that this would lead to mass unemployment. This did not happen. Instead the jobs that were lost were replaced by new jobs such as computer operators, systems analysts, computer engineers, and programmers. As more and more computers are used, unemployment will probably increase. Our society will have to accept this and cope with it. What must not happen is for a small part of the population to be employed at extremely high salaries whilst the rest of the population is unemployed. Different work patterns will be needed. Shorter hours of work, job sharing, lowering the retirement age and raising the school leaving age are some things that could lessen the problem.

Production.xls

Tutorial 4.10 on page 144 needs the following data in an Excel file.
In the table below, Q = quarter.

	1st Q	2nd Q	3rd Q	4th Q	Total
Coconut cultivation	20	52	85	85	
Tea cultivation	78	45	96	89	
Rubber cultivation	12	47	78	36	
Other	96	89	59	58	
Total production					

Script.doc

The following text can be used for Tutorial 3.15 on page 107.

Dial-Up Scripting Command Language
For Dial-Up Networking Scripting Support

Copyright (c) 1995 Microsoft Corp.

Table of Contents

1.0 Overview

Many Internet service providers and online services require you to manually enter information, such as your user name and password, to establish a connection. With Scripting support for Dial-Up Networking, you can write a script to automate this process.

A script is a text file that contains a series of commands, parameters, and expressions required by your Internet service provider or online service to establish the connection and use the service. You can use any text editor, such as Microsoft Notepad, to create a script file. Once you've created your script file, you can then assign it to a specific Dial-Up Networking connection by running the Dial-Up Scripting Tool.

2.0 Basic Structure of a Script

A command is the basic instruction that a script file contains. Some commands require parameters that further define what the command should do. An expression is a combination of operators and arguments that create a result. Expressions can be used as values in any command. Examples of expressions include arithmetic, relational comparisons, and string concatenations.

The basic form of a script for Dial-Up Networking follows:

```
;
; A comment begins with a semi-colon and extends to
; the end of the line.
;

proc main
     ; A script can have any number of variables
     ; and commands
```

```
    variable declarations

        command block

    endproc
```

A script must have a main procedure, specified by the **proc** keyword, and a matching **endproc** keyword, indicating the end of the procedure.

You must declare variables before you add commands. The first command in the main procedure is executed, and then any subsequent commands are executed in the order they appear in the script. The script ends when the end of the main procedure is reached.

3.0 <u>Variables</u>

Scripts may contain variables. Variable names must begin with a letter or an underscore ('_'), and may contain any sequence of upper- or lower-case letters, digits, and underscores. You cannot use a reserved word as a variable name. For more information, see the list of reserved words at the end of this document.

You must declare variables before you use them. When you declare a variable, you must also define its type. A variable of a certain type may only contain values of that same type. The following three types of variables are supported:

Type	Description
integer	A negative or positive number, such as 7, -12, or 5698.
string	A series of characters enclosed in double-quotes; for example, "Hello world!" or "Enter password:".
boolean	A logical boolean value of TRUE or FALSE.

Variables are assigned values using the following assignment statement:

variable = expression

The variable gets the evaluated expression.

Examples:

```
integer count = 5
integer timeout = (4 * 3)
integer i

boolean bDone = FALSE

string szIP = (getip 2)

set ipaddr szIP
```

Introduction.ppt

For Tutorial 6.6 on page 189, a PowerPoint file with slides similar to the following is needed.

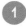

Introduction

- Define the subject matter
- State what the audience will learn in this session
- Find out any relevant background and interest of the audience

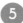

Topic One

- Explain details
- Give an example
- Exercise to re-enforce learning

Agenda

- List the topics to be covered
- List the times allotted to each

Topic Two

- Explain details
- Give an example
- Exercise to re-enforce learning

Overview

- Give the big picture of the subject
- Explain how all the individual topics fit together

Summary

- State what has been learned
- Define ways to apply training
- Request feedback of training session

Vocabulary

- Glossary of terms
- Define the terms as used in this subject

Where to Get More Information

- Other training sessions
- List books, articles, electronic sources
- Consulting services, other sources

Index

[Below]
The Open Agency
London UK

ACKNOWLEDGEMENTS

Caroline Roberts – Features Editor, Graphics International
Katie Weeks – Assistant Editor, How Design Magazine, USA
Helen Walters – Section Editor, Creative Review
Richard Draycott – Editor, The Drum
Mark Fowlestone – Managing Director, KLP Scotland
Joe McAspurn – Managing Director, IMP Edinburgh
Ken Cassidy – Managing Director, Pointsize
Alastair Smith – Creative Photographer, Glasgow. +44 (0)7798 574 395
Paul Gray – Creative Director, BD-TANK
Gary Doherty – Senior Designer, BD-TANK
Eric Witham – Creative Director, Big Group, Bournemouth
Gary Dawson – Production Manager, BD-TANK
Xavier Young – Photographer, London. +44 (0)207 713 5502

Special thanks to
Aidan Walker, Luke Herriott, Laura Owen and all at RotoVision
Scott Campbell – Davidson Pre Press, Glasgow. +44 (0)141 248 1222
Ghill Donald – Managing Director, BD-TANK
Paul Hampton – The Picture House, Glasgow. +44 (0)141 948 0000
Scott Mackie – CMR Origination & Print Glasgow. +44 (0)1355 247773
Joan Grady – Freelance Copywriter, Glasgow. +44 (0)141 342 4020
Crown Press – Colour printers, Glasgow. +44 (0)141 221 8990

Lorna Kilpatrick – For her patience and speed typing.

IF YOUR AGENCY WOULD LIKE TO SUBMIT HOLIDAY MAILINGS
FOR FUTURE VOLUMES OF 'FESTIVE' PLEASE SEND YOUR WORK TO:

HI RES JPEGS:
SCOTT@TRAFFIC-DESIGN.CO.UK

TRANSPARENCIES OR SLIDES:
SCOTT WITHAM. 25 CALDERWOOD ROAD, RUTHERGLEN,
GLASGOW, SCOTLAND G73 3HD, UK.

INDEX

DESIGN
CPD
LOCATION
SYDNEY, AUSTRALIA
CREATIVE DIRECTORS
CHRIS PERKS, NIGEL BEECHLEY,
CHRIS TRAVERS
CREATIVE TEAM
HANS KOHLA,
AGNIESZKA ROZYCKA,
BELINDA O'CONNER

The simple yet open brief went to
CPD's designers within the Sydney and
Melbourne studios. The cards designed
for Christmas 2001 have a special
message of peace.

DESIGN
GUNTER ADVERTISING
LOCATION
MADISON, USA
CREATIVE DIRECTOR
RANDY GUNTER
CREATIVE TEAM
SARAH GRIMM, COLLIN SCHNEIDER,
JASON HENDRICKS,
BENNY SYVERSON,
VERNON MOORE

"Once again, we see the holiday card as an opportunity to try something different. The card was sent with 3D glasses, and the card and interactive website were both designed in 3D.

"'The Elves Who Hold Their Knees' included an extremely manipulated audio track recorded by agency members, a historic bibliography of the band and a website with a Flash video."

DESIGN
SPLASH OF PAINT
LOCATION
READING, UK
CREATIVE DIRECTOR
MALCOLM HATTON

"A designer's Yuletide log."

DESIGN
IMAGE NOW
LOCATION
DUBLIN, IRELAND
CREATIVE TEAM
IMAGE NOW

"If nothing else, it gives the clients' kids something to occupy themselves with if they're bored with the PS2 and there's nothing on the telly."

DESIGN
CAHAN & ASSOCIATES
LOCATION
SAN FRANCISCO, USA
CREATIVE DIRECTOR
BILL CAHAN
CREATIVE TEAM
GARY WILLIAMS

"We wanted to tell friends and family about our holiday party. Everyone likes to have fun at a party and reindeer games are fun."

come and play. 12.13.01 reindeer games.

inks + music at cahan & associates.
5 to 9 pm. 171 2nd street, 5th floor.
15 or rsvp@cahanassociates.com.

reindeer games.

food + drinks + music at cahan & associates.
from 6 to 9 pm. 171 2nd street, 5th floor.
rsvp: 415.621.0915 or rsvp@cahanassociates.com.

12.13.01

come and play.

DESIGN
CLEAR
LOCATION
LONDON, UK
CREATIVE DIRECTOR
IAN LETTICE

"Clear is the 'explanation agency'. We wanted to create a mailing that reminded our potential and existing clients what we do, but in a humorous way. The two-part clear acrylic Christmas tree kit, with three-step instructions, demonstrated clarity, from every aspect!"

DESIGN
CREATIVE LYNX PARTNERSHIP
LOCATION
MANCHESTER, UK
CREATIVE DIRECTOR
NICK JACKSON

"A subtle change of our logo from CLP to SG (Seasons Greetings) plus a festive colouring makes our full range of December stationery quite different."

DESIGN
IRIS ASSOCIATES
LOCATION
SHEFFIELD, UK
CREATIVE DIRECTOR
DAVID WOOD
CREATIVE TEAM
ADAM PEACH

"We saw this mailer as an opportunity to excite, stimulate and have fun joining the spirit of the festive season. As we all love to make our own decorations and Christmas messages, we felt this would give people the chance to combine both whilst having a lasting 'feel-good, creative' impression of Iris."

DESIGN
CITIGATE LLOYD NORTHOVER
LOCATION
LONDON, UK
CREATIVE DIRECTOR
JEREMY SHAW

"Having offices around the globe, we had to focus on the 'holiday season' rather than Christmas itself. We produced an edited book of the over-indulgences that have become a part of the festive season."

Enjoying the
festive season

ed

DESIGN
PROCTER & STEVENSON
LOCATION
BRISTOL, UK
CREATIVE TEAM
PROCTER & STEVENSON,
PETER THORPE, MARCUS AMMS

"Every year the designers at Procter and Stevenson are asked to express their creative talent in new and innovative ways. In 2001, it was to take everyday items found in the office and to find new and innovative uses. This celebration of design talent illustrates the diversity of our designers and their ability to think laterally whilst having fun."

INTRODUCING A TUCKER CLARKE-WILLIAMS CREATIVE PRODUCTION

— A LITTLE —
CHRISTMAS KINDNESS

GOES A LONG WAY

THE COMPLETE
UNCUT
VERSION
NEVER BEFORE
SEEN!

A SHORT FILM BASED ON A TRUE LIFE INCIDENT

Insert this card into a corder ↑ Do not touch the tape inside VHS

A LITTLE CHRISTMAS
KINDNESS GOES
A LONG WAY

a short film by Tucker Clarke-Williams Creative

Running Time approx 140 secs

WARNING: All rights of the producer and the owner of the work reproduced reserved. Unauthorised copying, hiring, lending, public performance, radio or TV broadcasting of this video is highly unlikely.

DESIGN
MAGNETO TCW
LOCATION
MANCHESTER, UK
CREATIVE DIRECTORS
DEBBIE MORRIS, TIM SINCLAIR
CREATIVE TEAM
JOHN MURPHY

"We are well known as print designers, but wanted to show clients we were capable of much more – as this was our first time making a film."

DESIGN
NEWENGLISH
LOCATION
LEICESTER, UK
CREATIVE DIRECTOR
CARL BEBBINGTON
CREATIVE TEAM
PHIL THURLBY, WENDY LEWIS

"Every year we send out a festive mailer – this time we thought we would try and help to take the stress out of Christmas, leaving more time for eating and drinking."

no more
wrapping
paper...ever!™

have a stress free christmas in 3 easy steps...

1. place gloves on hands 2. close eyes 3. puzzle over gift

Happy Christmas from all at
newenglish

DESIGN
RED & GREEN MARKETING LTD
(FORMERLY GREENLEAF)
LOCATION
TUNBRIDGE WELLS, UK
CREATIVE DIRECTOR
ROBERT SAYELL
CREATIVE TEAM
NICK CHEESMAN

Happy Christmas from
everyone at Greenleaf

"Do not be afraid. I bring you good news of great joy that
will be for all the people. Today in the town of David a
Saviour has been born to you; he is Christ the Lord."

Luke 2:10-11

DESIGN
PSD: FITCH
LOCATION
LEEDS, UK
CREATIVE DIRECTOR
PSD: FITCH
CREATIVE TEAM
CARMEN HOMSY

"We wanted to create a Christmas
mailer that reflects PSD: Fitch's
multi-disciplinary approach and also
something functional that could sit on
the recipient's desk all year round.

"The mailer got a fantastic response
from our clients, who kept the clips
on their desks to hold their memos
and photos."

bright merry snow flake

❄ **Instant Snow**
Do not open until 25th December 2000!
Open and shake for guaranteed snow on Christmas Day.

Make your own Instant Snow

Requirements
Waste paper
Hole punch
Energy
Five minutes

DESIGN
BWA DESIGN
LOCATION
LONDON, UK
CREATIVE DIRECTORS
VALERIE WORSDALE,
WEBSTER WICKHAM
CREATIVE TEAM
JIM DARKE, HELEN BURCHELL

"A sense of humour combined with
creativity is usually our goal for each
Christmas card! As designers we also
have a strong environmental
awareness; therefore, we aim to only
ever use recycled materials – the snow
gave us the chance to recycle many
unused mock-ups!"

DESIGN
FIBRE
LOCATION
LONDON, UK
CREATIVE DIRECTOR
DAVID RAINBIRD
CREATIVE TEAM
NATHAN USMAR LAUDER

"We hate Christmas cards. We avoid them every year. Christmas 2000 was different. We figured that sending a shredded card could be as festive as sending a whole one and a good piece of 'fibre' promotion."

La nostra speranza è

della terra

porti la fine
di tutte le guerre

Love and peace

du monde entier

to bring peace
and tranquility

Corriamo tutto l'anno,
almeno il giorno di Natale,
lasciateci fare le belle statuine!

DESIGN
BALENA CORPORATION
LOCATION
BOLOGNA, ITALY
CREATIVE DIRECTOR
MATTEO RIGHI
CREATIVE TEAM
GEORGIA MATTEINI PALMERINI,
DANIELE VENTURELLI

"The first greeting card was created for
Luciano Pavarotti. It's a booklet with five
different illustrations of Santa Claus
(Classic, Native American, African,
Japanese and Arab). You can create
your own personal Father Christmas.

"The figures of the crib are the real
people who work for the agency.
The meaning of the phrase is a very
beautiful Italian saying that means 'We
rush all year, for Christmas let us do
beautiful statuettes'. To do a 'beautiful
statuette' means to be relaxed and take
a break from working so hard."

DESIGN
HOWDY
LOCATION
LONDON, UK
CREATIVE DIRECTOR
NEIL SMITH
CREATIVE TEAM
SHARON CLAMPIN,
DAMIAN BROWNING,
ANKI WESSLING

"Festive mailings are a good excuse
to contact clients and lapsed clients,
friends and suppliers and to produce
a piece of work that reflects our
personality and approach. They are
also a good excuse to have a bit
of fun."

DESIGN
DE-CONSTRUCT (FORMERLY DEEP-
END)
LOCATION
LONDON, UK
CREATIVE DIRECTOR
ALEX GRIFFIN

"We really wanted to add something
extra to our mailout, and in keeping with
the goodwill of Christmas we supplied a
set of festive transfers so people could
make their own cards or just add some
sparkle to their paperwork!"

DESIGN
HEARD DESIGN
LOCATION
LONDON, UK
CREATIVE DIRECTOR
TIM HEARD

Each team member (creative and non-creative) at Heard was given 24 hours to come up with an image that reminded them of Christmas and New Year. This allowed everyone a chance to contribute their own personal touch, thus portraying the feeling of a 'cohesive working team/environment'.

DESIGN
MARCUS MELTON DESIGN
LOCATION
FRANKLIN, USA
CREATIVE DIRECTOR
MARCUS MELTON

"This was an opportunity to explore alternative techniques, hopefully be innovative, and at the very least spread a little good cheer!"

DESIGN
CACTUS
LOCATION
GLASGOW, UK
CREATIVE DIRECTOR
SIMON DEAR
CREATIVE TEAM
KEVIN LITTLE

This dual-purpose card is both a
Christmas card and a moving (new
address) card. The card carried not only
a replacement bulb but a replacement
address for Cactus as well.

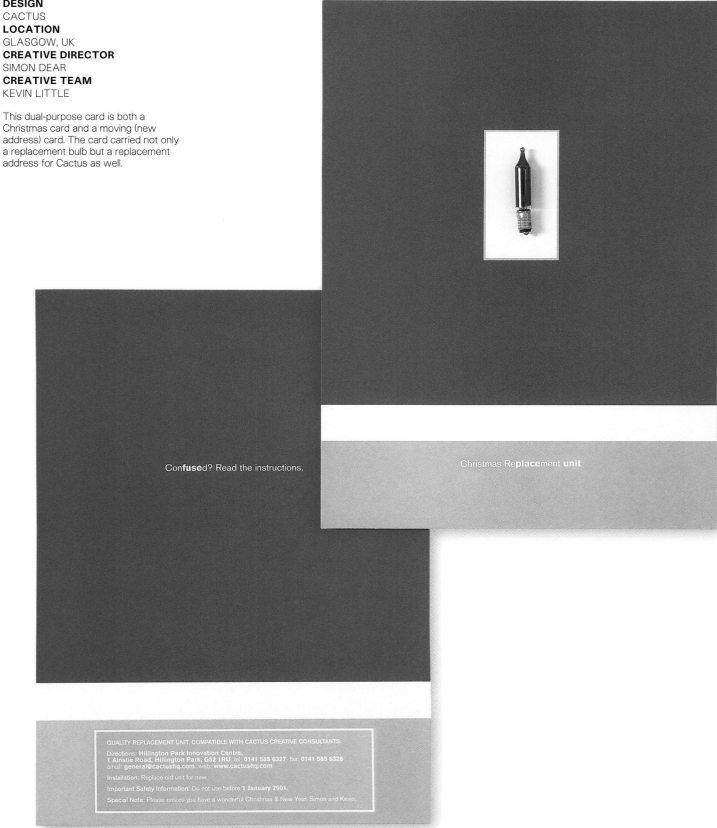

DESIGN
BROWNS
LOCATION
LONDON, UK
CREATIVE DIRECTOR
MIKE TURNER
CREATIVE TEAM
SCOTT MILLER, MIKE ABRAHAM

"To avoid the usual Christmas card,
we thought we would do a book on
religion instead."

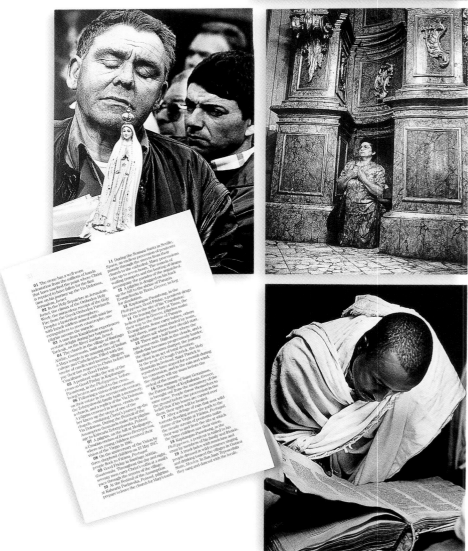

DESIGN
PEMBERTON & WHITEFOORD
LOCATION
LONDON, UK
CREATIVE DIRECTOR
ADRIAN WHITEFOORD
CREATIVE TEAM
RICHARD HENNINGS,
MATT PATTINSON

Christmas is about giving and caring but above all about tolerance! For its Christmas mailers, Pemberton & Whitefoord produced this small book entitled 'White Lies'. The book pokes fun at the minor frustrations we all endure, year in, year out. It is actually more about being kind to each other than lying. The bold illustrations and witty captions sum up the 'grin and bear it' aspect of the festive season perfectly.

and it's the perfect fit, thanks nan…

easy to follow instructions…

a nice quiet Xmas at home with the relatives…

non-shedding Xmas tree…

yes, it is my favourite aftershave…

mum, your icing just melts in the mouth…

DESIGN
INTERBRAND
LOCATION
LONDON, UK
CREATIVE DIRECTOR
MARK SMITH
CREATIVE TEAM
JANE STANYON

"We needed to produce a mailer that fulfilled three objectives: firstly to communicate that Interbrand was moving to new offices in the Strand; secondly to wish our clients and contacts a Happy Christmas and New Year; and finally to inform people that 'Interbrand Newell and Sorrell' would just be called Interbrand."

DESIGN
CHECKLAND KINDLEYSIDES
LOCATION
LEICESTER, UK
CREATIVE DIRECTOR
RICHARD WHITMORE
CREATIVE TEAM
STEVE FARRAR

"We produce a Christmas card every year to send to our clients. Away from the norm, the agency seeks to amuse and pose questions to the recipient (are you a devil... or an angel?). The design uses colours not usually associated with Christmas and a range of print finishes to create a visually interesting piece."

DESIGN
I.D. DESIGNERS
LOCATION
LONDON, UK
CREATIVE DIRECTOR
IVAN DODD

"The two cards selected for this book were chosen from a collection of personal Christmas/New Year cards designed, produced and sent to clients and friends over the last 40+ years."

Do It Yourself
"This is one of the oldest greetings and was produced at the time DIY started to become a UK hobby."

Cigar/Union Jack Fan
"This fan was a 'ready-made' I discovered amongst old stock at a long-gone novelty shop in Islington, London. This find coincided nicely with the 'Establishment Satire' movement of the time (early sixties), which also spawned the Soho satire club, The Establishment, founded by Peter Cook, Dudley Moore and pals."

DO-IT-YOURSELF GREETINGS

ABCDEFGH
JKLMNOPQ
STUVWXYZ
12345678
abcdefghijk
nopqrstuvwx

from Jennifer and Ivan Dodd

DESIGN
DUFFY LONDON
LOCATION
LONDON, UK
CREATIVE DIRECTOR
ADAM WHITAKER
CREATIVE TEAM
JAMES TOWNSEND, LOGAN FISHER

Socks
"A traditional Christmas gift with a Duffy twist – sent to a selection of clients."

Stockings
"We sent out a Christmas stocking filled with traditional items such as nuts and chocolates."

DESIGN
WASSCO
LOCATION
NEW YORK, USA
CREATIVE DIRECTOR
CHIP WASS

"Everybody loves cheese."

DESIGN
CARTER WONG TOMLIN
LOCATION
LONDON, UK
CREATIVE DIRECTOR
PHIL CARTER
CREATIVE TEAM
NEIL HEDGER, NICKY SKINNER,
PHIL WONG, CLARE WIGG,
ALI TOMLIN, JOHN MILLAR,
PETER DUNKLEY, PAUL DUNN

"The idea came from passing travel agents' windows. Various destinations fitting to the festive period were topped off with 'happy holidays' inside.

"We used these Christmas guidelines as a way of showing all the different methods of using type and imagery for Christmas cards."

DESIGN
BIG GROUP
LOCATION
LONDON, UK
CREATIVE DIRECTOR
ERIC WITHAM
CREATIVE TEAM
COLIN GREY

"X-ray – a simple pun on the theme of Xmas that involved x-ray photography of a Christmas tree and fairy lights."

DESIGN
JONES DESIGN GROUP
LOCATION
ATLANTA, USA
CREATIVE DIRECTOR
VICKY JONES
CREATIVE TEAM
BRODY BOYER,
KATHERINE STAGGS,
CAROLINE MCALPINE,
CHRIS MILLER

"Our annual festive mailings serve as an opportunity to passionately collaborate as a team."

DESIGN
SAATCHI & SAATCHI DESIGN
LOCATION
LONDON, UK
CREATIVE DIRECTORS
IAIN ROSS, IAN LANKSBURY
CREATIVE TEAM
PRAD NAIR, RYDAL BOWTELL

In order to design a Christmas card for Saatchi & Saatchi Design conveying seasonal greetings and company values, the designer needs to express and reinforce innovative, imaginative and lateral thought. Here, the printed card element needed to work in construction with an online interactive version. The combined solution provided fun and an imaginative twist on a corporate theme.

DESIGN
PREJEAN LOBUE /
DAVID CARTER DESIGN
ASSOCIATES
LOCATION
LAFAYETTE, LOUISIANA USA /
DALLAS, TEXAS USA
CREATIVE DIRECTOR
GARY LOBUE JR, KEVIN PREJEAN,
LORI B. WILSON
CREATIVE TEAM
SCOTT SIMMONS, LISA PREJEAN,
MAX WRIGHT, LINDA HELTON,
BARBARA LAMBASE,
ROBERT PRINCE,
KEITH GRAVES, KLEIN & WILSON

"To reflect upon and/or celebrate the
past year's events while promoting
our company's capabilities, talents
and personality."

OFFICIAL ARTHAUS FAIRY
FAIRY

CUT HERE
CHRISTMAS™ BAD BAD FAIRY
DO NOT LEAVE THIS FAIRY ALONE IT IS NOT TO BE TRUSTED

bah! CHRISTMAS™

bah!
humbug!

THIS IS A CHRISTMAS-FREE ZONE: GO AWAY

CHRISTMAS™
mr scrooge
OFFICIAL HOME OF THE ARTHAUS MR SCROOGE

COMPLETE NON-BELIEVER
DO NOT BOTHER ME WITH MERRIMENT
I LIKE TO BE MISERABLE
ACCESS STRICTLY PROHIBITED
ALL RESTRICTIONS APPLY

ANOTHER DEVICE BROUGHT TO YOU BY ARTHAUS

CHRISTMAS™
DAINTY DANCIN' SANTA
CUT/INSERT/LIMBER//DANCE
EVERYONE LOVES SANTA. ADULTS AND CHILDREN WILL ENJOY THIS DAINTY DANCING VERSION. CUT AND CUDDLY AND BEAMING CHRISTMAS CHEER, WATCH HIM AMAZINGLY COME TO LIFE. SIMPLY CUT-OUT THE FINGERHOLES AND MAKE HIM DANCE. ALWAYS MAKE IT FUNKY.

OFFICIAL ARTHAUS FATHER CHRISTMAS
SANTA

XMAS FESTIVE SPIRIT
ARTHAUS

CHRISTMAS™
mr scrooge door hanger
CUT//HANG//SIT//SULK
THE PERFECT SOLUTION FOR THOSE WHO CAN'T ABIDE SOCIAL MOANERS WHO CAN'T ANSWER FOR THE ANT ABIDE KEEP CHRISTMAS AT LAST, AN ANSWER FOR THE ANT ABIDE CHRISTMAS AT LAST. AT LAST AN ANSWER FOR THE ANT ABIDE SOCIAL MOANERS WHO CAN'T TOLERATE THE TINSEL. CHRISTMAS OUT—AND MAY IT STAY OUT.

DESIGN
ARTHAUS VISUAL COMMS LTD
LOCATION
MARLOW, UK
CREATIVE DIRECTOR
ADRIAN METCALFE
CREATIVE TEAM
RICHARD JONES

Love it or hate it, alleged festive fun is hard to avoid. The combination of modern-day over-exposure, commercialism and the 'Groundhog Day' analogy make quite a Christmas cocktail. Arthaus used these factors to produce a number of amusing cut-out-and-keep survival items contained in a card. Items included the Mr Brahms and Lizst put-me-in-a-taxi card, the emergency bad fairy, a sullen Santa and the pulling power of some emergency mistletoe. It was all branded under the title 'Christmas TM' as a tribute to its own evolution. The only thing they couldn't cater for were those Brussels sprouts.

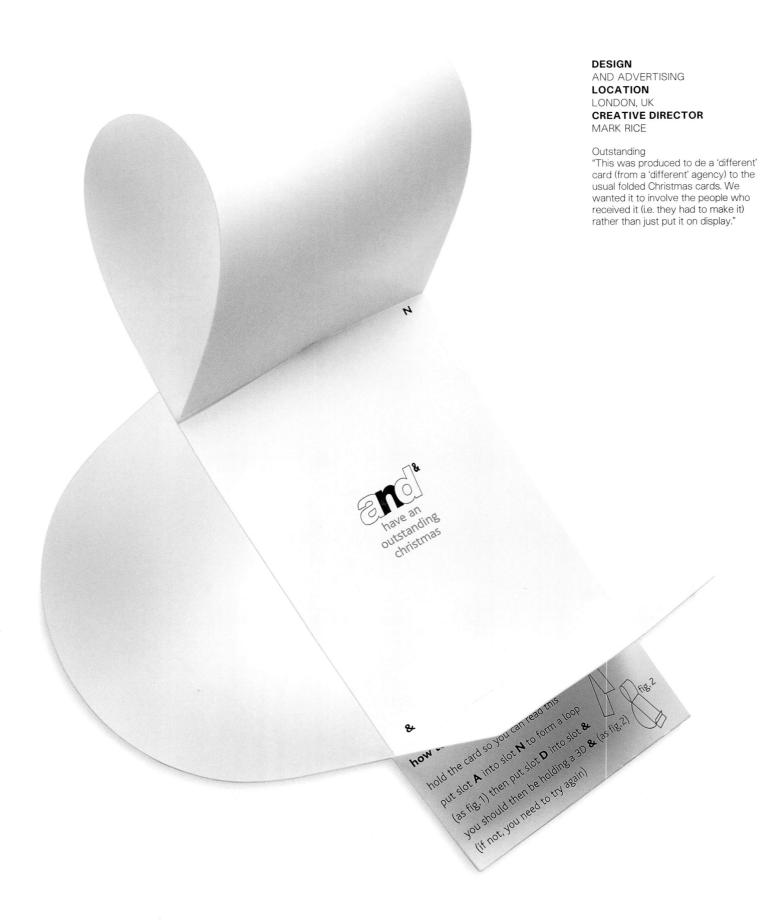

DESIGN
AND ADVERTISING
LOCATION
LONDON, UK
CREATIVE DIRECTOR
MARK RICE

Outstanding
"This was produced to de a 'different'
card (from a 'different' agency) to the
usual folded Christmas cards. We
wanted it to involve the people who
received it (i.e. they had to make it)
rather than just put it on display."

N

and&
have an
outstanding
christmas

&

how

fig. 2

fig. 2

hold the card so you can read this
put slot **A** into slot **N** to form a loop
(as fig. 1) then put slot **D** into slot **&**
you should then be holding a 3D **&** (as fig. 2)
(if not, you need to try again)

DESIGN
CONRAN DESIGN GROUP
LOCATION
LONDON, UK
CREATIVE DIRECTOR
SASHA VIDAKOVIC
CREATIVE TEAM
CAROLINE MEE, DOMENIC MINIERI
& ALL AT CONRAN DESIGN GROUP

Trees From Everyone
"Often Christmas cards from a company can seem very corporate and impersonal. We wanted to show that our card was from everyone at Conran Design Group, as it's the co-operation of our whole team, from the receptionist to the designers, directors and financial administrators, that make us who we are. Getting everyone to design a tree showed the variety of ways in which we approach projects and gave a real feeling of inclusion between all our staff."

Hugging
"The action of hugging is so simple and rewarding, yet, as a society, it is something we seem to have forgotten how to do. The card was a reminder of this."

Our step by step guide to spreading cheer and goodwill...

Sasha

Everyone at Conran Design Group wishes you all the best for the holiday season.

DESIGN
VANILLA DESIGN
LOCATION
GLASGOW, UK
CREATIVE DIRECTOR
ELIZABETH CARTER

"Instant snowman kit. Just add snow."

Merry Christmas and a Happy New Year.

INSTRUCTIONS

CONTENTS

FIG. 01 BUILD SNOWMAN.

Hat and scarf optional.

FIG. 02 ADD BUTTONS.

Place buttons as shown in illustration.

FIG. 03 ATTACH NOSE.

Attach cone here.

x 6

x 1

Vanilla Design 3/2 Canada Court 81 Miller Street Glasgow G1 1EB 0141.204.0782 info@vanilladesign.co.uk www.vanilladesign.co.uk

BEST BEFORE END
WINTER 2002

DESIGN
STATICREATIVE DESIGN STUDIO
LOCATION
BUFFALO, USA
CREATIVE DIRECTOR
CHAD DAVID SHEARER
CREATIVE TEAM
IAN MCDOWELL

"In the past, we have sent out greetings to celebrate the holidays and keep our studio fresh in people's minds. This was the first year we incorporated a marketing slant to it. The results were beyond our expectations."

DESIGN
NLA
LOCATION
LONDON, UK
CREATIVE DIRECTOR
PETER OVERY

NLA is a sister company to New Leaf,
which is a creative production
services company. Every year since
conception, New Leaf has produced a
Christmas card to send out to clients
and friends.

a cynically transparent sales message

Wishing you all the best thirdperson.
year and a very ications for your business.
everyone at Thirdperson

a genuine message of seasonal goodwill

DESIGN
THIRDPERSON
LOCATION
LONDON, UK
CREATIVE DIRECTORS
RICHARD NEWEY, TIM REED

"It was our first year and we faced
the seasonal business dilemma
as to whether to add a sales message
to a company Christmas card.
We were unsure, so we did both,
using the trace paper to obscure
the alternative message."

DESIGN
BELYEA
LOCATION
SEATTLE, USA
CREATIVE DIRECTOR
PATRICIA BELYEA
CREATIVE TEAM
NAOMI MURPHY, ROSANNE OLSON,
NANCY STENZ, RON LARS HANSEN,
JOCELYN CURRY, ANNE BUCKLEY

4 + 20 Blackbirds
"It was impossible to refuse when a
premium printer, 2,000 miles away from
Seattle, asked us to design a desktop
calendar featuring Rosanne Olson's
work. Her new body of fine art
photography was a delicious fantasy of
figures and feathered friends. The stark
black and white images (produced as
tritones) were paired with the edgy
calligraphy of Nancy Stentz to
produce a memorable calendar."

Pinhole Travels Calendar
"After shooting with her pinhole camera
for two years, Rosanne Olson had a
collection of incredible and moody
images. These were the inspiration for
Belyea's 1999 gift calendar."

Flora Calendar
"Belyea had a tradition of creating arty
calendars as collaborations between
our design firm, photographer Rosanne
Olson and The Allied Printers. The
printer asked us to develop a more
conventional concept, such as flowers.
We readily agreed, knowing that our
flower calendar would be like no other."

DESIGN
HOOP ASSOCIATES
LOCATION
LONDON, UK
CREATIVE DIRECTOR
PAUL NUNNELEY
CREATIVE TEAM
RUSSELL WEIGHTON

"As we all know, Christmas is an extremely dangerous time of year. With poisonous liquids, noxious vapours, harmful foodstuffs, as well as hazardous jumpers and anxiety-inducing TV to contend with, we felt it was necessary to issue festive safety instructions."

DESIGN
BLØK DESIGN
LOCATION
TORONTO, CANADA

"This project was a wonderful excuse
to experiment with patterns, colours
and forms and share with both our
clients and friends the passion we have
for the essential aspects of design."

to **from** **merry**

☐ Sonya	
☐ Sophie	
☐ Stavros	
☐ Stefanie	
☐ Stephen	
☐ Steve	
☐ Stewart	
☐ Stuart	
☐ Sue	
☐ Susanna	
☐ Tad	
☐ Tiffany	
☐ Tim	
☐ Tina	
☐ Tommy	
☐ Tony	
☐ Tracey	
☐ Tracy	
☐ Ulrika	
☐ Vernon	
☐ Vicky	
☐ Victoria	
☐ Viv	
☐ Vivienne	
☐ Wayne	
☐ Wendy	
☐ William	
☐ Xena	
☐ Yvonne	
☐ Zoe	

☐ Alan	☐ Julie
☐ Andy	☐ Kevin
☐ Ben	☐ Lionel
☐ Betty	☐ Lise
☐ Billy	☐ Mala
☐ Catherine	☐ Michael
☐ Chris	☐ Mike
☐ Clare	☐ Oliver
☐ Debbie	☐ Peter
☐ Eileen	☐ Rachel
☐ Faye	☐ Robin
☐ Harriet	☐ Sandra
☐ Ivan	☒ Simon
☐ Jimmy	☐ Steve

Best wishes Best wishes

Please detach the relevant reply card (Manchester or Leeds address) indicating your preferred charity and post back to us. We will then make a £5.00 donation on your behalf.

This year we thought it would be nice if we donated your Christmas gift to a children's charity. We figured you'd support this gesture and appreciate the added bonus of one less hangover.

the chase
Manchester

the chase
Leeds

DESIGN
THE CHASE
LOCATION
MANCHESTER, UK
CREATIVE DIRECTOR
BEN CASEY
CREATIVE TEAM
HARRIET DEVOY, STEVE ROYLE

"Every year we try to produce a Christmas card that has a bit more thought to raise an eyebrow or a smile from our client/suppliers/friends. The 'Wishbone' idea related to the fact that we would make a donation to a charity of the recipients' choice instead of giving presents, whilst the 'X marks the Spot' was a clever observation, stylishly executed."

DESIGN
SAVAGE DESIGN GROUP INC
LOCATION
HOUSTON, USA
CREATIVE DIRECTOR
PAULA SAVAGE
CREATIVE TEAM
DAHLIA SALAZAR, TERRY VINE,
MICHAEL HART, BO BOTHE,
JAY STEVENS, ROBIN TOOMS

The Little Book of Big Wishes
"Using a two-colour format, the
book expresses a personal
goodwill wish from every person
in the studio. An online version of
the book was also created in a
'wish-a-day' calendar format
complete with animation and sound."

Wrap It Up
"Savage Design's holiday wrapping
series is based on our principle of
'moving communications'. We created
the different styles by breaking into
teams and each member 'built' upon
the imagery of another team member."

Stardust
"To help lighten the holiday rush and
spread holiday cheer, Savage Design
Group created an eclectic greetings
card that recipients could enjoy and
then personally use. Each card is
unique in style, and the series was
designed to appeal to a wide variety
of personalities."

wrap it up

DESIGN
CRENEAU INTERNATIONAL
LOCATION
LONDON, UK
CREATIVE DIRECTOR
WILL ERENS

"My table at home is too small to sit all my friends at – this allows them to eat Christmas dinner with me!"

CRÉNEAU INTERNATIONAL DESIGN

Wild Turkey in Curried Rice

Ingredients: rice, wild turkey, powdered butter fat, powdered cream, starch, seasoning, freeze-dried fruits (banana, pineapple), almonds, curry, iodised sea salt, sugar, guarken flour thickener, citric acid, silicic acid.
Dried meat content: 8g (equals approx. 40 g fresh meat)

net weight 125 g
added water 300 ml
ready quantity 425 g
package provides:
1 portion à 425 g

average nutritional
values per portion:
protein 17,4 g
fat 11,5 g
carbohydrates 74,0 g
kcal/kJ 469/1959
best before:
03.2003

To prepare: Stir contents into boiling water and simmer for approx. 8 minutes.

D–HE
ELIZ-215
EWG

Packaged in a
protective atmosphere
L008

4 015753 050017

CRÉNEAU INTERNATIONAL DESIGN IZ DE ROODE BERG HELLEBEEMDEN 13 B-3500 HASSELT BELGIUM
T +32 11 28 47 00 F +32 11 28 47 01 E info@creneau.com W www.creneau.com

DESIGN
LEWIS MOBERLY
LOCATION
LONDON, UK
CREATIVE DIRECTOR
MARY LEWIS
CREATIVE TEAM
MARGARET NOLAN,
PAUL CILIA LA CORTE

"The wording on each of the windows relates to something associated with Christmas. Inside, each window reveals a relevant piece of Lewis Moberly work. This card tells us a story of the seasons of change from spring, summer, autumn and winter through an ingenious series of laser-cut shapes, and also is a pun on the word 'seasons'."

Star of Wonder

For centuries we've looked to the stars for guidance. Humbled by the darkness, the twinkling beacon draws us closer to our destination. • • • • • As we go forward in this season of celebration, we hope this small reminder will guide you and yours into the coming year.

DESIGN
RICKABAUGH GRAPHICS
LOCATION
COLUMBUS, USA
CREATIVE DIRECTOR
ERIC RICKABAUGH
CREATIVE TEAM
MARK KRUMEL AND
RICKABAUGH GRAPHICS

Holiday Toast
"When we created this holiday promotion we were still giving clients gifts at the holidays. What better than a nice wooden box filled with some holiday spirit? The label was a play on the words 'Holiday Toast'. Though we now take all this money and donate it to charities, this was a most memorable gift."

Star of Wonder
This holiday promotion, all built around the theme of stars, featured two custom-designed sheets of wrapping paper.

THERE'S SOMETHING
FOR YOUR SAKE

LITTLE
HOLIDAY
TOAST

FROM YOUR FRIENDS AT
RICKABAUGH GRAPHICS

S.Y.
304877
53

**WARRE'S
WARRIOR
PORTO**

DESIGN
NB:STUDIO
LOCATION
LONDON, UK

"For Fun!!!"

Festive sticker set

DESIGN
APART
LOCATION
ZURICH, SWITZERLAND
CREATIVE DIRECTOR
FRY GIONI
CREATIVE TEAM
CONNY JAGER, JULIA STAAT,
SILKE SCHMEING,
TANYA SCHATEMANN

"At Christmas time we wanted to surprise our clients with a gift that would contain both the aim of our agency Apart and the personality of our employees. The logo of Apart is a cat, therefore we illustrated ourselves as cats. Each of the six cats came with the typical character of the single person. In addition, every employee designed ten of the different wrappings."

apart giavischa in sonor
e dultschin nadal plein
bienas, bunas ed autras
carinadads per tgierp
ed olma. cordial engrazia-
ment per la fritgeivla
collaboraziun.

DESIGN
NAME
LOCATION
LEEDS, UK
CREATIVE DIRECTOR
MICHAEL HARRIS
CREATIVE TEAM
STUART MOREY

Created as a series of 12, each mailout contained a Christmas cracker novelty, motto and hat. Each set was vacuum packed and mailed with an address label and stamp on the reverse. This was a lightweight, cost-effective and, above all, fun solution that generated a 'swapsies' situation in marketing departments across the country.

Scott Witham
Deadline 21
25 Calderwood Road
Rutherglen
Glasgow
Scotland
G73 3HD

DESIGN
BLEED
LOCATION
OSLO, NORWAY

"This was a web-based game for Bleed
clients and friends. For the highest scores
we sent out T-shirts as prizes."

DESIGN
RALPH SELBY ASSOCIATES
LOCATION
WIRKSWORTH, UK
CREATIVE DIRECTOR
RALPH SELBY

"Each year at Christmas we give our friends and clients a new toy – always a tree and always a different material or process."

DESIGN
CRESCENT LODGE DESIGN
LOCATION
LONDON, UK
CREATIVE DIRECTOR
LYNDA BROCKBANK
CREATIVE TEAM
JANE TOBITT, MELISSA MAYES,
DUNCAN PARE

"These are warm, end-of-the-year greetings – objects rather than cards, gifts intended to celebrate the relationships we have with all the people we work with. They aren't traditional Christmas greetings because not everyone celebrates Christmas. To an extent they are self promotional and when you are the client, it's tempting to show off a bit."

DESIGN
CORE 77
LOCATION
NEW YORK, USA
CREATIVE DIRECTOR
ALLAN CHOCHINOV

"We send a mailing every year, and we always try to do a memorable object rather than a card. In this time of economic uncertainty, an object with 2002 uses is always welcome."

DESIGN
GLAZER
LOCATION
LONDON, UK
CREATIVE DIRECTOR
DAVID JONES
CREATIVE TEAM
CLARE BRITTLE, SOPHIE HAYES,
GEOFF APPLETON,
RICHARD HOLLIM

Pantomime
"Following in the tradition of the
Christmas pantomime, we thought we
would design our own spoof panto
poster for our 2001 mailing."

Nativity
"The 2001 card took the form of an
off-the-shelf nativity scene. Glazer
employees were combined with
illustrations of the nativity cast and
die-cut so they could be arranged
against a backdrop of the stable."

'Rapping' Paper
"We wanted to produce a mailing that
would be useful and raise a smile. So
for 1999, we designed an A1 sheet of
wrapping paper with a 'rapping'
message on it."

DESIGN
TAXI ADVERTISING & DESIGN
LOCATION
TORONTO & MONTREAL, CANADA
CREATIVE DIRECTOR
PAUL LAVOIE

"This card cut though the holiday clutter by including a practical way for clients and friends to celebrate safely and remember our brand name: a taxi chit."

"Direct mail is our main method of promotion, and festive mailings are a great way to keep in touch with our database."

SPRINGETTS
Christmas Packaging

DESIGN
CDT DESIGN LTD
LOCATION
LONDON, UK
CREATIVE DIRECTORS
NEIL WALKER, MIKE DEMPSEY
CREATIVE TEAM
ANDY SEYMOUR, PAUL ZAC

DESIGN
LABEL COMMUNICATIONS
LOCATION
GENEVA, SWITZERLAND
CREATIVE DIRECTOR
PATRIC BUETIKOFER
CREATIVE TEAM
ELLA OED MANN, VINCENT
THEVENON, VLADIMIR MARTI

"Our Christmas cards are produced to
thank the clients and to push the
agency's creative limits."

Merci!

Merci encore!

De toujours nous en demander davantage...

Merci encore!

Ainsi, cette carte de vœux est un peu la vôtre.

Toute l'équipe de Label Communication vous
remercie de votre confiance. Surtout, nous
vous souhaitons d'excellentes fêtes et vous
donnons rendez-vous l'année prochaine pour
construire ensemble de nouveaux concepts.

DESIGN
344 DESIGN LLC
LOCATION
LOS ANGELES, USA
CREATIVE DIRECTOR
STEFAN G BUCHER

"The whole point of 344 is to create objects you can fall in love with.

"I keep the company branding to a minimum because these are gifts and I want people to be able to hang them without feeling that I am out to hawk my wares. There is no phone number, address, website or even the word 'design', just 344, that's it. A secret handshake for friends and family. (And yes, there are hidden messages for the very, very attentive. Never underestimate the power of 4 point type and varnish.)"

DESIGN
WHY NOT ASSOCIATES
LOCATION
LONDON, UK
CREATIVE TEAM
WHY NOT ASSOCIATES
EXTRA MATERIAL BY
ROCCO REDONDO, PHOTODISC

DESIGN
ONIO DESIGN PVT LTD
LOCATION
PUNE, INDIA
CREATIVE DIRECTOR
MANOJ KOTHARI
CREATIVE TEAM
PRAKASH KHANZODE

"We wanted to mail something that people could use and not throw in the dustbin after a day. 'Diwali' is a festival of light, so something 'creative and usable' was the target behind this."

On this festival of light a
small endeavor from ONIO
to brighten your home
- a handmade paper lamp enclosed.

Unfold Open & Mount

* To avoid
overheating
of the lamp
please use 25W bulb

1. 2. 3. 4 5.

May this Diwali bring to you and your
family joy, peace and health for the year ahead.

Prakash Khanzode and Manoj Kothari
ONIO DESIGN
Email- onio2@giaspn01.vsnl.net.in

Office-
E-14, Srichetan Hsg. Society
47/1 Aundh Road, Pune -411 003
Ph- 0212-316262

DIWALI 98' WISHES

DESIGN
GBH
LOCATION
LONDON, UK
CREATIVE DIRECTORS
JASON GREGORY, PETER HALE,
MARK BONNER

GBH made the observation that December 25th isn't just Christmas but a very special birthday too. "One thing led to another and soon we had a full-blown birthday card, complete with a real 'I am 2001' badge. In order not to offend, the legend inside read 'For God's sake it's just a joke'."

For God's sake it's just a joke!

DESIGN
CATO PURNELL & PARTNERS
LOCATION
MELBOURNE, AUSTRALIA

"The festive mailing was created as part of our 'broader visual language'."

DESIGN
DEVER DESIGNS
LOCATION
LAUREL, USA
CREATIVE DIRECTOR
JEFFREY L DEVER

"We always try to create something unusual that will be recognised as spiritual, but not overtly religious, for the holiday season and particularly the New Year season. For this card, we used the metaphor of time as a gift, which was further enhanced by the use of a ribbon."

TIME is a gift,
an allotment in our lives.
Each year
a new beginning
unfolds without reprise.

Our prayer is on this sojourn
our paths will cross
again.
With yet another traveler
that we might count a friend.

A BLEST NEW YEAR FROM
Dever Designs

Why do you
say that?

DESIGN
PENTAGRAM DESIGN LTD
LOCATION
LONDON, UK
CREATIVE DIRECTORS
JOHN MCCONNELL,
DAVID HILLMAN
CREATIVE TEAM
LAURA COLEY, PENTAGRAM
DESIGN LTD

Each year for Christmas, Pentagram designs and publishes a small booklet and sends it to friends, colleagues and clients. These annual greetings booklets are intended to provide diversions in the less busy moments of the Christmas and New Year season. The booklets traditionally avoid any reference to the festive season, adopting a strong graphic vocabulary in order to set them apart from the myriad of cards received during the period.

All the King's Horses
This idea employs a distinctly graphic take on the traditional jigsaw puzzle. Nine graphic icons (including 'Ladies' and 'Gentlemen' toilet signs, a train and a telephone) were chopped up and rearranged to create a series of abstract images. The challenge was to guess the final icon. Answers are provided inside the back cover of the booklet.

Why Do You Say That?
We say them all the time – phrases so familiar we rarely think what they mean or where they come from. Here are just a few, with a visual clue to each so that you can figure out why they mean what they do. If you still can't work out how these things became such popular and commonly used expressions in the English language, the answers are on the back.

'Bloody computer
crashed, and I'm
at the end of my
tether'

'So it's <u>back to</u>
<u>square one</u> for
the design team'

All the King's horses

DESIGN
PCI : LIVE
LOCATION
LONDON, UK
CREATIVE DIRECTORS
FELICITY KELLY, DAVID MORGAN
CREATIVE TEAM
NADINE AKHRAS, TIKI GRAVES,
FRIXOS AFXENTIOU

"There was no immediate criteria for last year's Christmas card other than it had to be fun and endure the festive season. We wanted to create a piece of direct mail/marketing that people would react to with a smile. The animation on the CD gave us an opportunity to explore different media and have some festive fun and cheer!

"A great way to combine some corporate values and an interactive piece of direct mail, our Christmas tree brought to life what we as an events company stood for: excitement, creativity, face-to-face business, interactivity, light-heartedness and wit! A combination of a Christmas greeting and company cheer."

DESIGN
KYSEN COMMUNICATIONS GROUP
LOCATION
LONDON, UK
CREATIVE DIRECTOR
NICK O'TOOLE

"Sometimes our solutions are unusual; on other occasions they are refreshingly simple and different.

"Kysen has spent the past ten years following this design philosophy and, judging by the smiles, we managed to achieve just that with the Christmas and Millennium cards that we sent out to our clients."

DESIGN
BLUE STUDIOS
LOCATION
BALTIMORE, USA
CREATIVE DIRECTOR
KEN FEURER
CREATIVE TEAM
LEO BATTERSBY,
DAVE WHEELOCK

"We view the holiday mailer as a nice way to thank clients and friends for their support through the year and as a fun way to showcase our creativity."

DESIGN
FIELD DESIGN CONSULTANTS LTD
LOCATION
LONDON, UK
CREATIVE DIRECTOR
NIGEL ROBERTS

"Rather than sending a company brochure to prospective clients, we decided to direct them towards our website by means of an unusual seasonal mailer. We like the idea that the mittens would be cool but also practical, and that people would really enjoy wearing them."

A VERY SHINY NOSE

SEE THE BLAZING YULE BEFORE US

LET STEEPLE BELLS BE SWUNGEN

TROLL THE ANCIENT YULETIDE CAROL

OH WHAT FUN

SHEPHERDS QUAKE AT THE SIGHT

THE HOLLY BEARS A BERRY

FOLLOW ME IN MERRY MEASURE

SHEPHERDS WHY THIS JUBILEE?

BRING ME PINE LOGS HITHER

WE ALL LIKE FIGGY PUDDING

DON WE NOW OUR GAY APPAREL

DESIGN
BOB'S YOUR UNCLE
LOCATION
BOSTON, USA
CREATIVE DIRECTOR
MARTIN YEELES
CREATIVE TEAM
MARK FISHER

The calendars were produced as a useful gift and desktop reminders to current and prospective clients.

200!

A CALENDAR OF BRITISH EXCLAMATIONS

tin design

Codswallop!

JANUARY

mon	tue	wed	thu	fri		sat	sun
1	2	3	4	5		6	7
8	9	10	11	12		13	14
15	16	17	18	19		20	21
22	23	24	25	26		27	28
29	30	31					

TIN

A Calendar of British Expressions

Designed by Martin Yeeles at Tin Design | 617.923.8976

1998

Illustrations by Mark Fisher | 978.392.0303

February

						1							
2	3	4	5	6	7	8	9	10	11	12	13	14	15
16	17	18	19	20	21	22	23	24	25	26	27	28	

Thick as two short planks | Really stupid

CAPRICORN
AQUARIUS
PISCES
ARIES
TAURUS
GEMINI
CANCER
LEO
VIRGO
LIBRA
SCORPIO
SAGITTARIUS

2002

CAPRICORN
PATIENT
WRY
DISCIPLINED
PESSIMIST

DECEMBER **JANUARY**

22 23 24 25 26 27 28 29 **30** 31 1 2 3 4 5 **6** 7 8 9 10 11 **12** **13** 14 15 16 17 18 **19 20**

DESIGN
TWIST CREATIVE INC
LOCATION
CLEVELAND, USA
CREATIVE DIRECTOR
CONNIE OZAN
CREATIVE TEAM
NICHOLL JENSEN, MICHAEL OZAN

"The Twist self-promotion is a
celebration of the launch of our
new name. We chose to send our
clients, friends, family and prospects
a holiday gift that celebrates giving.
Each piece of original art is in a
postcard form. We have included
pencils and stickers for a complete
stationery set. It is an art you share."

DESIGN
NOFRONTIERE
LOCATION
VIENNA, AUSTRIA
CREATIVE DIRECTOR
MAURITIO POLETTO
CREATIVE TEAM
ENRICO BRAVI

"Our goal was to produce 'different' Christmas cards – not the tree, not Santa Claus, no clichés so we decided to produce a collection of our logos and wish everybody in all languages a Merry Christmas. 300 cards were produced; all of these are numbered and unique."

"DEAR NOFRONTIERE I LIKE YOUR LOGO"
A CALCULATED RANDOMNESS FROM A SEA OF PROBABILITY.

"DEAR NOFRONTIERE I LIKE YOUR LOGO"
A CALCULATED RANDOMNESS FROM A SEA OF PROBABILITY.

"DEAR NOFRONTIERE I LIKE YOUR LOGO"
A CALCULATED RANDOMNESS FROM A SEA OF PROBABILITY.

Frohe Weihnachten und ein gutes neues Jahr!
Merry Christmas and a Happy New Year!
Buon natale e felice anno nuovo!
Joyeux Noel et une bonne année novelle!
Veselé vánoce a šťastný nový rok!
God jul og godt nytt år!
God jul och gott nytt år !
God jul og godt nytår!
Boże Narodzenie i szczeslίwy nowy rok!
Sretan bozic i novu godinu!
Frohi Wienacht, u n'äs guets Nois!
Kellemes Karácsonyi Unnepeket és Boldog Uj Évet!

NOFRONTIERE TONGUES IN DECEMBER 2001

N. COPIES	14 J / 337
YEAR	2001
SIGNATURE	

LIMITED EDITION PRINT / AUTHENTICATED BY THE ARTIST.
CREATE YOUR OWN ARTWORK AT WWW.NOFRONTIERE.COM/PS

KISS

MY

ASS

DESIGN
HEAD TO HEAD
LOCATION
LONDON, UK
CREATIVE DIRECTOR
WALTER DENNY
CREATIVE TEAM
TOBY ORTON

"As an agency our business is all about grabbing attention, so a Christmas card is a good opportunity to show what we can do. Our festive mailing has to cut through the layers of clutter that engulf most clients' desks at Christmas. It also had to be relevant and capture the personality of the agency."

merry christmas
from head to head

DESIGN
PYRAMID ID
LOCATION
LEAMINGTON SPA, UK
CREATIVE DIRECTOR
PAUL HARTLEY
CREATIVE TEAM
DAVID MARTIN

"Pyramid endeavour to produce a festive greeting card and present each year for our clients and aim to make it useful as well as creative. The 'I hate Xmas' mailing was humorous and I'm sure many people feel the same way as Scrooge!"

Twinkle, Twinkle
Little Star

SYSTEM DESIGN PLC

I HATE CHRISTMAS

Ebenezer Scrooge 1843

DESIGN
CUTTS CREATIVE
LOCATION
BRISBANE, AUSTRALIA
CREATIVE DIRECTOR
HANNAH CUTTS
CREATIVE TEAM
JESSIE CUTTS, LETICIA MORAN,
RACHEL ARTHUR

"Each year we create a January to
January calendar as a present for
clients. They are simple and meant to
be scribbled upon. Photos in them are
from holidays to reinforce that they
have a good Christmas vacation."

DESIGN
ZEN DESIGN GROUP
LOCATION
BERKLEY, USA
CREATIVE DIRECTOR
SUN YU
CREATIVE TEAM
KOK HWA CHUNG, MARIE GEBBIA

The Zen Design Group decided to
usher in 2002 by using the horse in
their holiday clamshell, representing
their area of expertise, packaging
design. The recipient can enjoy the
origami ornament or become proactive
with the instructions and additional
paper supplied within the package.

DESIGN
ABM
LOCATION
BARCELONA, SPAIN
CREATIVE DIRECTOR
JAUME ANGLADA
CREATIVE TEAM
NACHO TABARES, JAUME DIANA,
ISABEL BENAVIDES, IVAN BAQUÉRO

"During the week before Christmas the image of pine cones started to appear – on the notice boards, between the sheets of a document, in the rest rooms etc. Closer to Christmas Day, the number of pine cones increased. The last day before the holidays, at the end of the Christmas dinner, cards were given to everybody with 'we are a pine cone' written on them. (In Spanish this expression means 'we are the whole thing', 'we are together'.)"

Merry Christmas /HNY2002

DESIGN
PAUL GRAY
LOCATION
GLASGOW, UK
CREATIVE DIRECTOR
PAUL GRAY

"A personal Christmas mailing from myself and my partner to add the personal touch."

LOGO	ADDRESS	TELEPHONE	E MAIL	WITH OUR LOVE
	Apartment 7	0141 887 7202	GrayAprtmntsvn@aol.com	Paul
	Orr Square Church			Lisa
	Orr Square			
	Oakshaw			
	Paisley			
	PA1 2DL			

DESIGN
FRCH DESIGN WORLDWIDE
LOCATION
CINCINNATI, USA
CREATIVE DIRECTOR
CINDY NOEL

"Our holiday card becomes a sculpture that can remain on the recipient's desk for a whole year."

'tis the season
COLOR IT BRIGHT

DESIGN
WYSIWYG COMMUNICATIONS
LOCATION
CALCUTTA, INDIA
CREATIVE DIRECTOR
NIDHI HARLALKA
CREATIVE TEAM
MOUSIM MITRA, MIHIR CHANCHANI

"A holiday mailer represents a unique opportunity. It allows us to greet our clients and gives us a chance to showcase our design talent without any restrictions of colour and shape. Free to operate as we like, we give our imaginations full rein."

DESIGN
SINCLAIR/LEE
LOCATION
BRISBANE, AUSTRALIA
CREATIVE TEAM
NATALIE TAYLOR,
CATHERINE KERR

"This self-promotional piece is a three-dimensional card that the recipient assembles. It is an interactive solution to the age-old problem of producing a Christmas card that stands out among the masses and has an extended life.

"Our firm's idea of a fabulous Christmas holiday was the emotion behind the creation of this piece."

DESIGN
FOUNDATION 33
LOCATION
LONDON, UK
CREATIVE DIRECTOR
DANIEL EATOCK

"To make people happy and to spread love."

Christmas & New Year Greeting Card 1997/1998

SECTION ONE

Using a red felt pen tick box to indicate the recipient/s of this card

AKAMA	CURRIE	KNOWLES	SCHOFIELD
ALTMAN	DAVIES	LAMB	SCHUMACHER
ANDERSEN	DISLEY	LATHAM	SHAW
ASHTON	EATOCK	LAYCOCK	SHIELDS
ATACK	EDWARDS	LEES	SMITH
BAKER	EVANS	LEWIS	STRINGFELLOW
BARLOW	FORSTER	LINDSAY*	SWIFT
BARNES	FREER	McCOY	TAYLOR
BARONNE	GAIN	McLOUGHLIN	THOMPSON
BASSET	GARRETT	METCALFE	TURNBULL
BEARDSWORTH	GEE	MORRIS	TURNER
BELLAMY	GERRARD	MURPHY	TWIST
BELLINGHAM	HARRISON	MUSKETT	UNWIN
BLEAKLEY	HASLAM	NEIL	YATES
BLETCHLEY	HEATON	OWEN	YU
BOOTHMAN	HENN	OLIVIER	VERALL
BRADBURN	HINDLEY	PATTISON	WADDLE
BUTTERFIELD	HOLLEY	RADATSZ	WADSWORTH
CARR	HOLT	REDDY	WARD
CARTLEDGE	HOWARD	RHEAD	WHALLEY
CAWLEY	IRVING	RIGBY	WHATMOUGH
CLARK	JOANNOU	ROSS	WHILE
COOMBES	JONES	ROYLE	WILKINSON

No responsibility can be accepted for names that have been incorrectly spelt

If surname does not appear on the mailing list complete Section Two

SECTION TWO

Only complete this section if the surname is not listed in Section One

Surnames added to this section will be added to next year's official mailing list and will annually receive Christmas cards.

Mr Mrs Miss Ms

Card invalid unless a surname has been specified in Sections One or Two

OCCASION CARD

Before giving card, tick the box relevant to the occasion being celebrated.

- ☐ Birthday
- ☐ Valentine
- ☐ Mother's Day
- ☐ Easter
- ☐ Father's Day
- ☐ Christmas
- ☐ New Year
- ☐ Anniversary
- ☐ Good luck
- ☐ Congratulations
- ☐ Well done
- ☐ Other*

*Please specify

↑ A MESSAGE OF NO MORE THAN FIFTY WORDS SHOULD BE HAND-WRITTEN INSIDE THIS CARD

HAPPY CHRISTMAS 1996

ONLY VALID FOR PERSONS NAMED BELOW

NATIONAL LOTTERY TICKET. *PLAY THE GAME AND SEE IF YOU'VE WON!*
PRIZES RANGE FROM £1 TO £25,000. OVERALL ODDS OF WINNING ARE APPROX. 1 IN 4.55

IF YOU CAN READ THIS THEN YOUR NATIONAL LOTTERY TICKET HAS BEEN NICKED!

*FOR PLAY INSTRUCTIONS SEE INSIDE CARD DO NOT DETACH

WE CANNOT ACCEPT RESPONSIBILITY FOR LOSS OF THIS LOTTERY TICKET. NOT EXCHANGEABLE FOR CASH FROM SENDER

↑ PLACE THIS WAY UP ON TOP OF MANTLEPIECE

Eatock Family Composite Christmas Tree

Merry Christmas 1999 / Happy New Year 2000

Peace On Earth

Peace On Earth

What a beautiful concept for the future.

DESIGN
RIORDON DESIGN GROUP INC
LOCATION
OAKVILLE, CANADA
CREATIVE DIRECTOR
RIC RIORDON
CREATIVE TEAM
AMY MONTGOMERY,
SHARON PECE

"Each year we design and produce a festive mailing, partly as a promotional venture, but also as a gesture of appreciation to our clients and suppliers. This year we wanted to design a more reflective, spiritual and philosophical piece. The calendar featured interesting quotes from the Bible and more editorial images, in an effort to be sensitive to the growing trouble in the world."

DESIGN
THE OPEN AGENCY
LOCATION
LONDON, UK
CREATIVE DIRECTOR
GARY COOKE
CREATIVE TEAM
AL FULLER, MARTYN ROUTLEDGE,
ANDY HOLTON, IAIN HUTCHINSON

PORT

STILTON
Specially Selected by

SELECTED **DEC**'DATES

A MERRY CHRISTMAS · Mon 26 · Tue 27 · Wed 28 · Thu 29 · Fri 30 · Sat 31 & A HAPPY NEW YEAR · Thu 1 · Fri 2 · Sat 3 · Sun 4 · Mon 5 · Tue 6 · Wed 7 · Thu 8 · Fri 9 · Sat 10 · Sun 11 · Mon 12 · Tue 13 · Wed 14 · Thu 15 · Fri 16 · Sat 17 · Sun 18 · Mon 19 · Tue 20 · Wed 21 · Thu 22 · Fri 23 · Sat 24 · Sun 25

PRODUCE OF BETHLEHEM Specially Selected for **THE HORSEMAN COOKE DESIGN AGENCY LTD**

THIS WAY UP

instructions for an evergreen christmas

1 buy a house with a nice large garden
2 prevent reindeers from entering your garden
3 find a suitable plot and dig a small hole
4 place contents of tube into hole
5 water regularly and wait until december
10 purchase one large chopper and a red bucket
▶ use your imagination and enjoy your christmas

Merry Christmas from The Open Agency

DESIGN
THE OPEN AGENCY
LOCATION
LONDON, UK
CREATIVE DIRECTOR
GARY COOKE
CREATIVE TEAM
AL FULLER, MARTYN ROUTLEDGE,
ANDY HOLTON, IAIN HUTCHINSON

"The Open Agency is not a company to
miss out on celebrating any festive
occasion! Christmas is another excuse
to have a bit of fun and remind our
clients that we are an ideas agency."

October

Spicy Pumpkin Soup

After enjoying a rich, curried pumpkin soup at the Vermont home of Paul Ferber, law school professor, skiier, and *bon vivant*, I decided that those cute little pumpkins that grace roadside stands every October deserve to become more than decorations. This soup can be made with almost any combination of vegetables; try winter squash, leek and potato, and all kinds of mixed greens. Paul's recipe called for 2 cups of heavy cream. I hope he doesn't mind the revision.

1 each large onion, celery stalk, carrot
2 Tb. butter, 1 Tb. salad oil
1/2 tsp. each ground cumin, turmeric, ginger, coriander
1/4 tsp. each white pepper, allspice, cayenne
1 3-lb. pumpkin
1 tsp. salt; 1 bay leaf
1 can chicken broth plus 2 cups water
1/2 cup half-and-half or heavy cream

Peel the onion, celery (to remove strings), and carrot, and dice roughly. Heat the butter and oil in a large soup pot and sauté vegetables until tender. Cut the pumpkin in half crosswise, remove the seeds and fibers, and with a sharp knife, peel and cut the flesh into chunks. Add to the pot.
Blend in the spices and stir until fragrant. Add the broth and water and bring to a simmer. Add salt and bay leaf. Cover and simmer about 40 minutes or until pumpkin is very tender, almost falling apart.
Transfer the contents of the pot, minus bay leaf, to a food processor and purée. Don't overdo the processing – the soup should have some texture. Reheat slowly, season with salt and white pepper, and add the half-and-half or cream.
Serve topped with a sprinkling of ground cumin.

23

1995
A Year of Recipes

by
Ellen Shapiro

Illustrated by
Paul Hoffman

DESIGN
SHAPIRO DESIGN ASSOCIATES
LOCATION
IRVINGTON, USA
CREATIVE DIRECTOR
ELLEN SHAPIRO

"We designed fairly traditional holiday greetings often with gifts (such as donations to 'Share our Strengths' – a hunger relief organisation). In 1999 we started publishing Alphagram Learning Materials, which help children to read. Then we began a series based on alphabet letters and holiday letter-sound pictograms."

TO THANK YOU THIS HOLIDAY SEASON

IN THE NAME OF YOUR COMPANY,
A DONATION HAS BEEN MADE TO
SHARE OUR STRENGTH
(SOS), ONE OF THE NATION'S LARGEST
HUNGER RELIEF ORGANIZATIONS.

SHAPIRO DESIGN ASSOCIATES INC.

No L

Have a great new year, decade, and century anyway.

from all of us at
Shapiro Design Associates &
Alphagram Learning Materials

Holiday Letter-Sounds

shapiro design
and
alphagram
wish you
**a peaceful &
joyous year**

DESIGN
SAYLES GRAPHIC DESIGN
LOCATION
DES MOINES, USA
CREATIVE DIRECTOR
JOHN SAYLES

Using 'The Twelve Days of Christmas' as a theme, this custom-designed holiday clock was a unique and memorable gift. The ceramic clock measures 18" in diameter and features original illustrations by John Sayles.

DESIGN
STILL WATERS RUN DEEP
LOCATION
LONDON, UK
CREATIVE DIRECTOR
ANITA BRIGHTLEY-HODGES
CREATIVE TEAM
ALLISON JACOBS, NATASHA
SEARS, TAMSIN ROQUES

"Still Waters Run Deep has always sent a variety of creative mailings throughout the year. They are a fun way to showcase our talents as designers as well as an opportunity to thank our clients and suppliers for their loyalty over the past year."

DESIGN
CREATISCOPE
LOCATION
LONDON, UK
CREATIVE TEAM
JOHN GROVER, MARK STEWART-BIRCH

"As this was one of Creatiscope's first
pieces of self-promotion, we aimed to
make a creative impact."

DESIGN
KBDA
LOCATION
LOS ANGELES, USA
CREATIVE DIRECTOR
KIM BAER
CREATIVE TEAM
BARBARA COOPER, LIZ BURRILL,
MAGGIE VAN OPPEN,
KATE RIVINUS, JAMIE DIERSING,
HELEN DUVALL,
JAMIE CAVANAUGH,
LISA PACKARD,
STEPHANIE ANDREWS,
MICHAEL LEJEUNE, JIM BAEHR

"We've found the best promotions are gifts and especially gifts people can really use! Our clients regularly thank us for keeping them on our mailing list."

DESIGN
MORRIS CREATIVE INC
LOCATION
SAN DIEGO, USA
CREATIVE DIRECTOR
STEVEN MORRIS

"We're constantly looking to entertain our audience and show our services and capabilities. A fun, festive mailing like this allows us to apply our product and packaging creativity."

DESIGN
999
LOCATION
GLASGOW & MANCHESTER, UK
CREATIVE DIRECTORS
KEITH FORBES, AILEEN GERAGHT
CREATIVE TEAM
CHRIS HEYES, JAMES DENLEY,
SIMON HENSHAW,
LEWIS MCINTYRE

"Our Christmas cards give us the chance to showcase our creative skills, as well as demonstrating to our clients we still have a sense of humour despite another year of hard work on their behalf."

DESIGN
MOTIVE DESIGN
LOCATION
PHOENIX, USA
CREATIVE DIRECTORS
JESSE VON GLUCK,
LAURA VON GLUCK
CREATIVE TEAM
KEE RASH

"One of the goals of our design firm was to help bring Christmas to children who would normally go without. Artfully illustrated boxes titled 'Jack in the Box' are delivered to corporations around Arizona. When the potential donors receive it, a message explains that some kids won't get 'Jack' for Christmas. The empty box replicated the feeling many children experience during the holidays. The idea is that the donor fills the box and gets it distributed through St Vincent de Paul of Arizona. This project was made possible by a grant from Sappi Fine Paper."

bureau GRAS fnidsen 28b, 1811 ng alkmaar
ontwerpers voor drukwerk en internet

1
9. 10. 2. 3.
8. 4.
6.
7. 5.

prettige kerstdagen en een creatief 2000

ontwerpers voor drukwerk en internet www.bureaugras.nl

Wij wensen u een prachtige
Kerstboom

...en een gelukkig nieuwjaar!

DESIGN
BUREAU GRAS
LOCATION
ALKMAAR, NETHERLANDS
CREATIVE DIRECTOR
RUUD WINDER
CREATIVE TEAM
ROBB GAITT, BART KEUZENKAMP,
MARJIJKE DEKKER,
ELLEN DE GRAAF

"To create a totally different Christmas
card every year gives us the
opportunity to send our best wishes in
an original way and show off our design
skills to our clients and colleagues."

PRIORITY
PRIORITAIRE

€ 0,27 FL 0.60 NEDERLAND 2001

€ 0,27 FL 0.60 NEDERLAND 2001

bureau **GRAS** p.o. box 3001 1801 ga alkmaar the netherlands

Deadline21
Scott Witham
25 Calderwood Rd
Rutherglen
Glasgow Scotland
G73 3HD UK

Wij wensen u een prachtige
Kerstboom

We wish you a beautiful Christmastree

DESIGN
INKAHOOTS
LOCATION
BRISBANE, AUSTRALIA
CREATIVE DIRECTORS
JASON GRANT,
ROBYN MCDONALD,
BEN MANGAN

"Inkahoots uses festive mailings and
other promotions as an opportunity
to raise awareness and promote
engagement with issues that are
important to us."

the US response (to September 11) will be a gift to Bin Laden... exactly the things
that will promote massive support and which will bring more, perhaps worse terrorist
attacks. Which will then bring a growing intensification of the war... In general,
the atrocities and the reaction to them reinforce the most brutal and repressive
elements everywhere. This is how things work. The dynamic is well known.

NOAM CHOMSKY

OUR ALLIES BECOME OUR ENEMIES
OUR ENEMIES BECOME OUR ALLIES

Back in Oz

In a malicious dereliction of public duty
the Government demonises desperate
asylum seekers to win a third term election
victory. Three more years of orchestrated
social division and deception. *Look forward to...*

CRIMINALLY UNDERFUNDED PUBLIC EDUCATION...DISMANTLING OF MEDICARE...EROSION OF
WORKERS RIGHTS BY ATTACKING UNIONS...UNDERMINING OF INDIGENOUS STRUGGLE FOR SELF
DETERMINATION...SALE OF PUBLICLY OWNED ASSETS...EXPANSION OF USELESS WORK FOR THE
DOLE IN PLACE OF REAL TRAINING...VICTIMISATION OF THE POOR AND DISADVANTAGED...

Peace this season and throughout the new year, from all at Inkahoots

MERRY XMAS

seeing is believing... but what we see also depends on what we believe
→ believing is seeing? looking, seeing & knowing are inseparable.
If reality is an illusion, design is a dream... and Inkahoots is the vibrating
waterbed floating in a velvet room with mirrored ceilings.

peace
I n k a h o o t s

DESIGN
METHODOLOGIE
LOCATION
SEATTLE, USA
CREATIVE TEAM
GABE GOLDMAN,
SARINA MONTENEGRO

"We produce a festive mailing every year. It's a great opportunity to send something special to clients, partners and friends. This was produced in December 2001. We wanted to send out a message of hope."

For the person who has everything it's the actualsize multi-purpose gift

"It's a... (tick appropriate)

- dish-o-dry 3000
- one-log trouser
- contemporary urban streetwear
- younger sibling flick-o-matic
- broach
- happy the hand puppet
- part of 150 person marquee
- emergency hanky

- combo placemat napkin tablecloth
- imitation Pokemon throw rug
- temporary housing
- abrasive single bed sheet
- sort of magic carpet
- contemporary visual art (framing extra $500)
- kitchen dehydrator 3000
- imitation expensive teatowel

...just what I always wanted"

happy holidays from actualsize

DESIGN
ACTUAL SIZE
LOCATION
MELBOURNE, AUSTRALIA
CREATIVE DIRECTOR
LUKE FLOOD
CREATIVE TEAM
ADELE SMITH, GARTH ORIANDER

"The ideas for our festive mailings are based on the tradition of receiving crap and diabolically inappropriate and/or ill-fitting gifts from elderly relatives. Socks, underpants, talcum powder and so on are foisted upon Australians under the age of 70, along with a simultaneous barrage of questions concerning when one was getting married and when we would draw a picture of our old Gran and we weren't ashamed of her, were we and had she ruined the day?"

New bicycle, train set, totem tennis, blow-up pool, trampoline, walkie-talkie set?

actualsize

Cheers from Actual Size

Actual Size will be closed between 20 December–10 January

DESIGN
WILLIAMS AND PHOA
LOCATION
LONDON, UK
CREATIVE DIRECTOR
CLIFFORD HISCOCK
CREATIVE TEAM
MATTHEW SHANNON, ROSS
SHAW, ROBB GAITT

Williams and Phoa sent out a
self-adhesive, off-the-shelf, refrigerator
thermometer 'tipped-in' to a
pre-debossed area on the front. The
message inside reads 'Warm wishes
this Christmas from Williams and Phoa'.

There were 441 screenprinted dots on
front, some of which are printed with
luminous ink. In the dark, the triangular
shape of a Christmas tree becomes
visible. The message inside reads
'Williams and Phoa wish you a brilliant
Christmas and a bright New Year'.

DESIGN
GRAPHIC PARTNERS
LOCATION
EDINBURGH, UK
CREATIVE DIRECTOR
GRAPHIC PARTNERS
CREATIVE TEAM
MHAIRI MCDONALD

Graphic Partners wanted to get across
the message that the thought behind
something is the most important
thing – in a tongue-in-cheek way.

DESIGN
BLATMAN DESIGN
LOCATION
SOMERVILLE, USA
CREATIVE DIRECTOR
RESA BLATMAN

"Although I don't do much in the way of advertising, the December holidays are a good time to show my clients that I appreciate their patronage. I use attractive stock imagery that I manipulate, and I write my own poetry or include the poetry of others as a gift for my family, friends and clients."

DESIGN
THE IMAGINATION GROUP LTD
LOCATION
LONDON, UK
CREATIVE DIRECTOR
GARY WITHERS

The Christmas decorations at the London headquarters of design consultancy Imagination have become a seasonal institution. The exterior of the Imagination building has been festooned as a gift-wrapped parcel, a festive table setting and a giant Christmas wreath, all made of light. The company photographs its annual 'gift' to London for the Imagination Christmas card.

DESIGN
DEAF EYE
LOCATION
LOS ANGELES, USA
CREATIVE DIRECTOR
MARILYN JOSLYN
CREATIVE TEAM
MATTHEW COGSWELL,
SAM HUBBELL

"A festive mailing is not only good self-promotion, but it shows client appreciation. In keeping with our corporate identity, we chose to create a strong, simple yet whimsical design."

MERRY **CHRISTMAS**
XMAS 00 | HAPPY **NEW** YEAR NY0
❋ FROM ALL AT **BIGGARTDON**

DESIGN
BD-TANK
LOCATION
GLASGOW, UK
CREATIVE DIRECTORS
GHILL DONALD, WILLIE BIGGART
PAUL GRAY, STUART GILMOUR
CREATIVE TEAM
SCOTT WITHAM, GARY DOHERTY,
JOAN GRADY, TIM WILCOX,
MAGGIE MURRAY, GARY DAWSON
AVRIL MCGRATH

This was a team effort from all at
BD-Tank, from designers working on
the typography to the account handlers
assisting in the production.

All the inflatable mailings contained
hand-finished gift boxes, each one with
a chocolate inside.

N.Y.B.D. BOOZE
CHRISTMAS PARTY

CELEBRATE CHRISTMAS
IN PREPARATION FOR THE
BIG TRIP TO NEW YORK

THURSDAY 21ST DECEMBER

TIME
19.00 HOURS

LOCATION
MCPHABBS (FOR PICK UP)

DESTINATION
CLASSIFIED INFORMATION

DRESSCODE
SMART

This is the famous BD Christmas night out. We take great pleasure
in inviting you to join us in the festivities at a secret location
which will be disclosed at a later stage in the proceedings.

BDweiser
KING OF BOOZE®

This Christmas night out is the genuine article.
Brewed in Scotland to a secret recipe.

DESIGN
SHERRY DESIGN LTD
LOCATION
LONDON, UK
CREATIVE DIRECTOR
KARLA THOMPSON
CREATIVE TEAM
ALAN SHERRY

"We see Christmas as a good
opportunity to remind our clients that
our core business is ideas. We like to
create something fresh and exciting
each year that both surprises them and
appeals to their sense of humour."

DESIGN
CENTO PER CENTO
LOCATION
MILAN, ITALY
CREATIVE DIRECTOR
PIER PAOLO PITACCO

"The wish to create something that gives emotion and memories is now more important than the simple gesture of sending a greeting card. Our intent is to communicate two feelings – those of peace and love."

DESIGN
WPA LONDON
LOCATION
LONDON, UK & MELBOURNE,
AUSTRALIA
CREATIVE TEAM
NEIL BARNETT,
LORNA MACLENNAN,
GARY KEMPSTON, RACHEL LOMAS,
KATE LINDNER, PAUL MONKIVITCH,
PETER WALKER, VAN LE,
MICHAEL BLYTHE

A light-hearted interpretation of the
working life of designers at WPA
London and WPA Melbourne.

DESIGN
THINKING CAP DESIGN
LOCATION
APPLETON, USA
CREATIVE DIRECTOR
KELLY D LAWRENCE
CREATIVE TEAM
KEITH LENNOP, CHRIS LADING

"We had a small budget for the production of our holiday promotion, making it that much more creative. A few of our clients' businesses are focused on tourism during the 'snow' months and we hadn't seen any snow until December. I found these snow domes in a discount shop and inserted the Thinking Cap Design character."

HAPPY HOLIDAYS: AISLE 6

*Wishing you the key ingredients
for a prosperous New Year.
Hollis Design*

DESIGN
HOLLIS
LOCATION
SAN DIEGO, USA
CREATIVE DIRECTOR
DON HOLLIS
CREATIVE TEAM
GUUSJE BENDELER, JOHN SHULZ,
PAM MEIERDING, GINA ROSENTHAL

Give Peas a Chance
"Post-9/11 holidays seemed a difficult subject. We wanted to share our holiday spirit while finding a simple message with value and relevance in today's world. In searching for that message, we discovered an old one that was well worth repeating. John Lennon said it best. We just said it again with a little holiday twist."

Joy, Cheer, Peas
"The purpose behind our fold-out mailer was to find a universal message to share for the holidays while still communicating something about what we do as a design firm. Product packaging photographed in a Pop Art style proved to be an appropriate recipe."

DESIGN
NICK CLARK DESIGN
LOCATION
LONDON, UK
CREATIVE DIRECTOR
NICK CLARK

"We'd started a tradition with our own Christmas cards, each year having to better the year before. For 2002 we just wanted to say 'Christmas – Bah, Humbug' – so we did!"

Have a real cracker of a christmas.
[from Nick Clark Design]

Christmas from Nick Clark
Baaa

Traditional Minty
Baaa! *Humbugs*
Over festive antidote - only to be used in conjuction with a sheep apparatus

DESIGN
ONE O'CLOCK GUN
LOCATION
EDINBURGH, UK
CREATIVE DIRECTOR
MARK HOSKER
CREATIVE TEAM
MICHAEL DUNLOP,
VICKY BEMBRIDGE

"Producing a festive mailer is a great
opportunity to be our own client as well
as to show off our creative talents with
no restrictions. It's a fun time of year to
do a fun project."

DESIGN
METHOD INTEGRATED MARKETING
LOCATION
COLUMBUS, USA
CREATIVE DIRECTOR
BEVERLY BETHGE
CREATIVE TEAM
SCOTT RAZEK, JEFF WALTER,
TODD STEVENS

"On the 'Sock Monkey and Kitty' mailer, well, our clients have come to expect a bit of goofiness in the holiday mailers and, darn it, we just like sock monkeys! And, of course we love bouncing kitty head dolls.

"On the 'What's So Funny' card, it was the right sentiment at the right time and summed up our thoughts of this past year very nicely."

We want to give you something truly special to remember the first holiday season of the new millennium.

Introducing,

The Method Limited Edition Holiday Keepsake 2000.

Meticulously handcrafted by skilled artisans, each Limited Edition Keepsake takes a full 14 days to complete, and has been recognized for it's timeless beauty and overall design excellence around the globe.

We hope that you and your family cherish this simple token of holiday cheer as much as we do.

Happy Holidays from Method Integrated Marketing

This season, some of our clients are receiving really nice holiday gifts.

Some aren't.

Happy Holidays from Method.

DESIGN
ID2 COMMUNICATIONS INC
(FORMERLY INKWELL DESIGN INC)
LOCATION
VICTORIA, CANADA
CREATIVE DIRECTOR
VALERIE ELLIOT
CREATIVE TEAM
STEPHAN JACOB, KERRY SWARTZ

"iD2 Communications' creative festive
gifts thank our clients for their business
over the past year in a memorable
and personal way. They also
demonstrate iD2's creative abilities.
Illustrating our love for diversity of
culture, we send our gifts out at the
calendar New Year, setting them apart
from the many received over the
Christmas season."

DESIGN
SJI ASSOCIATES
LOCATION
NEW YORK, USA

"For SJI Associates, the holidays are a chance to create unique self-promotion pieces that combine a showcase for fresh design with the opportunity to send good wishes to their clients."

DESIGN
SUTTON COOPER
LOCATION
LONDON, UK
CREATIVE DIRECTOR
LINDA SUTTON
CREATIVE TEAM
ROGER COOPER, STEVE WAKEHAM

"A seasonal mailer is an enjoyable opportunity to become the client."

DESIGN
PLUS ONE DESIGN
LOCATION
BRISTOL, UK
CREATIVE DIRECTOR
DENISE HARRIS
CREATIVE TEAM
MARIE HAWKINS, PAUL HOCKING

Plus One have traditionally hand-made their Christmas cards. This textile snowball design was made to be hung on the company Christmas tree. The idea is light-hearted and simply fun.

DESIGN
PHILIPP UND KEUNTJE GMBH
LOCATION
HAMBURG, GERMANY
CREATIVE DIRECTOR
JANA LIEBIG
CREATIVE TEAM
EVA ROHNG, MICHEL FONG,
ALEX BUSCH, YONA HECKL,
JUSTUS VON ENGELHARDT,
SVEN SCHRODER

"First of all, we wanted to create
something people would want to keep
around for a long time. Something that
survives Christmas. Something people
have fun with. What could be better
than a game including our staff, our
building and the charming beauty of
St Pauli, Hamburg?"

IDENTITY PROTECTION KIT

AFRAID YOU MIGHT **BLOW YOUR COVER** AT THIS YEAR'S **CHRISTMAS PARTY?** THIS HANDY GUISE LETS YOU DROP OF A HAT AND MAKE A SMOOTH GETAWAY IF SWITCH IDENTITIES AT THE THINGS GET TOO HAIRY. OF COURSE, IF YOU ARE LOOKING FOR MORE EFFECTIVE WAYS OF PROTECTING YOUR IDENTITY OR CREATING A NEW IMAGE... YOU SHOULD BE TALKING TO MAX!

DESIGN
MAX AND CO
LOCATION
ABERDEEN, UK
CREATIVE DIRECTOR
CLAIRE CORMACK
CREATIVE TEAM
TANIA FENTON, MAIRI MACLEOD, KELLY MEARNS, DAVID ELLIOT

"The 'Identity Protection Kit' cleverly combines the concepts of corporate and personal identity comprising a set of joke-shop nose glasses mounted inside a specially commissioned box. The cheap disguise is a subtle dig at brand naïvety and the so-called identity 'solutions' that result in numerous ineffectual clones. The attached gift tag continues our tradition of reminding clients that if they want things done properly, they need to talk to 'Max'."

DESIGN
VIRGIN PROJECTS
LOCATION
LONDON, UK
CREATIVE DIRECTOR
TIM FRASER
CREATIVE TEAM
GEMMA THOMSON

"We wanted to thank our clients for their interest and business for the year. The idea was to congratulate them for this by telling them that we thought they were stars! Rather than blatantly promoting ourselves, we felt we should reward them with a fun item that was well made in traditional Christmas packaging."

DESIGN
STOCKS TAYLOR BENSON
LOCATION
LEICESTER, UK
CREATIVE DIRECTORS
JOHN BENSON, GLENN TAYLOR,
DARREN SEYMOUR
CREATIVE TEAM
JONATHAN RAGG,
VICKEY FELTHAM

"If we can't produce highly creative, imaginative Christmas cards year after year for ourselves, how can we produce innovative and successful design solutions time after time for our clients?"

DESIGN
GS DESIGN INC
LOCATION
MILWAUKEE, USA
CREATIVE DIRECTORS
MIKE MAGESTRO, KELLY HEISMAN,
DAVE KOTLAN
CREATIVE TEAM
STEVE RADTKE

GS Design's 2001 holiday promotion
[see page 12] placed a humorous spin
on a sensitive and newsworthy topic.
The kit consisted of a magnetic DNA
Acceleration Chamber (a cocktail
shaker), a 50ml Erlenmeyer flask, a
50ml beaker and a Genetic Cloning
Guide – packaged in a white foam
containment system. Recipients were
able to replicate White Russians and
other 'clones'.

For its 2000 holiday promotion, GS
Design wanted to create a quality
giveaway package, reminiscent of
a 1950s holiday cookbook. Lucky
recipients received a specially designed
culinary kit consisting of a 'Meat
Man' cutter, cookbook and savoury
seasonings. Tasteful indeed.

DESIGN
KRAFT & WERK
LOCATION
MARIBOR, SLOVENIA
CREATIVE DIRECTOR
DAMIJAN VESLIGAJ

"2002 kW wine is Kraft & Werk's festive mailing for our clients and friends and goes out with our best wishes."

DESIGN
RESERVOIR + OH BOY, ARTIFACTS
LOCATION
SAN FRANCISCO, USA
CREATIVE DIRECTOR
DAVID SALANITRO
CREATIVE TEAM
TED BLUEY

"Holiday = Cheers"

DESIGN
TRICKETT & WEBB
LOCATION
LONDON, UK
CREATIVE DIRECTORS
LYNN TRICKETT, BRIAN WEBB
CREATIVE TEAM
HEIDI LIGHTFOOT, GAVIN
ANDERSON

"Part of a series of enamel badge Christmas cards. We are badge enthusiasts and can't resist the challenge of thinking of yet another slant on Christmas!

"Our Christmas card is a reminder to ourselves as well as our clients that we should all aim to be a little more witty in the New Year. It is also an opportunity to indulge one of our 'collective' passions – enamel badges. Everyone can identify with enamel badges – from ex-Mickey Mouse club members to bowling club fanatics. Whenever a new, young designer tries his hand at our Christmas badge, there is a learning curve while we try to explain the difference between a badge and a piece of jewellery. Badge good, jewellery not. All subtle stuff – but worth it in the end!"

A right little corker from Trickett & Webb

Suka & Friends Design involved Mark Twain, Anne Frank, Benjamin Franklin, Jacqueline Kennedy Onassis and others for their 2001 holiday card entitled 'Joy Full Thoughts'. The card delivered words of wit and wisdom on the topic of joy.

DESIGN
SUKA & FRIENDS DESIGN INC
LOCATION
NEW YORK, USA
CREATIVE DIRECTORS
BRIAN WONG, GWEN HABERMAN

"The 2001 holiday season played a particularly meaningful role in the post-9/11 recovery for New York. Suka & Friends embraced the return to home-based comforts with a box of homemade treats prepared by Suka staff for clients, vendors and friends."

DESIGN
THOMPSON DESIGN
LOCATION
LEEDS, UK
CREATIVE DIRECTOR
IAN THOMPSON
CREATIVE TEAM
DAVID SMITHSON

"'365 Days of Joy' is a response to the tough year that 2001 proved to be for almost everyone. We chose to remind people of life's simple joys and set ourselves the challenge of coming up with one for each day of the year. Design, like other creative disciplines, is about making a connection with people and finding a common language."

feeling you get when you have a great idea and you just can't wait to see it happen 4/When you're away from home and you come across a picture where else you'd rather be 6/Meeting someone for the first time and finding you've lots in common 7/Soft, fresh, early morning light 8/Discovering ne and seeing them get a rosy glow 10/Watching a movie for the second time and discovering that you really love it 11/Coming to the end of a really away 13/Eating something which turns out to be surprisingly delicious 14/Laughing until it hurts 15/Finding something hilarious in the midst of a rger bar 17/Seeing someone who's done you a disservice get their's - big time, then feeling sorry for them - just a bit 18/The intoxicating smell of cially at christmas 20/Hot apple pie with a crisp coating of brown sugar and cinnamon, melted ice cream on top 21/At last, a babysitter that says /Unexpected contact from an old friend 25/A long and lazy lie-in 26/Man Utd losing any match 27/Coming home after a great night out with friends st time you sit down in a newly decorated room 31/A song you haven't heard for ages, which makes you feel the way you used to 32/A really classic al human contact 35/When you really get an insight into what it feels like to be someone else 36/Fish and chips, red hot, on a cool evening walking covering new strengths 39/A good video, wine, takeaway and the rest 40/Introducing someone to a brand new experience 41/The lush smell of a he crunch of papery leaves underfoot 44/A special meal that really goes to plan 45/Discovering you actually like Sushi 46/For once, the two of us old bottled beer with a bit of lime in the neck, in the garden 50/When pay day comes around again 51/Finding a tenner you didn't know you had good at being positive 54/Scary hide-and-seek with the kids 55/Making your first mark with a newly sharpened pencil 56/Pebbles with little fossils ruffle of letters coming through the letterbox 60/The first plunge into a still, empty pool 61/The sound of a golf ball bouncing on a frozen pond skin 65/Sand that's almost too hot to walk on 66/Sinking into a crisp, comfy bed when you're exhausted 67/How Joey always is, in 'Friends' 68/The of the movie - even bad ones seem to start well 72/The last thing in the ironing basket 73/People who sing as they go about their business 74/The ce on a bucket of water 77/That rare occasion when your hair looks just right 78/The oily aroma of hot tarmac 79/The smell of freshly baked bread 2/Squeaky clean teeth just after you've brushed them 83/Experimenting with the consistency of cornflour 84/Somebody titivating with your hair Waking to a kiss 89/The last hundred metres of a long run 90/Curling up in a chair, gazing dozily into a real fire 91/Finding the hot water bottle with ate, any chocolate 95/Finishing work before a holiday 96/Losing a bit of weight the hols 97/The inky, pulpy smell of a brand new book 98/Mastering of the smell of pine needles from a Christmas tree 102/Taking ages cooking something everyone loves, then eating it in a ove something 106/Making someone titter 107/Poking an outdoor fire with a long stick 108/The noise of the night when you're camping 109/The er still when you're not 112/Sparkler writing 113/Watching the Yorkshire puds rise 114/The nostalgic smell of coal and smoke from a steam train g a big wave 118/Polishing old shoes 119/Eating in the open air 120/Riding a bike at great speed down a hill 121/The smell of liniment in the changing iscovering it's not so bad after all 125/The perfect pass 126/The way 'Radiohead' make you feel strangely positive 127/The second calm after the g someone who is passionate about the same things you are 132/The perfect, deep blue 133/The place where you can dance however you like ad of the day 136/A respectful tone in someone's voice 137/Knowing you've done something truly special 138/John Lennon covering 'Stand by me' eems just perfect, right now 141/Settling down for 'Big Brother' 142/Watching the days get longer 143/Finding out you've got the job 144/Watching tions 147/Watching a worry disappear 148/When everything you touch, turns to gold 149/Mastering the chords of a great song 150/When you do in anything 153/Knowing you've made the right decision 154/Driving home a new car 155/Moving house in summer 156/The Royle family playing K 158/Omar Sharif's entrance in 'Lawrence of Arabia' 159/The smell of your clothes after a country walk 160/Getting loads of questions right on at requires no responsibility at all 163/Jonathan Ross's dress sense 164/Learning to accept failure 165/When Smokey sings 164/Kylie's bum gnition at last 171/Arriving at the airport 172/Comfy well-worn shoes 173/A Cadbury's flake 174/When you know you're still a baby to your mum ot country 177/A train journey in a foreign place 178/Getting your holiday photos back 179/Little piles of snow on the window frame 180/Messing obody's perfect' line at the end of 'Some Like it Hot' 184/Finding the real treasure in a junk shop 185/Getting the barbecue lit 186/The bowling alley lights go to green just as you approach - all the way home 190/When the ball of paper actually goes in the bin 191/Finishing a bit of f****** Ikea the smells of Christmas 196/Choosing paint colours 197/The soothing sound of the sea 198/Encountering something which gives you a real sense The first stride of the horse breaking into a gallop 201/Knowing you're loved 202/Tea in a china cup that's little at the bottom and big at the top reaking through the clouds 206/When Woody discovers a VW Beetle that starts first time after 25 years in 'The Sleeper' 207/Reading the Sunday 212/Deciding where to go away this year 213/Really getting sucked into a play you thought might be difficult 214/The first chapter of a book you thusiastic dog 217/Eating food you've grown yourself 218/The smell of smoking kippers 219/The freedom to be silly 220/Finding a brand new piece 224/The right chemistry 225/A song which seems to have been written just for you 226/Exploring a new place for the first time 227/That restaurant the best in you 229/The line of a well-toned back 230/Finding crabs and stuff in a rock pool 231/When its OK to be a bit of a bloke sometimes 35/Watching a good friend becoming successful 236/When you know this is a defining moment 237/The white-knuckle thrills of a scary ride 241/Making sure the kids get a big enough bags of sweets for you to pinch some 242/Making a new friend when you least expect it 243/Bumping a bike 246/Taking things to bits 247/Samantha in 'Sex and the city' 248/When you're on a roll 249/The vertical opera house pan in 'Citizen Kane' ur advice to others pay off 253/Being the life and soul of the party 254/Catching a cricket ball 255/Scoring a direct hit with the perfect snowball the sea fill it in 258/Popping bubble wrap 259/Helping a stranger bump start a car 260/Seeing yourself on the telly 261/A new generation discovering wrapping 263/Racing rain drops down a window 264/Getting 'quiz' on a triple word score 265/Getting dolled-up for an evening out 266/Finding from the waves crashing over the sea wall 269/Breaking the seal on a new jar of coffee 270/'Honky Tonk Women' on the Speedway 271/Finding a e for a warm smile 274/Getting a larger portion of chips because the person behind the counter fancies you 275/Flirting with a stranger 276/Frosty s outlook on life 279/Being on the guest list for a gig 280/Guinness in the right glass 281/Girls in small T-shirts 282/Getting to the stop just as the at first sight 286/Snowdrops pushing through the frost 287/The feeling of warm sun on your skin 288/The hairs on the back of your neck standing 292/Coming across two magpies 293/Better still, three 294/OK, any number apart from one 295/Seeing your mate fall over drunk 296/Occasionally e of a mirror 298/Melancholy faces of pansies in winter 299/Dust in a streak of sunlight 300/The squeak and crunch of snow under your feet 301/A table shoes 303/A Valentine's card that's a genuine mystery 304/The arrival of the AA man 305/When Tim Robbins plays Mozart to the inmates in trol in a puddle 309/Meeting a deadline 310/The little nods and waves you get when you give way in traffic 311/An unexpected lock-in 312/Buying me 316/Laurel and Hardy with the piano on the stairs 317/'Fawlty Towers', absolutely all of it 318/Window shopping 319/The first sight of a robin in m a nightmare and realising everything's alright 323/Beckham scoring from the half way line 324/Playing air guitar in private 325/Sneezing, second owing that you'll never stop learning 329/Discovering that the bloke who said your creativity dries up after thirty was just talking about himself ise people 332/Discovering something new about yourself 333/Looking for shapes in the clouds 334/Play fighting 335/Hearing a tune for the first ings 337/Getting older, but feeling younger 338/Getting covered in mud and not caring 339/Me time 340/Meeting a british ex-pat in New York who homework 342/Staying calm when someone's messed up 343/Discovering how to see problems as opportunities 344/Keeping your head whilst ng than you thought 347/Accepting that there are some things you'll always be rubbish at 348/Finding poetry in everything 349/Having no regrets your feminine side 353/Getting in touch with your masculine side 354/Making-up 355/Finding the faith to do things your way 356/No longer caring n's drawings of you 360/Rutger Hauer's 'Tears in rain' speech in 'Bladerunner', which was apparently all his idea 361/When the other woman turns g the respect of someone you admire 365/And, of course lots of other things we could mention but, we think are best left to your own imagination

eptember 11th and the
tain a positive attitude. We
of the simple joys of living,
at Thompson Design, and
ig you a joyous new year.

www.thompsondesign.co.uk
0113 232 9222

Thompson Design

LEEDS -4.1.02 GREAT BRITAIN POSTAGE PAID 0057 T 290850

...early morning light 8/Discover...
...11/Coming to the end of a...
...something hilarious in the midst of...
...a bit 18/The intoxicating smell...
...21/At last, a babysitter that...
...after a great night out with the...
...way you used to 32/A really clea...
...and hot, on a cool evening with...
...experience 41/The lush smell of...
...Sushi 46/For once, the feel of...
...a tenner you didn't know you...
...pencil 56/Pebbles with li...
...golf ball bouncing on a fresh p...
...Joey always is, in 'Friends' 68/...
...they go about their business 74/...
...The smell of freshly baked br...
...Somebody titivating with their...

Thompson Design
The Old Stables
Springwood Gardens
Leeds LS8 2QB

Telephone 0113 232 9222
Fax 0113 232 3775
info@thompsondesign.co.uk
www.thompsondesign.co.uk

...sleeper 207/Reading...
...214/The first chapter of a book you...
...silly 220/Finding a brand new place...
...for the first time 227/That restaurant...
...OK to be a bit of a bloke sometime...
...white-knuckle thrills of a scary ri...
...when you least expect it 2...
...opera house pan in 'Citizen Kane'...
...a direct hit with the perfect snowball...
...261/A new generation discovering...
...up for an evening out 2...Finding...
...men' on the Speedway 2...finding th...
...Flirting with a stranger 2...Frosty...
...282/Getting to the store just as the...
...on the back of your neck 2...standing...
...mate fall over drunk 296/...ssionally...
...crunch of snow under you...
...Robbins plays Mozart to th...mates in...
...An unexpected lock-in 3.../Buying...
...eeping 319/The first sight...robin in...
...star in private 325/Sneeze...second...
...thirty was just talking ab...himself...
...ting 335/Hearing a tune...the fir...
...ing a british ex-pat in New York where...
...nities 344/Keeping your...d whilst...
...in everything 349/Havin...regret...
...things your way 356/No lo...r caring...
...dea 361/When the other w...an turns...
...are best left to your own imagination...

www.thompsondesi...co.uk
...3 232 9222

1/The way Morecambe and Wise always make you feel 2/The smell of the trees in early autu... of the children and you've never seen anything so beautiful 5/Right here right now – when t... how much easier it is to solve someone else's problem, rather than your own 9/Compliment... tough task 12/Walking over the brow of a hill and coming across a view that simply takes y... crisis 16/That bit in 'American Beauty' when Kevin Spacey serves his cheating wife at the t... smoke and gunpowder on bonfire night 19/Rearranging the furniture in preparation for a p... 'yes' 22/The kids' unbridled excitement on Christmas Eve 23/Watching a good match after... 28/Diving into a crystal clear sea 29/Rich Sunday roast, yorkshire puds, thick gravy – the lot... film, undisturbed with hot coffee and biscuits 33/When you know you've just bagged a bar... by the sea 37/Seeing a poorly child turn the corner towards recovery 38/Coping with a cris... newly mown lawn 42/A long weekend away with someone you love 43/Crisp autumn morn... and no one else 47/The worthy feeling you get after exercise 48/A damn fine cup of coffe... 52/Watching something you've really worked at, turn out just right 53/Finding out you're act... in them 57/Catching sticklebacks with a net and a tin bucket 58/Saving the best 'til last 5... 62/Cracking open a huge conker 63/Rolling down a grassy bank 64/Damp, pink, squeaky-c... angel-face of a sleeping child 69/An empty in-tray 70/The first step into unsullied snow 71/... little plays that children perform and insist you watch 75/The first coffee of the day 76/Crac... 80/Being appalled whilst watching the Eurovision Song Contest 81/The songs kids sing o... 85/Pea-pod popping 86/The dawn mist that collects in valleys 87/Children's nocturnal mutt... icy toes 92/Coming home after a long spell away 93/Watching your child perform on stage... something which once seemed impossible 99/Cloudless summer skies 100/Knowing you'l... fraction of the time 103/The Epidural – thank god 104/Winning a hard-fought point 105/Le... sweet, jammy smell of strawberries 110/Sledging 'til it's slushy 111/Kissing under the mist... 115/The slightly burnt taste of sticky bonfire toffee 116/Realising you've another hour in bed... rooms before a game 122/A brand new pair of shoes 123/A long soak in a steaming hot b... storm 128/A real breakthrough 129/The voice of Sam Cooke 130/Eddie Izzard's attitude... 134/Those moments when you don't seem to have a care in the world 135/Setting off hom... 139/Watching the days diminish before the holidays 140/A song you've barely noticed befo... all the obstacles fall away 145/Realising that crazy idea might actually work 146/Exceedin... something which clearly makes someone's day better 151/Singing along in the car 152/Pe... guess the value, whilst watching 'The Antiques Roadshow' 157/A photo of yourself where... 'Millionaire' 161/Getting any question right on 'University Challenge' 162/Once in a whil... 167/Robbie's bum 168/Moving to an exciting new place 169/Making a life change 170/A... 175/Completing a tough level on the Playstation 176/The smell of heat as you get off the p... about with a real fire to get it going 181/Pancakes for breakfast 182/Watching the eclipse... in 'The Big Lebowski' 187/Live music, when it really rocks 188/Making a connection 189/... furniture 192/Finding your way without a map 193/Anything new 194/Homer Simpson's 'D... of history 199/The sound of wind and rain on the windows when you're warm and safe in... 203/Food that looks so good, you don't want to spoil it 204/Swatting an angry wasp 205/... papers in peace 208/Breakfast in bed 209/TV in bed 210/Actually, anything in bed 211/Ba... just know is going to be great 215/Getting drunk on champagne 216/Being welcomed hom... for a collection 221/A clear motorway 222/Five skims on a stone 223/Discovering a great t... where you always seem to have great conversations 228/Someone who always seems to... 232/Overhearing intriguing conversations 233/Watching the world go by 234/A sympath... 238/Deliciously naughty, fatty food 239/Meeting a hero 240/Recounting a funny story abou... into someone you know in a foreign place 244/Winning a pitch 245/Teaching your kids h... 250/Getting a smile from a pretty girl at the bus stop 251/Realising your potential 252/W... 256/Working as a dedicated team to dig a massive, but aimless hole in the beach 257/Then... 'The Wizard of Oz', just the way you did 262/Wrapping presents and anticipating the excite... out someone's only human after all 267/The first time you open the sun roof in spring 268/... parking space at Ikea 272/Singing along to Abba 273/Holding the door open for someone... grass that crackles underfoot 277/The thud of a ball as it hits the back of the net 278/Bill... bus arrives 283/Leaning back against the radiator on a cold day 284/Winning at anything... up 289/Half past five, every Friday 290/Watching monkeys mess about 291/Kittens playing... still being asked your age when you buy booze 297/The rainbows you get when the sun h... row of raindrops glistening on the edge of a window frame 302/Taking off a pair of really... 'The Shawshank Redemption' 306/The cute nape of a baby's neck 307/Squashing beer ca... your very first car 313/Building a snowman 314/Then knocking it down 315/Parking perfe... winter 320/A pair of trousers that really fit 321/When it's safe to let your guard down 322/... only apparently to the other great physical pleasure 326/Maturing 327/But not getting o... 330/Taking the stairs and beating the lift 331/Mastering something pointless but cool tha... time that leaves you speechless 336/When the phone stops ringing and you can finally ge... doesn't have an american accent 341/Knowing any of the answers to your twelve year o... everyone around you is losing their's 345/Finding the strength to go on 346/Being better in... 350/Discovering bravery you didn't think you had 351/Beating the system 352/Getting in... about what might have been 357/Forgiving your ex 358/Learning from those you admire... out to be stupid 362/Making a perfect omelette 363/Hitting the nail square on the head...

2002

365 days of joy

How can claim that 2001 was a great year... threat to the world's economy have ma... feel this might be a time to take stock... So here are 363 of the everyday things t... we hope you can find some that do it fo...

DESIGN
D7 DI CREW
LOCATION
BUENOS AIRES, ARGENTINA
CREATIVE DIRECTORS
STEVE MACLEAN,
LUCIANA FAIMAN
CREATIVE TEAM
SOL BOECHI

"Our job is to build strong personalities for the companies and products we work for. D7 di crew treat these brands as living beings, and we advise on the right behaviour that best suits each situation. Showing companies' feelings with greeting communications can be part of that personality; sharing those feelings is our objective."

DESIGN
TOP DESIGN STUDIO
LOCATION
LOS ANGELES, USA
CREATIVE DIRECTOR
PELEG TOP
CREATIVE TEAM
MARY YANISH

"We chose the 'relax' theme for this year's annual year-end mailing as we felt we needed to remind people to slow down, take a breath and enjoy the simple things in life."

DESIGN
DIRECT DESIGN STUDIO
LOCATION
MOSCOW, RUSSIA
CREATIVE DIRECTORS
DMITRY PIORYSHKOV,
LEONID FEIGIN

"It gives us great pleasure to work
on designs for festive mailings and
agency souvenirs. It is both an original
test and a form of relaxation for us;
in each piece of work we put a part of
our soul."

DESIGN
DIESEL DESIGN
LOCATION
SAN FRANCISCO, USA
CREATIVE DIRECTOR
JEFFREY HARKNESS
CREATIVE TEAM
JOSH GLENN, MARCO CONTRARAS

"At Diesel, we always strive for maximum interactivity with a nod towards traditional design principles. These pieces attempt to make a visual and tactile impact without overwhelming the recipient."

D-I-Y Snowperson^{PC} Kit

Seasons greetings!
In the spirit of goodwill please accept your very own
D-I-Y Snowperson^{PC} Kit from Eye II Eye Communications.

Instructions:

1. Wait until the snow lays around about, deep and crisp and even.

2. Assemble snow in usual fashion by rolling some snow around in some snow
 until large enough to form torso of Snowperson^{PC}.

3. Repeat step 2 with a lesser quantity of snow and place on top of torso.
 This will form the Snowperson^{PC} head.

 You are now ready to use your D-I-Y Snowperson^{PC} Kit!

4. Simply remove carrot and pieces of coal from Air Box™. Sufferers of
 'burstophobia' may wish to receive assistance from a work colleague or friend.

5. Follow the diagram below and carefully inserting the carrot and pieces of coal
 into the Snowperson^{PC}.

 See how your Snowperson^{PC} face starts to magically appear!

For a truly original Snowperson^{PC} why not try experimenting with different carrot and
coal arrangements of your own. The addition of a hat, pipe or wig can also be fun.

Send us a photograph of your Snowperson^{PC}. There's a bottle of champagne for the
most creative use of the items in this pack. Please post or e-mail your entry to Tina,
Eye II Eye, 68 Oxford Street, London W1N 1BN, or tina@eyeiieye.co.uk.

DESIGN
PERCEPTOR (FORMERLY EYE II EYE)
LOCATION
LONDON, UK
CREATIVE DIRECTOR
TONY O'BRIEN
CREATIVE TEAM
ADRIAN BRITTON

"We wanted to produce a piece
that was a bit of fun and engaged
our clients – we also prayed for
some snow!"

DESIGN
LANCER DESIGN PTE
LOCATION
SINGAPORE
CREATIVE DIRECTOR
MARK PHOOI
CREATIVE TEAM
MUHAMAD YAZID M., KAREN MAH

"The design concept for this greeting card was based on that of our latest published book *Discover Singapore* – the first publication in our exclusive series on travel in the Asia-Pacific region. The festive card, aimed at generating awareness for *Discover Singapore* and our new initiative in publishing, was sent to hotels, clients and other business associates."

DESIGN
THOMAS HEATHERWICK STUDIO
LOCATION
LONDON, UK

"We produced several hundred cards, which we hope will have flummoxed and amused the postmen and recipients around the United Kingdom and abroad."

DESIGN
SIBLEY PETEET DESIGN
LOCATION
DALLAS, USA
CREATIVE DIRECTOR
DON SIBLEY
CREATIVE TEAM
BRANDON KIRK

"Dallas, Texas rarely sees snow around
the holidays. We designed a holiday card
with a series of die cuts that allow the
recipient to build their own snowman
regardless of the weather outside."

DESIGN
MINALE TATTERSFIELD
& PARTNERS LTD
LOCATION
RICHMOND, UK
CREATIVE DIRECTORS
MARCELLO MINALE,
ALEX MARANZANO
CREATIVE TEAM
MARIO POTES, LIZ JAMES,
IAN DELANY

"We always enjoy doing festive mailers, especially our own. They are one of the few occasions when you can use creative wit and humour, without being constrained by restrictive guidelines."

DESIGN
J WALTER THOMPSON
LOCATION
BUENOS AIRES, ARGENTINA

"Every year end we want to
share a positive message for the
future with a humorous and
light-hearted approach."

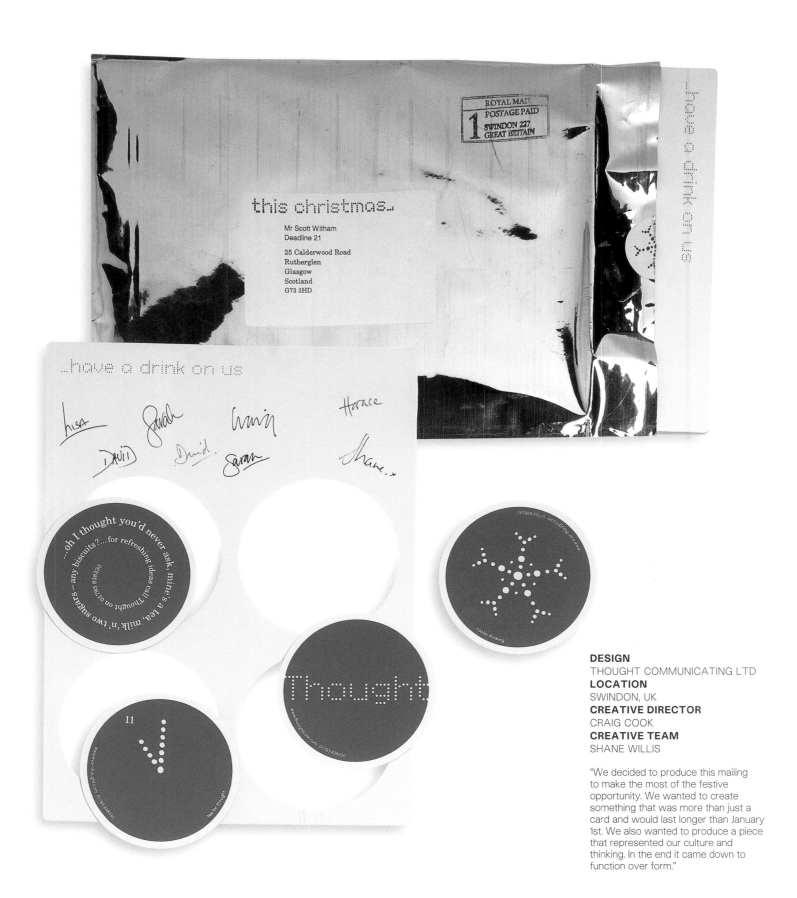

this christmas...

Mr Scott Witham
Deadline 21

25 Calderwood Road
Rutherglen
Glasgow
Scotland
G73 3HD

...have a drink on us

DESIGN
THOUGHT COMMUNICATING LTD
LOCATION
SWINDON, UK
CREATIVE DIRECTOR
CRAIG COOK
CREATIVE TEAM
SHANE WILLIS

"We decided to produce this mailing to make the most of the festive opportunity. We wanted to create something that was more than just a card and would last longer than January 1st. We also wanted to produce a piece that represented our culture and thinking. In the end it came down to function over form."

DESIGN
RSW CREATIVE
LOCATION
DALLAS, USA
CREATIVE DIRECTORS
PAUL JERDE, BRAD WINES
CREATIVE TEAM
KRISTIN BAXTER, CRAIG CRUTCHFIELD, STEVE STAFFORD

"We try to send mailers to prospects on a monthly basis. Most are very business-oriented: article reprints, white papers on marketing strategy and such. Our annual holiday mailers allow us to step back and have fun. They're basically designed to entertain, show our personality, and extend a bit of goodwill."

DESIGN
LIPPA PEARCE DESIGN
LOCATION
LONDON, UK
CREATIVE DIRECTORS
HARRY PEARCE, DOMENIC LIPPA

I

WITNESS

23920145191 9

DESIGN
LIPPA PEARCE DESIGN
LOCATION
LONDON, UK
CREATIVE DIRECTORS
HARRY PEARCE, DOMENIC LIPPA

NO'S
RIGHT

YOURSELF

RNOAD

PAINTING

123 456 789

OFTENOFTEN
OFTEN OFTEN
OFTEN OFTEN
OFTEN
OFTENOFTEN
OFTEN
OFTENOFTEN
OFTENOFTEN
OFTEN
OFTEN OFTEN
OFTEN OFTEN
OFTEN
NOT

LAID

WA YS

BLOOD
WATER

LOOK

LOOKLEAP

A M
P M

HE ADA CHE

BLIND

MANOEUVRE

BIT

i's RIGHT i's

WRITING

LOOK
LOOK

HEARTED

AU
X2

FLATS
FLATS
FLATS
FLATS

SCREW

RIVER RIVER RIVER RIVER
RIVER RIVER RIVER RIVER
RIVER RIVER RIVER RIVER
RIVER RIVER RIVER RIVER
RIVER RIVER RIVER RIVER
RIVER RIVER RIVER RIVER

DESIGN
LIPPA PEARCE DESIGN
LOCATION
LONDON, UK
CREATIVE DIRECTORS
HARRY PEARCE, DOMENIC LIPPA

"All our festive mailings explore
typography, humour and wit. Each has
a unique approach defined by the
changing subject matter for each year."

i met a man who wasn't there

O

work, walked a plank, these bubbles mark

∞ ⊕ ∘ ∘ ∘

where Hank sank

s-i-o-u-x
sioux-e-y-e
eye-?-n-l
g-h-o-d
sighed
sioux.eye
sighed?

he wasn't again today

DESIGN
PYLON
LOCATION
TORONTO, CANADA
CREATIVE DIRECTORS
SCOTT CHRISTIE, KEVIN HOCH
CREATIVE TEAM
GILL AIKEN, JOSH THORPE

"People get a lot of Christmas cards so we try to do something a little out of the ordinary each year. These promotions give us a chance to have a bit of fun, experiment with unusual methods and materials, and help maintain our reputation for creativity."

Reserved Parking for the Last-Minute Christmas Shopper

Happy Holidays from the gang at Pylon

DESIGN
INTERDESIGN
LOCATION
PARIS, FRANCE
CREATIVE DIRECTOR
MARC PIEL

"Our end of year mailing is a way of saying thank you to all our past clients, suppliers and friends. We are a product design office, so we try to add a third dimension to the 2D paper. We always get tremendous feedback."

DESIGN
EGG DESIGN & MARKETING
LOCATION
LONDON, UK
CREATIVE DIRECTOR
CHRIS PERFECT
CREATIVE TEAM
SARAH BLACKBURN

"Every Easter, our clients enjoy receiving our chocolate Easter eggs. But Christmas is a challenge – thinking of new ideas each year that involve an egg is lots of fun."

DESIGN
AMOEBA CORP
LOCATION
TORONTO, CANADA
CREATIVE DIRECTORS
MIKEY RICHARDSON,
MICHAEL KELAR

"We wanted to produce something fun and collaborative to give recipients the idea that the message was from all of us – our entire staff. The robot is our 'mascot' so we're constantly having fun with new projects involving it."

DESIGN
FRONT PAGE DESIGN
LOCATION
GLASGOW, UK
CREATIVE TEAM
JOHN TAFE, FELICITY JOHNSON

"We wanted to put a smile on our clients' and suppliers' faces with a fun and memorable gift that they could enjoy over and over. Jingle balls delivered with impact."

DESIGN
R DESIGN
LOCATION
LONDON, UK
CREATIVE DIRECTOR
DAVID RICHMOND

"It's a great excuse to keep in touch and also remind people you're still around."

DESIGN
CITRUS
LOCATION
LEICESTER, UK
CREATIVE DIRECTORS
STEVE MEADES, JIM COOPER

"We produce a festive mailing because there is a challenge in taking a very traditional theme and creating something that is not only 'different' but acts as a great self-promotional item."

DESIGN
BAER DESIGN GROUP
LOCATION
EVANSTON, USA
CREATIVE DIRECTOR
TODD BAER

"A twist to the season! This holiday
promotion for the Baer Design Group
spread holiday cheer and promoted our
corporate identity services."

Have we twisted the
holiday season too far
for commercial gains?

Happy Holidays
BaerDesignGroup

Bocce Gift
"The Bocce Ball gift concept followed on from the previous year's gift of pasta. Again, it was meant to symbolise a time when friends and family get together. Bocce is true to our Italian heritage and a hell of a lot of fun to play. Our Christmas party was held at a local Bocce court where the entire agency learnt to play (it gets easier after a few vinos, by the way)."

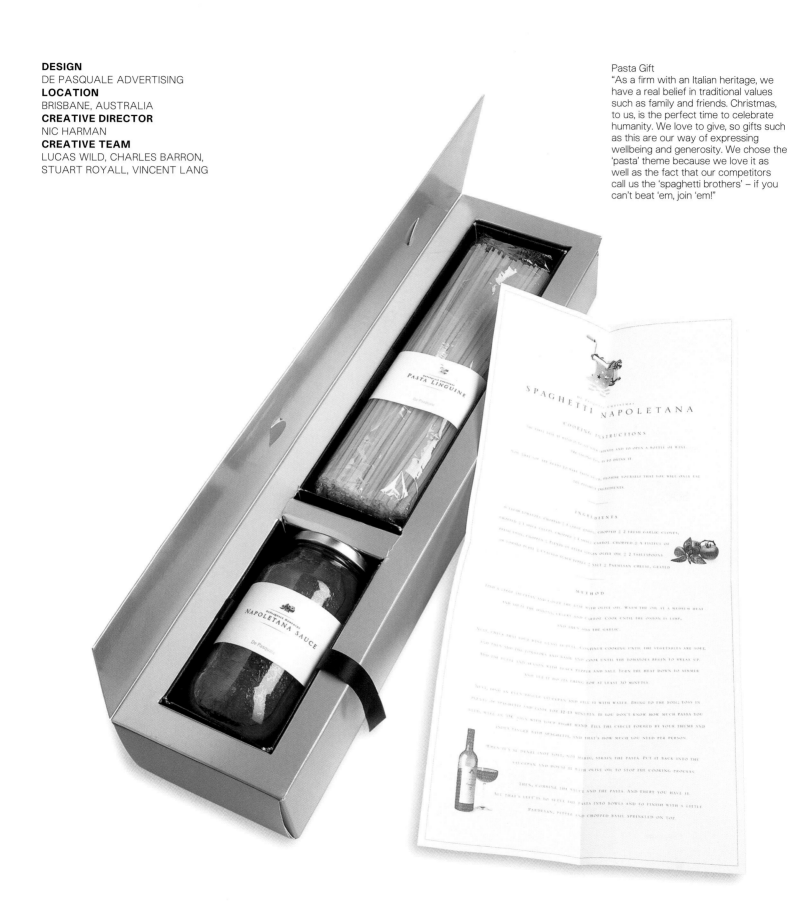

DESIGN
DE PASQUALE ADVERTISING
LOCATION
BRISBANE, AUSTRALIA
CREATIVE DIRECTOR
NIC HARMAN
CREATIVE TEAM
LUCAS WILD, CHARLES BARRON,
STUART ROYALL, VINCENT LANG

Pasta Gift
"As a firm with an Italian heritage, we have a real belief in traditional values such as family and friends. Christmas, to us, is the perfect time to celebrate humanity. We love to give, so gifts such as this are our way of expressing wellbeing and generosity. We chose the 'pasta' theme because we love it as well as the fact that our competitors call us the 'spaghetti brothers' – if you can't beat 'em, join 'em!"

DESIGN
AFTER HOURS CREATIVE
LOCATION
PHOENIX, USA
CREATIVE DIRECTOR
RUSS HAAN

We'd like to punch
a few holes in your
holiday plans.

But we thought
you'd rather do it
yourself.

bags

sand

hole punch

DESIGN
AFTER HOURS CREATIVE
LOCATION
PHOENIX, USA
CREATIVE DIRECTOR
RUSS HAAN

"For an idea to make the cut as an After Hours holiday mailing, we apply the following criteria: it must involve an activity; every component of the activity must be able to be included in the piece; it must be something that can be done with kids; it must not be about Christmas only; it must have potential for politically incorrect copy; and it must be able to be mailed."

/ THE WORK /

RECT DESIGN / AFTER HOURS CREATIVE / LIPPA PEARCE /
RSW / AMOEBA / TOP / FRONT PAGE / SIBLEY PETEET / THE EG
EYE II EYE / THOMPSON / GS / SUKA AND FRIENDS / TRICI
ANCER / KRAFT & WERK / MAX & CO / VIRGIN / PHILIPP UNI
ICK CLARK / THINKING CAP / WPA / CENTO PER CENT
MAGINATION / BLATMAN / GRAPHIC PARTNERS / WILLIAMS &
ORRIS / ONE O' CLOCK GUN / KBDA / BUREAU GRAS / 999 / C
HAPIRO / RIORDON / FOUNDATION 33 / SINCLAIR LEE / WYSIV
EAD TO HEAD / NOFRONTIERE / TWIST / FIELD / BLUE / KYSO
OT / 344 / LABEL / CDT / HOWDY / HEARD / DODDS / SELBY
RESCENT LODGE / IDENT / NAME / APART / NB STUDIOS / LE
AVAGE / HOOP / TRAFFIC / THIRD PERSON / BLOK / VANILL

NTERBRAND / PEMBERTON AND WHITEFOORD / BROWNS /
NEW ENGLISH / MELTON / PROCTOR & STEVENSON / IRIS / CL
F PAINT / BALENA CORPORATION / CPD / CAHAN / GUNTER
DE PASQUALE / STOCKS TAYLOR BENSON / R DESIGN / CITRU
GG / INTER DESIGN / HEATHERWICK / DI CREW / PYLON /
RICKETT & WEBB / HM&E / BIG GROUP / MINALE TATTERSFI
ND KEUNTJE / PLUS ONE / SUTTON COOPER / SJI / ID2 / MET
HERRY / HOLLIS / BD-TANK / THOUGHT / DEAF EYE / IMAGIN
CTUAL SIZE / METHODOLOGIE / INKAHOOTS / MOTIVE / M
REATISCOPE / STILL WATERS RUN DEEP / SAYLES / PCI / C
WYSIWYG / FRCH / GRAY / ABM / ZEN / CUTTS CREATIVE / PY
YSON / PENTAGRAM / DEVER / CATO PURNELL / GBH / ON
SELBY / SPRINGETTS / TAXI / BOBS YOUR UNCLE / GLAZ

[Opposite]
GS Design
Wisconsin, USA

[Below]
The Open Agency
London, UK

The agency Christmas gift. It's the hardest brief of the year, but in a strange kind of way, it's the one we enjoy the most. Truth is, we love to give, and we love to create things of beauty. Maybe it's because we have a culture that is very family-like; maybe it all comes from our Italian heritage. The gift is a small token of thanks to our alliance partners – our clients and our suppliers. We love having them around, and we love working with them. Yet we acknowledge that our gift is comparatively small in relation to their contribution to our business success, so we try to make it heartfelt. We look for gift ideas that are sincere, that celebrate the spirit of Christmas and that reflect our agency's personality.

Nic Harman
De Pasquale Advertising
Brisbane, Australia

India – colour, design, exuberance, a blend of tradition and modernity. Modern Indian work blends individual style with heritage to create a whole new tradition. We like to put our greetings cards into a design that fuses the reality of our present with the rhythms of India's past.

While India is in our blood and bones, our designs reflect today's satellite TV world, a world that flashes by at the speed of light. Our holiday mailers, by their design, catch the moment when one year dissolves into another. As our name suggests, what you seek is what you get: we seek the opportunity to express wishes and welcomes in our own very special way.

Nidhi Harlalka
WYSIWYG Communications
Calcutta, India

By the time we get round to thinking about our own Christmas card we are usually punch drunk and looking forward to the New Year. We might well have been thinking 'Christmas' for some of our clients since spring! It's quite hard to get Christmas mailings right. You can't be sentimental, but it's not a good idea to be offensive. If a Christmas card is based on humour, the joke needs to sneak up on you, rather than shout in your face. My own favourite was from a Dutch design group. It was a very simple postcard of a group of absolutely miserable people, 'celebrating' over their pints in a nondescript bar. I was sure they were Dutch – it turned out they were Irish! Truly, we are all Europeans now.

Lynn Trickett
Trickett & Webb
London, UK

FOREWORDS

Festive client gifts are essential self-promotion pieces that offer an additional opportunity to communicate with your clients. The creation of these gifts can open many doors and expand the client's vision of what you are as a company. The gifts showcase work that goes well beyond what clients have already seen. For instance, if you don't normally do much packaging work, highlight your creative strengths in package design. Or, if your company would like to do more interactive work, include an interactive CD .

Consider developing a piece with the participation of all staff members. Allow junior designers, account executives and PR staff to add their ideas. Demonstrate the wealth of creativity in your studio and how

instrumental each staff member is to the success of your company – a side often not seen by your client.

Rarely is the financial investment as important as the creativity. Small studios are just as able to impress a client as large ones. Your goal should be to create a gift that is memorable, that leaves a lasting impression. It should be seen by many and displayed in offices for months afterwards. People like to see their name beautifully rendered – it makes them feel special and important. And no matter how humble we like to think ourselves, we all enjoy being recognised. Take the opportunity to make someone feel good.

Although Christmas is a holiday widely celebrated it is also a hectic time when gifts can go unnoticed.

You may choose to give your gift at a different time, to demonstrate that your agency embraces, values and recognises diversity while also standing apart from the many gifts received at Christmas.

Find a holiday that appeals to you and to your company's philosophies. You don't have to limit yourself to traditional holidays – remember, gifts will be welcomed at any time of the year. How about a gift for Burns' Night, Groundhog Day or the Solstice?

Be creative, enjoy the process and let your clients know that they make your business a success!

Valerie Elliott
iD2 Communications Inc
Victoria, Canada

[Opposite]
CDT
London, UK

[Below]
The Open Agency
London, UK

The holidays are pure torture!

Family obligations, strapped budgets, not enough time and unrealistic 'goody goody' feelings combine to send everyone to the brink of insanity. We thought if we could distract our clients and those around them with humorous activities and an irreverent thought or two it might be a good thing. If they actually ended up with something they could give as a gift, play with or just enjoy, then so much the better. And hey, if it was actually designed nicely, why then suddenly the day would be brighter, the snow would be cleaner and the world would be a happier place. Really. Especially the snow part.

Russ Haan
After Hours Creative
Phoenix, Arizona, USA

Creating a totally different Christmas card every year gives us the chance to send our best wishes in an original way and show off our design skills to our clients and colleagues.

I never sit down to create a Christmas card; the ideas for them simply crop up in the strangest places. Our card for 2001, the plant-inserter and Christmas tree seeds, came about during a holiday in Greece while basking with my sketch pad in the sun. Every year I develop more Christmas ideas, so we have some in stock for the future. I hope to create another great Christmas card for 2002, perhaps during my holidays in France! After all, there is nothing more beautiful than the development of a brilliant idea.

Ruud Winder
Bureau Gras
Alkmaar, Netherlands

Jumping on the festive bandwagon as we do at the back end of every year, the perennial creative spectre raises its ugly head. As if we haven't got enough on our minds, the annual creative challenge creeps up on us, bearing with it the opportunity to flex our creative muscle within a boundless seasonal brief that takes its roots in the arena of the humble greetings card.

At worst, the creative process offers thinly veiled and highly inappropriate promotional sales messages often (thankfully) to hilarious effect. At the tip of the creative iceberg, though, some brilliant ideas break the surface, proving that this is a time to lay down the creative gauntlet and show what you can really do.

Stuart Gilmour
BD -Tank
Glasgow, UK

FOREWORDS

The process of design is a constant flow of gathering and outpouring. Many thoughts and ideas don't seem to fit within the straitjacket of a project. Nevertheless, they are worthy of a home. Some ideas are saved, and, if they stand the test of time and scrutiny, they become our seasonal card. Our seasonal piece has always been used to draw attention to, or raise money for, a charity. A founding principle of Lippa Pearce was that we would donate design time and energy freely every year to Human Rights. Our seasonal card is one small aspect.

Harry Pearce
Lippa Pearce Design
London, UK

For me, creating a self-promotional piece of work is a job like any other. It always starts with the same three simple questions: who am I talking to; what do I want to say; and how will I say it? How does it differ from work for any client?

The main difference is that in self-promotion you have also to play the role of the client – and an ideal one at that; a client who is brave, open-minded and who you know well. In short, the road to your creativity lies wide open. And that is a challenge I am always pleased to take.

Damijan Vesligaj
Kraft & Werk
Maribor, Slovenia

The 21st century saw huge revolutions in communication and today we persist in giving one another cards and heartfelt mailings. We impart our humour and thoughts several times a year in these massive migrations of cards and souvenirs all over the world. Therefore it gives us great pleasure to produce our agency festive mailing year after year. It's both a creative challenge and a great source of fun.

In each holiday mailing we send out, we like to think our thoughts and hopes for the New Year travel with it.

Dmitry Pioryshkov
Direct Design Studio
Moscow, Russia

[Opposite]
Motive
Phoenix, USA

[Below]
Citrus
Leicester, UK

EVERY YEAR DESIGNERS ARE FACED WITH THE SAME PAINFUL DILEMMA – WHAT SHALL WE DO FOR THE AGENCY FESTIVE MAILING? IT MUST BE HIGHLY CREATIVE, IT MUST DEMONSTRATE OUR ABILITIES... AND ALL OUR COMPETITORS ARE DOING THE SAME THING AT THE SAME TIME

INTRODUCTION

Looking at the vast array of astonishingly imaginative ideas produced on one simple and very repetitive theme – Christmas, or its non-Christian counterparts – I had long harboured the desire to produce a book containing nothing but the best creative solutions from agencies worldwide which use the festive mailing as a vehicle to show off their talents. Designers use reference material covering the range of the creative spectrum. Why not a collection of self-promotional festive mailings from the best agencies in the world?

After contacting only a handful of agencies, it became clear not only that there was a wealth of work waiting to be showcased, but that the creative industry was willing to support such an idea. Word soon began to spread.

After two years of exhaustive collection and mailing campaigns, an estimated 8,000 agencies had been made aware of the quest to gather material for the book – a project that, however unlikely it may seem, was the first of its kind.

The submission rate and enthusiasm shown by the global design community left me speechless. Work arrived by the vanload and letters of support and phone calls of interest came daily. The quality and variety of the samples submitted – from the USA, Russia, Australia, Argentina, Europe, India and the Far East – was breathtaking.

As a work of reference, this book was created to be a tool for designers: to demonstrate the use of humour, materials and pure imagination when creating an agency mailing.

I hope you share my enthusiasm for this exceptionally creative selection.

Scott Witham
Creative Director
Traffic Design Consultants
Glasgow, Scotland
scott@traffic-design.co.uk

This holiday season some kids will get

"Jack"

No toys, no games, no nothing.
Together, we can change this.

Please place a new toy in this box for a child of
a family in need -- green boxes for boys, orange
boxes for girls. Boxes should be returned to
St. Vincent de Paul by December 18th. Your
gift then will be given to a very special child.
So fill this box and pass out Joy, not Jack.

Thank you.

CONTENTS

The Open Agency
London, UK

FESTIVE GRAPHICS

The art and design of self promotion

RotoVision

DIRECT DESIGN / AFTER HOURS CREATIVE / LIPPA PEARCH
DE PASQUALE / STOCKS TAYLOR BENSON / R DESIGN / CITRUS
RSW / AMOEBA / TOP / FRONT PAGE / SIBLEY PETEET / TH
EGG / INTER DESIGN / HEATHERWICK / DI CREW / PYLON
DIESEL / EYE II EYE / THOMPSON / GS / SUKA AND FRIEND
TRICKETT & WEBB / HM&E / BIG GROUP / MINALE TATTERSFIEL
LANCER / KRAFT & WERK / MAX & CO / VIRGIN / PHILIPP UN
KEUNTJE / PLUS ONE / SUTTON COOPER / SJI / ID2 / METHO
NICK CLARK / THINKING CAP / WPA / CENTO PER CENTO
SHERRY / HOLLIS / BD-TANK / THOUGHT / DEAF EY
MAGINATION / BLATMAN / GRAPHIC PARTNERS / WILLIAMS
PHOA / ACTUAL SIZE / METHODOLOGIE / INKAHOOTS / MOTIV
MORRIS / ONE O' CLOCK GUN / KBDA / BUREAU GRAS / 99
CREATISCOPE / STILL WATERS RUN DEEP / SAYLES / PC
OPEN / SHAPIRO / RIORDON / FOUNDATION 33 / SINCLAIR LE
WYSIWYG / FRCH / GRAY / ABM / ZEN / CUTTS CREATIV
PYRAMID / HEAD TO HEAD / NOFRONTIERE / TWIST / FIEL
BLUE / KYSON / PENTAGRAM / DEVER / CATO PURNELL / GB
ONIO / WHY NOT / 344 / LABEL / CDT / HOWDY / HEAR
DODDS / SELBY / SPRINGETTS / TAXI / BOBS YOUR UNCL
GLAZER / CORE 77 / CRESCENT LODGE / IDENT / NAME / APAR
NB STUDIOS / LEWIS MOBERLY / THE CHASE / RICKABAUG
CRENEAU / NLA / SAVAGE / HOOP / TRAFFIC / THIRD PERSO
BLOK / VANILLA / BELYEA / CONRAN / STATICREATIV
ARTHAUS / JONES / AND / PREJEAN LOBUE / SAATCHI & SAATC
CARTER WONG TOMLIN / DUFFY / WASSCO / CHECKLAN

A RotoVision Book
Published and distributed by
RotoVision SA
Route Suisse 9
CH-1295 Mies
Switzerland

RotoVision SA
Sales & Editorial Office
Sheridan House
112/116A Western Road
Hove
BN3 1DD
UK

Tel: +44 (0)1273 72 72 68
Fax: +44 (0)1273 72 72 69
Email: sales@rotovision.com
Website: www.rotovision.com

Copyright © RotoVision SA 2004

10 9 8 7 6 5 4 3 2 1

ISBN 2-88046-791-8

Book design by Scott Witham and
Traffic Design Consultants, Glasgow.

Photography by Xavier Young and
individual agencies.

Reprographics in Singapore by
Provision Pte Ltd
Tel: +65 6334 7720
Fax: +65 6334 7721